Murat Ülker

Leadership in a Time of Crisis

Simple Explanations of Complex Topics

Edited by Prof. Dr. Ali Atıf Bir

PETER LANG

Berlin - Bruxelles - Chennai - Lausanne - New York - Oxford

Bibliographic Information published by the Deutsche Nationalbibliothek
The Deutsche Nationalbibliothek lists this publication in the Deutsche
Nationalbibliografie; detailed bibliographic data is available online at
http://dnb.d-nb.de.

Library of Congress Cataloging-in-Publication Data
A CIP catalog record for this book has been applied for at the
Library of Congress.

Illustrations: Emre Senan

ISBN 978-3-631-90072-7 (Print)
E-ISBN 978-3-631-90122-9 (E-PDF)
E-ISBN 978-3-631-90496-1 (E-PUB)
10.3726/b21294

© 2024 Peter Lang Group AG, Lausanne
Published by Peter Lang GmbH, Berlin, Germany

info@peterlang.com - www.peterlang.com

This publication has been peer reviewed.

Contents

Business

Other Topics

Business

Telework

It is said that every cloud has a silver lining, and now this saying has become an indispensable part of the future. Human Resources (HR) managers have agreed that some work may be done remotely (from home) as they move to a new, sparse (social distanced) office setup. However, it seems as if it is going to be difficult for all of us in some way or another, to leave office life and give up our old habits.

On the other hand, it is not easy even for a workaholic like me to maintain discipline remotely (from home), study, motivate myself, and finally realize the criteria for success (KPIs)! However, I love teleworking and have even grown accustomed to working remotely.

It has been somewhat prophetic, and I feel fortunate. My highly skilled friends, whom I had trusted with the management of our two primary businesses and with Yildiz Holding before Covid-19, became CEOs. When I transferred my position to my beloved nephew Ali Ülker, whom I have worked with for three decades, I decided to work remotely as an activist main shareholder and a consultant in my field of expertise (i.e., innovation, etc.) in pladis, and Godiva, but in real terms, as chairman of the board.

My goal is not to avoid visiting the office at all, nor to not even extend the weekend by working remotely or only by working remotely on Fridays and Mondays, but rather, for example to give the choice to my senior managers and guests who work with me remotely for meetings at the office, or those who lose time in desperate delays, reducing their stress. In short, my goal is to provide satisfaction. Except for the market and facility visits and team meetings, which we can call work on-site, it consists of business reviews (QBR), board meetings, and meetings in the office, which I have already been doing. After a recent business results review meeting, I decided to continue these meetings via telework with my CEO friend after the pandemic as both focus and time efficiency are higher. As of yet, I still do not feel comfortable when I join a physical meeting remotely, where everybody else is physically present or vice versa.

I mean that telework will be the accepted norm for the new generations, as some professions that have been eliminated thanks to the use of robotic software (bot) and artificial intelligence (AI), will allow this to happen. In comparison, all current educational systems, with a few exceptions (e.g., Finland), seem to be constructed to train bureaucrats and technocrats for rigid office life.

What I mentioned in the conclusion (see below) of an article I previously shared, is important and those are the subjects I expect will be pursued and

realized. However, the main permanent change will take place when the youth, who have been trained for telework for the necessities of the new work life, enter the world of work.

The youth who can motivate themselves in this new business life, have self-discipline and can spread the balance of work and private life over twenty-four hours and the entire year, balancing not only a work agenda but also their personal life, and not limiting work and entertainment only to physical environments, but also young people who are active in online platforms.

In conclusion, our suggestions for the immediate implem entation of the above projects are as follows:

1. In order to obtain efficiency when doing telework, first, an office should be set up in the home with material, technical equipment, and support from the company.
2. The teleworker must do at least one day of work in the company office; this working day should be fixed, and services such as the central office dining room and service should be adapted to this approach. Teleworkers should not take advantage of flexible working hours.
3. Priority should be given to the teleworking staff's work processes, technology, and software support that enable them to see the whole process; this software should be extremely simple, and technological problems and complexities should not be an obstacle. It should not be forgotten that the Teams application is currently widely used throughout Yildiz Holding.
4. Daily, weekly, and monthly performance management applications should be adapted for employees, and KPIs should be provided through this application. Safety and convenience features should be the most important issues in the applications that are used.
5. Supporting the teleworker to show the entire work, providing communication and cooperation, and enabling them to work fast are the factors that increase the satisfaction of the teleworker in business life. These projects should be put into operation simultaneously.
6. Another important issue concerns the training, motivation, and mental state of the teleworker and regular follow-up on these. These applications should be implemented as soon as possible. At Yildiz Holding, there is now an application that asks employees "how are you?" every day with the help of AI. This application will be expanded.
7. When developing all systems, processes, and applications, the primary principle should be utilizing AI analysis and bots (robotic processes).

8. The fact that telework is a permanent part of our way of doing business depends on the quality of leadership that is put forward when all projects are implemented and afterward. Leaders should be visible, clear, communicate well, and barriers in the middle should be eliminated with the HR department in order to keep the home employee connected with the company.

Our Subject Is Innovation and Our Future

During the Covid-19 pandemic, businesses suffered, some went belly up, and some will revive. But how? The quarterly business results made me suspicious. Then I researched how to revive our related business, that is, B2B, and ensure other successes continue to flourish. Changing the way we do business will make our business sustainable. Do not be complacent – your turn is also coming!

Experiencing science and positive science mean reaching the truth through trial and error. We should not be content with testing and validating conclusions drawn from distilled theorics about practical life. It is quite difficult for us to achieve the necessary innovations in today's competitive conditions at the desired speed! Yet, if we were able to create a single leaf that produces energy through photosynthesis or a cow-eating grass and delivering milk and meat, we would have neither hunger nor environmental problems. Hopefully, one day in the future… Sometimes I ask myself, how did technology develop when there were no wheels?

Perhaps, before the theory we should put the goal at the center of life, and the lesson we will then learn from life is not to focus on what happens in nature but on how it happens.

Renato Bruni's book *Erba Volant: Neuf Histoires Formidables et Scientifiques sur l'Esprit pratique des Plantes et leur Sens de l'Innovation* explores the issue of learning innovation from plants. Bio-innovation is a branch of science that aims to find solutions to our problems by studying and inspiring nature. It proposes both technological and sociologically sustainable, environmentally friendly solutions. Bruni proposes that in bio-innovation, nature is not only an aesthetically inspiring source but also possesses the most suitable shapes, strategies, materials, and more for the study of dynamics. In other words, this is a science that uses the knowledge gained by examining other living things to design products that are both beneficial to people and environmentally friendly. Importantly, it may be wrong to consider bio-innovation as simply a copy of ordinary nature because biological structures are too complex to be imitated. Therefore, experts working in this field investigate nature extensively to find and understand the functions and systems that can be transferred to products.

A second good example is James L. Adams' *Conceptual Blockbusting: A Guide to Better Ideas*, which also makes us aware of the mental and physical obstacles that prevent us from creating value. Based on the human body, he discusses the miracle of our biology. In order to develop a new thought, we primarily put ourselves and/or remove the obstacles that exist around us,

allowing us to realize ourselves and our capabilities, and teaching us ways to develop new thoughts. In this book, by Adams, a professor at Stanford University, published almost thirty years ago and updated this year, he discusses in great detail how one can find a good idea. We call this innovation, but how one finds the initial idea is very important. Accessing information has become easy today. When we were students, we had to walk around the library to find resources. We used to skim through journals to come up with different ideas. Is that the case anymore? No, we have Google, the world's wealth of information, right in front of us, at our fingertips. How can we find a good idea with such an abundance of resources? Adams provides the answer.

Adams has pursued his academic career as a professor of both industrial and mechanical engineering. Prior to his career in academia, he also took part in the team that designed the first spacecraft produced by NASA. Adams published the first edition of his book in 1974 for a problem-solving course he has since taught for many years. This book, which has been released in many editions over the years, is currently up to date with the author's own recent additions. In fact, although many topics have been taught to us, we recognize that no one has taught us how to think and cannot teach this. Adams suggests that we can gain better problem-solving skills and approaches to discovering ideas, especially by recognizing the various obstacles. Choosing a particular strategy as the best way among many ideas or concepts can work in problem-solving. That's why many interesting mental exercises and puzzles are included in Adams' book.

Adams talks about six basic obstacles: perceptual, emotional, cultural, environmental, intellectual, and expressive. The author emphasizes how these obstacles can occur and how they should be worked through in order to eliminate them.

Perceptual obstacles are related to more people perceiving a subject. To solve a problem, it is necessary first to define it. The inability to identify a problem or to access information or data required to solve a problem actually falls into this category. Our minds can create these barriers in various ways. For example, generalizing or stereotyping is a perceptual obstacle. Apart from that, defining a problem or isolating a problem is a common obstacle. Having too much data, not being able to evaluate a subject from different perspectives, or using sensory inputs can also prevent us from solving a problem; it can stop us from finding the ideas we want. Perceptual obstacles are described in detail in this section, with examples from different fields.

Emotional barriers are those that take away our ability to solve problems. Because emotions are mixed and not always easily identifiable, we can get drowned in emotions. We may feel dark or feel happy. Moreover, we also

have fears. Emotional obstacles consist of all kinds of fear, anxiety, insecurity, and other emotions that take us away from a perspective that will solve a problem. We can be afraid of taking risks, uncertainty can make us uneasy, and it may be easier to judge rather than think of something new. Adams says: "It is not easy to notice the emotions you have that hinder you, but noticing what emotions you are exposed to will definitely improve your problem solving skills."[1]

As a social entity, we are a part of many cultures. We can be influenced by different cultures socially, ethnically, locally, and even globally. A culture's habits, ways of living, and thinking may also differ. Cultural obstacles are also those created by the cultures we are influenced by and in which we live. Admonitions and advice such as "Let's not discuss taboos," "Playing games is only for children," "There is no room for humor when solving problems," and "Problems are solved with a budget and money" are actually cultural obstacles. Such obstacles are embedded within our own cultural codes.

Environmental barriers, like cultural barriers, develop outside our sphere of influence. These are the obstacles imposed by our social and physical environment. Anything that distracts us physically can be included in the environmental barrier category. An ongoing phone call can prevent us from focusing on message notifications, the weather, the features of the place where we work, and more. Environmental barriers also include topics such as the environment of the non-supportive person and limited resources.

Intellectual obstacles are another type of obstacle. Lack of mental strategies and functioning or approach error fall into this category. For example, if you do not have the necessary information to solve a problem or lack mental ability, you cannot solve your problem. Or you try to solve a problem with a mathematical language, but if the problem is essentially a visual problem, the obstacle you are experiencing is of an intellectual type. To eliminate such obstacles, Adams again provides information on important topics such as the choice of problem-solving language and flexibility in using strategies.

Expressive barriers are like intellectual barriers, but are those that are related to ourselves. These are barriers that suppress your ability to express your ideas not only to others but even to yourself verbally or in writing. Adams explains, in particular, difficulties with expression through very important exercises.

The value of this book emerges in in a section that especially regarding the language of thinking. Do we think visually or sensually? Or do we think conceptually? Adams discusses the importance of determining the language of problem-solving through exercises on these issues. As you think about the conceptual issues in the book, and review and practice with your own experience, your mind becomes more prone to finding new ideas. Do you think of "brainstorming" when it comes to finding ideas? Finding ideas or solving

complex problems doesn't always happen individually. Adams' book, which has two different chapters for teams and organizations working in groups, explains very fluently the dynamics of the group, leadership, and methods of finding ideas and problem-solving that can be applied in institutions. The book is not a guide. It is also obvious that you will challenge your mind while reading Adams because the exercises in the book and the chapters that question your habits make us better problem solvers than we are today.

Esranur Kaygin's *Inovasyon mi Dediniz?* (Did you say innovation?) was written concisely as a guide for the business world. Discussed in practical, realistic terms are the following: the fundamentals of digital conversion, measures to create an invention culture, and meausures to be taken against the destinative innovation threat. Disruptive innovation, which I call "upside-down" innovation, is a real threat, and yet, many businesses ignore it. However, with digital transformation, this can become an opportunity, not a threat. Companies innovate at unprecedented speeds, and competition grows exponentially, so the need for innovation is no longer a "make/do"; rather, it's a question of how to do it. Approximately two-thirds of the innovations made in the sector we are in will disappear within three years. This equates to a serious waste of resources. Consumers understand new experiences derived from innovation. So the story behind innovation and the scenario ahead are very important. This road is also a big challenge for us. In order to navigate this path successfully, we need a spirit of creativity.

The reason why we create disruption groups at Yildiz Holding is not that we do not innovate but to be more disruptive, to make the results more predictable, so the value can be improved, and our business improved, and our innovations that strengthen our bonds with our consumers also improved. In other words, how do we internalize the innovation process by overcoming the limitations in our own minds without losing our core values, our purpose, our authenticity, and the invisible obstacles that the processes have uncovered over time and that are inspired by each other? Seek the answer to the question. If it is not known, it's time to invent it; "not possible" is impossible!

How can we connect those who have an idea to contribute to a problem, a consumer need, and/or efficiency toward a more systematic process? Radical inventions or ideas that affect people can sometimes involve a large amount of technology, sometimes uncertainty. When you have a radical invention, you may not be sure how to proceed at first. But don't let this stop you. In other words, I want the ideas that will facilitate our way of disruption, will make it clear, and will guarantee success. What do we do, and how could our innovations disappear in three years?

Kaygin summarized the basic texts of innovation in an eclectic way in her nearly 100-page book. The basic logic of the book is discussed in an article

titled "Disruptive Technologies: Catching the Wave," by Professor Clayton M. Christensen. In this article, Christensen first describes two distinct definitions of innovation that disrupt. The first is to move from the lower segment of an existing market to the upper segment, and the second is to create a new market with an innovation that upsets the new market. For example, Tesla is an upside-down innovation starting from the upper segment of the market and moving to the lower segment. In addition, disruptive business models such as Spotify, LinkedIn, Facebook, Google, Alibaba, Uber, Apple, and Netflix are examined, and Christiansen shows that each is one of the two approaches mentioned in the article.

Another brand that turns the upper segment upside down is Dyson. When Dyson launched its first vacuum, it was at a price of 3,000 dollars. With its modern design and water absorption feature, it was an astonishing appliance to many people in the upper segment. Today, the price of the vacuum is 300 dollars because Dyson has reduced its price using technological progress. Thus, it started to take a share from the lower segment. The important thing in innovation is undoubtedly to know which type of innovation will be suitable for the company's innovation strategy. In order to comply with the strategy, it is necessary to ask two questions: (1) How well did you describe the problem? (2) How well defined is the area?

Such a systematic way of thinking is important to distinguish between randomly generated ideas and organized ideas. Indeed, if you have absorbed what innovation is, you immediately realize that all four types are valid in your company. These are basic research (the type of innovation done at universities and research and development (R & D) laboratories), are better done (maintaining innovation), turn a category and the market upside down, and combine a product with the functionality of many different products. For example, Amazon merged book sales with Kindle and sold more books.

Kaygin also talks about the importance of corporate culture in order to create disruptive business models and technologies in a company. We all know about the failure of Kodak, but the details are in presented the book. In 1975, Steve Sasson (a Kodak employee) developed the digital camera, but his bosses told him to keep it to himself.

Because this idea had the potential to threaten their core business, we all know the result: Kodak, which had been operating for one hundred thirty-two years, applied for bankruptcy protection in 2012 because it was not innovative. What did Fuji do in return? It fearlessly introduced its first digital camera to the world by adopting disruptive innovation to its main business and successfully continued its business. We all know that all kinds of initiatives, start-ups, and ideas that turn upside down require marketing knowledge. Kaygin has devoted part of her book to how to adapt innovation to the market. While innovation is weighed as an idea, she states that

it should be evaluated in the fields of structuring, proposal, and experience. She explains how the revenue model should be revealed during the configuration phase; how to explain the value to business partners; how to organize the company's capabilities and assets to implement the new idea; how to create the supply chain of the product or service; how to narrate the product to the customer; and how to create customer loyalty. If you want to learn about this in-depth, it is necessary to look at the details from other resources.

In short, in order to cope with the inevitable changes in front of us, we must simply repeat the same things every day, as we always do, and try to do better/more every other day. However, that is not enough, so for to achieve continuing success, we must change the way we do business. Do not be complacent – your turn is also coming!

Reference

(1) Adams, J. (2020). *İyi Fikir Bulma Sanatı*. Istanbul: thekitap.

The End of the Plaza Empire and the Inevitable Rise of Telework in Business Life

Working from home, remote working, or teleworking is not a new concept. Before the coronavirus pandemic, there was a telework evolution that coincided with the digital revolution in the business world. This evolution turned into a revolution with the onset of the coronavirus outbreak, which overnight emptied offices all around the world, including Turkey, moving work into homes.

Nicholas Bloom, a Stanford University economics professor, was the first scientist to demonstrate evidence, as a result of his field experiment in 2015 published in a prestigious magazine, that telework improves business performance, reduces time spent on the road, puts an end to office politics, and improves work–life balance.

Ironically, Bloom switched to telework due to the coronavirus pandemic and has been working from home with his four-year-old son and spouse for around two months, teaching students at Stanford through technology.

So, did the real experiment change Bloom's views on telework? If you read this article to the end, you will learn whether or not it changed, and you will be very surprised at the result.

The Birth of Today's Offices

First, everyone knows the history of digital transformation by heart, but let's go back to the history of the "office world" to understand where the teleworking "evolution" that few people know about actually evolved.

The first office building in the world, in the sense we are familiar with, belonged to the East India Company, which was established in London in 1822 as a result of the Industrial Revolution. As the name suggests, the East India Company was associated with Britain's period.[1] It is interesting that after that time, all the world's empires collapsed, then first offices, and later the plaza empires continued to dominate in every country, even to this day. Countries' most magnificent skyscrapers were plazas. Never mind plazas, corporate identities with their silhouettes then became part of the identity of a country.

Turkey's first office buildings constructed in a modern sense were built by architect Gulio Mongeri, the Ziraat Bank General Directorate building in Ankara in 1925 and the İs Bank General Directorate building in Ankara in 1929 by Mongeri.

When Did Offices Turn into Plazas?

The word "office" was transformed into a "plaza" with business buildings built in the 1980s in the Maslak region of Istanbul. The first example of this was the Yapi Kredi Plaza buildings designed by famous architects Haluk Tumay and Ayhan Boke.

The reason for the shift from the word "office" to the word "plaza" was to change the perception of these buildings, which increased their domination in business life through the change in jargon. In fact, we can see the desire to revise the mental perception of this subject in the "studios" of artists. For some reason, artists don't have an office. Actually, "studios" are the offices of artists. However, as "office" is commercial jargon, artists took their business linguistically to the next level with the word "studio."

The transformative power of offices does not actually come from the buildings themselves or their size. Thanks to these working buildings, people started to spend more time with their colleagues and in the business environment rather than with their families. In other words, the time employees were together increased. The real transformation arose from this.

Where Did the Idea of a Holiday Originate?

In today's societies, the main thing is to work, and having a holiday is something that is done when one is not working. In Roman times, however, when people weren't vacationing was when they worked. In other words, 2,000 years ago, it was normal to take a vacation, which in Latin is expressed as *otium* (leisure time), and when they could not take a vacation, they were doing *negotium*, which is the negation of *otium*, meaning the non-existence of leisure.

Today, when it comes to business life, there is "action integrated with the sector." *Negotium*, on the other hand, was a word that felt like a vacation, that is, the denial of pleasure. It is interesting to note that the Romans did not have offices for work. They had a mobile business life with stone tablets and stone chip pens, just like our current situation. The famous writer, lawyer, and politician of 2,000 years ago, Pliny the Younger, wrote a letter to his friend Tacitus and suggested a great method for working life: "and, whilst I sat at my nets, you would have found me, not with boar spear or javelin, but pencil and tablet, by my side … So for the future, let me advise you, whenever you hunt, to take your tablets along with you, as well as your basket and bottle, for be assured you will find Minerva no less fond of traversing the hills than Diana. Farewell."[2]

In fact, if one looks at the three major religions, they all assert it is essential to work. In all primitive cultures, there is no perception of holidays

like in our present day. However, due to both social relations and religious insights, holy day holidays began to be celebrated over time. For example, in Judaism, the Sabbath is of religious origin and begins on Friday evening after the sun sets and ends on Saturday evening. The day of rest in Christianity is Sunday and is devoted to religious rituals and worship. In the history of Islam, there is no concept of a day for religious observance. Essentially, Islam recommends that people work as long as they can. Even Friday is not a religious holiday. The Quran commands us to stop shopping when Friday prayers take place, and after praying, the Quran commands people to seek sustenance from Allah's grace by penetrating throughout the Earth.[3]

Today, except for some Islamic countries, Saturdays and Sundays are public days of rest all over the world. The main thing is not to work on vacation but to work while you actually work and reward yourself.

What Do Office Employees Feel?

How rewarded do the office or plaza employees of today feel? Presently, these feelings are measured by HR departments, and programs are implemented in order to encourage employees to feel rewarded.

The history of these measurements and applications goes back to the early 1900s. With the Industrial Revolution, the scientific management era began. In order to use factories efficiently and effectively, F. Taylor's motion and time measurements were implemented, and then the same method was used to ensure employees' high performance in offices.[4] In many studies conducted with this aim in mind, when employees were found to perform better when observed, open offices were born.

Although the open office concept still continues today, various open office concepts have been tried and tested over time. For example, in 1939, because open offices increased status separation, open offices with kitchens and similar common areas emerged, eliminating these limits. Later, the concept was taken even further, and it became the *Burolandschaft* open office model born in Germany.

In this model, the aim was to develop workflow and communication among employees by using irregular geometry and organic circular models in the office layout. However, this method was criticized for increasing inefficiency in the office, and this problem was addressed through a concept called the "Action Office," but such offices were still criticized for minimizing interaction, although employees were provided customizable space.

In the 1980s, employers switched to the model called the "Cubicle Farm," which divides the same area with small panels by focusing on costs. This model was also criticized for eliminating creativity and energetic work due

to the uniform appearance of the setting. After the 2000s, due to the stress of living in big cities, the time employees spent commuting to and from work, and the intensity of increasing competition, efforts to increase the quality of the time spent at work emerged. Some of these approaches are play areas, cafes, open kitchens, meditation rooms, and plants that clean the air and increase oxygen.[5]

Today, the discussion of "open office–closed office efficient working" still continues. While one side criticizes open offices for making noise and for limited personal space, the other side insists that close proximity leads to hidden lameness. So what do employees think about this? When we investigated this question, we came across a "2019 U.S. Workplace Survey." According to this research, 77% of employees want to have both common areas and private areas where they can work and spend time on their own.[6]

It's exactly at this point that we need to draw attention to shared offices, such as WeWork in the USA, and Kolektif House in Turkey, which have become the trend in the last ten years and the numbers of which have increased as a result of digitalization.

The main reason behind the spread of such offices is not digitalization but employees' demand for both common and personal space in offices. On the other hand, in terms of the advancement of civilization, we are now living 2,000 years after the Romans; therefore, with the onset of the ages of industrialization, communication, and digitalization and the difficulty of living in big cities, it has become very important to work less and balance business and private lives.

More precisely, due to the coronavirus outbreak, plazas became less important until they were empty. Employers started to build free dining halls, free snack bars, cafes, innovation rooms, and libraries to make their new type of work attractive and to increase the time spent in the workplace by providing home-like comforts for the changing generations. But an annoying tendency for employers was beginning to emerge: increasing costs at work and laziness brought out by comfort![7] The reason for this was that the attitude of "finishing the job" as the main reason for an employee's existence began to decline.

Plazas have started to become unnecessary meetings in comfortable meeting rooms, resulting in jargon, and in producing less work rather than helping to work quickly and efficiently. Many experts agree that if F. Taylor's motion–time studies were performed again today, the results would be quite annoying.

The other point they agree on is that the majority of their employees can actually complete their work within two hours of work per day.

What Do Meetings Mean?

In 2014, Bain & Company's research found that many executives spend more than twenty hours a week in meetings. But what is important is this: these meetings are ones that the manager, in terms of goals and profitability, does not have hold! According to Perlow, Hadley, and Eun's article "Stop the Meeting Madness," published in *HBR* in 2017,[8] before 1960, meetings took less than ten hours a week for managers. This figure increased to twenty-three hours in 2017.

In the same article, the researchers presented the results from their survey of one hundred eighty-two senior managers. According to the results, 65% of the executives said that meetings prevented them from finishing work; 71% of the meetings were inefficient and ineffective; 64% prevented deepening in the thinking process; and 62% of them resulted in opportunities to escape and bring their teams together.

On the walls of Yildiz Holding, the principles about meetings as proposed by our founder, Sabri Ülker, are hung framed on the wall. Sabri Ülker was very sensitive about meeting efficiently.

We can briefly summarize his principles as follows: the meeting starts on time and adheres to the agenda; everyone expresses his/her opinion; the meeting is not interrupted for any reason; criticisms are productive and listening is important; clear decisions are made; it concludes at the specified time; and the date and agenda of the next meeting are determined. Recently, the following rules were added as well: "Who will take action regarding the strategic decisions made at the meeting and until what date?" The important thing is that meetings should not be held merely in order to have a meeting; instead, meetings should be held to make a strategic decision or to solve a problem. There should be no meeting held to solve the problems that people face while doing their daily routine. Moreover, if meetings are approached in this manner, an efficient meeting will be held.

How Did Teleworking and the Teleworking Group Originate?

As you can see from the discussion above, the idea of teleworking is not a concept that entered the business world along with the coronavirus. Rather, it was a system aimed at producing faster, more efficient, and less costly business over the years, and academicians, who had already begun to create ground with their research, and which small entrepreneurs and freelancers had to spread with the "home office" working order with the obligation of cost reduction.

The first scientific study on business results related to the teleworking method was published in the *Quarterly Journal of Economics* in 2015.[9]

An interesting field experiment by Stanford economics professor Nicholas Bloom revealed that teleworking increased job performance due to reduced time spent on commuting, to bringing about the end to office politics, and to improving work–life balance.

Bloom conducted a field experiment with 1,000 employees of the Chinese travel company Ctrip and found that the nine-month teleworker showed a 13% performance boost. This meant an extra one day more of work for each employee and a 50% quitting rate. In the experiment, four days of telework and one day of work were absolutely necessary.

A key point that Bloom emphasized as a result of his research is that 500 of the 1,000 employees who participated in the study volunteered for telework. Fifty percent of these 500 employees wanted to return to work in the office after nine months. This was because they stated that they were working inefficiently and that their mental health was impaired.

Disruptive working groups based on volunteering are very common in Yildiz Holding. The purpose of these groups is to produce ideas that will permanently change the way of doing business in order to adapt the company to a new situation in a short time and to inform the top management about the feasibility of these projects by turning them into projects.

In the early days of the coronavirus pandemic, we created a global working group based on volunteerism to adapt all of our companies under the umbrella of the Holding. With the Yildiz Holding Teleworking Disruption Group, eighty-two project ideas came from our companies all over the world. These ideas were evaluated by the Working Group in three workshop group sessions. Sixty-six ideas were directly related to telework, and nine of them were retained as draft ideas. The remaining fifty-seven ideas were combined, and were reduced to ideas for forty-four projects (Digital Competence and Communication fifteen, Business Development and Management twenty-two, and Culture and Growth seven). Then all project proposals were graded by the Working Group. What was interesting here was that the Working Group carried out all its work through teleworking.

Almost all of the projects that reached the Yildiz Holding Teleworking Disruption Group are parallel to the results of academic and applied research on teleworking, which we mentioned in this article. For example, six of them coincide with Bloom's findings as there are projects aimed at increasing the motivation of remote workers and protecting their mental health. These projects are:

> Ezgi Dogan (pladis Ülker): Organizing socializing video meetings to make remote employees feel a part of the office. Gul Senay (Sok Marketler): Creating and filling a Digital Event Calendar to keep your work motivation alive. Rasit Cebi (Bizim Toptan): Developing home office software to create work–life balance. Amy Zuckerman (Godiva): Developing a Wellness app to keep employees constantly

active. Annie Young Scrivner (Godiva): Developing a Beauty app. Caroline Le Roch (Godiva): Developing an entertaining and rewarding online social gaming application in the areas of how work is done and of performance improvement with the aim of increasing employee engagement. The following project proposals can also be seen as motivational projects through better communication.

Mahmut Sami Mulayim (Onem Gida): creating a digital library to meet the information needs of the employees. Onur Moralar (g2mEksper): Using AR to make video calls more authentic. Mehmet Fatih Devrim (CCC): Establishing a VR system to visit factories. Carlos Canals (pladis NA & Canada): Implementing cyber store check for a full inventory of locations our products are available, to craft better plans (SOYA). This may be done by developing Vispera to use in different sales regions and channels. Deniz Teymur (g2mEksper): Virtual office and customer visits. Similarly, the project proposal of Roza Altin (Onem Gida) includes improvement of the common areas and their technical equipment and the selection and use of suitable hardware and software for task management in order to support working from home and the central office. In addition, Roza Altin and Ozge Demirkol Mete (g2mEksper) recommend implementing a cultural exchange program so that different generations can work together from home as well as continuing cultural exchange with formal and distance education programs.

According to a large-scale study conducted by Gallup in 2012, the tendency of employees to spend four of five days a week teleworking is increasing.[10] In the same research, it was revealed that if a company of 500 people was teleworking for three days a week, it would save 3,000 dollars per employee per year and 8,000 dollars per employee if the tendency of employees increased to 15%.

There are also many Gallup studies showing that telework has contributed to environmental sustainability. For example, in 2015, Xerox reported that home workers used ninety-two million fewer miles, which produced 41,000 tons less carbon dioxide. Likewise, in the Sun Microsystems OpenWork program, when 24,000 people started working from home, 32,000 tons of carbon dioxide were prevented from being released into the air.

One of the suggestions for the Yildiz Holding Teleworking Disruption Group belongs to Sanne Wolters (pladis Europe). The proposal includes analyzing best practices in the world and taking the best aspects of these practices that suit the needs of Yildiz Holding. As can be seen from the Gallup research, many companies have started telework initiatives. Examining these projects will reduce errors.

As mentioned at the beginning of this article, the coronavirus pandemic turned into a revolution in the business world, and almost overnight, it emptied offices all over the world and carried them into our homes. According to a Public Opinion Survey conducted by Kadir Has University, 76% of the Turkish society does not go to work in an office due to Covid-19. However, it is not clear whether these individuals work from home.

On a questionnaire created by the website Webrazzi on Twitter, 14,942 people voted. According to this survey, the rate of home workers is 44%. There is no doubt that this result is not one that can be generalized because the samples and variables are not controlled. But we know that many large and small companies have been moving to a work-from-home arrangement for two months during the beginning of the pandemic.

At this point, we can return to Professor Bloom, who has been working at home along with his four-year-old son and family for two months. Let us ask whether Bloom's thoughts on working from home have changed. In fact, they have not changed and instead have become clearer.[11] According to Bloom, working from home when we were staying at home due to the coronavirus differs in four ways from working from home in normal times: (1) children and family, (2) workplace constraints, (3) privacy, (4) volunteering. Therefore, the results of the coronavirus pandemic cannot be compared with the results of working from home during normal times.

Bloom emphasizes that under normal circumstances, other members of the family would be at school or work, so the performance of the employee would increase. Bloom expresses that it is essential to work from home by evaluating the employee's own preferences and conditions in order to get full results from telework. Bloom suggests organizing a room as an "office" in order to ensure work efficiency. He underlines that working in the living room, in front of the television, in the corner on the shore is not "telework." According to Bloom, office work is a must once a week. Because it is not possible to have creativity and innovation without face-to-face contact, the employee should go to the workplace and take on his workplace identity for one day and reveal his personal chemistry with his personal communication experience.

Why Was Telework Adopted?

If these conditions are met and a business invests in information technologies, employees on the road may prefer the telework option to reduce costs and increase performance. Another issue that Bloom emphasized, especially for achieving success, is the establishment of a regular control mechanism for the managers' home working teams. Meanwhile, Bloom also states that changes are required in laws and regulations in order to implement the telework system more efficiently and in all sectors. Just as Bloom emphasized the indispensability of working from home, his suggestions for the arrangement of the home and the office environment and office tools associated with it are very important in home working projects.

What Do Yildiz Holding Employees Want to Do?

Many projects were proposed to the Yildiz Holding Teleworking Disruption Group, suggesting the same subject. These project proposals can be summarized as follows:

> Isil Buk (Bizim Toptan), Yasemin Dogan (Sok Marketler), Omer Karadaban (g2mEksper), Doga Unay (pladis), and Rasit Cebi (Bizim Toptan) evaluate the suitability of the home environment to obtain the desired efficiency; to bring the office environment and tools in line with the telework type of office when it comes to the office work of the same person, and to improve efficiency and cost savings while doing this.

The projects presented to the Yildiz Holding Teleworking Disruption Group are quite satisfactory in terms of the regular checking of the teams by the manager as mentioned by Professor Bloom:

> Yahya Ülker (Yildiz Holding), Ezgi Dogan (pladis Ülker): Daily, weekly, and monthly monitoring with Asana and creative KPIs. Hamide Guven Sen (Bizim Toptan): Establishing a performance system by producing and evaluating daily, weekly, monthly data. Gokce İcer (Bizim Toptan), Utkan Mentes (Most Teknoloji), and Ozge Demirkol Mete (g2mEksper): Making this system's special software for Yildiz Holding. Huriye Akcetin (pladis Global): Creating a talent pool from different countries to support recruitment difficulties for some roles. Additionally, forming a global expert pool within specific areas for consulting services wherever needed. Onder Sami Atay (CCC): Developing a project-based hourly contracted external workforce and its performance system. Rasit Cebi (Bizim Toptan), Mustafa Kabakci (pladis): Developing a "solution to frequently asked questions" app for daily routines, and especially IT problems within the company. We still do not have academic studies that reveal the details of the large home telework period of the past [two months] and their impact on employees. We only have a questionnaire that has a "task management" app, conducted by Slack, with 2,877 employees over the Internet.[12]

According to Slack's survey, inadequate process management and inadequate communication, lack of belonging, loneliness, and a sense of isolation are factors that reduce efficiency in telework. Home workers find communication through technology very tiring. However, the values increase as a result after the first month. Sixty percent of those who are still more experienced state that they perform better. The important conclusion from Slack's research is that if there is trust between the organization and the employee; if the organization has clearly stated its objectives; if the employee can see their place in the whole of their work; and if the organization establishes communication and cooperation with the help of correct and practical technology and frees the employee from the feeling of isolation, then the working order will increase productivity by producing job satisfaction. At this point, we can say that the following project proposals that reached the Yildiz Holding

Teleworking Disruption Working Group are very accurate in terms of showing the entire realm of work, providing communication and cooperation, being fast working, and contributing to increasing efficiency by providing job satisfaction:

> Selcuk Guler (CCC): From raw material to transportation, all operations are displayed on a screen for remote monitoring. Altug Akbay (pladis TR sales): Developing software that involves planning and approving the activity and campaign processes without coming together using artificial data analysis and application to robotic processes. Abdulbaki Keskin (Yildiz Holding): Establishing a daily meeting organizing system for faster, more organized meetings and follow-up and to make faster decisions and combine this with task management systems. Ibrahim Yamac (CCC): Remote signature system. Yusuf Levent (pladis – Horizon): Remote approval system to reduce paper waste, save time and record everything. Mehmet Fatih Devrim (CCC): Creating a remote work schedule to see who works where and when. Recep Ali Yilmaz (Bizim Toptan): Moving the internal phones to Teams to get a telephone connection from outside and to diversify the input sources of the meeting. Sercan Guleryuz (Horizon): Develop real-time field information software from field representatives remotely. Serhat Yunsuroglu (Onem Gida): Remote factory management system development.

Some of the project proposals received by the Yildiz Holding Teleworking Disruption Group are project proposals that are specific to Yildiz Holding and will be differentiated by addressing its different aspects:

> Adem Yilmaz Yavuz (Yildiz Holding): Developing a platform that will apply GOYA to work remotely. Amy Zuckerman (Godiva): Developing a translation app that provides subtitles according to the language you speak. In order to realize the following three projects, which are still in draft concept, the proposal owners should be informed to develop their suggestions and given the necessary support:
>
> Aylin Kadirdag (CEO Office): Connected Workplace. Zafer Ucar (pladis): Remote Sales. Enes Onder and Omer Beddur (Biskot Karaman): Performance Management/ Risk Prevention.

Due to the development history of offices, the advantages of digitalization, the difficulties of living in big cities and employees' desire to spend more time on themselves and their families, and positive results of the teleworking experience caused by the coronavirus outbreak, it is likely that teleworking will grow in all sectors. Those who will successfully experience this transformation are those who know themselves well and establish their own system because there is no teleworking game plan suitable for all companies. Companies need to succeed by creating a plan that suits them.

References

(1) Nixey, C. (2020). "Death of Office," *The Economist*, May 5.
(2) Plinus. (2018). *Genc Plinus'un Mektuplari*, Dogu-Bati.

(3) Demirci, K. (1997). *Islam Ansiklopedisi*, 15, pp. 132–134.

(4) Koroglu, V. (2017). "Stratejik Yönetim Acisindan Taylorizm Prensiplerinin Zamanimiza Yansimalari," *Cag Universitesi Sosyal Bilimler Dergisi*, 14, p. 1.

(5) Cagnol, R. (2013). "A Brief History of the Office," Deskmag, http://www.deskmag.com, April 12.

(6) "U.S. Workplace Survey." (2019). Gensler Research Institute.

(7) Maier, C. (2014). *Hello Laziness*, Orion Books.

(8) Perlow, L. et al. (2017). "Stop the Meeting Madness," *HBR*, July–August.

(9) Bloom, N. et al. (2015). "Does Working from Home Work? Evidence from a Chinese Experiment," *Quarterly Journal of Economics*, Feb. 7.

(10) Hickman, A., and Robison, J. (2020). "Is Working Remotely Effective? Gallup Research Says Yes," https://www.gallup.com/workplace/283985/working-remotely-effective-gallup-research-says-yes.aspx, January 24.

(11) Gorlick, A. (2020). "The Productivity Pitfalls of Working from Home in the Age of Covid-19," *Stanford News*, Mar. 30.

(12) "Remote Work in the Age of Covid-19." (2020).https://slack.com/blog/collaboration/report-remote-work-during-coronavirus, April 21.

The Best Bargain Is an Expensive CEO

We are going through a difficult period with increasing competition, economic difficulties, and the pandemic that has enveloped our world. In August 2020, the time for budgets had arrived. It would be difficult to make valid forecasts, especially when strategies needed to be updated, especially detailed plans. I wondered what would be the effect of an abundance of cash desperately pumped into the markets by governments in an economic recession worldwide. It seems, as if recession and inflation will happen simultaneously in the cooling world economy.

Actually, I have wanted to write about budgeting and implementation, but it would be better to commence this chapter with a different topic and then move to the issue of budgets. One of the most important issues in strategic management literature, which is the topic I will discuss, is how to determine CEO and senior management team wages (salary and bonus). In this chapter, I will only discuss the CEO, but it should not be forgotten that my views include all other management teams.

In short, the payment made to a CEO according to the performance of the business under his management is called "pay for performance." Now, what would you say if I told you that although this subject is so important and often discussed, the research and field studies conducted so far have not found a strong relationship between CEO performance and company performance?[1,2] There are few studies showing such a relationship, and these studies also suggest that the effect decreases when a CEO's risk increases or the effect disappears after two years.[3,4] I couldn't believe this. This subject has been researched, and a relationship could not be found because studies focused on stock exchange companies aiming at short-term investor satisfaction, as that was the data available to them. However, my experience is different!

Nicholas J. Price from Diligent Insight wrote in his article titled "CEO Pay and Company Performance," dated July 29, 2019, "In past decades, the CEO's pay wasn't always given much attention, especially in regards to a company's performance. As cases of corporate fraud became public, shareholders began questioning the pay of CEOs and other high-ranking executives. Now that public companies are required to be more transparent about CEO pay and how it compares to what they pay the median employee, shareholders and others have all new sources of information with which to evaluate the equity of how companies pay their employees at all levels."[5]

Indeed, many field studies show that high CEO pay does not necessarily equate to the highest company performance! The stock option provided

to CEOs does not always bring superior performance. While the option only directs the CEO toward short-term goals, his full ownership of the company shares may lead him/her to think of him/herself as "the owner of the company." The *Wall Street Journal* analyzed data from MyLogIQ and Institutional Shareholder Services (ISS) in 2017 to show company performances and included company CEO salaries. The results of the analysis revealed basically that CEOs of companies with average performance get high wages, and good performers earn low wages. Herman Augunis, a business professor at George Washington University, found similar results in his research on 4,000 CEOs. Although there is no relationship between CEO salary and business performance, CEOs receive, on average, 10% of their wages as a cash base and the remainder as a stock option or balance sheet bonus (equity incentive) for motivation and better management of the company.[6]

Interestingly, although such a relationship between CEO salary and company performance could not be established clearly, there has been a negative reaction to high CEO salaries, especially in the USA, in recent years, and the methods of determining CEOs' salaries have come under serious discussion.

Of course, this also has the effect of the law requiring disclosure of how many times the median salary, the CEO salaries in public companies is. As it turned out, the median employee salary in some companies was one in 300 of the CEO salary. For this reason, leftist activists and academics have increased the intensity of their questioning concerning CEO salaries.[7]

The largest insider inquiry is the "Peer Review" in the *Handbook of Board Governance*, edited by Richard Leblanc, where many academics and practitioners from the United States to New Zealand and from England to Australia participate with their writings in "Peer Groups: Understanding CEO Compensation and a Proposal for a New Approach."[8]

Elson and Ferrere (2016) first briefly summarize how CEO salary is determined in an industry as follows: "In setting the pay of their CEOs, boards invariably reference the pay of the executives at other enterprises in similar industries and of similar size and complexity. In what is described as 'competitive benchmarking' ... This process is alleged to provide an effective gauge of 'market wages' which are necessary for executive retention."[8]

The authors then drop another bomb: "The CEO's abilities are compatible with the company he works for; these skills cannot be transferred to another company!" Elson and Ferrere prove these hypotheses with evidence that the majority of CEOs in the USA are appointed from within. They say: "[A] CEO's success comes from growing up within the operations of that company and having the way of functioning specific to that company!"[8]

For example, in the S&P 500, between 2009 and 2012, there were nearly fifty CEO appointments. Seventy-five of these CEOs were internally appointed.

The reasons why Yahoo and Avon prefer external CEO appointments have to do with the changing structure of their sectors and dramatic changes such as restructuring of an organization due to falling sales. Again, in 2012, a group of researchers conducted research in 1,500 companies based on Wharton Research Data Services (WRSD) data and found 1,069 senior management displacements between 1993 and 2009. Seven hundred sixty-seven of them were in a position other than CEO, and they took a position other than CEO at another company. Two hundred sixty-seven of them were in a position other than CEO, and they transferred to another company as CEO. Only twenty-seven CEOs were transferred to another company as CEO. In other words, those who transfer to other companies as CEOs are not CEOs, but their assistants are reporting to them. In 2013, the Conference Board's *CEO Succession Report* contained another piece of interesting data, which is that the average duration of those who have been appointed as CEOs in their companies is 15.8 years. Based on this, the authors suggest:

> There is no such general management ability to ensure success. There is no such thing as a CEO that can wave his magical hand, and presto, that company will succeed. There is no such thing such as a CEO market. The success of a CEO comes from the firm-specific information he has accumulated in his career. Deep information specific to a company cannot be repeated in another company. Therefore, the industry comparison of the salaries is wrong. By the way, there is not only a CEO in an organization.
>
> There are management teams. And the payment to be made to the CEO is also related to the salaries of other people in the company.[8]

On the other hand, Elson and Ferrere's CEO does not think the payments made are unrelated to company performance. They say: "If you think the payment made to the CEO is not related to company performance, just give them a check for one dollar and see how the results are affected!"[8] The authors contend that a top management's remuneration structure is very important for an effective corporate culture. They determined that "the Board of Directors should really show effort and creativity in order for the wage structure to be flexible and to positively affect morale."[8] The board of directors can compare wages within the industry, but it should always act on its own judgment and subjective decisions. "No computer program and consultant can replace real board of directors experience."[8]

In fact, there are two important books that lay the ground for similar views like those of Elson and Ferrere. One, titled *Indispensable and Other Myths*,[9] is by law professor Michael Dorff, and the other, titled *The CEO*

Pay Machines: How It Trashes America and How to Stop It, is by Steven Clifford, who has served as a journalist and manager for many years.[10]

Dorff, in contrast to Elson and Ferrere, reveals that overpaying CEOs does not lead them to the right critical behavior and that this kind of remuneration, mostly made up of stock transfers, never motivates CEOs.

Clifford defends his views more strongly, saying that the continuous increase in CEO salary is a company dogma; that as the CEO ages within the company, the method of determining wages becomes subjective; and that as a result, the board of directors members have no responsibility regarding as a right to make unprofitable choices. "The industry has done bad business, but we cannot do anything about this. 'We have to pay' has become the dominant thought over time, that tying the bonus to the budget does nothing but give the CEO a 'punching bag' so that they can only focus on their bonus and do not see anything else, they can even manipulate the accounts to hold the bonus."[10] He underlines that they have less bargaining power vis-à-vis CEOs because they are well informed and the board of directors is not.

The reason Clifford has expressed such harsh criticism is that he thinks the added value CEOs bring to companies is not clear. "The CEO guides the business and has an oversight role, but at the end of the day, it is their normal duty to produce a good product and service. For this reason, it is unreasonable and unfair for a CEO to gain hundreds or even thousand times more than a typical employee,"[10] he explains. I do not agree!

Regarding payment to a CEO, *Harvard Business Review* since 1990, when discussions about these payments started, has not strayed far from the topic. However, it has not published an article that took a very clear stance. In fact, Jensen and Muphy's article titled "CEO Incentives: It's Not How Much You Pay But How," published in 1990,[11] was one of the first articles on this subject, and their writings today have still maintained a neutral stance. I find this to be the correct attitude. After the authors point out that the CEO salary is important to the success of the business, they also identify that getting rewarded appropriately is important for two reasons. One is to determine which CEO behavior will be rewarded, and the other is to determine what kind of CEO the company will actually work with. Two issues to be considered are paying the right wages suitable for a CEO's ability and establishing the best relationship between CEO behavior and the salary and bonus given. The authors advocate the establishment of a very aggressive payment method according to the performance period in the 1990s. Frankly, I believe that the non-application of this aggressive "pay for performance" method and not establishing a relationship between the payments made to the CEO and the success of the company are reasons for the debates in the last twenty years. If the correct behaviors are determined clearly, CEOs definitely find creative ways to increase the financial

performance of the company. I think Al Dunlop's saying "The best bargain is an expensive CEO,"[12] as he wrote in his 1990 book *Mean Business*, still applies. You will neither pay more nor less to a CEO. A successful CEO is a source of wealth for a company, for a country, for the world. In any case, if long-term company revenues are not associated with company profit and CEO behavior, everyone who believes otherwise is deceiving each other. All criticisms will be correct. Paying a CEO a bargaining fee does not mean putting a company's money into the CEO's pocket. A talented CEO who takes the risk is rewarded. Other CEOs who do not take risks are deprived. While doing this, one-time mistakes should not be taken into account, but an attempt should be made at increasing CEO efficiency with balanced metrics.

If there is no correlation between the CEO's remuneration and company success, what is the success? A lot of research has been done on this subject, and factors such as the size of the company, operational complexity, financial strength, the CEO's power, the Board's competence, the CEO's team (human capital), and the CEO's network have been found to be effective factors in its success.[13] These factors are definitely effective, but I still believe that the reward system for a CEO and senior management team will make a positive contribution to business success when correct targets are determined and correct measurements are made.

The Covid-19 outbreak showed us once again that our budget and annual operation plans covering three to five years are very important elements to ensure control of our companies and guarantee their success. Moreover, the changes brought by the Covid-19 crisis also showed us that we should be very aggressive in making a budget, making Annual Operation Plans (AOP) connected to it, and monitoring it, and we should definitely associate the realization of these plans with senior management performance in an "aggressive" manner. In our case, the top management (CEO) receives the initial half of his/her annual income as fixed and the other half as a premium when goals are achieved, and if he/she shows the ability to exceed targets, this ratio reaches up to twice the fixed amount as a bonus in increasing rates. We still believe in this system. We can be flexible, but we must definitely be aggressive. It is no longer possible to make a static budget; it is necessary to move forward with corrections and with forecasts based on accurate data (Rolling Budgets). There is also the issue of harmonizing short-term goals, namely the Annual Operating Plan, with the long-term three-to-five-year plans (Strategic Plan). In other words, we sometimes organize our performance-based payment plans over the years by considering three-to-five-year strategic targets.

At this point, I would like to emphasize both an article in the *Harvard Business Review* on the CEO payment system and the importance of making a budget in achieving company goals. Seymour Burchman's article entitled "A New Framework for Executives Compensation," in *Harvard Business*

Review, dated February 2020,[14] states that CEOs are no longer accountable only to shareholders. He emphasizes that they should also work with targets toward increasing other stakeholders. Because technology has turned many industries upside down, the disruption situation is not only about software companies but also industrial companies. Activist social forces are gaining more and more power to influence corporate management. Therefore, CEOs need to set goals based on strategic agility, not the strategic status quo. In traditional plans (on a budget), CEOs get a bonus if they hit a target for three years in a row, Burchman says, but CEOs now have to focus longer and reshape to compete. A dilemma arises here: Will CEOs focus on increasing revenue or on a radical transformation? Are three-year plans sufficient to achieve seasonal performances? Are budget structures that motivate CEOs flexible enough to transform quickly? Does a CEO, who focuses solely on financial results, adapt to the interests of stakeholders? How can goals with both long-term transformation and short-term strategic agility be set within an effective stakeholder ecosystem? Can we build a structure that can do one without giving up the other?

Burchman's answer is yes. He says that if you structure the plans and budget within the framework of the mission, that will motivate the CEO and senior management team, and if you connect the strategic goals with the mission, you will be able to achieve short-term and long-term goals together because your mission is consistent. By constantly focusing on the mission, thinking about the stakeholder ecosystem and making adjustments in the annual operation plans on the road with agile decisions, you will not miss the long-term transformation, and you will be ready to be reshaped continuously.

I strongly agree with Buchman. This is why, at Yildiz Holding's Quarterly Business Review (QBR) meetings, the budget performance includes not only an exchange of actual figures but also an analysis of the market and competition, as well as a review of our long-term strategy for the relevant quarter of the current year. Most important is an analysis of the expected competition and market movements in the upcoming period, estimating what our numbers will be, and discussing the actions that will be taken.

In order for a mission to be an effective guide and be measurable in the long term, it should answer the following questions:

1. Who or what is our company working for?
2. What results should we achieve in order for stakeholders to gain this benefit?
3. How can we continuously improve these results to outperform competitors?

Let me give an example from our company. Our mission is very clear, "Make Happy, Be Happy." Each of our business units can put the prefix "in every

bite…," "in every sale…," "in every transaction…" at the beginning of our mission.

If guided by these discourses, the stakeholder-based basis for payments to the CEO and senior management team emerges that will be developed and reviewed every year to gain an advantage over the competition. Only your mission can deliver clear benefits for customers and employees, together with stakeholders. Mission-oriented goals connect CEOs' performance other than financial goals to other measurable goals, for example, the net promoter score, consumer satisfaction score, and churn rate for customers. For employees: absenteeism rates, satisfaction rates, and turnover rates, over time, brand awareness, market share, return on investment (ROI) by market, and profitability compared to competitors can be such measurable goals.

The feature of these metrics is that it depends on the success of the work in detail. Although managers decide in favor of one of the stakeholders in the short term, these goals balance long-term sustainable performance. Alex Admans of London Business School and Rob Markey of Bain & Company emphasize the importance of striking this balance, stating that high employee satisfaction and high net promoter score success is a challenge for competitors.

In the method suggested by Burchman, the CEO and the board of directors set long-term goals depending on the mission. Then, the CEO's annual bonus targets are determined. These are intermediate milestones to be completed in the annual operating plans, for example, the number of new products that get the desired market share. In the current traditional system, when the board of directors approves the new set of three-year targets, the three-year plans that were determined two years earlier are still valid. This means achieving three separate sets of goals. Instead of such period intersections, the system in which one begins and the other ends is the best, says Burchman. I call this updating and agree with Burchman's views. The mission-related objectives should remain constant throughout the given period, and the metrics should not stay the same and should become increasingly difficult. If there is an improvement in this approach compared to competitors in relation to the previous year, a bonus is earned. The board of directors takes a two-sided approach to resolve the short-term–long-term ruptures experienced today. It links the CEO's long-term bonuses with the mission and balances them with short-term bonuses. Thus, CEO behavior is effectively monitored and guided. I say short-term achievements are rewarded in annual operations plans (KPI), and long-term results are rewarded based on long-term plans (LTP). I find his proposal applies to all kinds of company cultures. In an age of radical transformation, a board of directors and a CEO should focus on how the long-term bonus system works. If the Board and the CEO are stuck in three-year plans that include only financial targets, unless they move to a

long-term, flexible, and data-driven agile system that includes stakeholders, it will be difficult to achieve superior performance.

References

(1) Barkema, H. G., and Gomez-Mejia, L. R. (1998). "Managerial Compensation and Firm Performance: A General Research Framework," *Academy of Management Journal*, 41(2), pp. 135–145.

(2) Conyon, M. J., and Peck, S. I. (1998). "Board Control, Remuneration Committees, and Top Management Compensation," *Academy of Management Journal*, 41(2), pp. 146–157.

(3) Mishra, C. et al. (2000). "Effectiveness of CEO Pay-For-Performance," *Review of Financial Economics*, Spring 9(1), pp. 1–13.

(4) Joskow, L. P., and Rose, N. L. (1994). "CEO Pay and Firm Performance: Dynamics, AsymmeTries, and Alternative Performance Measures," *NBER Working Paper*, 4976.

(5) Price, J. N. (2016). "CEO Pay & Company Performance," *Diligent Insight*.

(6) Ibid.

(7) www.payscale.com/data-packages/ceo-pay.

(8) Elson, M. C., and Ferrere, C. K. (2016). "Peer Groups: Understanding CEO Compensation and a Proposal for a New Approach," in R. Leblanc (ed.), *The Handbook of Board Governance*, Wiley, pp. 463–472.

(9) Dorff, M. (2014). *Indispensable and Other Myths*, University of California Press.

(10) Clifford, S. (2017). *The CEO Pay Machine: How It Trashes America and How to Stop It*, Blue Rider Press.

(11) Jensen, J. M., and Murphy, K. J. (1990). "CEO Incentives – It's Not How Much You Pay, But How," *HBR* , Jan.

(12) Elson, C. M. (2003). "What's Wrong with Executive Compensation," *HBR*, Jan.

(13) Wua, H. et al. (2018). "Politically Connected CEOs, Firm Performance, and CEO Pay," *Journal of Business Research*, 91, pp. 169–180.

(14) Burchman, S. (2020). "A New Framework for Executives Compensation," *HBR*, Feb.

Telework Update: New Normal or Back to Old Normal

It has been two months since my article entitled "The End of the Plaza Empire and the Inevitable Rise of Telework in Business Life" appeared. During this time, the perception of risk concerning the coronavirus in the world has decreased due to the relative decrease in the number of cases, distractions, and acclimation. Employees began using offices more in line with social distancing rules. This has left me and my generation facing a dilemma. While I was unwilling to work remotely and yet have grown accustomed to it, now a return to the office has begun. In fact, of course, the hybrid model is the most effective one. However, let us also not forget that, before the pandemic, working two days a week "from home" was also an abused activity/practice in the sense of working only three days a week.

Meanwhile, both in Turkey and abroad, daily newspapers and magazine articles have published reviews on a variety of forms of telework. Obviously, most of them are not different from what I mentioned in my article and do not examine the subject in depth. Here I summarize Maria Haggerty's article titled "Four Signs That Your Team Will Not Be Able to Work from Home in the Long Run"[1] and Chip Cutter's article with the title "Companies Finally Think That Working from Home Is Not a Great Thing."[2]

According to Haggerty, Gartner Survey met with 229 HR executives in the USA and found that 41% of employees are likely to work part-time remotely. This is compared to 30% before the pandemic. Many companies in Haggerty's view are preparing to work from home in the long run, but there are signs that some cannot do it, she says, and she summarizes these signs in the following four headings:

1. It is difficult to collaborate remotely. Physically coming together, discussing, and brainstorming provide a different type of energy. This collaboration is important for some creative work. It is not found in telework because the essence of cooperation is communication.
2. Vulnerability is a cost. Telework reduces overall administration costs. However, security risks create vulnerability as homeworkers connect to the internet from public networks. For this reason, connecting to company IT from home remotely requires support. This is another cost.
3. People want socialization. It is difficult for employees to get used to their physical, economic, and mental conditions working from home. They enjoy being at work.

4. It is difficult to measure performance. Measuring performance by results alone may not be a fair process. The efforts of the employee are important. These efforts cannot be evaluated remotely.

In Catter's article, he says that the fact that telework is not attractive is attributed to the long duration of projects in remote work, the decrease in the quality of work, and the training of new employees and their orientation to the company. It is emphasized that it is not possible for new recruits to learn the job from young people who work with them in telework, and this is a big deficiency. It is said that remote work has been carried out in a discipline with the fear of losing a job, but it is not possible to sustain this fear in the long term. It is also claimed that problems are solved in an hour, face to face, instead of a day of telework. Catter states that in telework, people cannot read body language, interact instantly, and do not understand company jargon. According to Catter's article, half of Canon's 11,000 employees voluntarily returned to work in May 2020.

After making such a negative observation, Catter switches to the opposite corner and tells us that the future will develop as a hybrid system, with more time being allocated toward working remotely, but the teams will have regular office hours, and some companies have already switched to this system. For example, the online education company Coursera announced that half of its 650 employees would work in the office for three days and two days remotely after the pandemic period. At Discovery Financial Service, where thousands of people work, less than one in three preferred to work remotely, while the majority preferred to work in a hybrid and flexible system. I think that what the HR manager of this company, Andy Eichfeld, said is the lifeblood of work:

> "I think that the corporate culture we created has gradually disappeared in remote work management. We still need to save it while he can!"

In relation to the two articles above by Haggerty and Catter, it is very clearly seen in his negative approaches that Eichfeld speaks with the old mindset. What Eichfeld should do is reproduce the existing company culture under remote working conditions, and if he cannot, then create a new culture according to the conditions of the new world. Likewise, he should adapt the performance system, business manner, collaboration communication, and job satisfaction conditions to new hybrid conditions.

Yildiz Holding has already begun implementing culture-building projects in line with the "new norm." For example, the "Digital Corridor" application, which turns spontaneous conversations into digital socialization tools, has already been launched. Employees at all levels, chosen randomly by the digital application every week, come together on the online platform and find an opportunity to socialize.

Yildiz Holding's CEO, Mehmet Tutuncu, regarding the problems of socializing in remote works, states, "The age of digitalization we are in offers us new opportunities in such issues. The Digital Corridor is one of them. The goal is the happiness and motivation of the employees." While explaining this innovation, he expresses his opinion about telework in correspondence as follows: "I think the jobs that can be worked completely from afar will be outsourced in the future. There are office-related jobs that can be managed outside the office. We can also experience two separate structures, crisis and working under normal conditions." Let's not forget that new generations will come from schools having learned the conditions of distance education and distance work, and be better equipped. It should not be difficult for them to establish a new orientation system and to create a remote/hybrid working culture. As long as we want, as long as we don't overshadow them with the old normal.

References

(1) www.inc.com/maria-haggerty/4-signs-your-team-cant-work-from-home-long-term.html.
(2) Cutter, C. (2020). "Companies Start to Think Remote Work Isn't So Great After All," *Wall Street Journal*, July 24.

Could 75% of Companies Perish by 2027?

The Electronic World Marketing Summit (eWMS) was held online, November 6–8, 2020 under the auspices of Philip Kotler, who is considered the father of modern marketing. Famous marketing practitioners and academics from 80 countries shared their opinions online for 48 hours in 104 countries. According to what I've read in the news, 2.5 million people followed the summit at the same time. Huge participation!

Whereas forty years ago, when technology was the main limitation, maybe it was important to be a sales-oriented company, but marketing was a luxury. While I was trying to make sales forecasts with regression analysis and integral area calculations based on company data when I was a new graduate, a Turkish ex-pat came to the newly established Sales and Marketing R & D Department from abroad. In the first analysis he made regarding advertising, it caused sales to drop, and the advertising had to be ended. As you can imagine, he went just as quickly back to where he came from. Yes, according to the analysis, there was increasing ad spending and falling sales. But the reason why customers' orders had dropped was the uneasiness in the market caused by the September 12, 1980 coup in Turkey, and we could only sell goods as substitutes for our advertised products. In any case, in the 1990s, we assigned product managers in marketing. Secondary display areas were our target. However, we were faced with the traditional, scholastic denial of sales. In an executive meeting, the General Manager of Sales reproached these marketers for being indifferent and for dreaming. I said, of course, I was paying them to make a dream come true for me, and the business had declined. In fact, marketing is specific, subject to your product, market, and consumer characteristics. Marketing science; data, statistics, and estimation techniques; and best practice applications, I guess it should be made up of these things. I always used to get low marks in marketing and even in management courses. This was because the teacher was asking how a brand would behave if a particular case happened, and my answer would be different from the book. But sometimes this was because I didn't attend class and sometimes because I didn't agree. There is no single right solution in business life anyway. You choose the optimum from among many options.

Among the speakers who were from Turkey was the Istanbul Chamber of Commerce chairman of the board, Sekib Avdagic. The title of Sekib's speech was "Perception of Business Life during Covid-19: Transformation of Commerce and the Requirement of Reevaluation of the Global Supply Chain According to the New Norm," and he gave a very positive and motivating

talk. He stated that Turkey was affected by the Covid-19 crisis like other countries; is at the world's crossroads as a brand city known worldwide; is very attractive for commercial and business people from Asia and Europe; currently has the most advanced airport in the world; and continues to be one of the centers of global trade with its financial players. Stating that innovation should become a vehicle, both in business and national terms, Mr. Avdagic stated that according to global data, more than 400,000 new products had been introduced to the Turkish markets during the pandemic.

I could not watch the speeches in real-time as the summit was based on global time. I viewed Kotler's speech and then those of a few speakers from the program who attracted my attention, browsing through the videos. Assistant friends also watched other speeches and summarized them. First, let me tell you that you can still download and watch these videos for a fee, and if you really want to follow the agenda of marketing in the world, do not delay; download and watch them all. I have summarized a few of them and linked them to the topic from my weekly agenda: #makehappybehappy.

The title of Kotler's speech is "New Marketing in Critical Times." He said that consumers' reactions to Covid-19 were primarily to stock up on food, give up unneeded spending, and use online shopping systems. Kotler remarked that new consumer behaviors emerged in this process and pointed out that some weak companies, brands, and stores had already disappeared. He said that even the middle class, not low-income people, were turning to low-cost products. Kotler stated that in this period, most consumers gave up on activities such as holidays, entertainment, and concerts, saved money on fuel because they did not go to work but worked from home, and therefore saved money; and even considering the possibility of a second pandemic wave, many people consciously saved money. He also emphasized the importance of the concept of "home" as one for which habits changed. He added that because of matters such as cooking at home, having fun at home, and working from home, the importance people attach to their homes increased and this has simplified people's lives.

He classified the emerging consumer types in the "New Normal" into five categories as a result of the increased sensitivity of people to social issues (such as Covid-19, climate change, racism, and democracy) due to the pandemic disaster they experienced:

1. *Life Simplifiers:* Those who consume less food and drink oppose saving, rent instead of buying, and strive to minimize their expenses.
2. *Degrowth Activists:* Those who are opposed to expenditures for unnecessary needs due to the increasing population and the consumption of limited resources. They say that the world population will exceed 9.8 billion by 2050 and that world resources are insufficient for this. They

believe that advertising and marketing activities pump up unnecessary human needs and will cause the world to run out of resources.

3. *Climate Activists:* Those who work to eliminate their carbon footprint, to resist climate change, who aim to increase wastewater usage, and who are against the use of plastic.

4. *Sane Food Choosers:* Those who do not want animals slaughtered, who want to consume vegetable protein and food sources because they think animal proteins are poisonous to the human body, and who adopt a vegan or vegetarian diet. These people try to stay healthy by consuming vegetable sources (vegetables, fruits, and cereals).

5. *Conservation Activists:* Those who aim to use the products they buy for a long time. Therefore, they try to make their possessions last through taking such actions as repair, maintenance, and protection renewal, are not stingy, and do not comsume brand or luxury items, but purchase products that they can use for a long time.

Kotler observed that in the face of changing consumer and market behavior, companies must answer the following three questions: How will they respond to new conditions and constraints? How and when can normalization and full recovery be achieved for countries? How are capitalism and marketing affected by this?

Kotler went on to talk about typical decisions companies should make: "In this period, companies should make a rough estimate of when these troubled times will end and how long it will last, determine the markets to be kept or abandoned, decide which products should be retained and which should be abandoned, put their price level and promotion decisions on the table, guarantee customers (customers who are already customers), analyze the content of the marketing plan."[1] New generation marketing tools in the new period, as determined by Kotler, include AI systems (social and digital media, algorithms), sensors, AR/VR systems, robotics, natural language processing (NLP) applications, telephone integrations (such as Alexa), and chatbots, marketing automation, customer experience mapping systems, touchpoint marketing, content marketing, influencer marketing, neuromarketing, the lean marketing strategies of Eric Ries.

Kotler stated that after the Covid-19 crisis, he would proceed with a model he called "slow normalization": "This will not be done until all the countries of the world return to normal, and even when they do, the return to normal life will be slow and economies will recover slowly."[1] Kotler suggested that antibody, virus tests, and monitoring systems would be developed and easy to apply, and a reliable and safe vaccine would be found within one year from the beginning of the Covid-19 pandemic. "The state continues to send checks to citizens and companies. The USA starts restructuring programs

within two years. However, if 2% growth spreads over the four-year period, none of this will happen, and the country will never be able to fully normalize,"[1] he added. However, I think these are pure assumptions; if no vaccine or cure is available, nothing will be normalized.

Kotler answered the question of how capitalism would be affected by the process we were going through: "Many countries are now focused on happiness and well-being rather than the GDP." Saying that hard work and losing their health will not carry people into the future, Kotler said, "How do Scandinavian countries achieve this?" He then asked a rhetorical question: "How can only the Scandinavian countries in the world at the moment build a happy and highly productive life? Many Americans have recently realized that productivity does not lead to equality; the huge gap between rich and poor, income inequality, and tax inequality do. We must do what has to be done and move on to social capitalism, leaving traditional capitalism."[1] So he almost says, #makehappybehappy.

Sadia Kibria, CEO of WMD Group, in her speech titled "The Next Big Thing,"[2] stated, In January 2020, Microsoft will be 'carbon negative' by 2030, and by 2050 they will eliminate all carbon emissions they have consumed since 1975. A month later, in February 2020, Amazon's boss Jeff Bezos announced that he would save the world through the Bezos World Foundation. In 2018, China announced a transition to electric vehicles that will reduce dependence on oil and penalize all cars that pollute the world. General Motors declared that they will develop 20 models of electric vehicles by 2030. Today, solar cars are being researched and promoted. "Social entrepreneurship must be the next big thing," he says. "First, you must understand the reason." He continued, "In 2019, 800 jewelers closed in the USA. The demand for luxury jewelry is falling in the USA. Tiffany & Co was bought by Louis Vuitton because tourists no longer buy their rings." The new generation (Gen X and Y) buy diamond rings with emotion, not brand-name ones. Therefore, new consumers do not want to pay triple for a diamond ring just because it is from Tiffany.

Nike is taking action to work with just 40 of its 14,000 retail partners, because people now shop online. It also has moved its stores online. Sears is closing 150 stores in North America. Nine West is closing its stores and moving to e-commerce. Consumers are changing. Moreover, new consumers want emotional communication with brands. The global population is now 8 billion. Generation Y and post-Y are getting older. Their inheritors will be Generation X, and then Z will replace Y, and post-Millennials will replace Millennials. The new consumers of the world are Gen Z and Y. So why still do business with boomer logic and that of Gen X? The new rhythm of the world will pass on following Gen Y and Z, namely after the Millennials and post-Millennial. The children of 92% of the Gen Z and Y generations support

companies that promote social needs and the environment. Sixty-eight percent choose products that provide social benefits, and 73% are willing to pay more for a meaningful brand. "Generations are changing. Therefore, when designing brands and services, pay attention to change now."[2] I think what Kibria was saying is also essentially, #makehappybehappy.

Kozo Takaoka, former CEO of Nestle Japan, emphasized in his speech titled "Digital Transformation and Innovation," that success in marketing is about focusing on customers and defining their problems. It is important to be able to look at the problems of existing customers, produce solutions for them, and create added value with these solutions. However, when we consider these problems, we see two different problems and two different types of solutions. The solution to customer problems that are visibly "defined" is "renovation," and "innovation" is the solution to "unidentified" problems that even customers are not aware of. You should examine customers, find solutions for the problems they are not aware of, remind them that they have problems with these solutions, and help them notice and feel such. This is the most basic psychological need. "In my model, people don't think of an innovation; you have to find it and bring it to them," said Takaoka.[3] And he continued: "The household usually consists of 1 or 2 people. The child is almost absent. However, the number of households has increased from thirty million to fifty-five million in the last thirty years. And these people either eat outside or consume ready meals. And people prefer single-person instant coffees to consume. Based on this prediction, we created the Nescafe Ambassador. We sell machines at cost or a little more because these machines work with Nescafe, and we wanted to profit from coffee, not from the machine, and that is what happened. Our coffee income increased by 50%, and people started to make fast and delicious coffee at home with a single machine. And we offered them good coffee at the cost of 0.3 dollars."[3] This situation continued during the pandemic period, and many businesses continued to make a profit during the pandemic thanks to this machine we produced. Again, the application of #makehappybehappy is seen here.

Australian business innovation specialist Linden Brown talked about the two most important roles of marketing in his speech entitled "The Role of Marketing Leadership in Creating a Customer-Centric Culture." "Survival" and "growth" are about marketing to all customers in the market, not just part of it, he said. He stated that existing customers determine customer experience, and the only concept that determines new customer acquisition is "customer experience." Brand reputation and customer advocacy can only be sustained by providing excellent customer experiences, and he emphasized that: "Heinz ketchup is the world's best-selling ketchup brand, but Heinz has two different product packaging, one in a glass bottle (product-oriented) and the spout cannot be controlled, the other is the plastic bottle

(customer-oriented) and the user has the opportunity to consume as much ketchup as he wishes, thanks to the valve on the mouth. The product purchased in a glass bottle is not customer-focused due to the fact that it cannot be controlled and spilled, and the part remaining at the bottom cannot be used."[4] Moreover, he made the final hit with the last sentence: "Many studies show that market-driven companies are 31% more profitable than self-centered companies that plan their strategy according to the information and findings from the market."[4] In other words, if you don't think "Let's make happy" while developing a strategy, and if you think only "Let's be happy," there is no path to success in any way! So #makehappybehappy!

Kotler said at the beginning of his speech that they were writing Marketing 5.0 with Indonesian Brand Plus CEO Iwan Setiawan, with whom they cowrote Marketing 4.0. In his speech entitled "Digital Marketing versus Traditional Marketing," he said that they cowrote 5.0, which was released in March 2021, and he continued:

> Marketing 3.0 was completely traditional marketing work. Marketing 4.0 brought digital and traditional marketing together but was never 100% digital. Marketing 5.0, on the other hand, is discussed in detail from a digital perspective; the technology will be 2020–2030, and the dominant generation Gen Alpha. Marketing between 2010 and 2020 was the dominant generation 'Gen Z' in 4.0, and it was a period where digitalization efforts gained weight, and the first level of digitization took place but still, it couldn't completely be 100% digital. In the new period, marketing is affected by digital tools, but it does not continue in this area completely.[5]

He went on to compare the human characteristics with the machine features:

Human	Machine
Thinking	Artificial intelligence
Communicating	Natural language processing
Sensing	Sensor tech
İmagining	Mixed reality
Connecting	IoT and blockchain

Later, in the technology development stages, he classified the basic elements of Marketing 5.0 into five categories, saying that "biotechnology" offers human-inspired solutions:

1. *Data-based marketing* is marketing where marketers gain insights and trends based on data and on making the best decision by grouping data. It is necessary to collect data from all possible data sources. These resources are social media, the web, point-of-service (POS) devices, the Internet of Things (IoT), interaction, and salesperson call center data.

2. *Agile marketing* is the quick, rapid, and decentralized management of real-time transactions. These small groups of five to eight people, con sisting of influential people, quickly and effectively transform instant data into processing. They are modular and fast. They have constantly evolved and are flexible systems.

3. *Predictive marketing* is marketing based on a statistical or machine learning model. Three main components are customer management, product management, and brand management. It is used to manage customer preferences in different sources with data and to develop them to provide the best option. Netflix, Amazon, and media companies use this form of marketing extensively.

4. *Context marketing* is about providing a digital experience in the physical space. Sensors are used in this marketing type. Sensors can gather much data from people: gender, body temperature, body posture, and so on, and these features blend with AI and offer accordingly.

5. *Augmented marketing* is often used in sales and customer service "chat box" (message) boxes. The customer interface works like a message box. This message box application performs a progressive chat to obtain the referral data and tries to provide the most suitable result to the user. The message box feeds/supports the user with educational information. The sales team provides quality guidance in sales as a consultant negotiates, and concludes. In this more personalized, more focused, and more specific method, the area is slowly narrowed, and the appropriate solution is offered.

Marketing professor Jagdish Sheth, in a speech entitled "Why Do Good Companies Fail?" provided the answer to this question. Sheth began his speech with these words: "Humans are mortal, and likewise, companies are mortal as well. Globalization, global competition, global existence, competition, natural disasters, and Covid-19 etc. The destructive competition that occurs in this environment causes many companies to shut down and many companies to fail. What is the bad habit of good companies?"[6] he asked, and he answered:

> It's all about leadership. Many companies that were good in the 1980s didn't exist when they continued on into the 1990s. Why? Many companies used the 'From Good to Great' model. However, most of them could not fulfill their level 5.0 leadership studies. By 1983, 1/3 of the 1970 Fortune 500 list had disappeared. In 1958, Standard & Poor's 500 determined the lifetime of one company as 61 years; today this figure is under 18 years. McKinsey says 75% of existing companies will disappear by 2027. But why do good companies fail despite this prediction? Because they don't want to adapt or change to the changing ecosystem. They continue with their past experiences. For example, GE, Sears, Digital, and IBM were left behind not because they weren't good but because they couldn't keep up with change. Many

good companies do not exist today because these companies have failed to adapt to change and have adopted various bad habits to survive and keep their business.[6]

Later, Sheth explained the seven bad habits as follows: denial, arrogance, complacency, competence dependence, competitive myopia, capacity obsession, and internal power warfare (turf wars).

Denial: This rather dangerous habit is probably the new reality of all companies. Many companies are conservative companies that stick to myths and rituals. These companies are closed to changing habits and consumer behavior as they view their past success as the basis for their current success. The three realities these companies deny are: disruptive technology integration (Uber), changing organic foods, and nontraditional competition (China and India).

Arrogance: This is a bubble of self-importance and superiority. For example, GE was rather arrogant after thirty-three years of successful management by Alfred P. Sloan, and it could not sustain its success.

Complacency: These companies try to survive based on their past success. They care so much about their past success that they cannot see that they have achieved nothing later. Taxi companies, for example, failed against Uber. These companies forgot about how they achieved success in the past. In the monopoly state of the market, it is quite easy for all companies to succeed. Some companies are supported by the state because of the unique product they produce, and this can bring them quite valuable success. However, there is no rule that this success will continue under competitive conditions. Marks and Spencer are examples of these companies.

Competence Dependency: Some companies depend on someone's competencies to buy them. For example, Singer sewing machines were a very important value for home sewing but now almost no one sews at home. Singer just stayed in our minds like an old machine. Nor could Kodak could continue its success due to the companies that disappeared after photographic film evolved to digital. Kodak was unable to adapt to digital cameras, because nobody used old-style cameras any longer and therefore film that needed to be developed.

Competitive Myopia: Some companies are so focused on their closest competitors that they are vulnerable to external threats. Coca-Cola and Pepsi, McDonald's and Burger King are companies that have been affected by this myopia.

Capacity Obsession: Some companies think that they are unique in the market and offer more goods to the market than necessary. They think that this approach will increase their profit margins, but because of other competitors in the market, they sell most of their goods for less than their value, and the money spent on sustainability is well above the profit

earned. Levi's is one of these companies. These companies miscalculate the purchasing capacity of the industry. The fact that 5,000 people buy jeans does not mean that 5,000 people will buy Levi's. Automobile companies encounter a similar situation.

Internal Power Wars (Turf Wars): Some companies apply quite different methods of in-house authorization. For example, in family companies, many departments interfere with each other. Like an engineer looking at the HR department, or the boss trying to identify who will be hired, the engineer gets involved in the marketer's job. In such cases, companies can make wrong decisions and ruin the business due to not knowing the job correctly.

"These seven bad habits cause successful companies to fail and go bankrupt over time," said Sheth. I also say that, from what I have been listening to, bankrupt companies don't know #makehappybehappy. Companies that intend to survive in 2027 need to heed all these things and tidy themselves up. The speeches at the world marketing summit were very instructive. I have summarized a few of them here in my own way. If you wish, I can summarize a few more interesting ones. But if you go and watch the presentations from start to finish, you can be one of the companies that will survive in 2027.

References

(1) Kotler, P. (2020, Nov 7–8) New Marketing in Critical Times. https://worldmarketingsummit.org/conferences/electronic-world-marketing-summit-2020/

(2) Kibria, S. (2020, Nov 7–8) *The Next Big Thing*. https://worldmarketingsummit.org/conferences/electronic-world-marketing-summit-2020/

(3) Takaoka, K. (2020, Nov 7–8) *Digital Transformation and Innovation*. https://worldmarketingsummit.org/conferences/electronic-world-marketing-summit-2020/

(4) Brown, L. (2020, Nov 7–8) *The Role of Marketing Leadership in Creating a Customer-Centric Culture* https://worldmarketingsummit.org/conferences/electronic-world-marketing-summit-2020/

(5) Setiewan, I. (2020, Nov 7-8) *Digital Marketing versus Traditional Marketing*. https://worldmarketingsummit.org/conferences/electronic-world-marketing-summit-2020/

(6) Sheth, J. (2020, Nov 7-8) *Why Do Good Companies Fail?*. https://worldmarketingsummit.org/conferences/electronic-world-marketing-summit-2020/

What Is the Secret of Ülker's Marketing Success?

As I see the interest in marketing is quite high from the comments received on my article entitled "Could 75% of Companies Perish by 2027?" I stated that nearly eighty famous marketing practitioners and academicians attended the EWMS world marketing summit held online on 6–8 November, and I summarized a few speeches. In my opinion, there were a few more important speeches, and I summarize these in this chapter as well. I also examine the Ülker brand as an example.

Laura Ries, daughter of Al Ries, one of the founders of the positioning concept, was also among the speakers. She is promoted as a "positioning expert." In her speech entitled "The Effect of Marketing on Consumer Behavior," she said that his father's positioning strategy, which he explained in his book *Positioning: The Battle for Your Mind*,[1] which has been translated into twenty-two languages and is one of the best-selling marketing books in the world, now works differently:

> GE, GM, and IBM are having a very hard time. The time for the important brands of the 20th century is about to run out. So why? Because these brands have a single name behind everything. Ten years ago, GE's sales were 157 billion dollars, and profits were 11 billion dollars. Today, it has a sales volume of 95 billion dollars and a profit of 5.4 billion dollars. One of the things that weakens the brand is that they put a single name on everything. GM announced its bankruptcy in 2009. Chevrolet; big, small, expensive, cheap, sports, etc., cars, and it went bankrupt with all those cars. IBM is also having a hard time.[2]

Ries said, "There are five rules for positioning in the 21st century," and explained them one by one. Below, I have listed and explained how these rules have worked for us.

Be global, not national: Many firms can earn high revenues from their sales within one country. But the world is now very global thanks to the internet. Since its establishment, the internet has broken down borders between countries. Since the establishment of the internet, China has been producing globally. The some latest studies shows that China has an export volume of 2.4 trillion dollars. This is 1.6 trillion dollars in the USA, 1.5 trillion dollars in Germany, and 730 billion dollars in Japan. This suggests that China has increased its sales by "exporting" and playing globally. Being able to export is the biggest investment to be made in a country's GDP. However, you need to focus on global trade; you cannot sell everything. You need to limit your product range. Think of a small neighborhood where a grocery store sells everything and earns well, but when you get out of this little area

and go to a bigger area, you find many small marketplaces that specialize in their field. To play globally, you need to have less variety of products, and people need to get to know you by certain products.

When we look at the USA, there are fifty-two digital brands that stand out globally. However, in China, Huawei is holding onto all this market and challenging its competitors in the USA, that is, reducing your product range; this is important in terms of positioning. *Today, Ülker is the export champion in our country's category and is an international brand specializing in biscuits and chocolates produced in many countries.*

Focus on your competitors, not your customers: Your customers always ask you to do good work, the best, the highest quality, the most special, and you may feel obliged to realize this. However, there are many companies in the market, and they all strive to achieve the best. For example, four airlines (United/Delta/American/US Airway) in the USA announced their bankruptcies. Yet, Southwest still stands because this airline focuses on what is different, not on the good. Moreover, what's better for their customers is simply selling seats rather than providing more specific services. No orange juice, no food service, just peanuts. And they didn't go bankrupt because they focused on the difference. They focused on being different from their competitors.

Another example is that when Red Bull began selling in thinner metal cans, all other energy drink companies began offering similarly slim canned energy drinks. They said, we calculated the best rates for you and made a calorie calculation. Even Coca-Cola offered energy drinks in thin cans. Only Monster put its products in large metal cans, did not count calories, and did not calculate sugar. Now, Red Bull has 43%, Monster 39%, Rockstar 10%, and Coca-Cola 1% market share. This is no accident – be different. *For example, the Ülker Cubuk Krakers have been, for decades, always the only product suitable for every budget.*

Have a narrow product portfolio, not a wide one: It seems normal to focus on selling everything in the market, but you cannot sell everything.

Think of the car companies trying to sell everything at once. BMW offers, for example, all the features available on the market. But this is not a successful approach. Due to this strategy, BMW is currently ranked 11th. When it comes to electric cars, only Tesla comes to mind. Another example is Great Wall Motors. This Chinese company focuses on one model only, cheap SUVs. The vehicle named Haval sells quite well. *For example, the focus of the Ülker brand is the Biscuit and Chocolate category. As Ülker, we do not intend to enter the construction business.*

Be multi-branded, not just a single brand: A brand cannot do everything – consumers have neither such a perception nor expectation. You start with a

single brand, but then you have to turn each different product you produce into another brand. Apple, Coca-Cola, and Proctor & Gamble (P&G) are companies that have made products under these brand names.

Apple: iPhone, iPod, iPad, and so on. Coca-Cola has twenty brands, and P&G has twenty-five brands. However, Kodak announced its bankruptcy because it made a branding mistake and named the new digital brand it had released as "Kodak." However, Kodak had released a digital device in 1975, but in consumer perception, it was an old-style production company with film containing Kodak chemicals, and when the company named its new brand Kodak, the consumer refused to buy it. *For example, Ülker has Biskrem, Halley, Probis, Dankek, Hanimeller, Dido, Laviva, 8 Kek, Cizi, 9 Kat Tat Cokonat, Cokomel, Ikram, Rondo, Metro, Bizim…*

Focus on the visual, not just the text: All brands try to stay in line with their mottos, but the main thing is the visuals. If you associate yourself with visuals, the consumer perceives you much more clearly. I call this the "visual hammer." The visual hammer is a very successful strategy. It makes you authentic. Take Coca-Cola and Pepsi. Coca-Cola has a visual hammer with its logo, and the moment you see it, you say, this Coke, not Pepsi. McDonald's is easily recognizable by its golden arches, but Burger King? Making a small visual change can give you a lot. *For example, the Ülker brand is iconic through the style of writing of the name, with the spelling "UE," with an umlaut over the "U" and a particular font.*

Turkish children know and prefer the brand from the age of two.

London Imperial College's professor Sandra Vandermerwe gave one of the most interesting speeches at the summit. You may already be familiar with Abraham Maslow's Hierarchy of Needs. It is one of the most talked-about human psychology theories in business life. Maslow, a US psychologist, wrote an article on the hierarchy of needs in 1943. There has been no other model that defines human needs since then. I suggest that young people, those trying to do start-up business, first understand Maslow's need theory well. Because people buy to meet an abstract or a concrete need, either this need is defined and you redefine this need, or this need is hidden and you create it. Sandra Vandermerwe says that Covid-19, which unexpectedly entered our lives, changed our behavior, because our individual needs have changed. "Our most basic needs established by Maslow have transformed into completely different shapes with Covid-19, and now we marketers are working to understand new consumer behavior and create models suitable for it." She asks the question: "So what has changed? How does our basic needs map help us?"[3] Then she summarizes the new need map as follows:

Maslow's Needs	New Customer's Needs
Physiological	Contingency
Security	Resilience
Love & Belonging	Networking
Status & Respect	Purpose & Affirmation
Self-realization	Self-Sustainment
Self-transcendence	Righteous Deeds

I compared Vandermerwe and Maslow in my own way:

Maslow	Postcorona Vandermerwe
Physiological needs	Contingency (What might I need right now based on future conditions?)
Feeling safe	Preparing for the future to be safer
Feeling close to a reference group	Becoming a group member to realize the most appropriate behavior
Self-esteem and recognition by others	Inspiration and inspiring others
Inspiration and inspiring others	A feeling of self-empowerment and control of your destiny
Don't think beyond yourself	Doing good for society, country, and the universe

As you can see, Vandermerwe also reached the #makehappybehappy philosophy, and of course, I agree.

Famous brand professor David Aaker said similar things in his speech entitled "Winning in the Post-Covid-19 World," but his examples were different. "If we want to earn now, we have to do meaningful work first,"[3] he said. Here he gave us two company examples. The first one is Unilever. He explained that Unilever launched a campaign ten years ago to eliminate its carbon footprint and support sustainable life, and rearranged the company goals accordingly. "We now understand the importance of this step for social well-being and better health,"[3] he said. The second example was Unilever's Lifebuoy brand, which produces hygiene products. This company drew attention to the importance of handwashing during the pandemic. However, having conducted a similar study the pandemic, it started a "wash hands" campaign based on the fact that two million children under the age of five die every year due to poor hygiene conditions and malnutrition, and in addition with the "tree of life," supported children who have difficulty obtaining nourishment. For this reason, what they did during the pandemic was found more convincing.

Aaker said, "A second point we learned during the pandemic is the brand communities that meet social needs," and he explained the issue as follows:

> We all wanted to communicate, see what we value, and be connected with someone. Many of us have experienced the unhappiness of meeting social needs digitally. But here, the importance of brand communities is realized- a brand community is a community of people who are involved in your brand and share the same passion as you. They want to participate in an activity, share a similar area of interest, and create a common ground on a topic. Your brand's website is important to convey this feeling. If we give an example of this, one of them is Etsy. Etsy is a digital company that sells handicraft products. People can exhibit and sell their handicrafts here. The other is Sephora's "beauty insider community." People can share their comments on beauty products in this forum.[3]

I have noticed brand communities like this and others helping people build social networks and be part of a group. Brands can now be reached with these networks and ties. However, such groups that marketers do not see or want to see are more active on WhatsApp, which is not accessible in any way, and this trend is spreading. t is not possible to reach herein by any means, including marketing authorization, right now!

From Germany, Professor Dr. Hermann Simon's talk titled "True Profit: After Corona Has Never Been So Important" was not a marketing speech but rather a talk about business administration. "Banks and government agencies only have real profits. Companies can keep real profits, but they don't like to explain it. Interest, taxes, expenses, and other expenses are important factors that reduce the profits of companies."[4] Simon made a very striking start, "And the companies that have the Right Profit at this time will survive these days. Companies enjoy disclosing their earned profits to the public but are unaware of how much of it is real profits. Many companies calculate profit from a simple account, but this figure can be the end of many things. The 'correct profit' is the last figure that gets even the smallest expenditure deducted. And companies can continue this period successfully only if this final figure (Net Profit) is positive,"[4] he said. His statements were even more important. What he later said was interesting for global companies:

> There is a negative correlation between the size of the economy and the profit margin in your country. Countries with the highest profit rate in the current situation are Russia, Brazil, and India. Countries with low-profit margins are Japan, Germany, France, and America. Countries with the largest economies have the lowest profit margins. It is very difficult to do business and hold on to these countries. Because as the economy expands, your profit will shrink compared to the country. This situation is also valid for the sectors. Companies operating in the field of biotechnology have a profit margin of 21%, while the profit margin of companies operating in the automobile industry is 7.4%. Because biotech companies have a relatively new and limited scope, companies doing business in this field are able to retain their profits.

On the other hand, the profit margin for automobile companies is lower. In other words, an automobile manufacturer must try harder to take a share of the market and make a profitable venture. This situation is much more dramatic for the FMCG sector. It is much more difficult to get a share and hold on in sectors where the margin is high, but the True Profit is low.[4]

Simon then gave information about the companies and surprised the audience even more: Currently, the most profitable company is Saudi Aramco, with 110,975 billion dollars (annually). The daily profit of this company is 304 million dollars. Apple is in second place with an annual profit of 59,531 billion dollars and a daily profit of 163 million dollars. Bank of China ranks third with an annual profit of 44,895 billion dollars and a daily profit of 123 million dollars. Fourth is Samsung, and fifth is JPMorgan Chase. Yet, despite the high profitability figures announced by Apple to the world, how can Saudi Aramco rank above it? All of this information are related to economic balances, and many of the systems you see have been rearranged to gain public trust.

The point emphasized by Simon is correct. Therefore, in order to ensure the continuity of our businesses for society and for sustainable success, we should closely examine profit margins in times of crisis and focus on the Right Profit, not on our net profit but on the remaining cash (free cash flow) and consider this in the accounts. Otherwise, we may be living and letting others live in a fantasy world.

The speech made by Larry Light, former Global CEO of McDonald's, drew attention to the difference between business schools and real life, revealing the reasons why young people are no longer interested in business education as before.

Light said, "With Covid-19, the already decreasing student demand decreased by 70%, even in online MBA alone, there was a 60% decrease, in addition, one-year MBA programs also decreased by 50%. Because students who enter these departments often complain that they are not getting value for their money. Many complain that MBA programs do not support creative thinking and that their education kills their creative potential. Many of the students, especially Gen Z (born in 2000), see these schools as racist, sexist, closed to development and creativity, and destroying the imagination."[5]

These schools seem to see business education as just about reading what has been written so far. They seem to have difficulty keeping up their curriculum with time and technology. To me, they are not up to date. I think students are now learning more from Google University. In addition to what they can learn from books and the internet in school, it would be better if they learned a little bit of practice and studied some different case studies, but I now see that there is an obstacle here as well. I do not see up-to-date information in most of the books and articles I have read. What I have

read, rather, are heroic stories of that period written about the achievements of people. Indeed, it is not possible to understand the full practical consequences of such study. It is not possible to understand the reasons for failures in real life. It has never been more important for business schools to engage with the industry.

Because the sector is widening the gap in practice due to the Covid-19 pandemic and change is happening, schools that are claiming to raise the employees of the future should now update themselves immediately. Light says:

> MBA programs are based on financial engineering. This form of education is a devastating disease. Financial engineering has one good point. Maximizing profits in a short time and at all costs. This doctrine reduces our chances of fighting with companies that greedily see people as capital. For example, this financial engineering is the reason for General Electric's failure. Similarly, there are many firms that are going bankrupt, and people are not capital. Quality budgeting should replace financial engineering. Sustainable models are produced in this model. Another point about these schools is the educational models based on extreme analysis. Over-analysis models are methods that stop students' creativity and put them into a certain area. Good analysts come out of this training, but these people are closed to creativity and imagination.[5]

I have said it before in articles that I've shared, analysis, research, and insight are extremely important for renovation and innovation. But if there is no creativity, who will produce something new from existing data? It is not possible for me to manage companies in today's stormy seas with the information in a book. It is necessary to add to this, transform the results into behavior, and train human resources that will bring companies to safe harbors.

Light concluded his speech, saying: "Facebook had its CMO resign just two years later. Why is that? Because the CMO did not understand its users. So it is difficult to present marketing cases today with simple marketing. A business cannot be managed with simple marketing knowledge in times of crisis."[5]

I wonder what Ülker's marketing secret is? Most of the time, people say, "it is successful because it has very good distribution," which is true. It is our responsibility to take our products even to the remotest corners of the geography we are in, to contribute to the economy, and to provide the customer with value. But this doesn't explain everything. The definition of effective marketing is maximum customer satisfaction responsibly and profitably! What is it not? It is not new advertising forms, use of different tools, events, promotions, campaigns, and so on. The important thing is that the customer demands it. True responsibility in marketing is the responsibility to understand the needs and desires of our customers. That's why I say that Ülker's

success lies in the following words: "The consumer (buyer) is satisfied, and the customer (seller) is satisfied!" (an old Turkish saying). In other words, if my consumer (buyer) is satisfied, and also my customer (seller) is satisfied, then the producer (maker – us) is as well!

References

(1) Al, R., and Trout, J. (2001). *Positioning: The Battle for Your Mind*, McGraw Hill Education.

(2) Ries, L. (2020, Nov 7-8) *The Effect of Marketing on Consumer Behavior?*. https://worldmarketingsummit.org/conferences/electronic-world-marketing-summit-2020/

(3) Aeker, D. (2020, Nov 7-8) Winning in the Post-Covid-19 World. https://worldmarketingsummit.org/conferences/electronic-world-marketing-summit-2020/

(4) Simon, H. (2020, Nov 7-8) *True Profit: After Corona Has Never Been So Important.* https://worldmarketingsummit.org/conferences/electronic-world-marketing-summit-2020/

(5) Light, L. (2020, Nov 7-8). https://worldmarketingsummit.org/conferences/electronic-world-marketing-summit-2020/

Make Happy, Be Happy

Since 2014, we have been celebrating the "Make Happy, Be Happy" day every year, on the third Thursday of November, which crowns the basic mission that guides us throughout the year at Yildiz Holding.

Our mission derives from my beloved father's saying, "We believe that every child, no matter where they live, has the right to have a beautiful childhood." In the early days when we took steps toward globalization by realizing pladis, Godiva, and Demet operations, I summed up my father's words from my point of view: "We do not only produce biscuits and chocolate; with every bite, we promise happiness to the world." For some time, these two expressions have been used to describe our core mission. Later, I came to realize that Yildiz Holding, in the four corners of the world – Turkey, the Middle East, North Africa, the Turkic Republics, the Americas, Japan, the UK, Continental Europe, Africa, China, Russia, and Southeast Asia – with more than four billion consumers and more than 65,000 employees of various religions, languages, and races, are all concerned with providing products/services to create "benefit" every day. And while doing this, they are providing examples of spearheading social affairs in many parts of the world, helping with social assistance projects, and participating in competitions. They are committed to their work. This is what is called "beneficial work" (righteous deeds) – we do the work that produces benefits and works that benefit people. That's how my thoughts turned into a slogan, and it has made everything meaningful. Victor Hugo said, "No power on earth can stop an idea whose time has come."[1] Exactly. The #makehappybehappy time has arrived, and this motto leads all of us in our work. Looking back, Ülker began its journey as a family business. We have always continued on our way by absorbing our family values (customs) into our corporate values. We have combined all of our companies and brands with the essence of a family business.

In the last six years, #makehappybehappy has turned into a volunteer movement in all of our management units and companies. Throughout the year, our employees strive to make our consumers happy while fulfilling their duties through new products and innovations, while observing the reputation of our iconic brands, and moreover, almost competing with each other to generate social benefits in their environment, especially when it comes to children. The Sabri Ülker Foundation has reached just over seven million students, parents, and tutors with the Balanced Nutrition Education Project in Turkey; the children's books published have provided a remedy for 700,000 families during the Covid-19 pandemic. I feel that our core

mission, which we summarize as #makehappybehappy, and which is a guide for all of us at the moment, includes a good understanding and is a philosophy that is a remedy for people who are searching for meaning, which has accelerated during the crisis in which we are currently living. Most of the happiness studies to date say this. For example, helping others instead of spending money on oneself has been proven to make people happier. The action that makes people happiest is to help others; in other words, it is our human nature.[2]

Looking back, Ülker began its journey as a family business. No matter how large we have grown and that we have become global, we have never given up on our family values. Being a family business for us means exemplifying honesty and dignity, setting goals and working toward them, leaving a good legacy to the future, and producing benefit through righteous deeds. In short, #makehappybehappy!

These spiritual values are the most precious legacy of Sabri Bey. If we have been able to build a successful global Yildiz Holding today, it is because we have been guided by our customs and still protect them in our institutions.

The interesting thing is that, although the companies that make-up pladis were established in different geographies, different times, and different cultures, they grow and develop with the same company values, similar to Ülker. This means that such values are universal in families. While bringing together Ülker, Godiva Chocolatier, United Biscuits, Jacobs, Carrs, Crawfords, BN, Verkade, and DeMet's Candy Company under the same roof, pladis creates a story that includes three hundred fifty years of history. In all this history, we bring together values. In other words, when we acquired these companies, we inherited not only material values but also moral ones. When we look at the stories of all these companies, I see that the founders, just like my father and uncle, have created and developed their companies and brands through great struggles.

As Yildiz Holding, we are a global company that includes pladis and Godiva as a result of seventy-five years of experience. Why?

1. We are agile, flexible, and entrepreneurial.
2. We operate in an area where a consumer group of four billion people lives.
3. We are consumer oriented.
4. We have innovative products and services that make a difference.
5. Our G0AL 21 target (G: G.O.Y.A., 0: zero defect, A: alignment, L: leader in the field).
6. Our way of life, #makehappybehappy, brings our hearts into our work.

Some words attributed to Mark Twain are: "One of the two most important days of your life is the day you were born, and the other is the day you learn

why."[5] Most of us spend our days in such a search. Sometimes people are disappointed that they cannot find what they are looking for.

However, by being aware of our main purpose in business life, let's make our work meaningful and make #makehappybehappy be our focus.[2]

There should be no significant difference between a company's mission and the company's reason for existence. In our opinion, the happiness of everything that is created, animate and inanimate, is important. Why worry about nature while making our customers happy? Our world is so generous and so fertile to us! Why should we consume our source of life? Sustainability means respecting and protecting people and the environment while doing your job.

An article entitled "One's Happiness Depends on Making Others Happy," by Prof. Mim Kemal Oke, appeared in *Vefa* magazine, in which he states that the source of our foundation culture was the philosophy of "making someone else happy."[3] I quote the following from the article: "while presenting products/services, I remembered once more how deeply encompassing our corporation mission is, summarized as 'Make Happy, Be Happy' and how it gives such great inner peace to work with a philosophy which serves the solidarity cycle to contribute to the 'good handover' of the world. If you want, you can find a supportive and directing source of guidance from the civilization we all came from."[3]

So if I may repeat, fairytales are not required to be happy; it is enough to just add meaning to whatever you do.

References

(1) Aimard, Gustave. (1861). The Freebooter. London: Ward and Lock. pp. 57.

(2) Lowenstein, K. (2019). "Nine Ways to Feel More Joy," in *The Science of Happiness*, Time, pp. 18–21.

(3) https://www.cirlot.com/news/the-two-most-important-days-in-your-life-are-the-day-you-are-born-and-the-day-you-find-out-why-mark-twain/

(4) Coleman, J. (2018) "A Purpose Is Not Found, It Is Built," in Levent Göktem, *Purpose, Meaning, Passion*, Optimist, pp. 31–37.

(5) Oke, M. K. (2020). "Kisinin Mutlulugu Baskasini Mutlu Etmesine Baglidir," *Vefa*, Yaz, pp. 14–15.

The Higher the Targets, the Higher the Performance!

A job only gives more productive results when employees in that job are happy and think that they are getting what they work for. Today, corporate companies' employee happiness has become as important as consumer or customer satisfaction. Now, even employees are called "internal customers."

In order to ensure employee satisfaction, it is very important to measure their performance fairly. We implement the 360-Degree Performance Evaluation System in this regard, and indeed, we have obtained satisfactory results. This system, which allows subordinate colleagues to be evaluated by team members as well as by the employee's superior, gives good results, such that those who do business with you, those you do business with, your teammates, or those who are below you, give orders or receive orders, are producing a 360-degree evaluation of you. We have been applying this method for quite some time, and doing this is like holding up a mirror to ourselves. In all evaluations, everyone actually does conscience calculating. Thus awareness is created. I think the approach is very useful in this respect.

I should point out that there are some difficulties for me in making this assessment. You may ask why I can't complete 360 on myself. The answer is: a chief assessment is not available for me. However, we can also look at it is this way: my biggest supervisor is, of course, my consumers, my customers. When we consider their evaluations, my grade does not look bad at all. In most surveys, Ülker, McVities, and Godiva are the most preferred brands. When we analyze the data, we see that our market share has increased. So, we get good marks from our stakeholders, and as such, my 360 is completed in this way. Make happy, be happy.

As I've said, employee satisfaction is important. We try to provide this satisfaction not only now but have a history of doing so in the past as well. We were conducting other performance evaluation systems until we reached 360.

In the early years of the company, a few people did performance reviews. In other words, three levels up, supervisors would evaluate all employees, while supervisors were unaware of each other. In the years that followed, a more systematic performance evaluation was established.

It was decided whether this should be a performance evaluation or grading. This system was even applied to workers. But I would like to note that some individuals, even the union, opposed the construction of such a system and the distribution of premiums accordingly. Workers should not receive money or premiums of different kinds. An interesting way of thinking!

Yet, the system we implemented had a disadvantage. Notes were given subjectively. While the entire year had to be evaluated, the events at the time of the grading and imminent events could be more effective. In order to prevent this, a solution was found for a few supervisors to give grades without knowing the others' opinions. After all, it was a way of grading, showing a trend. Additionally, there weren't many objections as everyone received the money in their pockets. The first bonus system was used for piece work (box filling, product sorting, etc.) and for the monthly sales success of salesmen. The salesmen's premium was at least as much as their salary, that is, 50%. Later, for senior managers, this could start from 60% of their total income and exceed 130%. As for me, my income was entirely dependent on the business performing well, though I only had a monthly salary at Yildiz Holding, and it was never the highest paid salary in the company.

Later, we developed performance measurements, establishing what is called management by goals. So, we said, let's put on our lenses. We said, let's set career goals, see how much it is noticed, and let's make a note of it. Let's do a mutual interview and note it like that. We got good results.

At the point we reached, there was a need to digitize the system in the form of "smart KPIs," with key performance indicators. We decided that the majority, that is, 90%, should be made up of numbers, and 10% should be the subjective side.

However, the most challenging part was still the challenge of face-to-face feedback, somewhat due to our Turkish culture. Some general manager colleges were even going back and raising the low-performance grade of a particular person after giving face-to-face feedback. This was because, according to them, the college had been warned and would do what was necessary. Now the whole year was wasted. Who cares! Evaluation and feedback were repeated several times during the year to prevent this.

We achieved very successful results in this system. The 360-degree evaluation has become a way to perfect our work by shedding light to guide it. Thus, the system evolved and became more refined.

Of course, in every evaluation system, there is a passive human and, therefore, subjective influence. When you look at this from above (helicopter view), it is immediately obvious. For example, the subjectivity of those who are obsessed with their supervisor in the 360 evaluations is apparent.

When I was the general manager, the threshold was 60 out of 100. We would part ways with those who could not reach at least sixty. Additionally, salary increases would also depend on this. Outstanding performers had astronomical salaries every year. The salary of a senior caretaker or foreman was sometimes higher than that of his supervisor. Once a manager, a friend whose work I liked, came up sadly and asked why he was still not fired, because the low wage increase clearly showed that he could not even get

sixty points, so he should have been dismissed the previous month while he was still working. When we investigated, we encountered a material error and corrected it. Another example is that we gave a very low score and low salary to another supervisor as a warning. However, his commitment to the company was so great that he agreed to it and came and thanked us.

As times change, new systems emerge. Technology companies are bringing new perspectives to company management, as is the case with AI applications. Companies that want to be innovative and want to make a difference in customer experience are struggling to recruit and keep talented employees. HR departments search for scientific and effective performance management tools that will motivate employees better and increase productivity. As I said at the beginning, numerous performance tracking methods have been developed and implemented, including the Critical Incidents Technique (Flanagan & Baras, 1954),[1] Management by Goals (Drucker, 1954),[2] Key Performance Indicators (KPI), Balanced Score Cards (Norton & Kaplan, 1992),[3] 360-Degree Evaluation (Kuzulu and İyem, 2016),[4] and Electronic Performance Monitoring Systems (EPTS). What I understand is Objectives and Key Results (OKR), the new performance management system implemented by innovation-based technology companies such as Oracle, LinkedIn, Facebook, Chinese Baidu, Uber, and Netflix, which was first implemented by Google. It is also applied in non-tech companies such as BMW, Disney, Exxon, Samsung, and Anheuser-Busch and it is claimed to increase success. Many consulting firms that I have seen are also marketing this method.

On August 16, 2020, I wrote in my article titled "The Best Bargain Is an Expensive CEO":

Our mission (Make Happy Be Happy) oriented goals connect CEOs' performances other than financial purposes to other measurable goals, and KPIs. For example, Net Promoter Score, consumer satisfaction score, and churn rate for customers. For employees: absenteeism rates, satisfaction rates, and turnover rates, over time, brand awareness, market share, return on investment by market, and profitability compared to competitors can be such measurable goals. The feature of these metrics is that it depends on the success of the work in detail. Although managers decide in favor of one of the stakeholders in the short term, these goals balance long-term sustainable performance.[5]

During a given period, mission-related objectives should remain constant, and metrics should not remain the same and instead become increasingly difficult. If there is an improvement in this approach compared to the competitors compared to the previous year, a bonus is earned. The Board of Directors takes a bilateral approach to resolve the short-term and long-term ruptures experienced today. It links a CEO's long-term bonuses with the mission and balances them with short-term bonuses. Thus, CEO behavior is effectively monitored and guided. Short-term achievements are rewarded in annual operations plans (KPI), and long-term results are rewarded based on long-term plans (LTP).

Erden Tuzunkan, the founding partner of the company Corvisio, wrote the following text as a comment and added a link explaining what the OKRs are:

> Murat Ülker, thank you for your valuable comments and analysis. I have benefited greatly from your article. At this point, I would like to make a contribution. In today's world, we are experiencing a very rapid transformation. As you mentioned in your article, both Board Members and CEOs have to act agile. This reveals the necessity of creative thinking and solution-oriented action.
>
> At this point, I think that the current KPI and financial reward system linked to the salary misses the creativity and development dimension of the job and falls short. I think the remedy is the #OKR methodology, which was first implemented in Google and then spread to giants like Intel and GE. Therefore, I think that in innovation-oriented and international companies like you, KR (Key Results) determined by the OKR method should also be used to evaluate the performance of CEOs. In order to get detailed information about OKR, I present the following article: https://corvisio.com/what-is-okr/[6]

I had heard of OKR. I think it was last year when I visited Alibaba during my trip to China and learned about business models. It was there that I learned that Jack Ma, who once thought "An idea without a KPI, is an empty idea," also combined the KPI/OKR performance system. I remembered this experience with Ender's comment and received the book *Measure What Matters*, by John Doerr, one of the inventors of OKRs. After a bit of googling, I found a lot of duplicate reports from the last five years on how to implement OKRs from the last five years. There were too many references to a book written by two consultants and published by Wiley.[7] I understood that when the method, which had begun at Google, started to become more widespread and marketed by consultants, the real developer of the method took control of the situation by writing a book.

"Since OKRs are a shock to the established order," Doerr says on the first pages, "it may make sense to ease into them. They must be approached slowly and carefully. They are short-term goals that drive the real business. It is they who keep the annual plans honest and executable. Nothing can move a person as much as the deadline. Organizations need to be more agile than ever before to gain a foothold in the global market."[7] After reading that paragraph, my interest grew even more. Now it is possible to summarize it as follows:

OKRs consist of two elements. The first is the TARGET. This element is qualitative and inspiring. The second is KEY RESULTS. This item is also numerical and measurable. Goals are what is wanted to be achieved, namely the answer to the question "WHAT?" Goals become very valuable when they are concrete, action oriented, guiding, and certain. KEY results are the things that are paired with goals, enabling us to track and compare HOW we are progressing toward a goal. Time limits are put on key results; they are

aggressive but realistic. They are measurable and verifiable. In the process of determining OKRs, goals are set first; a maximum of five (as few as possible) key results are determined for each goal; practice is carried out to achieve the goals; and regular feedback is provided. The most recurring words of the OKR system are: "we will hit that specific TARGET measured by the KEY RESULTS below."

It is claimed that the OKR system is not a hierarchical organization but rather a structure that opens the way for talented people who work horizontally and enables them to be employed, where managers give up their small feudal lordship for a greater purpose. It is said that where there are OKRs, talent comes before seniority. Other listed advantages are as follows: Managers become coaches, mentors, and architects. Actions and data sound more and express more than do words. In the OKR system, there is value in what you do, not what you know. It works in monthly and quarterly cycles; a target of at least 50% bottom-up or horizontally is set, often separate from salary and bonuses, and a desire to take risks is created.

Measuring what is important (HIGH TARGET OR TARGETS) begins with the following questions: What is the most important thing for the next three, or six, or twelve months? What are our main priorities in the upcoming period? Where should people focus their efforts? For corporate-level OKRs, all responsibility lies with the senior leader. And then at least 50% OKRs are spread from bottom to top, and on the subject of "how?" employees are freed.

OKRs seemed to me like a framework for defining and tracking the company's most important goals and associated results. OKRs are transparent; everyone knows what everyone's goals are and what they are doing; and it ensures performance consistency among employees, bringing with it the unlimited pursuit of accountability and excellence. The reason OKRs are popular is that they address the focus, compliance, and engagement problems that organizations experience while maintaining execution. It is important that OKRs can be traceable, reviewed according to conditions, and changed when necessary. Negotiation, feedback, and appreciation are at the core of the OKR system.

The OKR application can be simply divided into four steps: The first step is to set goals, including monthly/quarterly/yearly goals for the company, department, and employees. The aim is to reach a qualitative goal within a certain period of time. The second step is to identify key results for each goal, to measure whether key results are met at the end of the period. The third step is to implement the base plan. The fourth step is regular feedback.[8]

In his book, Doerr describes the OKR set of an imaginary American football team using a diagram using the KPI system. After the head coach sets the goal of winning the "Super Bowl," it spreads to all levels with the correct

subgoals and key results in line with the main goal. Key results are the target of the two managers below, who set their own key results. Then they become the targets of the other three.

Doerr says:

> To put it in moderation, cascading or cascading makes an operation more harmonious. However, when all goals are cascaded, the process becomes mechanical with four side effects: lack of agility, lack of flexibility, marginalization of participants and prevention of lower-level entry, and lack of horizontal connectivity. Unlike the KPI system, in OKR, a target can jump directly from the CEO to an individual employee. Or the company management can present its goals to everyone at once. In this way, everyone is sure where the company wants to go.[7]

Not only have OKR rankings brought success to the company, but the fact that enlarged Google ten times with OKR is its system that allows software developers to work on side projects once a week. Doerr Google claims that by freeing up 20% of its smartest workforce, it's changing the world. He says: "The strongest OKRs in an innovative organization come from those who are outside of top management. Salespersons understand changing customer demands better than management; financial analysts are the first to understand that the foundations of a business have changed. An optimal OKR system frees participants to set at least some of their own goals and most or all of their key outcomes."[7]

Doerr gives many examples of companies adapting their KPI system to the OKR system for a better perception. One is Adobe. In the table below, Adobe's "Before and After" system is given. While Adobe became an innovative company with OKR, it also increased its growth coefficient. As you can see, the important issue here is the reward system – it does not depend on OKR!

	Before	After
Setting Priorities	Employees' priorities are set at the beginning of the year and are often irreversible.	Priorities are determined and regularly regulated with the manager.
Feedback Process	A long process of accepting achievements, requesting feedback, and writing reviews.	A continuous process of feedback and dialogue without any written evaluation or documentation process.
Reward Decisions	An elaborate process of scoring and ranking each employee to determine salary increases and rewards.	There is no official marking or ranking. Salary and benefits are determined on an annual basis based on executive performance.

Meeting Frequency	Feedback sessions are irregular and cannot be followed. Employees' productivity increases in the last period of the year when performance evaluation interviews take place.	Interviews are expected to be conducted quarterly as continuous feedback becomes standard. There is consistent employee productivity due to conversation and feedback spread throughout the year.
Role of Human Resources	HR teams manage paperwork and the process to make sure all steps in the system are taken.	The HR team equips employees and managers to create constructive visuals.
Education & Resources	Manages the guidance and resources from HR partners who do not reach everyone constantly.	A central Staff Resources Center provides assistance and answers when needed.

It analyzes the Doerr KPI system as a hidden competitor and makes OKRs more advantageous. Then let's take a look at what has been written on the KPIs that we have been successfully applying.

Key performance indicators (KPIs) are performance evaluation tools that were used for the first time in the UK. It is a system that simplifies performance evaluation according to the evaluation criteria of key indicators. KPIs follow the SMART goal-setting criteria. Its history goes back to the 1940s. In particular, the metrics used in performance dashboards are often referred to as KPIs as they are used to measure how well an organization or individuals are performing against predefined goals and objectives.

KPIs focus employees' attention on the tasks and processes managers deem most critical to the success of the business. Eckerson says there are two main types of KPIs: leading and lagging indicators. Kerzner believes that if the purpose of creating an assessment is to increase utility, the KPI should reflect the factors controlled and that the KPI only measures some of the goals. KPI is the mature performance management system of much more mature companies, but it also includes clumsiness. One of the theoretical underpinnings of the KPI is the Pareto principle, which is to concentrate 80% of resources on 20% of key indicators. For this reason, KPIs inevitably ignore some things that we also consider unimportant. The weak points of KPIs are:[9]

1. Employees always do what their performance evaluation measures. The high emphasis of the KPI on some indicators makes it easier to ignore some new market factors.
2. In practice, auditing KPIs can be expensive or difficult for organizations. For example, it is not that easy actually to measure employee satisfaction.

3. KPIs require time, effort, and employee involvement to meet their high expectations, but in fact, there is no clear indication of "who uses what" and how to use it. Lack of communication makes it difficult for the KPIs to effectively achieve the final organizational goals.

As the rising star of performance evaluation tools, OKRs' advantages can be summarized as follows:[7]

1. OKRs focus on what matters most. Moreover, OKRs ask you to set the most fundamental priorities and focus on a limited subset of potential variables relevant to any company's management.
2. OKR scores are not directly linked to performance; they are for reference only. Through OKRs, employees are willing to do what they think is good for the organization and can also spark new thinking that leads to unpredictable levels of success.
3. OKRs are not a top-down exercise of goals – they reflect a top-down and bottom-up mix of goal setting, and this can increase communication times between upper and lower levels. They both argue many times about the goal and the key result and ultimately do it together.
4. In a company, teams must be able to see the performance goals of other teams. OKRs improve employees' perception of fairness and motivate employees to improve their personal performance, encouraging the whole organization to engage in transparency.
5. At the individual level, OKRs reflect a mix of personal growth ambitions and contributions to the company.

Well, does the OKR system have no disadvantages? Of course, there are also disadvantages. These are stated below:[7, 9]

1. OKRs need high-quality employees, where high responsibility and creativity are required to meet the needs of the employees. However, it is difficult for standard personnel to meet these needs.
2. It makes managers question their management ability and leadership style; some styles, such as authoritarian leadership, are not suitable for this type of management model.
3. OKRs can lead to a lack of teamwork. Individuals can focus more on their personal OKRs rather than the team-level OKRs.

I know that no matter what performance evaluation tool it is, its sole purpose is to achieve the strategic goals of the organization, realize the profit of the company, and create value. If anyone knows a goal other than that, let us learn about it.

My conclusion is that OKR and KPI have the same goal. They both derive from OKR and KPI organizational strategies and point to organizational

goals. I think it could not have been expected to be any other way. The whole aim is to align the company/companies toward common goals. The valid word in both KPI and OKR is "key" because each KPI and OKR must be associated with a specific result. Moreover, both OKR and KPI require management controllability.

The key indicators highlighted in KPIs and the key results highlighted in OKRs seemed similar again to me. KPIs also contain a target value, but the KPI target covers a wider range than do OKRs.

Also, there are numerical requirements for both vehicles. While determining a suitable number of figures for the KPI, the OKR's goal is to limit the business to five figures. More than five key results are not suitable for every goal.

I think if we look at the application, KPIs pay more attention to digitizing and expressing employee performance. The results are directly linked to the employee's benefits, such as wages and bonuses. In this case, it is mentioned that the employees put their own interests first, so to speak.[9] Thus, it can ignore the strategies that guide the KPIs, and excessive adherence to numerical indicators emerges. OKRs, in contrast, are goal-achieving tools that do not conflict with the direct interests of the employees and are mostly used to evaluate the completion of the target. OKRs also have quantitative indicators but focus only on key outcomes that can promote the better achievement of goals, so employees are eager to improve performance.

KPIs are formed from top to bottom, and few managers participate in this process while developing and valuing in their strategies. Not all KPIs are clear and specific, either. It can be easy to take KPIs out of context or misunderstand them. The result may have nothing to do with the original intention.

Most OKRs are developed from bottom to top. Thus, teams and individuals are enabled to claim their own goals from the outset.

If we explain it from a point that I know well, with a metaphor from product manufacturing:

The KPI evaluation method is a standard production line that does not leave people with authority; it is a simple operation with a clear pattern and a low operating cost. Therefore, their strengths can be captured by copying the tools. New entries to the market can be made easily.

The OKR method is a mass "customized" production process. The outputs of a certain standard may vary according to the needs of the customers and the market. Once adopted, it is no longer the same product, but it supports its main idea not only to maintain the production standard but also to meet changing needs.

OKRs allow employees to adjust according to their personal goals while maintaining the core objectives of the organization. However, KPIs are

not corrected over time according to market changes and employee needs. "OKRs are not magic wands," says Doerr. "They are no substitute for healthy reasoning, strong leadership, and creative workplace culture. If these basic elements are available, OKRs can bring you to the top."[7]

I think no performance management system is a magic bullet. The KPI-based system also requires leadership and creativity to achieve the goals in the long term. If OKRs really lead to a more innovative environment in non-technology companies, as is explained, if they provide ten times growth, why not start somewhere and build OKRs on the KPI system supported by a 360-degree valuation and LTIP?

In Yildiz Holding, the situation is different. We have a successful KPI system that reflects on the results. In fact, we now support this with the LTIP system.

As for the OKR system, it will be implemented by Yahya Bey in the New Ventures section of our company, where our youngest executives are in charge of start-ups and new, specially digital businesses.

I talked to Ayca on the advice of Yahya, and this is what I learned:

> Although KPIs are detected annually, OKRs can be renewed every quarter. In fact, a relationship such as a target and plan can be defined as the relationship between two indicators (KPI, OKR), the first of which determines what we want (target), while the second one is the preference of how we want (method), because there are always multiple ways and methods to achieve the goal. Our choices are important in terms of cost, time, and ability to keep or exceed the target. In other words, OKR is the name of our determination for every level manager, how we will apply the tactics we will determine according to our strategy. For example, be KPI, NIS (negative net working capital). How do we achieve this? OKRs for various departments; they can be deferring month-end balances for accounting (financial wizard), stock reduction for business, or additional maturity for purchasing. But the result will be either short-term success, maximum attention for inventory management in the business, or reputation cost of establishing maturity pressure on dealers, respectively, according to the choice of the administration.

This is the way in which the strategic determination of how to achieve the subgoals in all departments will be done with OKRs. But I think we should avoid OKRs in top management in terms of empowerment and delegation.

References

(1) Flanagan, J. (1954). "The Critical Incident Technique, American Institute for Research and University of Pittsburgh," *Psychological Bulletin*, 51(4).

(2) Drucker, P. (1954). *The Practice of Management*, Harper Business.

(3) Norton, P. D., and Kaplan, R. S. (1992). "The Balanced Scorecard – Measures That Drive Performance," *HBR*.

(4) Kuzulu, E., and Iyem, C. (2018). "360 Degree Feedback Appraisal an Effective Way of Performance Evaluation," *International Journal of Academic Research in Business and Social Sciences*, 17(3) 6; Gunay, Z. (2018). "Calisanlarin 360 Derece Performans Degerlemeye Yaklasimlari: Bir Telekomunikasyon Sirketi Ornegi," *Bingol Universitesi Sosyal Bilimler Dergisi*, 8, p. 16.

(5) Ülker, M. (2020 August 23) The Best Bargain is an expensive CEO. https://www.linkedin.com/pulse/best-bargain-expensive-ceo-pay-performance-urban-legend-murat-%C3%BClker/

(6) Corvisio (2020), What is OKR? https://corvisio.com/what-is-okr/

(7) Doerr, J. (2020). *Onemli Olani Olc*, Buzdagi; Nivan, P. R., and Lamorte, B. (2016). *Objectives and Key Results: Driving Focus, Alignment, and Engagement with OKRs*, Wiley, p. 224.

(8) Trinkenreich, B., Santos, G., Barcellos, M.P., & Conte, T.U. (2019). "Combining GQM strategies and OKR-preliminary results from a participative case study in industry", Proc. Int. Conf. Product-Focused Softw. Process. Improvement, pp.103–111. https://www.researchgate.net/publication/336590987.

(9) Zhou, H., and He, Y. (2018). "Comparative Study of OKR and KPI," International Conference on E-commerce and Contemporary Economic Development (ECED), 319–323. 10.12783/dtem/eced2018/23986.

Post-Corona Economy: Simit or Doughnut Economics

In August 2020, I read in several newspapers that Amsterdam was shifting to the "doughnut economy" model. It was officially accepted as a model by the Municipality of Amsterdam. With the cyclical economy practices that would be applied to waste, it has set a goal to become a circular city by the year 2050. Academician Kate Raworth was commissioned to develop the doughnut model on an urban scale.

I asked myself, "Where did this doughnut economy come from in the middle of the pandemic?" Of course, I was curious, and I did some research. In an interview with the *Guardian* newspaper, Marieke van Doorninck, deputy mayor of Amsterdam Municipality, said: "I think it can help us overcome the effects of the crisis. It may look strange that we are talking about the period after that, but as a government, we have to … The model is to help us not to fall back on easy mechanisms."[1]

Raworth explained the process of downscaling the model to the city level: "A holistic approach has emerged that encompasses both local and global social and ecological perspectives. The basic question at the scale of the city; she defines as the question of whether the city can be a home for growing people in a thriving place while taking care of the well-being of all people and the health of the planet."[2]

My curiosity piqued, I continued reading. Van Doorninck explained that the doughnut economy requires addressing social and environmental problems together, giving an example from Amsterdam's housing crisis:

> About 20% of the people living in the city cannot meet their basic needs after paying their rent. Only 12% of the approximately 60,000 applications for social housing are accepted. The first solution that comes to mind is new housing construction. However, Amsterdam's doughnut economy criteria say that the region's carbon dioxide emissions increased by 31% compared to 1990. Besides, the share of construction materials, food, and consumer products brought from outside the city is 62% of the total emission. The city administration plans to make regulations to ensure that recyclable and bio-based materials such as wood are used as much as possible.[3]

But there's another dimension to the problem: housing speculation. Van Doorninck said, "The fact that houses are too expensive is not only about too few being built. There is a lot of capital flowing around the world trying to find an investment, and right now, real estate is seen as the best way to invest, so that drives up prices."[4]

When I read these remarks, I remembered that I had read a few articles about this model before. I googled it. Kate Raworth is a lecturer at Oxford University's Environmental Change Institute and Cambridge University's Institute for Sustainability Leadership. She wrote the book *Doughnut Economics: 7 Ways to Think Like a 21st Century Economist* in 2017, and it was a bestseller. A year later, she was the primary guest of the World Economic Forum. Gila Benmayor wrote in an article in *Hurriyet* in 2018, Raworth's "Economists have been obsessed with the GDP for seventy years. Let go of the obsession with economic growth. Forget growth instead focus on how anyone will be able to distribute the world's diminishing resources equally. Growing can be to some extent. If something grows too big in nature, it turns into cancer words stayed in her mind."[5] True, these are very effective words.

In her article, Benmayor wrote that some view Raworth as an incurable "utopian." Then she added: "But on the other hand, there is the fact that the economic system is clogged, the income gap is growing, the earth is getting warmer, and even the oceans are dying."[5] Now is the time for all of us to be 'utopian.' "[6]

How come this "utopia" became an alternative economic model for some after the coronavirus pandemic?! Then, I remembered an article Verda Ozer wrote on Milliyet.com.tr in June 2020, which states:

"Corona has revealed how fragile and unfair the global economic system is." "It showed us how inequalities between and within countries have increased and how wide the gap between rich and poor has widened." Then she recommended a solution: doughnut economics.

She states that Raworth is a proponent of this model, summarizing it as: "We need to create a model that recognizes that man is deeply connected to nature rather than trying to dominate it and based on the fact that people's brains are interconnected with a drive for cooperation, empathy, and cooperation."[7]

Then she goes further:

"Well as to the question of why a doughnut, she answers this question very well: Because of its round and hollow shape, reminiscent of our simit. The periphery of the donut represents the boundaries of the earth. In other words, global warming, air pollution, loss of biodiversity, etc. The periphery of the inner circle is what we need for a good life: things like food, clean water, housing, energy, education, and health care. Those between the two rings are the lucky ones in the world. As to the space in the middle of the doughnut, here are those who cannot afford to abide by that "Stay at Home" slogan."[7]

"But I think the most important feature of the doughnut is that it is round. I think it best shows that everyone and everything is interconnected, that we are all in the same circle,"[7] she concludes in her article.

When my curiosity was piqued even more, I, of course, ordered the book and started to read it. It was published in Turkish by Can Sanat Publications in 2019, and *Doughnut Economy* became *Simit Ekonomisi*.[8]

According to Raworth's thesis, the mainstream theory, which is a combination of classical economic theory, which started with Adam Smith, the ancestor of capitalism; neoclassical economic theory, which was revised with the crisis in the 1870s; and Keynesian theory, is quite inadequate to predict the global crisis and take preventive measures despite the changing perceptions and understanding of individuals globally!

One of the main reasons why the impending crisis could not be foreseen and the necessary measures could not be taken is that people in decision-making positions were brought up with economic theories that date back to the 1850s. For this reason, they could not correctly build the innovations brought by the twenty-first century, taking into account the changing world conditions.

Raworth says that the benchmark of Keynesian theory is gross domestic product (GDP), which is thought to represent the size of the economy and/or income. However, while the damage done to the environment in terms of growth is not included in this measure, expenses incurred to repair the damage are included.

Based on this, instead of mainstream economic theory, which includes the basic assumptions that accept people as rational individuals, she brings forward the doughnut proposition where everyone can live safely and fairly in the area between a social ceiling that no one should go under, and an ecological ceiling created by global pressures that no one should go beyond.

At the heart of the premise, Raworth argues that the doughnut should be made up of adequate food, clean water, and proper sanitation; access to energy and clean cooking facilities; access to education and healthcare; decent housing; a minimum income and decent work; and access to information and community support networks. She lists twelve basic needs that no one should be left without in the inner circle that represent the social base, and she states that the main purpose of the twenty-first century is to ensure that people take part in this doughnut. Raworth offers seven ways to create this field that focuses on development, not growth:

The first way is to change the goal. The aim here is to stop seeing GDP as a benchmark and to aim for a developing and fair income-sharing instead of a constantly growing economy. Moreover, the aim is to take into account the planet we live on while this development takes place.

The second way is to see the big picture. At this stage, it is necessary to recognize that the neoliberal economy has plunged us into inequality and financial crises. While constructing a new economic model, the welfare of the planet we live on and of humanity should also be taken into account.

The third way is the development of human nature. The rational economic human model is the pillar of mainstream economics. This human model has a complex, and self-interested nature. No matter how selfish a person may be, he has an altruistic nature that is concerned with the fate of others in his nature.

Fourth, it is necessary to understand the systems. It is imperative to abandon the perspective that sees the economy as a machine and adopt the perspective that sees it as an organism.

Fifth, the design must be made for sharing. The most important thing to do in the twenty-first century, is to design an economy that will challenge the constraints of markets and ensure a more equitable sharing of common heritages.

Sixth, it is necessary to create in order to regenerate. It is necessary to accept the invalidity of the philosophy of first growing up and then being cleaned. Ecological destruction is not a luxury concern. At this point, a dynamic economy model should be adopted, not a linear one.

Seventh, one must be skeptical, or "agnostic" about growth. An economic model based on social welfare and sustainability should be created instead of the main target being the growth or stability of GDP.

My first question is, how can all humanity agree on an economic understanding that will be better for the whole world for the sake of a collective purpose when even the indicators such as GDP can be said to be biased? Where do we put the concept of class struggle put forward by Karl Marx, while the model is based on a sharing infrastructure as it is? Will we ignore that? According to Marx, inequalities in income distribution and different life the struggles shape the perceptions and, the priorities of people at different levels of society. Isn't it too optimistic to think that all humanity can gather around a "higher" purpose under these conditions? While proposing such a so-called egalitarian model, we should not forget Marx's discourse, right?

Even Raworth claims the opposite and tries to reinforce this idea by giving examples from countries such as India, saying the basic social needs of a country should be met before creating awareness of the importance of the ecological ceiling. Raworth says: "Our beliefs about human nature shape that nature."[2] Marx also objects to this idea. Is it because, according to him, the material conditions in which man exists, determine the reality and the beliefs of man, I wonder? Raworth's ideas, in my view, do not take social realities into account. A person can be potentially altruistic, but it is difficult to think that this altruism explains the behavior of the person struggling with various problems in daily life.

Raworth states that man should not be seen as the conqueror of lands and communities but as a mere member and citizen of them (trustee, user). These efforts of Raworth to reconceptualize human nature are truly utopian.

Raworth does not take into account class differences and the different world-views that have resulted from them. On the other hand, Raworth's new economic order reveals only the ultimate purpose of human nature "how?" Of course, the fact that she is insufficient in answering the question does not mean that her thoughts are wrong! Raworth says, "The time has come to see ourselves in a co-creative partnership as intertwined individuals with the earth."[2]

As explained in Raworth's book, it is impossible not to agree with many statements that include thoughts that resources are overexploited, that the ecological limit has been reached, and that the current system works with a focus on material wealth and growth, leaving out many human values! However, it is debatable how useful it will be to emphasize these without concrete steps and features specifying the system to replace these values. There is a project report in Amsterdam, but there is no model yet. Perhaps it will be made up as they go along.

Raworth warns about ecological destruction, rejecting the widespread belief that economic growth will surely eliminate pollution: "Ecological destruction is not a luxury concern for countries to leave on one side until they are rich enough to give it their attention. Rather than wait for growth to clean it up – because it won't – it is far smarter to create economies that are regenerative by design, restoring and renewing the local-to-global cycles of life on which human well-being depends."[2]

This is easy to write. The point is to agree on the subject of exactly which economy will restore and renew the local-to-global cycles of life on which human well-being depends, but how?

Raworth states that countries do not need to reach a certain economic level in order to have environmental awareness. She embodies this through the example of India and states that although the country has made progress economically, it has not advanced in terms of environmental outcomes. India's actions and environmental conditions are always assumed to be self-determined, yet this is not true. In the economic and environmental activities of a country, the colonization efforts and the political interests of global companies and other countries in the history of that country should not be forgotten. Raworth states that an economic structure in which the material wealth of nations is not a priority should be developed within the capitalist economic system, and this is possible. Raworth criticizes a land developer who doesn't want to make his building oxygen releasing: "It is indicative of the mindset of doing business that is born into the designs of contemporary capitalism and is found almost everywhere ... Mainstream business operators still ask how much financial value we can derive from this. Creative designs will fall far short of their potential if the business world simply pursues this area of overlap."[2]

Let's look at Marx again. Marx also stated that the technological conditions in the industrial society held great potential for humanity. However, he added that the relations of production, that is, the social relations arising from the production system, overshadow this potential. Based on Marx's words, this mentality of doing business was not born within capitalist designs but with them. The author, Raworth, rightly makes use of anthropology by referring to the communities that conduct their economic relations on a different plane and mentions that it is possible to establish such economic structures all across communities. It can be admitted that these communities pose problems for capitalism and offer hope for another system. But to be convinced of these problems, it is necessary to explain how a renewable economy is possible in urban life, rather than alternative economies in small communities. However, Raworth accepts that it does not apply to today's cities: "There may not be such a city on any map in the world yet, but there are initiatives and projects that aim to put these design principles into practice on various continents. Park 20/20 in the Netherlands, Newlight Technologies in California."[2]

It seems that Raworth was already called upon by politicians to implement this model in Amsterdam, the closest city to her model, and she went into this project with hope. But she admits in her book that it is unclear whether these attempts will ultimately deliver on promises: "For example, even though the buildings of Park 20/20 are made with recyclable materials, will they really be recycled one day? Sundrop Farms' greenhouses are largely solar-powered, but on cloudy days they make use of a gas boiler that is kept in reserve: Can they be successful without using this boiler?"[2]

These initiatives may be steps in good faith toward sustainability, or they may be an effort to improve a city's reputation by using green, as the author points out in the section where she outlines the types of doing business in the doughnut economy. However, it is doubtful how important progress has been made to "develop the classical economic understanding which is common in global capitalism for the good of humanity."

In the "design to divide" section, Raworth states that the power in the corporate world is in the hands of the stakeholders, namely the upper class, while the workers are excluded and are seen as inputs that can be fired at any time. There are two designs that Raworth thinks will end this class discrimination: established membership and stakeholder finance.

"Essential membership" guarantees that a worker will become a permanent employee of a company. Stakeholder finance, in contrast, is the financing of stakeholder investments, rather than ownership partnerships, with the promise of a fixed and fair return. Is the solution for employees to work in one place permanently a solution that all employees will wholeheartedly agree with? Under what conditions will workers or employees

accept this? The mentioned issues require an in-depth study of concepts such as forced labor and wage labor – as Marx did – and although she includes the views of founding fathers of classic economics such as Adam Smith, John Stuart Mill, and David Ricardo to support her thesis, she does not attempt to overcome these possible obstacles by not detailing the problems posed by Marx. For example, Marx stated that the poor working class, which lacks even the consciousness to initiate a change that he describes as lumpen-proletariat or industrialists who try to increase their profits by producing surplus value, are stuck in this cycle and that the arguments against the dominant economic understanding would directly look absurd because the current economic infrastructure determines the social culture, thought, and superstructure. Raworth makes no mention of these.

In fact, Raworth is aware of the difficulties faced by the economic order she speaks of. However, she still believes that humanity can act in a participative way by using renewable resources at the point reached and that they will want to leave a clean world to the next generations as the ultimate goal. Raworth's approach inevitably brings to mind Marx's approach to defenders of human and animal rights, journalists, and columnists without suggesting changing the principles of capitalism. As you know, Marx ridicules those who criticize the system in this way by saying that they want bourgeois socialism.

I find it useful to give examples from Marx because, while societies influenced by Marx's views progressed on this path as a result of revolutions, the red wind that blew for about seventy years caused many social disasters. This was probably not what the revolutionaries wanted. However, I don't know whether it was the USSR and glasnost that broke up. On the other hand, let's not forget that the architect of the Chinese miracle we are witnessing is the Chinese Communist Party. The authoritarian one-party system in China led the masses to a modern life of prosperity with good planning and hard work, regulating capital accumulation. Meanwhile, measures are being taken to attempt to defeat the pollution that occurred in nature with the same authoritarian method, for example, stopping all production until air pollution decreases.

In the West, for example, in Germany, governments obtained satisfactory results through classical incentive methods. Again in Raworth's example, in Germany in 2004, the government offered to introduce a feed-in tariff for households and institutions producing renewable energy and to pay above the retail price of electricity. This move led to extensive and transformative investments in wind, solar, hydroelectric, and biomass energies across the country, and in just ten years, 30% of the country's electricity came from renewable energy. In fact, the government had assigned a per-unit value to

the renewable energy initiative as an incentive, paid cash, and the transformation took place.

Raworth's idea is illuminating that the classical understanding of economy, in which the environment is polluted and resources are rapidly depleted, is an abstract, closed system in itself and does not include human beings. However, the statement "An understanding of the economy is required that will be good for all humanity and nature and that will feed everyone"[2] is a cliché, and the main aim is to talk about how this can happen and to show clear resources. I hope we will be able to see in the future the answers to these questions that I could not find in the book, in the model to be implemented in Amsterdam.

For example, by saying that "the gardeners of the economy have to struggle hard and deal with the picking, moving, grafting, pruning, and weeding of plants as they grow and mature,"[2] Raworth suggests that these things should not be left entirely on their own to be managed but should be pursued. There is no satisfactory explanation in the book as to the extent to which this differs from state control over the economy; it is not clear who will do those "things." So throughout the book there are uncertainties about which concrete steps can be taken to develop an economic understanding that values people and nature more than the current economic order. I think it is necessary to better understand the recipes and their results before trying new models. And of course, we also need to listen to those who, like Bjorn Lomborg, argue that climate change is real but that the end of the world is not something that will come in the "right now," as it is thought, and who therefore think that our planet is actually harmed by polluting our minds with bad science and pouring the world's resources into the wrong places with a bad economy. We need to discuss this too, and maybe even starting with whether the consequences of climate change are as exaggerated as they seem!

In my view, the annual economic value of the world's wetlands is 3.4 billion dollars, while services related to the spread of insects and pollen correspond to 160 billion dollars. We see that economists can calculate the monetary value of "natural capital and ecosystems." If governments value and certify these assets, as a result of the circulation of these values, which have become financial instruments in the markets, the value of nature is determined and can become an attraction pursued by capitalist motives all over the world. As you know, there is now, however, the opposite practice, punishment, and taxation system. Getting taste and pleasure from life is punished with additional taxes (such as VAT, and SCT). This is the preferred approach because it provides additional tax revenue to governments. In contrast, the circulation of nature values, whose worth is determined, in financial markets will make environmentalism an attractive investment.

Of course, I do not mean carbon-emission papers, which currently have an artificial market. This method cunningly provides an average correction on paper, taking advantage of the contribution of clean industries while the environment is polluted. However, instead of encouraging developments that will prevent the pollution of the environment, in contrast, it makes polluting activities possible.

As Yildiz Holding, we carry out activities to reduce carbon emissions in many of our companies, especially Ülker, Sok Markets, Bizim Toptan, and Superfresh, in line with the United Nations Sustainable Development Goals. We implement quality and safety-oriented approaches in talent management and value chain, and report them regularly. We support the United Nations' calls for global cooperation on this issue. With our 65,000 employees, we are sincerely moving toward becoming an environmentally friendly company. We do this by allocating our resources to the right places, by taking result-oriented actions, but without causing any waste. As I mentioned above, the fact that global warming, in other words, climate change, is real is one thing; it is another thing to tout that it will lead to an apocalypse, creating a climate of fear like a pandemic.

References

(1) https://www.theguardian.com/world/2020/apr/08/amsterdam-dough nut-model-mend-post-coronavirus-economy

(2) https://www.milliyet.com.tr/yazarlar/verda-ozer/simit-ekonomisi-6237059

(3) Boffey, D. (2020, April 8). Amsterdam to embrace 'doughnut' model to mend post-coronavirus economy. the Guardian. https://www.theg uardian.com/world/2020/apr/08/amsterdam-doughnut-model-mend-post-coronavirus-economy

(4) https://sosyalekonomi.org/amsterdam-simit-ekonomisi-modelini-uyguluyor/

(5) Benmayor, G. (2018, February 7). *Dünyayı "Ben bir dönek ekonomistim" diyen Kate Raworth gibi ekonomistler kurtaracak.* Hürriyet. https://www.hurriyet.com.tr/yazarlar/gila-benmayor/dunyayi-ben-bir-donek-ekonomistim-diyen-kate-raworth-gibi-ekonomistler-kur taracak-40733625

(6) https://www.hurriyet.com.tr/yazarlar/gila-benmayor/dunyayi-ben-bir-donek-ekonomistim-diyen-kate-raworth-gibi-ekonomistler-kurtaracak-40733625

(7) Özer, V. (2020, June 17). *Simit ekonomisi. Milliyet.* https://www.milli yet.com.tr/yazarlar/verda-ozer/simit-ekonomisi-6237059

(8) Raworth, K. (2019). *Simit Ekonomisi*, Can Yayinlari.

Are Most Super-Rich People Patriotic, Generous, and Genuinely Interested in the Welfare of Their State?

In November 2020, Scott Galloway, a professor at New York University, published a very interesting book titled *Post Corona: From Crisis to Opportunity*. Galloway is someone who has worked in the advertising and marketing sectors for a long time, founded companies, and has done research, but like the most "left-leaning" employees in the sector, he later moved on to academia and seems somewhat opposed to the advertising/ marketing industry. Galloway talks about the effects of the pandemic on the USA exclusively in his book, but his analysis is actually valid for the whole world because the pandemic caused the same problems in almost all countries, even if the countries' solutions were different.

"I begin with two theses. First, the pandemic's most enduring impact is accelerating the existing dynamics … Second, in any crisis, there is an opportunity; the greater and more disruptive the crisis, the greater the opportunities. However, my optimism on the second point is tempered by the first – many of the trends the pandemic accelerates are negative and weaken our capacity to recover and thrive in a post corona world," says Galloway.[1]

Then Galloway tries to prove his theses:

> The first example is that since e-commerce took root in 2000, e-commerce retail share has grown by roughly 1% each year. At the beginning of 2020, about 16% of the retail industry was traded on digital channels. Eight weeks after the epidemic reached the USA (mid-March–April), this number jumped to 27% and will not decline. E-commerce has achieved ten years of growth in only eight weeks.[1]

Take any trend – social, business, or personal – and fast-forward ten years. Even if your firm isn't there yet, consumer behavior and the market now rest on the year 2030 point on the trend line – positive or negative. In this case, if your company has a weak balance sheet, it is no longer recoverable. If you are in the basic necessities business in retail, your products are now more necessary, but if you are in the nonessential consumer goods business, the products you sell are no longer necessary, so you have to work harder to create a demand for them.

The second example: For decades, companies have invested in equipment for virtual meetings with a desire for rapid development. For instance, universities have invested heavily in technology to catch up with the times, including programs like Blackboard. Advertisers tried hard to promote digital technology, virtual meetings, distance education, and distance healthcare

services. However, there was no improvement. Companies continued to hold company meetings face-to-face and employees personally attended company meetings by traveling long distances. Universities still haven't gotten beyond the pen-written board and PowerPoint. Hospitals continue to work in the same way. All these technological innovations were kept on the sidelines without being used. But with the pandemic, tens of years of development were achieved at once within weeks. People's relationship with technology was suddenly based on the year 2030 predictions.

The third example: It took forty-two years for Apple to reach a value of 1 trillion dollars, but that number doubled between March and August 2020. So twenty weeks was enough to reach another trillion dollars. For decades, mayors and planning officials of major cities have called for the use of bicycles instead of cars to lower air pollution. During the pandemic, people preferred bicycles to public transport. Within a few weeks, a reduction in air pollution and a reduction in the carbon footprint, which had not been achieved for decades, were achieved.

The concept of economic inequality, which economists have been warning about for decades, has suddenly become noticeable. It is only now understood that income inequality is more of a dystopia rather than a utopia. Due to the Covid-19 pandemic, at least one person in half of USA households lost their job or experienced a salary cut. Households with an annual income of less than 40,000 dollars were the most affected, with almost 40% losing their jobs in early April.

All these negative situations experienced during the pandemic provided very useful transitions in people's perception of telehealth services, universities' attitudes toward distance education, and in the structuring of the approach of markets to order delivery.

Galloway then fiercely criticizes the USA:

> Despite our belief that we spend more on healthcare than any other nation and that we are the most innovative society in history, we are one of the countries with the most losses. It took only ten weeks for us to drag 40 million to disaster against the 20 million jobs we have created in the last ten years. Travel is prohibited, restaurants are closed, and the sales of liquor and weapons have increased. More than 2 million Generation Z have moved in with their families, and 75 million young people are going to school amid uncertainty, conflict, and danger. Our response to this crisis has not been successful.[1]

"One of the most surprising aspects of the Covid crisis has been the resilience of capital markets," says Galloway, and he further sheds light on the effects of the pandemic on the economy:

> After a brief decline when the pandemic turned into a pandemic, the major market indices Dow Jones, S&P 500, and NASDAQ Composite, are back to their original

state. Despite the deaths of hundreds of thousands of people in the USA and record unemployment, they were able to recover most of the losses. There is also no sign that the virus is declining. On the cover of June, *Bloomberg Businessweek* put the title "The Great Break" in its report. The magazine writes that Wall Street professionals were stunned. Although 1000 people died in the USA every day, the rise of the markets continued.

As a result of the recovery, several large companies, especially large technology companies, had excessive profits. Small and medium-sized companies were not able to benefit from this recovery, and medium-sized companies shrank by 10%, while 600 smaller companies from the S&P 600 index shrank by 15%.

There are quite surprising names on the bankruptcy list given by Galloway, who says that the long list of bankruptcies in the US is shocking. Neiman Marcus, J. Crew, JCPenney, Brooks Brothers, Dollar, and Thrifty owned Hertz, Lord & Taylor, True Religion, Lucky Brand Jeans, Ann Taylor, Lane Bryant, Men's Wearhouse and John Varvatos, 24 Hour Fitness, Gold's Gym, GNC, Dean & DeLuca, Muji, Chesapeake Energy, Diamond Offshore, Whiting Petroleum … Reservation companies, entertainment, airlines, cruises. The number of casinos, hotels, and resort companies decreased by 50%. Tesla increased 242% while GM dropped 31%. Amazon rose 67%, and JCPenney went bankrupt. Those who win today are likely to be more successful tomorrow. [1]

As a result, with the policy decisions taken by the US government, 2.2 trillion dollars entered the economy, and this flowed largely to the capital markets. Therefore, companies that performed well before the pandemic benefited significantly from this worldwide crisis. But others were deprived, and their situation worsened. For example, airlines were not in a position to survive after this pandemic in its current form. Many airlines, including Virgin Atlantic, went bankrupt. But I guess none of them will go bankrupt because the US Congress gave these companies 25 billion dollars in April 2020 and probably would give more.

At this point, Galloway makes the following striking determination: "Cash is also king in the pandemic. Companies with strong balance sheets, cash, cheap debt, and especially low fixed expenses will survive. Costco maintains its place after the pandemic with eleven billion, Honeywell with fifteen billion, and Johnson & Johnson with twenty billion dollars. An oligopolistic formation "may occur in every category."[1]

We are in the product age now, and what we're going to talk about is new advertising models. Radio advertising fell 14% in 2020. In 2021, it was estimated that the Google–Facebook duo will dominate 61% of the digital advertising market. There will be a high rate of natural selection among US media firms.

Marketers think that people want to choose. Yet consumers don't want more choices. They are more confident in the options available to them. Customers want someone else to do the research and choose the options for them. The only thing left for them to do is to enjoy the moment.

There are two main business models, says Galloway. First, a company sells its goods for more than the cost of production. This is what is expected. Second, a company sells you something for less than its cost and exchanges it for the consumer behavioral data it obtains from other companies. Then all of a sudden, these companies have all the data on what we read, where we shop, who we talk to, what we eat, how we live, and so on, and they process it and sell it. Watch out, as free is the most expensive. If something is free, I guess you are the product.

In the first five months of the Covid-19 outbreak, the market value of nine major technology companies increased by 1.9 trillion dollars. These were not pharmaceutical and healthcare companies. The value of the big five companies: Microsoft, Amazon, Apple, Facebook, and Google increased by 24% in mid-2020. From the beginning of that year to the middle of August, a value increase of 2.3 trillion dollars was achieved, and the value increased by 47%. The combined value of these five companies is unprecedentedly 21% of the value of all publicly traded US companies. Unbelievable!

The dominance of big technology is no surprise. Normally, companies that are rising at such a fast rate are expected to decline rapidly. However, this time they probably won't. These companies are now the playmakers of the future. Amazon, Apple, Facebook, and Google started early. Now their size is their strong advantage.

Leadership is the ability to persuade people to work together for a common goal. Facebook and Google offer a combination of scale and detailed structure unmatched by anyone else as a competitive advantage.

Another advantage for Facebook and Google: these two companies are growing by taking advantage of fake news. During the pandemic, this increased even more, and this time, it turned into false news about the pandemic.

The opportunity for disruption in a sector is a dramatic increase in price without an increase in value or innovation. This is also known as an unearned margin. For example, the price of universities has increased by 1,400% in the USA in the last forty years. Health services is another industry that is likely to be up and down. Another factor is to rely on brand value, apart from product quality and distribution. However, the transition from the brand age to the product age will erode the competitive advantage of any of these companies. Many companies sell mass-produced, mediocre products, but some people believe in these products because of the investment in branding for generations. Digital technologies are an innovative category. Now people are more concerned with the service quality than the brand value of the product. Everyone has to think about what service they can offer, no matter what they sell. It should be cheap, high quality, and fast.

Galloway then focuses on start-ups that upset the capital market. He touches on unicorns, but I think unicorns should be handled exclusively. I also exclude his comparison with the American Dream, the new phases of capitalism, and Northern European socialism for the time being. But I cannot move on without citing this determination: "I also discovered that most of the super-rich are patriotic, generous, and genuinely interested in their state's wealth. This makes sense because reaching the top is only possible when people bring you there. But wealthy people, like everyone else, first think of themselves and their loved ones."[1]

There is something I learned from my late father, Sabri Bey: "You are not as rich as your money in your pocket, but as rich as your family and friends around you. It doesn't matter what I or anyone else owns or how rich they are, as you phrase it. What matters is what my country and nation have … I think this is the greatest wealth."

Galloway says big technology is no longer willing to innovate. There is a much more profitable opportunity. Data exploitation! Over the past decade, we have shifted from an innovation economy to a data exploitation economy. There is no such thing as a free social networking app. Companies are increasingly using algorithms to take advantage of human weaknesses. Most human illnesses and difficulties arise due to eating habits, for example, a little salt, little sugar, little fat, and little safety. As a result, when we get sufficient nutrients, our brain produces the ultimate reward, dopamine, and is happy. In other words, survival and reproduction are rewarded. This is the key point.

Reference

(1) Galloway, S., Post Corona: From Crisis to Opportunity, Penguin, 2020, 175 pp.

What Is My Grade This Year?

What would you not like to know about yourself? I explain below the logic of a 360-degree performance evaluation. In my article titled "The Higher the Targets, the Higher the Performance," which I wrote on November 12, 2020,[1] and in which I generally explained performance management methods, including OKRs, I said:

> In order to ensure employee satisfaction, it is very important to measure their performance fairly. We implement the 360 degree Performance Evaluation System in this regard, and indeed, we have obtained satisfactory results. This system, which allows subordinate colleagues to be evaluated by team members as well as the employee's superior, gives good results. So much so that those who do work with you, those you do work with, your teammates, or those who are below you, give orders or receive orders, are producing a 360 degree evaluation of you. We have been applying this for quite some time, and doing this is like holding up a mirror to ourselves. In all evaluations, everyone actually does a conscience accounting; an awareness is created. I think it is very useful in this respect.
>
> I should point out that there are some difficulties for me in making this assessment. If you ask why – I can't complete a 360 on myself. A chief assessment is not available for me. However, we can also look at that my biggest supervisor is, of course, my consumers, my customers. When we look at their evaluations, my grade does not look bad at all. In most surveys, Ülker, McVities, and Godiva are the most preferred brands.
>
> When we analyze, we see that our market share has increased. So, we get good marks from our stakeholders, and as such, my 360 is completed in this way. #makehappybehappy

By the way, let me share with you the "Become a Star Competency Model" that we have developed exclusively for ourselves for 360-degree valuation. In this model, there are six basic dimensions and subdimensions to be measured. The main dimensions are: customer focus, collaboration ability, transformation flexibility, development orientation, result orientation, values, and mission orientation. In the evaluation,

the "I have no idea" option is used together with a seven-point Likert scale. The expansions and sloganization of the main dimensions are as follows:

> Be a star of the customer: Know your customer well, be sensitive to their demands and expectations, and try to anticipate their needs before they occur. Consider customer benefits first in every action, decision and step. Take the initiative for customer happiness, work passionately to be preferred, and be sensitive. Promote this understanding in-house. (6.5) (6.5) (0.0)

Be the star in cooperation: Include all stakeholders, and produce results with cooperation. Benefit from the wealth that differences will add. Think and act interculturally and interdisciplinarily. Think of new ideas that will get you ahead of the competition. Plan tomorrow today, and benefit from the synergy of cooperation. (6.4) (6.3) (–0.1)

Be a star in transformation: Be aware of digital transformation, integrate technology into your business, be flexible, be innovative and entrepreneurial, and try to constantly improve your business and transform it by anticipating the needs of the future. Make a difference in competition, try to stay ahead of time, and update your habits. (6.6) (6.5) (–0.1)

Be a star in development: Improve yourself, your business, your team, and all your stakeholders. Be open to development and improvement with feedback. Learn constantly; be resistant to uncertain and complex situations. (6.4) (6.5) (\+0.1)

Be a star in results: Always be result oriented, preserve your energy and motivation, and focus on the result with effective planning, prioritization, and efficient work, paying attention to the contribution to the company and commercial benefit. Make sure your results are sustainable and create value for all stakeholders.

Generate 110% performance. Follow the progress on the way to the result and take the necessary actions on time. (6.6) (6.6) (0.0)
Be a star in hearts: Implement our Yildiz Holding values, adopt the principle of #makehappybehappy, and live it. Let your actions and thoughts be harmonious and give confidence to those around you. Use communication channels effectively. Be ethical, and let our ethical principles and honesty be the compass. (6.7) (6.7) (0.0)

Of course, the important thing is not to just write these principles but to apply them in the field. We have overcome many of our problems today by using performance management systems such as 360-degree feedback, HR planning, and management according to KPI results, which we have been persistently pursuing for many years. My friends and I have done our part in this regard. We have written the KPI Goals to increase employee satisfaction and eliminate the problems pointed out by 360-degree feedback, and we have always improved. Now, these goals are further elaborated with OKRs.

I was in a difficult situation with the 180-degree evaluation because I did not have a superior in the company. But every year at the business results and New Year's goals meeting, I shared my own performance evaluation and the grade I gave myself with all the top global executives (approximately 200 people), while also explaining the 180-degree evaluation results about

myself. I suggested to the executives at these meetings to take a look at my summary report notes together.

Now, go back and take a look at the numbers in brackets at the end of the main dimension descriptions I presented above. The first numbers are my 2019 results, and the second numbers are my 2020 results. The differences are in the last set of parentheses. In general, I moved my average from 6.51 to 6.53. Experts say that over 6.5 is a very good number if you are evaluated on a seven-point scale. However, after reaching this point, more work is required to ensure development. Of course, those with a little research and statistics knowledge know that my average only makes sense together with the company average, the average of my level, and standard deviations. The figures obtained are also a result of subjective perceptions in the model that we have concretized with questions. Achieving 7 on a dimension means being perfect for us, but can we measure absolute perfection? Of course, this is controversial. But even the worst metric I know is better than the unmeasurable, and it is as if everyone in the business world already knows that what is not measured can no longer be improved.

In addition to quantitative measurement, verbal and qualitative evaluations are also requested in the model. Listed below are the qualitative assessments made about me:

(My Strengths)
- Intellectual, open to change, reliable, stands behind his word, and does not let you down. Decisive, constantly improving, modest, accepting of new technologies, very good business knowledge, familiar with working in different cultures.
- Always seeking information to be up-to-date and shape the future, he is a leader who inspires not only me but many people with his innovative, open-mindedness, passion for his job, detail, way of sharing his knowledge, and elegance.
- Consultation, leadership, sincerity, feedback.
- I envy Murat Bey's approach, simplicity, and the difference between the main job and the details. In this way, you can get good tips about who should focus on what. A role model that sees difference as wealth. I also perceive his LinkedIn posts as a new type of activist leadership. (I wanted to share my perception, not knowing whether it was done for this purpose or not.) With his sincere and thought-provoking articles, he communicates simultaneously with the Yildiz Holding community and the entire world. I think these shares pass on to the business world and society as a vision and intention that includes integrity.
- Vision giving, strategic perspective.

- I think his new role suits him better. Always an out-of-the-box thinker and great visionary.
- Leader, decisive, competent, intellectual, overcoming difficulties, fearless, courageous, adopting technological, original, and new ideas with passion, not afraid to work, able to handle issues at a very high level with deep experience and high intelligence, problem solver, Fatherly, is the strongest leader you can know in life, who creates admiration and trust in people, exhibits business and human focus together, you can talk business as if you were chatting, often confusing the conversation, and knowing how to live beautifully and enjoyably.

(My Areas of Development)

- He should undertake innovation leadership. He should give more opportunities and support to the education/development of people in this regard. He should lead the seminal vision projects such as the "Innoday" event, he should expand the R & D network, support internal synergy projects, and further support cultural awareness that pladis and Godiva are an initiative of Yildiz Holding. He should support awareness more, give a vision for Yildiz Holding to achieve a sustainable governance model, and share this vision with a wider audience.
- Clearer expressions could be used in communication, and he can listen more.
- He could give more systematic communication in the new period.
- He should receive feedback, and he should put a premium on more entrepreneurship.
- He could support innovative technologies more and prioritize their development. He should be able to equip himself with good consultants and professionals, listen more, and try to understand.
- Can make extremely quick decisions; thinking that the complexity in his mind is the same in life, he may sometimes react with excessive skepticism. He expresses himself less than in his writing, which can be difficult to understand.
- If he is angry, he is very firmly so.

I have good colleagues who can see my strengths and benefit from qualitative results. And without spoiling me at all, the same friends also mentioned the aspects that I need to improve while moving from 6.5 to 7, that is, perfection. I am very pleased, thank you very much. Be sure I will do my best to reach the full score this year by leaning into all my development areas. You know, #makehappybehappy.

Note: The following is a letter from a former colleague:

Dear Murat Bey. While not invited to give you my feedback, I thought the best feedback and most honesty you could get would be from ex-employees. I am an Ex. So I will give you my thoughts:

1. Never abandon your fatherhood of this organization.
2. Never let your curiosity wane. You have the most contagious/greatest curiosity. It challenges the organization.
3. Keep your "what if then what's next" attitude. Always striving for a better next.
4. Allow mistakes. Encourage them as they are the best learnings. More importantly, you will encourage the organization to be more courageous.
5. Allow the experts to do their job and empower them.
6. Communicate your intentions better. You tend to be vague. Deciphering your messages and tendencies is a very difficult task for your organization.
7. Give your executives the room they need to feel their true positions. Minimize your interference.
8. You are the boldest I have worked with. This is a great sign to encourage the organization.
9. Reveal your inner person. I have seen bouts of that during our travels. Your inner self is incredibly endearing and refreshing.
10. Manage with visible empathy, especially during these times.

Your legacy will be great, Murat Bey. It can be even greater.

Reference

(1) Ülker, M. (2020). "The Higher the Targets, the Higher the Performance!" Nov. 12, LinkedIn Articles, https://www.linkedin.com/pulse/higher-targets-performance-murat-%C3%BClker/

Is This the End of Retailing as We Know It?

Starting in March 2020, when the global Covid-19 pandemic began, consumer behavior all over the world changed rapidly from brick-and-mortar stores to online stores, from going out to restaurants to ordering home online, from sitting at cafes to online ordering to "curbside pick-up and delivery." However, this trend had actually started years before. Brick-and-mortar stores had already been giving way to online retail. This was inevitable. In China, where capitalism and free enterprise have only just developed compared to the Western world, e-commerce was a solution for salvaging the economy due to the infrastructure and capital insufficiency of brick-and-mortar stores and logistics problems. When we asked colleagues working in our own offices about their shopping habits, none of them had gone shopping in the last two years, and they were doing all their shopping online. In addition, B2B distribution in all of China was carried out through e-commerce. For this reason, the effects of the pandemic were more easily overcome in China because the retail revolution had already happened. Our Godiva chocolate boutiques there normalized rapidly after the pandemic. Consumers filled our shops again. Their association with our brands and products covered their TikTok, and Instagram feeds.

In the USA, in contrast, branches of department stores had been closing for the last five years, and there had been talk that other shopping malls would inevitably close as well, except for luxury ones. The only transaction that was unusual during this trend was Amazon's acquisition of Wholefoods. When I asked them during my visit to Amazon, they said that Jeff Bezos had something in mind. I think the goal was to have a tool to observe shopper behavior in brick-and-mortar stores like Alibaba and to explore new types of conventional retail outlets.

I regard the situation as similar in our country and neighboring countries, because during the pandemic, all fast-moving consumer goods expenditures increased by double digits in retail and maybe three digits in e-commerce, while our traditional channel sales remained low. To understand this change and its consequences, let's first consider the results from some other countries.

While 81% of consumers did not shop online for groceries before the pandemic in the USA, 79% of them began to order online after the pandemic. While online grocery shopping was 1.2 million dollars in August 2019, it increased to 7.2 billion dollars in June 2020. The number of online shoppers rose from 16.1 million to 45.6 million. The personalized sales period has increased by means of AI from mobile apps. Targeted marketing

has increased. Purveyors of frequently purchased products started sending reminders to consumers so as not to be forgotten.[1]

When restaurants were closed, the shopping basket size increased as well as the amount of cooking at home. People started going to grocery stores less frequently and spending more. Consumers preferred to purchase products that could be stocked at home and have a longer shelf life. Home cooking has become healthier. The focus is now on the speed of delivery, convenience, and confidence. The period of walking comfortably and enjoying the market visit is over. Famous/iconic brands have started to be preferred instead of market brands. The search for new products has decreased. Stores have begun to allocate more space for the products they sell most. The number of people visiting the store with a shopping list has increased. Stores have also begun to invest in contactless and self-check-out systems. In fact, almost all retail chains have adopted sales and delivery online. Changing consumer habits have made innovation mandatory.[1]

Starbucks announced that it would close 100 stores in the USA and 100 stores in Canada in 2021. In 2020, they closed 400 stores in the USA and 200 stores in Canada, and it was announced that they would open a new type of "take-away" store.[2]

Walmart began redesigning its stores so that its customers could shop more quickly. Target started implementing the "curbside delivery" system. This curbside delivery has since become available in all shopping mall stores.[3] Shopping itself was no longer a priority; in terms of clothing, even more casual and comfortable clothes were being sold. Eleven thousand retail clothing stores closed in the USA in 2020. In 2019, this number was 9,300 for all categories. One hundred thousand retail stores were expected to close in the USA by 2021. The number of stores anticipated to be closed in shopping malls is 25,000.[4] In my opinion, only the top-class shopping malls will survive.

Another very interesting change: Airbnb.com, the housing rental e-commerce company that shook the world hotel industry with its entrance to the market in 2008, began to have big problems when its consumers started to return to hotels due to their concerns about hygiene and distance.[5]

In England, 3,000 retail street stores belonging to 32 brands have been transferred to crisis management, and 45,000 store personnel are about to lose their jobs.[6]

In Turkey, without having such exact figures for consumption behavior, research shows that consumer behavior in Turkey is in line with other countries. We see similar troubles in brick-and-mortar stores and shopping centers. Additionally, consumption behaviors vary according to socio-economic differences.[7] According to a research report from the Turkey Economic Policies Research Foundation (TEPAV), Interbank Card Center

(ICC) data reveal that the total card payments amount in the first nine months of 2020 increased to 819.6 billion TL by 15% compared to the same period the previous year. By the end of September 2020, the share of contactless credit cards in total credit cards reached 58%. In the first nine months of 2020, the number of contactless payments increased 3.5 times over the previous year to 1.1 billion, while the share of card payments made online was 21% of total card payments.[8] All of these data are proof of the increase in online shopping and contactless shopping during the pandemic. I wonder if, in the future, we will give up on the things that make our shopping so easy.

According to a survey conducted with 487 people between November 25 and December 15, 2020, it was determined that the rate of shopping on new-generation shopping platforms (Istegelsin, Banabi, Getir, Migros Hemen applications) during the pandemic period increased by 18% compared to the previous period. A consumer group, which previously had an awareness of new-generation shopping platforms but used them infrequently, started to shop from these platforms more frequently and intensively. In the study, it was determined that "perceived risk" is the most important reason that changes behavior. Participants mostly voiced thanks for the ability to use new-generation shopping platforms as a way of eliminating the need to deal with crowds of people. It has been found that participants who connect to digital media for more than three hours a day have higher interest and motivation in moving toward new-generation shopping platforms.[9]

There still isn't any data available yet in Turkey as to how many street shops, shops in malls, and restaurants closed in 2020. However, for example, the data of the Turkey Private Schools Association can give us an idea: 300,000 students canceled their enrollment, and six hundred thirty-six private schools closed.[10]

As can be seen, these changes experienced even in education have taken place in many sectors that do business with traditional retail points. Thus, a tremendous change is taking place due to risk perception based on escaping from crowds, and all employers and employees are indirectly affected by this change, and this will continue for a while. Even if there is normalization in the end, only those who can achieve this change from the retail and the sectors that serve retail will survive.

To understand this change and foresee how long it will take, we first need to consider some basic consumer behavior concepts. Until this time, introductory textbooks on consumer behavior, under the heading "Perceived Risk," have summarized in one to two pages the risks perceived by the consumer about the product and the brand before buying, which affect the purchasing decision process. The six main risks were:[11]

1. Performance risk: What if it doesn't turn out as expected?
2. Financial risk: What if I lose money?
3. Physical (security risk): What if the product or service hurts me?
4. Social risk: What if it hurts my reputation in society?
5. Psychological risk: What if it doesn't suit me?
6. Time risk: What if I can't change it right away?

So, did people move to online shopping because they felt these risks? What was the risk? What if I get Covid-19? What if my family and I get hurt? Which of the above risks match these questions? Doesn't it look like a physical risk? Yes, the physical risk discussed in textbooks, which was taught to us in classes, was related to the use of products/services. In other words, there was no risk of "getting hurt from the place of purchase or the channel" in marketing and consumer behavior books. Marketing books also seem to have forgotten the Spanish flu pandemic of one hundred years ago. The current risk is as follows: What if I get a virus from someone in a store, restaurant, cafe, or shopping mall?

So the billion-dollar question is, will people go back to brick-and-mortar stores when physical shopping opportunities are reborn? It is necessary to return to a concept we read about as undergraduates: Rogers' theory of the "diffusion of innovations," to answer this question. To ensure the rapid adoption of an innovation, for example, a new sales channel aimed at customers in the market, innovation must have some characteristics:[12]

- It should be perceived as a way of meeting the relevant need better than what it replaces (channel). That is, it should have a relative advantage.
- It must be compatible with current practices and does not require customer learning or training.
- It should be easy to understand and user-friendly; therefore, perceived complexity should be kept to a minimum.
- It should be highly testable; the product can be tried before committing. For example, shipping is free on the first order.
- Results and outputs must have high observability.

The reality is that all product categories and markets are always in the process of evolution. This is because they are affected by the changing conditions of customers. The economy changes, laws change, the weather changes, and new technology changes many aspects of life, including businesses. The effects of these changes are seen over time in the overall sales patterns of existing products and services. This sales pattern, as time passes, can be likened to a person's life: birth, growth, maturity, and regression. This notion gave birth to the product category life-stage concept. The key is when a product or service category declines, it is replaced by another category

because the need is not fulfilled. Ultimately, people have to eat and drink, shop for the product, and bring it to their homes or have it brought. The family needs to be fed, and new channels are needed to stay healthy. When I look at the numbers I've listed above, it seems that new channels have been discovered, and they are being seen every day.

A product's category life cycle provides a framework for life-stage cycle marketing, aiding managers in understanding what might happen in their market and in making marketing decisions about the products they are responsible for. We realized in this pandemic that the product category channel also had a life curve. Actually, we were feeling this. We were witnessing very intimately the transformation in retail.

Channel transformation was evolving with yemeksepeti.com, get.com, and our istegelsin.com. Inside Dubai Mall in Dubai, there is a much-loved bookstore called Kinokuniya. In 2019, I bought a book there called *The Future of Shopping*, by Snoeck and Neerman, who wrote: "Retail, as we've known for centuries, is dead. Economic, technological and demographic changes killed him. Or made it insignificant."[13] This is the take-away. The pandemic has brought about the death of retail points we know of, in most categories, five years earlier than anticipated. It used to be a choice for me to buy books from the bookstore. Now because of the pandemic, I'm forced to buy online. I've gotten used to it easily. I was carrying unnecessary weight, and wasting time. Will I go back to shopping for books that way? See the theory of diffusion of innovations: does the new way meet a person's needs better? Yes. Then why should I return to the old way?

If we go back to our basic question, which has been the subject of this chapter, can the life of classic stores in retail be extended? Conditions tend to be more suitable during the growth period for a channel, to be profitable, when it is adapting from the product category life cycle model. When a downturn occurs, I think there are several possible ways to extend the "life" of the channel belonging to a particular product or the entire category. In this case, let's make use of a strategic marketing tool, namely the Ansoff Matrix, discussed in our old textbooks.[14] When the Ansoff matrix is applied, there are four options to follow for a company that does not want to lose channel-bound sales volume:

The first is the *existing channel penetration,* where the company focuses on gaining market share from its competitors for its *existing customers*. In other words, in order to retain the existing customer in the existing channel, a company can switch to e-commerce quickly; it attempts to meet the needs of the customer, in the new channel, without losing him to the competitor's e-commerce. For those who still buy from the classic store, the offer is made more attractive, and the feeling of security is increased.

The second option is *to develop a new product* into an existing channel. The basic idea is to examine the needs of the company's existing customers, asking the question: "Why can't we supply this?" The main purpose here is to make the customers happy in the e-commerce channel who have the potential to be lost and to make the shrinking, classic store market attractive.

The third option is to *expand the market* to find new customers for the firm's existing products or services. For example, opening stores in places where the pandemic is felt less directly or shifting the e-commerce to the global arena.

The last option is to try to *introduce new products or services* to new customers. This is like a grocery store adding a vegetable and fruit aisle, and opening it up to e-commerce.

In fact, there is only one strategy for extending the life span of a channel: the omni-channel strategy.[15] In this approach, all distribution and communication channels have to offer the perfect customer experience in an integrated and uninterrupted manner by minimizing any risk perceived by the consumer! In other words, it is essential to bring together all channels profitably, according to the purchasing route preferred by the consumer, and to serve the consumer with a "single" channel spirit.

If you may still be wondering: So will all the shops close?

Of course not! This is just a change. Until now, e-commerce has been a low percentage of all purchases. But now, with this forced rapid growth, the proportion of e-commerce is rapidly changing and is irreversible. Just as we seldom now visit bank branches, we will visit retail points less frequently. Some retail locations will remain attractive. Which ones? The boutique spots that are attractive to you which leave a trace in your memory with their product experiences and treats, or those where you are perceived as a VIP, those where they have a butler service, in short, wherever you can live a TikTok and Instagram experience with today's popular understanding. These stores have already begun to be defined as "gold shops" in academic journals.[16]

References

(1) Morgan, B. (2020). "3 Lasting Changes to Grocery Shopping after Covid-19," *Forbes*, Dec. 14, https://www.forbes.com/sites/blakemor gan/2020/12/14/3-lasting-changes-to-grocery-shopping-after-covid-19/?sh=658daae954e7; Koslow, L., and Lee, J. (2020). "Covid-19 Consumer Sentiment Snapshot No. 8: A Glimpse of the Horizon," BCG.com, May 4, https://www.bcg.com/publications/2020/covid-consumer-sentiment-survey-snapshot-5-04-20.

(2) Salaky, K. (2020). "Starbucks Will Close 100 Additional U.S. Locations as It Continues to Adapt to Changing Consumer Habits," Delish, Nov. 2, https://www.delish.com/food-news/a34551483/starbucks-us-store-closures/

(3) Wilson, M. (2020). "Walmart's New Store Design Proves Browsing Is Dead," Fast Company, Sept. 30, https://www.fastcompany.com/90557727/walmarts-new-store-design-proves-browsing-is-dead

(4) Young, V. M. (2020). "Year in Review: More Than 11,000 Fashion-Related Doors Shutter in 2020," Sourcing Journal.com, Dec. 31, https://sourcingjournal.com/topics/retail/store-closings-bankruptcy-2020-covid-19-250100/.

(5) Glusac, E. (2020). "Hotel versus AirBnb, Has Covid-19 Disrupted the Disruptor?" NYTimes.com, May 14. Updated: Nov. 16, 2020, https://www.nytimes.com/2020/05/14/travel/hotels-versus-airbnb-pandemic.html.

(6) Baker, H. (2020). "Bristol Post Business Editor, Business-Live UK," Dec. 1. Updated: Dec. 7, 2020, https://www.business-live.co.uk/retail-consumer/list-shops-fallen-administration-2020-18177619.

(7) Erdogan, B. Z. (2020). "Yeni Normalde Tuketim ve Harcama Pratikleri," in M. Seker (ed.), *Kuresel Salginin Anatomisi, İnsan ve Toplumun Gelecegi*, TÜBA Yayini, p. 495.

(8) https://www.haberler.com/pandemide-internetten-vetemassiz-alisveris-artti-13738068-haberi/.

(9) https://uskudar.edu.tr/tr/icerik/6150/pandemi-yeni-nesil-alisveris-platformlarina-talebi-artirdi.

(10) https://www.cumhuriyet.com.tr/haber/300-bin-ogrenci-kaydini-sildirdi-5-bin-kisi-isini-kaybetti-salgin-egitimi-vurdu-1806805.

(11) Hoyer, W. D. vd. (2018). *Consumer Behavior*, Cengage Learning, 7th ed., pp. 58–60.

(12) Rogers, E. (2003). *Diffusion of Innovation,* Simon and Schuster, 5th ed.

(13) Snoeck, J., and Neerman, P. (2019). *Future of Shopping*, Lannoo Campus.

(14) Sharp, B. (2017). *Marketing*, Oxford University Press, pp. 310–311.

(15) https://nielseniq.com/global/en/insights/analysis/2020/a-guide-to-winning-in-store-in-2021/

(16) John, G., and Scheer, L. K. (2021). "Commentary: Governing Technology-Enabled Omnichannel Transactions," *Journal of Marketing*, 85(1), pp. 126–130.

We Know the Limits of a Company. What Are the Limits of a Family?

As a member of an entrepreneurial family and the owner of a 75-year-old family business, it is impossible not to be concerned with what has been written about the management of family businesses. Academic insight into the management of family businesses is just now being developed. Articles and research about family businesses are always similar, and the articles I've read seem to repeat themselves, as I've learned a lot about family business through experience. I read articles that tell the stories of different family businesses that are interesting and instructive. For example, a recent article describing the problems caused by the Spanish retail giant El Corte Ingles not implementing corporate governance principles suitable for growth while the family was growing, was quite interesting.[1] Indeed, as a company expands from generation to generation, corporate governance principles must be shaped according to the new outfit. Otherwise, family members' conflicts within the board of directors, as observed in El Corte Ingles, can have very devastating consequences.

In the early 2000s, I read two books on family business management, one titled *Family Business: Key Issues*,[2] and the other titled *Family Business as Paradox*.[3] I haven't come across any very different content since then.

Generally, in these books, the differences between family businesses and other companies, and the characteristics that make family businesses successful and unsuccessful are discussed as follows: partnership structure, family growth, role conflicts, professionalization and institutionalization issues, family habits, lack of motivation, and generation conflicts and transfer problems.[2]

These issues are well explained in the two aforementioned books. To start, it is emphasized that the primary focus of a family is to seek harmony and the main goal of work is to pursue performance. It is said that this is the main point of the potential for conflict because it is a paradox. It is later mentioned that success in family businesses can only be achieved with a transparent, clear, and trust-based corporate management system. Strong leadership that ensures continuous change is important in family businesses. Such leadership creates an organizational culture that keeps up with constant change and achieves success in this way.[4] Different things happen if the family grows faster than the company, or the company grows faster than the family. In the first situation, the family needs to meet their needs through the company, while in the second case, business and professional efficiency are essential.[5] In the January–February 2021 issue of *HBR*,

in Baron and Lachenauer's article entitled "Build a Family Business That Lasts,"[6] I once again did not find an opinion that differed significantly. The authors emphasize that family businesses have come to the fore with scandals, but the family business model has been successfully continuing for centuries. Then they ask, "Which one is right?" Are family businesses fragile or more durable than their counterparts? While 85% of all companies in the world are family businesses, more than 95% of companies in Turkey are family businesses.[7] The authors say that in public companies, the owners are investors. Their impact on the company is limited. In a family business, a small number of people own the shares, and these people are related to each other and have a high level of ability to direct the company. Studies show that family businesses are both more successful and longer-lasting than other companies. This is because families think long term and invest in innovation and new products for the future.[8] The book provides a summary of family business management information:

- In family businesses, business owners have five basic rights. These are shareholder structure design, corporate governance decisions, success definition, way of informing, and how to transfer to the next generation.
- Regarding shareholding issues, these decisions should be made: Will it be owned by one person, or will actively working family members be included, and will all members be given equal shares; will it be family or subordinates, such as the CEO, who make the decisions? Each of these has its advantages and disadvantages. What is important here is that no matter what method is chosen, the capital structure does not deteriorate, a liquidity problem does not occur, and there is no management weakness as a result of conflicts.
- Corporate governance decision is about how much control the family will have or how much freedom it will give to management.

The rules are clear in good family businesses.

- Here, the authors suggest a four-room model to think of business like a four-room house. Partners (first room) set high-level goals and select the board (second room); the board monitors the business and hires the CEO; management (third room) recommends business strategies and manages operations; and family members (fourth room) build the family union and nurture the next generation. Since the board and management report to the owners, the three rooms overlap. At the top is the owners' room. The family room, which is very important in maintaining the emotional connection of family members with the business, is located next to the other three rooms, emphasizing the importance of the family's influence and unity at all levels. Everyone's role is clear in a well-managed family

business. The four-room model clarifies hierarchies and boundaries in management. However, I think it is utopian because, for example, it is assumes there would be a family consisting of all these qualities and this number of individuals, and the income of the work would be enough for everyone! This is rare.

■ Having clear strategies for family businesses ensures longevity by satisfying their owners financially and otherwise. Families need emotional bonding with their companies in the long run. They may say, "This represents our grandfather's personal sacrifice to offer us a better life." In the absence of emotional bonding, it may be more tempting for owners to sell stocks.

■ What information will be shared with family members is important. A lack of effective communication is a major cause of the collapse of many family businesses. Three issues are crucial to successfully handing over to the next generation: (1) a transfer of assets, (2) a transfer of roles, and (3) the developing of the skills of the next generation.

The authors of the *HBR* article actually made an extensive summary of the *HBR Family Business Handbook*.[9] Some important issues that are not included in the article but are included in the book are the following:

■ We have to anticipate what will happen when the next generation takes over. An unplanned transition would be too risky. It is beneficial to prepare and coordinate the transition plan in advance.

■ Four main game-changing events should be taken into account: (1) Death and premature deaths can cause great emotional shock to family businesses. (2) New additions in the family and marriages change existing relationships. (3) Sometimes, doing everything equally creates inequality. (4) If the inappropriate behavior of family members cannot be prevented before reaching a crisis level, family relations can be damaged.

■ Before family members get involved in the job, they should conduct an audit and consultation, think thoroughly, and make a decision. Once you're in, it's hard to get out because you can't give up on your family.

■ Having business owners in family businesses creates different disputes because family members have the right to make the rules, as well as to change the rules.

■ Family offices have three basic functions. They manage family investments, provide services, and manage corporate management systems and processes.

When it comes to a family business, I understand a structure where the family is in charge of the business that they have founded and at which they actively work; they develop the business; and they fulfill the job requirements while

doing the job. If there is such a structure, a family business would be of great benefit to the development of the business, because in this structure, time and opportunities are spent without being regarded as sacrifices. You are business oriented. Maybe there is a lack of capital, but since this is known, work is done accordingly.

Enterprise capability and help family businesses get ahead. Low cost and efficiency are provided. These are the benefits of being a family business.

It is true that, despite past negative judgments, family businesses have succeeded in institutionalizing and creating great structures. There are especially good examples that can be cited. IBM, Ford, Unilever, P&G, and Toyota are the first examples that come to my mind. When we look at what their common features are, we see that besides being family businesses, they have become public and even global corporations. The share of families in these companies is now low, around 5%–15%. However, family members are still active and working in these companies. Other shareholders also rely on these people and keep them in charge. They are successful, after all.

Successful management in family businesses is only possible by establishing a balance between professionals and family. The balance between family and professionals can be established by treating both parties the same. Professionals should be allowed to take advantage of the value created by the company as if they were family members. These are long-term practices. This may include making someone a shareholder or putting a premium on shares. It can also be done by operating with significant amounts of premiums and adding premiums to be paid in future years, based on results.

It is also important that family members behave genuinely professionally. A good method is to evaluate and remunerate them according to their success in their work, just as professionals are treated as if there is no difference. For example, what is my situation while working in the company as a family member? When I look at what privileges I have, I see the following: I have flexible working hours, but when I calculate the time, I see that I work harder. My second privilege is that I can park my car comfortably in a wider place. I'm not looking for a parking spot. I also go in and out of the back door with my own key. These privileges satisfy me. What are my disadvantages? I cannot benefit from the premium system that other professionals benefit from. But otherwise, I'll have to pay more taxes anyway.

While this is the case in family businesses, companies where no family is in charge can be successful if managed well, and there are many examples of this throughout the world. For example, there are funds (private equities). What do they do? They buy a company by collecting money from everyone. The companies managed by a fund can be successful. However, there may be a situation where this success is confined to a short period of time. Because fund companies are obliged to manage a fund, this is for a maximum of five

years. The life of your work with this money spans three to five years. You have to be successful in that short time frame. Can a brand be created and cultivated in these companies, or a new category be created in such a period of time? I do not know. It seems like it is more like polishing and milking brands and categories!

As can be seen in the aforementioned literature regarding family businesses, the process of leaving the company for family members who are shareholders is difficult. Our own company had this experience in 1986. Fortunately, it was a no-fuss and noiseless separation, but it was still a difficult process to manage. It was difficult because it was the first time it had happened to us. It was new for everyone. We completed the process by mutually acquitting each other in writing.

The company was positively affected by this separation because we worked hard to pay off our debt to other members. Around 17% of the shares changed hands. We gave whatever we had in exchange for 17%. We weren't very rich at that time!

As for why we underwent the process of separation: In Ülker, Sabri Bey, his child (me), his son-in-law, and my dear uncle Asim Bey, and his two sons were involved. So, there were six bosses for one business. We were in a situation where all of us acted like a boss, and we had to deal with such artificial problems as managing each other. My uncle and father said, "Let's separate the business and keep our kinship." They said they decided to separate the business to stay relatives. We also complied with this decision. The process developed as described below.

As I mentioned before, neither my uncle nor my father left an inheritance when he died. They distributed their goods to their children while they were alive. To die without property is also good in terms of calculation in the hereafter. They stood over us and saw what and how much their children could do. My father asked me, "How should we do it?" as he was transferring his property to us. "You are two siblings and according to our religion, a boy gets two shares and a girl one share." "How should we handle this?" I said. "With so many goods, there is no need for such a thing," I added. I proposed we divide things equally. When he asked, "Are you sure?" I replied, "My only request is that my share is a little more, so I can keep my word." We did it accordingly. Our strategy continued like this until today. Does this situation please everyone? Is every job done right? I do not know. But our business has not been damaged as a result, and we have continued like this. My sister had said several times, "I wish I was a man so that I could help you more." She couldn't do it herself, but thankfully her son Ali took over our company, and he is doing more than just help.

Is it easy for two families to run a company? Maintaining partnerships, family or not, depends on the understanding of partnerships by the

individuals involved. A very good example of partnership can be seen in the Yazici and Ozilhan families of the Anadolu Group. Although the Yazici family has more shares, the Ozilhan family manages the company. Two partners can succeed without being from the same family.

At Yildiz Holding, we manage our business by considering everyone's priorities important. Our personal priority is important. When we look at the business, it is also a legal entity, and it has its own priorities. While at work, you have to do whatever the job requires. The work itself is the boss. We prepared it, cooked it, and now we will eat it. So, we will share the profit.

What are we going to do with that money? Everyone will do whatever they want. If he/she wants, he/she will put the money back into the business. If he/she wants, he/she will take it elsewhere or spend it. What will be the result of this: he/she will have more opportunities at work, or he/she will have more opportunities elsewhere. This is how I look at this.

When Yahya was younger, they asked him in elementary school what he wanted to be, and he said, "When I grow up, I will help my father." Yahya grew up, kept his word, and chose to take part in our business. My two sons are studying at the university. I have told them, "You are free to do whatever you want," just as my father told me. I don't know what they will do, but I want them to act according to their abilities and wishes.

I call the young people in our family my children, not Generation Y. Some are young, some are older, some are cheerful, and some are dignified. Years ago, Generation Y came to the fore. I won't hide that I was prejudiced toward these young people. I thought they didn't care about the world. I was so wrong. When I worked with them, I saw that they do care about the world, think about many issues, and try to find solutions to them. I'm learning from them now. I am sure that I will learn more from Generation Z as well. Working with young people requires both care and excitement. These generations will determine the business model of the future.

Every member of Generation Y and every member of Generation Z does not have the same characteristics as if they came out of a mold, simply because they were born between certain years. Since they were born in different times, there may even be differences in their perspective of the world, but they are born to the achievements of the world at the time of their birth, and they try to transcend that world.

Also, what I know is that the children of each new generation will be a generation that will challenge the other more than they force us.

So why would I want to work with my children? I may have a desire to be with them more and to see them more. Yes, family businesses are different organizations that have a lot of emotion. Family businesses are not homogeneous and are not alike because no family is alike. Trying to

make families seem uniform is the main problem facing those researching family businesses.[10] Another fundamental problem is providing a definition of "family."

Check out the family businesses that have succeeded: first, one person started the company and succeeded with his own skills. Later, when family members became interested in the successful company that appealed to them, it became a family business. In other words, it is a wrong logic to say, "We are a family, so let's start a company and do family business." I know a lot of "families" that have failed this way. They have very good professional lives but quit their jobs because a husband and wife decide to make a family business. Then they lose what they have got. Therefore, in the title of this chapter, we recognize what the definition of "company" in a family company ismeans, and its boundaries, but do we know the limits of the family, that is, what it means to them? As I said, it is incorrect to propose a recipe by heart or try to resemble another family business without knowing the establishment history of family businesses by individuals. As Henry Ford said, "Coming together is the beginning. Keeping together is moving forward. Working together is a success."

I hope that what you have read so far has been useful.

References

(1) Carlos, J. C., and Cabeza-Garcia, L. (2020). "When Family Firm Corporate Governance Fails: The Case of El Corte Ingles," *Journal of Family Business Management*, 10(2), pp. 97–115.

(2) Kenyon-Rouvinez, D., and Ward, L. J. (2005). *Family Business: Key Issues*, Palgrave, p. 90.

(3) Schuman, A. et al. (2010). *Family Business as Paradox*, Palgrave, p. 210.

(4) Kamaci, K. (2019). *Aile Isletmelerinde Kurumsallasma*, Egitim Kitabevi, p. 131.

(5) Pounder, P. (2015). "Family Business Insights: An Overview of the Literature," *Journal of Family Business Management*, 5(1), pp. 116–127; https://doi.org/10.1108/JFBM-10-2014-0023

(6) Lachenauer, R., and Baron, J. (2021). "Build a Family Business That Lasts," *HBR*, Jan.–Feb.

(7) Kirtas, M. G. (2018). "Uzun Omurlu Turk Aile Isletmelerinin Surdurulebilirligine Iliskin Coklu Ornek Olay Arastirmasi," *Journal of Economics and Management Research*, 7(1), pp. 68–95.

(8) Hiebl, M. R. V. (2014). "Risk Aversion in the Family Business: The Dark Side of Caution," *Journal of Business Strategy*, 35(5), pp. 38–42.

(9) Lachenauer, R., and Baron, J. (2021, January). "HBR's Family Business Handbook," *HBR*.

(10) Kraus, S. et al. (2011). 'Family Firm Research: Sketching a Research Field', *International Journal of Entrepreneurship and Innovation Management*, 13(1), pp. 32–47.

A Good Bargaining Method Is Possible with the Satisfaction of the Other Party

Let me tell you the secrets of bargaining today. For example, how did we win the Godiva trade? How did I buy a machine from a Swiss manufacturer when we couldn't afford it? What is industrial destiny? You will find the answers to these questions in this chapter. Bargaining is inevitable in business life. In order to continue your business, you have to get the other party to accept the most favorable price you can offer. As you can appreciate, I have sat at the bargaining table with many companies, both small and large, in every country. I have quite a lot of experience in this matter; it is said that experience is the result of the times you've been a loser. I have read and consulted at the same time. The best thing any bargaining method can provide is to protect you from accepting a deal you should refuse and help you make the most of the assets you have. Again, as always, let me first summarize what writers and illustrators say about successful bargaining, then let me explain my own actions and approach.

I think the most influential book written on this subject is *Getting to Yes: Negotiating Agreement Without Giving In*, by Harvard University professor Roger Fisher and colleagues, originally written in 1991 as a Harvard Negotiation Project and published by Bilgi University in Turkey in 2016.[1] In 2021, the Best Alternative To a Negotiated Agreement (BATNA) method from this book appeared as the basic method in almost every publication on this subject.

Fisher et al. argue against the process of positional bargaining: In its standard form, positional bargaining involves many different decisions, such as what to offer, what to reject, and what major concessions to make. The process is difficult and tedious. Threatening through wall-building or leaving the table are fairly common tactics. Bargaining by taking a position increases the time and cost of reaching an agreement and increases the risk of gaining no results. The competition between wills can become tense and spoil relations. Painful feelings can last a lifetime.

Many people are aware of the risk of this difficult positional negotiation and take a softer approach. They treat the other party as a friend and emphasize agreement as their goal rather than victory. Making offers and concessions, being compassionate and trusting, and avoiding confrontation are the norms. This is how many bargains happen between families and friends. This is effective in reaching agreements quickly; however, in these agreements, it may not be wise to take into account the fundamental interests of each party. Any bargain where keeping the relationship is the primary

concern, runs the risk of being a bad deal. Those who pursue soft, friendly positional bargains are vulnerable to a negotiator who plays hard.

The name of the bargaining method developed by the Harvard Bargaining Project is "principled negotiation." The four key points in this negotiation method are as follows:

1. People: People cannot communicate openly and confuse their ego with their position. Attack the problem instead of the people.
2. Interests: Focus on interests, not positions. Work to satisfy the core interests that drive the parties to adopt their positions.
3. Options: It is difficult to design optimal solutions under pressure. Making decisions in the presence of the other party narrows your vision. If you have too much at stake or if you spend all your time looking for the perfect solution, you can stifle your creativity. To remove these barriers, designate a specified time to generate possible solutions and options that advance common interests and resolve differences creatively.
4. Criteria: Base terms on impartial standards such as market value, expert opinion, custom, or the law. No one has to surrender. Both parties can work together for a fair solution.

Fisher and colleagues say that setting the "worst outcome as the bottom" can protect people from a very bad deal, but it will prevent finding acceptable solutions. As an alternative to the "bottom line," they propose the Best Alternative to a Negotiated Agreement (BATNA) method. They say that BATNA is flexible enough to allow the exploration of creative solutions and that the best result will be achieved by comparing the proposal to BATNA. Your strength in negotiations depends on the quality of your BATNA, not on resources such as wealth, physical strength, or political affiliations. Wealth can even weaken the bargaining position of someone trying to get a lower price. The relative negotiating power depends on how attractive the no-deal option is to each party.

The authors recommend these three different processes for creating BATNA: First, make a list of actions you can take if no agreement is reached. Then, turn the ideas with the highest potential into practical alternatives. Finally, temporarily choose the best alternative. This is BATNA. It is easier to improve the terms of any deal negotiated with a good BATNA. Knowing where to go will give you the confidence to close negotiations. The willingness to let go of negotiation allows you to present your interests more strongly.

The authors put forth that thinking about the other party's BATNA can better prepare you for negotiations. Knowing the alternatives allows you to anticipate what to expect during a negotiation. If the other party's BATNA is good enough that they don't need to negotiate on the merits, consider

what you can do to change their BATNA. If a power station is polluting a local area with harmful gases and their BATNAs are to ignore the protests and continue operating as usual, perhaps a complaint to the authorities will suffice to halt their operations. This makes their BATNA less attractive than it is. When both parties have attractive BATNAs, the best outcome may well be no agreement. In such a situation, a successful negotiation may be the one in which you decide to look elsewhere amicably and efficiently rather than reach an agreement.

If the BATNA approach fails, you can resort to a strategy that focuses on what the other party can do, say the authors. This involves countering the basic movements of bargaining that take a position, to turn the other party's attention to the merits of the case, and this is called "bargaining jujitsu." So just like in the martial arts of judo and jujitsu, it's about avoiding using your strength directly against your opponent but instead using your ability to step aside by employing your strength against them. The basic principles of jujitsu are to use questions instead of statements and choose silence if the other party expresses their position very strongly, attacks your ideas, or makes personal attacks.

Questions can lead the other party to confront the problem. Questions educate rather than criticize. Silence creates a sense of stalemate.

When people doubt what they've just said, the silence can be quite uncomfortable. Often, the other party will feel compelled to break the silence by answering your question in more detail or by coming up with a new suggestion. Ask questions, then pause. When you're not talking, you have some of your most effective negotiations, state Fisher et al.

When all else fails, the last resort is to call in a third party. Mediators can more easily separate people from the problem and steer the discussion toward interests and options.

Another important book on the subject of bargaining is *Negotiation Genius: How to Overcome Obstacles and Achieve Brilliant Results at the Bargaining Table and Beyond*, written in 2007 by Harvard professors Deepak Malhotra and Max Bazerman. This book also uses the BATNA method developed by Fisher et al. They added a field called the Zone of Possible Agreement (ZOPA) valuation to BATNA. So, the range of all agreements acceptable to both parties is the gap between the values you have allocated. "How much did you exceed your allocated value?" "How much of the current value did you claim?" These are two important questions to ask about this gap, the authors say. Then, they make the following suggestions:

- At the table, pay attention to the BATNA of the other party and the "allocated value." When privileges dwindle, it's a sign that you've reached ZOPA's limits, or so the other party wants you to think.

- You have two goals in responding to proposals: to complete the specific deal being negotiated and to strengthen your relationship with the other party. To create real value for both parties, keep the issues in balance with each other.
- Both parties should seek ways to make changes that improve the agreement for at least one party without anyone losing. Such changes can range from delivery dates to financing plans.
- After negotiation, check the deal again to see if there will be an improvement to a "post-settlement agreement." If it cannot be done, there is an agreement already signed. Everyone benefits if they can.

As a bargainer, you have to face the fact that "people act irrationally and make mistakes,"[2] write the authors. But the upside is that most mistakes in negotiations are "systematic and predictable," they add. For example:

- The "fixed pie bias" mistakenly assumes that there is a limited amount of values to split. Overcome this by creating more value.
- The "vitality bias" begins when one factor becomes too prominent, preventing consideration of other factors, such as when a proposed salary dwarfs all other factors in a job offer.
- The framing effect is a phenomenon that means that the decisions of others change depending on the way the information is presented. Another common bias is the "proneness to framing" bias. In other words, you think that the way you present some information will shape the other person's decision. To get rid of this bias, redefine the key points objectively. Use different reference points to evaluate the data.
- "Motivational biases" arise when what you want conflicts with what you know you should do. To deal with this, delegate decision-making authority to someone else, especially for troubling points.
- "Egocentrism" is another source of prejudice. People tend to interpret events in their favor, so different parties do not disagree about what they want; they also disagree about what is fair. To answer, use the "alien lens" to see things from a third-party perspective.
- Overconfidence and optimism are interrelated prejudices. People tend to see themselves as good and others as bad. Be aware of the risk of overconfidence. Avoid judging people as inside or outside your group; instead, build trust between the parties before negotiating.

The authors also underline the following issues as a bargaining principle:

- Emphasize that people will lose by rejecting your offer because they are more afraid of losing than they want to win.
- Try making an excessive request first. The other party will reject it, but your real offer will then appear more moderate.

- Do not lie. Be ready when others lie.
- It is also necessary to pay attention to conflicts of interest. People, including professional representatives such as lawyers or real estate brokers, interpret situations in ways that benefit them.
- Negotiating in an extremely weak position is quite challenging. Don't let people know you're weak.
- If they are really angry, accept this and address the basic motivation that drives the emotion.
- Finally, remember that you can't negotiate everything, and you shouldn't always try. Don't try to negotiate when it's culturally inappropriate, if everyone knows your BATNA, if you're under severe time pressure, or when it will damage an important relationship.

In 2017, Malhotra Deepak wrote the book *Negotiating the Impossibl,*[3] and suggested using the strategies of "empathy," "process," and "framing" to develop a more collaborative, value-creating negotiation, especially for stalemate negotiations. The main highlights are:

- When the other party opposes a proposal, think about how you want to "frame" it. Framing is the way you present something, as mentioned above.
- "Changing the framework" helped resolve a 2011 contract dispute between owners and players of the National Football League in the USA. The main point of contention was how to divide profits. Players asked the bosses to split the money fifty-fifty. Bosses offered players a 58% stake, but only after they took two billion dollars in profits. With the fate of the upcoming season at stake, bosses overcame the stalemate with yet another new sharing model framework (presentation form): They proposed splitting profits into three parts. For the first part, they gave players more than half of the profits from television rights, while in other parts, including stadium and post-season revenues, bosses had a larger share. Both sides declared "victory" at the end of the bargain.
- Think of the process as the nuts and bolts of the bargain. It includes who will be involved in this process, what will be on the agenda, and in what order the issues will be addressed. Identify the process as the first step in the negotiation. An agreed-upon format can help prevent deadlocks and ugly conflicts, as well as costly mistakes such as untimely compromises.
- Empathy allows you to see the negotiations from the other party's point of view and to understand and anticipate their actions. Your goal is to understand the other party's behavior, not justify it. When you can discern possible reasons behind their actions, you multiply your options to respond. Whatever the outcome, stick with it. There may come a time when the deal you've reached can be improved or what you haven't, you can have.

- In 1962, US President John F. Kennedy had an interest in resolving the Cuban missile crisis, a conflict over the Soviets building nuclear missile facilities in Cuba. Had Kennedy assumed the Soviets were acting in bad faith, he could have responded with airstrikes. Instead, he understood the Soviet point of view. The Russians were trying to balance the US nuclear advantages, including the US missile launch sites in Turkey and Italy. When the USA promised to remove the Turkish and Italian facilities under a negotiated agreement, the USSR agreed to remove the missiles from Cuba.

Psychology professor and negotiation expert Daniel Shapiro, in his book *Negotiating the Non-Negotiable*,[4] explains that emotional conflicts threaten your identity in bargaining, so that's where you need to look to resolve them. To heal the conflict, he recommends that we go beyond our core identity and look at the role identity plays, rather than dealing with superficial issues of conflict such as finance or politics. He says that if we feel that a conflict threatens our identity, we may think that our only alternative is to fight. Your opponent may feel this way too, he says, explaining that both sides can come up with alternatives. Shapiro states that two aspects of our identity, our "core identity" and our "relational identity," are vital to resolving conflicts.

According to Shapiro, our relational identity consists of attributes that determine our relationship with a particular person or group. In conflict, we face a special challenge with our relational identity. We need to know how to balance our need to engage with our group against our desire to preserve our freedom of choice and action. Shapiro states that if we believe we can resolve our differences, we can find ways to reach the people we disagree with. But if we feel our identity is threatened, we can respond according to the "tribal influence," which can make us behave from our own point of view, belligerently or even in a narrow-minded way.

Finally, Joshua N. Weiss, also from Harvard, in his book *The Book of Real World Negotiations*, gives examples of bargaining from the business world and daily life, summarizing the literature and listing the five principles that make a bargain perfect:

1. Having good preparation
2. Recognizing the mentality and the importance of the relationship
3. Engaging in creative problem-solving
4. Managing the emotional dimension of bargaining
5. Revealing the hidden dimensions of the bargain

As for my tradition, we have a "knife margin" tradition inherited from my father, both in establishing partnerships and in negotiations. This "knife

margin" is also not something I come across in bargaining literature. The late Sabri Bey used to say: "When dividing a cake, try to cut it right in the middle. But the knife with which you cut the cake has its share; the blade share. Always leave this share of knives on the other side." This is another expression of the win-win principle.

There is a beautiful proverb in Turkish, "Check your purse, then bargain." It is true: your bargaining power is as much as your money in your safe, in your pocket. However, I have seen from experience that sometimes, money alone is not enough in bargaining. I lived this in the Godiva trade. After we had agreed on everything, including the price, the CEO invited me back to dinner in New York and asked about our HR policy. When he was satisfied with my answer, he admitted that we weren't the highest bidders, but he trusted us. After reading Deepak and Max's book, I wonder if the CEO had called me for a "post-settlement agreement." Maybe, but he didn't want to.

While I wholeheartedly agree with the adage I mentioned above, that "If you don't have money or can't afford it, don't try to buy goods," sometimes even if you don't have enough money, you can find different, creative solutions at the bargaining table, as Weiss states. We had to buy machinery from a Swiss monopoly manufacturer. But, if I pay the amount they are asking for, it doesn't save me in the end because you have to calculate the return on the money you give. The calculation is also actually simple, "This is my money, this is my market, and this is how much money I can make."

I also made these calculations, but I could only pay half of the price they wanted, to save the investment. Yet, if I don't get that machine, I won't be able to get anywhere in productivity or quality. That's all I can give, I say, but the man is discouraged and leaves. But he also knows that I really want to buy it. Actually, he doesn't want to miss this sale opportunity either. Finally, he came to me with a solution and said, "I will not give you the whole machine, but I will give you some technical drawings. You can get it done in Turkey," he said. It was a good idea, but unfortunately, the price he asked for technical drawings was also very high. I used his offer, first of all: I said, "Don't give us the technical drawings, but give me a day with the engineer who made the technical drawings. Let me come with my engineer and see where the machines are made and how the machines work. Instead of technical drawings, give me sketch drawings of the machines. So I'll make the machines. Then send your engineer to our factory, and he will check if it is correct." He accepted. In this way, I made half of the machines myself. I bought other parts from them as well. We modernized our facility with these machines. At the bargaining table, it is necessary to take into account different alternatives. There is no such thing as two plus two equals four; it can be three or five, depending on the situation.

There were times when we got up from the bargaining table after being rejected. In the past, technology transfers were never easy. Fortunately, these are outdated issues now. In this sense, Jacobs has a very different meaning for me between the brands that fall under United Biscuits and the pladis roof. When we set up a new modern biscuit factory in Davutpasa in the 1970s, we wanted to produce crackers. We tried cracker production in the factory, but it didn't work. Was it better to ask someone who knows? Back then, there was a very famous cracker called TUC. The sole manufacturer of this biscuit and the owner of its technology was a man named Monsieur de Beukelaer. His factory was on the Belgian–Dutch border. My father made an appointment to meet him and went there. However, Monsieur de Beukelaer made my father and my cousin wait because he was taking a lunch nap.

When he woke up, our people told him crackers could not be made in Turkey, and they wanted to establish a facility. They asked him how they could go about doing it. De Beukelaer said: "I would like 4 percent of your turnover as a license fee." Besides that, he wanted it from sales; they would give it if it were out of profit. Would it even make that much profit? That was not clear either. Moreover, how would we pay the 4% he wanted from Turkey? There were no laws regarding this in Turkey. There were commercial conditions and other problems. They explained this, but Monsieur de Beukelaer did not warm up to the idea. So they returned empty-handed.

Then fortunately, we got support from the USA from an organization called the International Executive Service Corps (IESC). This establishment operated like a foundation, providing experts to companies from industrially developing countries. Retired managers who were successful abroad usually came with their wives for a certain fee, a certain donation to the establishment and expenses to be covered, and helped us with the issues we needed in our country. An expert from IESC named Richard Scheneider came. The man did indeed manage to make the cracker in one go. We named it the Crown Cracker. It has become a classic product that we sell a lot in Turkey.

In time, aside from the technology of TUC, which Monsieur de Beukelaer refused to give away, the TUC brand became ours in England. It must be some kind of industrial destiny. Fate! I have many such stories. We needed to diversify our products in the 1980s, but it was only possible with BOPP flexible packaging, which is known as gelatin film, that protects those products from air and moisture. However, it was not manufactured in Turkey. No one intended to invest in this area either. We had to do it ourselves. My father had a feasibility study done and saw that a total of ten million dollars was needed. Ten million dollars was a huge amount at that time. The World Bank gives loans to advance the industries of developing countries. They went to the World Bank. They explained the project.

Bank experts did not believe in the project. They did not give the loan. In the end, local and foreign partners were found, and Polinas was established. Then, years passed. One day, while I was on a plane, a man came up to me. "Are you Sabri Bey's son?" he said. I said yes, and he continued, "Your father asked us for a loan for Polinas, and we didn't give it. We said that you could not sell five thousand tons, but now we see that there are fifty thousand tons of production. We made a mistake." Then he sent his greetings to my father. Today, Polinas, which is only one of the facilities in our country with a capacity of one hundred thousand tons, sells to hundreds of companies in more than sixty-five countries on five continents.

I will discuss partnership with foreign cultures in another chapter further on, but let me mention this: During the final stage of my negotiation with the Japanese, I saw that I could not give the number they wanted, so my offer would be below the number they asked for. Then I said what I wanted to say and kept silent. Whatever they said, I never answered. They said my offer was too low, they even mentioned our previous deals because my price was lower than what we had paid before, and again I kept quiet. After a long silence, the chairman of the committee, the old Japanese chief engineer, said, "Sir, we have not seen a bargainer as good as you are – we accept your offer." Jujitsu worked, and well, I also was a judoka in my youth!

To sum up, after all this experience, I think that bargaining is first and foremost an art of compromise. When I look at what I did during the negotiations, I see that I acted in accordance with what was written on this subject. I personally always try to reach a win/win situation in negotiations. Every bargain has a "bottom point," or the final "twisting point," as Fisher et al. call it. I don't do that, so I don't go down to that point. I take care of the other person's BATNA.

This approach is not discussed in books. When you do this, the person on the other side of the table will be pleased. Maybe at that "point of twisting," he earned fifty thousand, whereas, in the bargain, he left a million, but that fifty thousand makes him happy. This is the secret of bargaining.

References

(1) Fisher, R., and Ury, W. (1991). *Getting to Yes*, Penguin.
(2) Deepak, M., and Bazerman, M. H. (2008). *Negotiation Genius*, Bantham.
(3) Deepak, M. (2017). *Negotiating the Impossible*, Berrett-Koehler.
(4) Shapiro, D. (2017). *Negotiating the Nonnegotiable: How to Resolve Your Most Emotionally Charged Conflicts*, Penguin Books.

What If I Say I Am Prejudiced? Is It Also a Bias That I Think I Am Biased?

I am one of those who admit that I have prejudices. Is this a source of pride for me? I'm not sure about that. Am I uncomfortable? I'm not sure about that either, but what I know is that I have preconceptions. That's why when a friend of mine said a book entitled *Think Again: The Power of Knowing What You Don't Know*, by professor of organizational psychology Adam Grant, was newly released and a great read about prejudice, and that I should check out, I immediately did so. My friend was right. This book explains with examples what we know and why we should reexamine what we accept by heart or not. So, did I get rid of my prejudices? Let me save that answer for the end of this chapter. First, let's look at what Grant is talking about.

"Intelligence is traditionally viewed as the ability to think and learn. Yet in a turbulent world, there's another set of cognitive skills that might matter more: the ability to rethink and unlearn,"[1] says Grant. He then mentions that we often prefer the ease of connecting with old views rather than the difficulty of grappling with new ones, expressing that there are deeper forces behind our resistance to rethinking, and continues as follows:

> Questioning ourselves makes the world more ambiguous. It requires us to admit that facts may have changed, that what was once true can now be false. Rethinking something we deeply believe in can be perceived as a threat to ourselves, and it can feel like something is breaking out of us.[1]

But this is not true in every field. We can be very innovative when it comes to our tangible assets, our clothes, and our belongings. However, when it comes to our knowledge and opinions, we tend to be conversative.

Grant talks about listening to opinions that make us feel good rather than ideas that make us think hard, and then cites a well-known example:

> You have probably heard that if you put the frog in a pot of hot water, it will jump out right away. But if you put the frog in warm water and gradually raise the temperature, the frog will wait and eventually die because he lacks the ability to rethink the situation and does not recognize the threat until it is too late. I did some research on this popular story told as if it were based on reality to get a better sense of the story, and I discovered a problem: The frog thrown into boiling water is badly scalded or runs away. But the frog performs better in the pot boiling over time, so the frog jumps out when the temperature of the water reaches an uncomfortable point.[1]

So, it is not the frogs that fail to reevaluate, it is us.

Everyone has a way of thinking that they use regularly and rarely question or scrutinize. These ways of thinking include beliefs, assumptions, ideas, and more. Grant talks about two different views regarding intelligence here. First, intelligence, in the traditional view, is the ability to think and learn, he says. Then, alternatively, intelligence is the ability to rethink and learn, that is, flexible thinking. Grant argues that these cognitive skills are essential in an increasingly complex and changing world. Rethinking can help you come up with new solutions to old problems and rethink old solutions for new problems. This is a way to learn more and experience less regret from the people around you. The difference in wisdom is being able to give up some of our most precious traits when the time comes.

Most of us are happy to stay true to our beliefs and opinions on the subjects we know and are experts in. Yet rethinking is a skill. We often fail to do this. When other people need to change their minds, it is easy to notice this. However, it is difficult for us to do the same ourselves. Instead, we tend to make our beliefs more permanent. Some of the arguments we take refuge in instead of rethinking are: "This is not this shape ... My experiences do not say that it is very complex ... No need to think about it anymore ... We have always done it this way..."

However, we shouldn't say such things. I do the opposite; I ask myself where and what I could have done wrong, or at least how I could do better. I try to learn and compare what is happening around me.

According to Grant, rethinking is the foundation of scientific thought. You need to doubt what you know, wonder about what you don't know, and update your view based on new data. You can reveal new facts by testing hypotheses and doing experiments, and always seeking the truth. Changing your mind is a sign of intellectual integrity and a response to the evidence. Hypotheses have a place in our lives as well as in the laboratory. Experiments can shape our daily decisions. Generally, great entrepreneurs and leaders have strong ideas and are open-minded. For this reason, we follow and love them. They have a scientist's inquisitiveness, but like many scientists, they can behave in the opposite way. In real life, scientists and entrepreneurs also tend to neglect professional behavior. They may tend to be blind to their beliefs instead of questioning, and they rarely admit that they are wrong.

Grant's idea is that mental strength does not guarantee mental skill! No matter how much brainpower you have, if you are not motivated to change your mind, you miss the opportunity to think again. Studies reveal that the higher we score on an IQ test, the more likely we are to get stuck in patterns. According to recent experiments, the smarter we are, the harder we must work on updating our beliefs. Many people are more conservative when their intelligence is questioned. I guess the reasons for my prejudices are similar, and it would be a lie if I were to say I was not surprised.

Two basic biases drive this model in psychology:

- The first is verification bias, seeing what we hope to see.
- The second is the bias to be desired, the tendency to act in a way that increases others' acceptance or approval of you.

These biases don't just prevent us from using our intelligence, Grant says. We can turn our intelligence into a weapon against the truth. Our intelligence generates reasons to cling passionately to our beliefs, to our causes. Whatever happens to us, we do it to ourselves.

I personally do not like to be praised, especially to my face, and I will distance myself from those who do this immediately and, when possible, not see them again. Also, the value of those who accept what I say without question or consideration is low in my eyes. But I never attempt to fight with the self-ignorant. By this, I mean those who speak to people with low awareness just to argue.

Grant says, the sad thing is that we are often unaware of the flaws that appear in our thinking. My favorite bias is reflected in the statement "I'm not biased," where people believe they are more objective than others. Intelligent people are more likely to fall into this trap. The smarter one is, the harder it can be to understand your own limits. Thinking well makes rethinking also difficult. After all, the purpose of learning is not to validate our beliefs but to improve.

In this instance, I suppose I am in the minority, as I believe I accept my prejudices. But that's all, so I just admit it. I'm not passionate about it. This is what I call pre-acceptance. Having this type of acceptance allows people to move forward quickly while thinking and considering experience gained as they age; this turns into a kind of insight.

Grant describes the cycle of rethinking as follows: Humility ▶ Doubt ▶ Curiosity ▶ Discovery.

He describes the cycle of overconfidence as follows: Pride ▶ Belief ▶ Confirmation and Being Desired ▶ Verification.

Grant continues: It all starts with intellectual humility. We should all be able to make a long list of areas in which we are ignorant. If knowledge is power, knowing what we do not know is wisdom. Accepting what we do not know and understanding exactly what we do not know will show us the way to know those things.

I think I have an advantage here. I do not hesitate to remain humble and will list things I do not know, even my mistakes.

Grant speaks of "mentor" and "fraudulent" syndromes: If one's self-confidence becomes more than his/her competence, he/she may fall victim to the mentor syndrome. The ideal level of trust is somewhere between that of being a mentor and being a tad dishonest. However, the question remains as to how to find that point.

Later, he describes the Dunning-Kruger effect. Grant says this defines the disconnection between competence and trust. Those who are most confident are usually the least competent. Although these people do not know, they act as if they know the best. As people gain experience, their self-confidence rises faster than their competence, and from that point on, their confidence will be above their competence. As they gain experience, they lose some of their humility. This starts a cycle of overconfidence and prevents us from doubting what we know and wondering what we do not know. We are now unaware of our own ignorance. Those who are new to any field rarely fall into the Dunning-Kruger trap. For example, if you don't know anything about football, you probably wouldn't believe you know more than a coach.

The mind needs humility to nourish itself properly, Grant says. Humility is also often misunderstood: It is not a result of low self-esteem. It is admitting that we are imperfect and fallible. Many people picture trust as a seesaw. When we gain too much confidence, we tend toward arrogance. If you lose trust, you will become humble and docile. This makes us feel badly and we are afraid of being humble. We want to keep the seesaw in balance. We don't want to be perceived as someone who has lost self-confidence.

As such, we want to have enough confidence. The ideal situation is that in which a humble individual with self-confidence believes in his/her abilities yet has sufficient suspicion and flexibility to recognize his/her mistakes. The individual can be inquisitive and flexible in this way and is always seeking the truth. Confident humility can be learned.

In later chapters of his book, Grant explains what kind of mistakes companies and other organizations encounter in their decision-making process by not "rethinking." In summary, he says:

1. Some leaders surround themselves with "yes-men" and let the sycophants seduce them, because instead of rethinking, they want to constantly receive approval. Other people in need of approval are CEOs. Studies show a CEO who enjoys praise and compliance is overconfident, and the firm suffers as a result. Instead of changing course, they stick to their current strategic plan and doom themselves to failure. We learn more from the people who challenge us than from those who approve of us.

2. Strong leaders take criticism into account and become stronger. Weak leaders silence criticism and become weaker. In every society, people seek belonging and status. We become part of a group by identifying with and taking pride when our group succeeds.

3. For mental and social reasons, stereotypes are formed, and it is difficult to eradicate them. Socially, the reason stereotypes are so popular is that we tend to relate to the people who have them. This makes stereotypes even more attractive. This is called group polarization, and it has been

proven in hundreds of experiments. Getting rid of these stereotypes can only happen when a different way of thinking or rethinking is gained. Otherwise, everything repeats itself.

4. In the last few years, psychological safety has become a buzzword in many workplaces. Although leaders could understand its importance, they often did not know exactly what it was and how to achieve it. Psychological security is not about loosening standards, or about comfort, tolerance, or unconditional praise. It is an environment of respect, trust, and sincerity where people can raise their concerns and suggestions without fear of retaliation. This is the foundation of a learning culture. When we see people being punished for failures and mistakes, we worry about demonstrating our competence and protecting our careers. We learn to engage in self-limiting behavior and bite our tongue instead of raising questions and concerns. Sometimes we do this because of the power distance: we're afraid to challenge the top.

5. Risk in performance cultures is when we declare a routine the best; it is turning around in the same place in time. Social scientists have discovered that people are more likely to pursue the same bad action plans only when they are held accountable for whether the outcome is successful or not. Simply praising and rewarding the results is dangerous because bad strategies are overtrusted, and people are encouraged to do things the way they always do. The solution is to create an accountability process in which people measure how carefully different options are considered when deciding something.

6. A bad decision process relies on shallow thinking. The foundation of a good process is deep and even reconsideration, and it enables people to form and express independent ideas.

7. Even if the outcome of a decision is positive, sometimes it cannot be qualified as a success. If it came out of a shallow process, it is a work of luck. If the decision process is deep, we can count it as an improvement.

8. In many organizations, leaders want assurance that the results will be positive before testing or investing in something new. This approach is the enemy of progress. That's why companies like Amazon care about disagreement but implement the principle of loyalty. As Jeff Bezos explains in his annual report: successful results are achieved by encouraging employees to have the confidence to disagree rather than by giving them orders. "I know we have different ideas about this, but would you bet me on it?"

9. A review of California banks found that managers often continue to approve additional loans to customers whose previous loans had already defaulted. As the bankers signed the first loan, they felt obliged to justify their initial decision. Interestingly, banks with a high manager turnover

ratio had a higher identification rate of nonperforming loans. If you are not the person who gave the green light to the first loan, you have every motivation to rethink that client's previous review. It is more likely to rethink and re-evaluate when initial decision makers and subsequent decision makers are separated in the process.

10. When we dedicate ourselves to a plan, and things don't go the way we hoped, a rethink is usually not the first thing we do. Most people give up at the first bend. Others give up everything else to achieve their goals. This tends lead them to put in twice as much effort for something. In doing so, our aim is only to proceed in the way we are determined and not to miss the target. The self-satisfaction achieved at this point is worth all the difficulties. However, the solution is neither to give up at the first bend nor to go blindly to the end when things do not go well. Rather, it is necessary to rethink. Although this may seem to slow us down and force us to reconsider decisions based on intermediate results, it saves us from absolute failure.

Grant concludes: The evidence shows that if false scientific beliefs are not dealt with in elementary school, then they become difficult to change. Rethinking should become a regular habit. Unfortunately, traditional educational methods sometimes do not allow students to acquire this habit.

Grant says effective education is a must right from the start.

As for me, I admit that I was prejudiced, and I know on what issues I am ignorant. In fact, I always go back and ask what I did wrong in my evaluations. I demand feedforward from young people and I am enlightened.

I am not neglecting my education, either, though, I receive it mostly indirectly in meetings and speeches and sometimes directly at my request.

Reference

(1) Grant, A. (2021), Think Again: The Power of Knowing What You Don't Know, Penguin Random House, ss.320.

You Can't Manage a Global Company without Understanding Different Cultures

I've had the opportunity to work with people from foreign cultures since I was young, and this diversity has aided me in gathering quite a lot of experience to evolve. How cultural differences affect business life, and what the consequences are, all depend on your attitude. Is it possible to ignore cultural differences? You cannot run a global company by ignoring cultural differences. It is essential for your success.

In my article entitled "Everyone Has a Role on the Board of Directors," I mentioned the book *Secrets of the Board*, which describes the habits of boards of directors of different cultures.

The systematic approach that this book and many studies base different cultural habits on belongs to Erin Meyer. Meyer is an INSEAD business school professor, and with her 2014 book *Culture Maps*,[1] she put forward a model that helps readers see the differences in foreign cultures based on the knowledge that had been revealed up to that time. The book's two main sources were Richard Nisbett's *Geography of Thought*,[2] and Dutch psychologist Geert Hofstede's *Cultures and Organizations: Software of the Mind*,[3] who himself worked in IBM's HR department in the 1970s. In his famous book, Nisbett proposes that the reason for people's different thoughts and views concerning the world are different ecologies, social structures, philosophies, and educational systems. Hofstede's approach is to use four scales for culture analysis:

1. Power distance: The extent to which people with lower power accept the unequal distribution of power by individuals in society. There is a clear hierarchy in countries with a high power distance index. In those with a lower power distance index, it is seen that people question authority and want equal distribution of power.
2. Uncertainty avoidance: The measure of the response of individuals in society to uncertain events. Countries with a high index apply strict codes of conduct. Rules and laws are written to reflect absolute truth. Countries with a low uncertainty avoidance index are more prone to differing opinions and accept less order in their lives.
3. Masculinity/femininity: In this scale, masculine represents society's preference for success, heroism, and material rewards, while feminine reflects a preference for cooperation, humility, and quality of life.
4. Individualism/collectivism: In individualistic societies, people's bonds with family and friends are weaker. In the collective society, it is seen that cooperation in groups and loyalty are higher.

Meyer, in contrast, created an eight-scale model based on the prediction that cultural behavior and belief patterns often influence our perceptions (what we see), our understanding (what we think), and our actions (what we do). While each dimension represents a fundamental area that managers should be aware of, how a dimension varies from one end to the other also reveals the cultural difference. Meyer's eight scales are as follows:[1]

1. Communication: low context – high context
2. Rating: direct negative feedback – indirect negative feedback
3. Persuasion: principles first – practices first
4. Leadership: egalitarian – hierarchical
5. Decision making: top-down – consensus-based
6. Trust: task-based – relationship-based
7. Conflict: conflict-based – conflict-avoidant
8. Planning: linear time – flexible time

Meyer created these scales based on the feedback of hundreds of international managers and put many countries on the scale to show what is acceptable or appropriate behavior in each country.

According to Meyer, if a manager is to build and manage global teams that work together successfully, he/she must understand not only the experiences of people from his/her culture in relation to people from other cultures but also how these cultures perceive each other. Culture is to us what water is to fish. We live and breathe it. The Chinese say that men in the game are blind to what men are looking on to see clearly. This means, you have to be in the same cultural dimension to communicate, understand, and be understood. This can be achieved with awareness and sacrifice.

Meyer's book contains many examples of cultural differences. I would like to start by describing two of them that caught my attention and clearly explained the differences. Meyer asked a staff member at the hotel where he was staying in New Delhi to describe the location of a restaurant he wanted to go to. The attendant replied: "It's very easy. There is a sign just to the left of the hotel and it never goes unnoticed." "Come on, show me, please," Meyer said to the attendant. He walked out the door with the hotel clerk, and they crossed the street together, turned left, and walked for ten minutes, slicing through the bustling traffic on the pavement, through many side streets, and past countless cattle on the road until finally just beyond a bank, on the second floor of a yellow stucco building, above a grocery store, they saw the small sign with the name of the restaurant. Meyer was surprised at the difference between the address description and the route followed. Then, he explained the main reason: in US and Anglo-Saxon cultures, people are trained to communicate precisely and as clearly as possible; good communication is all about intelligibility and clarity. In such cultures the responsibility

of getting the message right is on the sender. By contrast, in many Asian cultures, including India, China, Japan, and Indonesia, messages are often conveyed implicitly, requiring the listener to read between the lines, and good communication is implicit and layered. It relies heavily on subtext, and the responsibility for delivering the message is shared between the sender and the receiver. This restaurant's address description reminded me of an experience when I was young: when I asked the nomads in the Taurus Mountains for directions, they said *hoenguerde*, meaning just over there, and then we reached the place I was looking for behind many hills.

In the second example, Meyer notes that while Americans focus on individual characters apart from their settings, Asians focus more on the connections between the backgrounds and the main characters. A study by Professors Richard Nisbett and Takahiko Masuda among Japanese and American participants is interesting in this respect. The definition of a portrait is quite different for Americans and Japanese.[4]

Meyer gives the example of Taoism for Asia, stating that the ways in which different societies analyze the world are basically based on philosophical roots. Taoism, which influenced Buddhism and Confucianism, states that the universe works in harmony and that the seemingly opposite forces, yin and yang, whose counterparts are darkness and light, respectively, are intrinsically interconnected and interdependent. In other words, this philosophy argues that various elements are interdependent. Therefore, in order to encourage, manage, or persuade someone, it is necessary to explain the big picture and show how all the pieces fit together. If individuals don't understand what they're working on and how the pieces fit together, they don't feel comfortable or cannot be persuaded to take action. In these societies, it is said that certain divisions of labor and individual incentive schemes do not work.

Meyer, who explains that managers and team members who are unaware of cultural differences often experience frustration and difficulty in achieving organizational goals, describes the eight scales in her culture map model as follows. Meyer does not specify all countries placed on the scale in her book. There are opinions on this subject in the book Yılmaz Argüden's *Leading a Board*. Here I share my views from a broad perspective:

1. "Communication: Low Context and High Context."

For example, people in the USA communicate openly, stating briefly but clearly what they are talking about. They describe the steps and the work in detail as if talking to a simpleton. As for Turkish people, the proverb "no description needed for the wise," expresses just the opposite idea, but is not very useful in business. People from Asian cultures such as Japan and India communicate indirectly, relying on recipients to read between the lines

and interpret the message correctly. Especially, and mostly, the Japanese use symbols and exemplars. The USA is a "low-context" culture that values simple, direct, and concise communication. "High-context" cultures, in contrast, have a long common history. The USA remains at the bottom of the context. Canada, Australia, the Netherlands, Germany, and the UK are slightly higher in context. It is a high-context culture that prevails in Japan, Korea, Indonesia, and China. Italy, Spain, France, Mexico, and Brazil are in the middle. The British are less low context than the Americans. Brits often think that Americans don't understand their jokes. Americans, however, are not sure when the British are joking. Communicating between cultures is difficult, even if these cultures share the same language. In Turkey, we do not choose open and clear communication; rather, we communicate more indirectly and implicitly. The reason for this is our common cultural background and our expression skills, in combination with proverbs.

2. "Assessment: Direct Negative Feedback/Indirect Negative Feedback."

American managers learn to give hardened negative feedback with positive, supportive language. Indirect negative feedback approaches are sensitive, diplomatic, and specific. These managers take care to make positive comments as well as provide corrective information.

In contrast, the French evaluative style is direct, giving frank and honest feedback that is not tempered by praise. In some countries, it is socially acceptable to give feedback in front of others. However, a culture's communication style is not necessarily compatible with an appraisal approach. Some countries, such as Israel, have a high-context style of communication but give direct negative feedback. In Turkey, we often find it difficult to say negative things directly to a person's face; we prefer indirect language. Criticism in the presence of others is considered dishonorable, but it differs according to people's understanding and social status. For example, it is said, "You ask a lazy guy to do something – all you'll get is advice."

3. "Persuasion: Principles First/Practices First."

Two styles of reasoning at opposite ends of the persuasion dimension are "principles first" and "practices first." In the "principles first" approach, a theory is developed and then supporting facts and conclusions are presented. In "practices first," patterns or facts in the real world are observed first and then conclusions are drawn.

People from cultures like Russia, Italy, and France want to know the reason for something before they act. In countries that say practice first, such as the USA and Canada, more emphasis is placed on how to achieve a goal. Most people use both approaches at different times in various situations. For Turkey, practice comes first in daily life, and there is a situational

use in business life. These are called "moments of wisdom." It is said that "A word to the wise is enough."

4. "Leader: Egalitarian/Hierarchical."

This is actually Hofstede's power distance scale. Egalitarian and hierarchical leadership are two poles. Like Japan, China, and India, Mexico is on the hierarchical side of the leadership scale. At the egalitarian extreme are Denmark, Sweden, and Israel. Near the middle is the UK and the USA. For example, those working in egalitarian societies act autonomously; they communicate directly with people at different levels of authority. In hierarchical societies, however, people cannot afford to contradict the boss. Turkey is on the hierarchical side. This also explains what we understand about pluralist democracy.

5. "Decision Making: Top-Down/Consensus-Based."

Most egalitarian cultures value consensual decision-making, and most hierarchical societies believe in top-down decision-making. Concerning the question of who decides and how, the USA follows an egalitarian philosophy, but the responsible person makes the decisions on behalf of the group. At the other extreme, Germany stands as a hierarchical culture in which decisions are made by mutual consent. In cultures that decide by consensus, such as Japan, the process of reaching a decision is long, and everyone has a contribution. Once the group has made a decision, it is final and ready to implement. In top-down cultures, the supervisor makes a decision quickly. The UK and the USA are in the middle. India, China, and Nigeria are at the other extreme. Although I am not entirely sure, I think that Turkey is hierarchical but seeks consensus when necessary.

6. "Trusting: Task-Based/Relationship-Based."

There are two types of trust: "cognitive trust" and "emotional trust." Cognitive trust is our confidence in someone else's abilities to do a job or perform a task. Emotional trust comes from our love for someone. In some cultures, such as the USA, people with a "business is business" feeling distinguish these two forms of trust from each other in the workplace. It is emotional trust that plays a big role in business transactions in countries like Nigeria or India, as business is personal.

The trust scale has two ends: "task-based" and "relationship-based." Task-based cultures such as Denmark and the Netherlands distinguish between work and personal relationships. You build trust by performing well in these countries. Business relationships are shaped and grown around functionality and mutual benefit and usually end when the business ends. In relationship-based cultures such as China and Saudi Arabia, the line

between work and personal relationships is blurred; trust builds as people get to know each other. In these cultures, business interactions are based on personal and real relationships. Time spent outside meeting rooms often provides the most valuable opportunity for interaction. Meals and long conversations are personal, and socializing is a priority. Once people have made personal connections, it's time to do business. A "relationship-based" culture is dominant in Turkey. But a "relationship" doesn't mean trust right away. First, "establishing a relationship" is accepted as a duty, as if "trust is sought." As you get to know each other, either "trust" is formed or the relationship is broken. For example, when businesspeople come together in Anatolia in meetings, after greeting each other, they sit silently for a while and look at each other, then say *merhaba*, and exchange salutations with each other before the meeting, which starts with a proposal by the eldest or the authority figure. In contrast, with the Hijaz Arabs, this takes place in the form of asking each other about family, kids, and business without waiting for an answer, just for the sake of doing so. In old comics, however, the white man, to establish a relationship with the American Indians, first greeted them with their own greeting, "HUGH!"

7. "Conflict: Conflict/Conflict Avoidance."

How people discuss ideas and resolve disagreements and conflicts between them varies from country to country. In France, for example, they are comfortable challenging each other's ideas without fear of damaging their business relationship. France falls on the "confrontational" side of the scale of a conflict. In "conflict avoidance" countries like Japan, people think that disagreements harm group cohesion. Conflict-avoidance culture is essential in Turkey. Arabs, in contrast, openly express their conflicting opinions but avoid fighting.

8. "Timing: Right Time/Flexible Time."

The working day in Germany starts on time. In Nigeria, adapting to the environment is more important than starting on time. In right- time societies, workplaces and employees stick to schedules, respect work deadlines, and focus on one task at a time. In flexible time cultures, the workflow is variable, the schedule is adaptable, and many activities happen at the same time. In flexible time cultures, meetings often stray from the agenda, and people see such changes as natural and necessary. Effective managers allow and encourage productive diversions. Although we try to be strict in meetings in Turkey, the approach of "The caravan gets straight along the way" (making it up as you go along) prevails in project management.

We bought Godiva in 2008 and United Biscuit in 2014, and became the third-largest biscuit company in the world. Our organization was not global

when we made these acquisitions. Realizing this organizational change was not easy. Currently, our global employees are citizens of more than seventy different countries. For example, I speak English even with Turks in global meetings or in gatherings where there are people who do not speak Turkish. I do my correspondence in English. But now there is a fashion to learn Turkish among all other employees.

My foreign colleagues still call me "Bey" (Sir), following the dominant behavior of my associates that I could not prevent. This keeps me from being one of the team. We still maintain meaningless forms of address and hierarchy in corporate mailing correspondence; I couldn't manage to overcome this. We have had two truly global companies since 2016, Godiva and pladis. In that year, we hosted our executives from all over the world at Yildiz Holding in Istanbul. I wanted them to see the heart of our work, our home, and get to know us better. We operate in more than one hundred twenty countries. We have employees from different cultures on all the continents throughout the world.

The number of our employees at Yildiz Holding has reached seventy thousand, and we are working to improve on how we can understand and agree with each other. We create a common language, a way of doing business. First, we have a philosophy, #makehappybehappy. Our main target is G0AL21. These letters and numbers are acronyms, telling us what to do and how. G0AL21 actually tells us what and how each of us, and all of us collectively, can succeed and be a leader. It tells us how we can become "Leaders in Market," by working together flawlessly on the field. Otherwise, how could we get tens of thousands of people with seventy different national passports to work together to make our four billion potential consumers happy?!

In a recent global meeting, I looked at friends from different parts of the world and remembered our first export attempt in the early 1970s. In 1974, Kuwait was the first Gulf country that we exported to. We have factories in Saudi Arabia today, but back then, we had a lot of trouble even selling products. I went to Jidda in the early 1980s to develop export relations before I graduated from university. How would I know that I would get scolded as soon as I got there? At that time, the most important task was to deliver our products to the customer, passing them through the port and clearing customs. But there are processes that need to be completed in order to do this. For example, we delivered the samples to the official lab. They give *salah* (permission to sell). Otherwise, they come and destroy the goods. There are life/death systems. One day, I went to get the document, and so what did I see but that all hell had broken loose! They said, "The Chief in the lab is angry. He is looking for Sabri Bey's son."

I arrived immediately. "I am the son of Sabri Bey," I said. "Is that you? If you do this again, I won't give any permission for the goods like this..." I was then reprimanded.

What happened was that there was gelatin in the Cokomel. We put in beef gelatin and we wrote this on the label, but the Chief said, "You didn't write 100%, you cannot clear the goods." In any event, we apologized, he got over his anger, and we were able to clear the goods. We labeled the next shipment "100% beef gelatin." In any case, we couldn't get along with that man.

I asked what I should do to get rid of this man's anger. I had to hand over the business to an agent. Then I asked him about the transactions, how did you do it? He said, 'Arabic is a beautiful language. It is necessary to use the subtleties of this language." How so? I wondered. In any event, I don't know Arabic well enough. Of course, in those years Erin Meyer had not yet created a model that we could read and learn from.

It turns out that a person representing the agent knocked on the door of the Chief and first read a beautiful couplet from an Arabic poem outside the door. Then he greeted him with "Ahlan Wa Sahlan" (welcome and hello). He started by asking how his health was, how his children were, and how his work was going. Then the Chief asked the same things.

After that, it was time to talk business. When we start talking about business directly, these subjects become inappropriate. The word I hear most in Arabic is "Let me tell you." You will definitely listen to what the other person says so that there can be a rapprochement. I also remember that in the early days, I used to starve in business meetings. In Turkey, you chat while you eat at a lunch meeting and you usually talk about business when you go to coffee. In Arab countries, in contrast, business is discussed until midnight, but when the work is done, the people involved sit down to dinner. When they finish their meal, they wash their hands and leave. It is shameful to stay after a meal. They serve dinner nearly at midnight. I had a hard time at first because I didn't know this. Today, I understand how to do business with people from almost every country. Some like a smiling face, and some need a sullen face.

For Americans, smiling is essential. A cleaning lady taught me this! I was in a hospital in the USA. My mother was sick, and I was distressed. A woman mopping the floor in the hallway said to me early in the morning, "Why don't you say good morning to me? You're walking around with a sullen face." Americans definitely want a smile. In Spain, Iran, and Turkey, a sullen face is credible.

Every culture is different. For example, meetings with Turks, Italians, and Arabs are very long. All three are bargaining cultures. Sometimes they even bargain just for the sake of bargaining, but with these individuals, a meeting is fun. The most formal and short meeting, although quiet and somewhat

boring, is with the Japanese. I wrote the jujitsu technique on bargaining, on how to be successful despite this feature of the Japanese.

The German chamber of commerce used to give seminars to German exporting companies on how to set prices for investment goods. At that time, they would invite us as members of our German company there. Their aim was to advise companies on pricing by considering bargaining. In other words, Turks are very hard negotiators, and you make your price one-third higher so that you can get the job done with a big cut. But sometimes it is also calculated otherwise. Let's say, only two companies from Turkey can buy the machines you sell. But ten companies from the UK will be buyers. I can sell the machines to the British for 100 units each. They can buy but no one can buy from the Turks for 100 units. In that case, I must offer a lower price for the Turks, at least to catch an opportunity to sell to one company in Turkey. That's better than not selling at all. In other words, it can be an advantage in bargaining to take into account the unique cultural and corporate conditions of a country. I remember we traded a lot this way. As seen in Meyer's cultural scales, Germany is the country to be taken as an example in terms of timely and planned behavior in all matters.

One of the memories I'll never forget related to cultural differences is that we inspected a factory in the Netherlands during a night shift. The company that would supply us with the machine used in this factory arranged the visit. I wondered why we were wandering like fugitives at night; it turns out they couldn't get permission from the factory manager. Then he said: "These are Arabs, and they are very rich. If they set up this factory, they will make you the manager of the factory." Thereupon, the factory manager gave permission to visit at night to avoid attracting attention. I tried to apply Meyer's cultural scale to this subject, but I was not very successful. Some attractive offers, moods, and physiological needs are equally important to all people, and this was a good example. But, when it comes to hard bargaining, I don't know if we can surpass the Arabs and Italians.

An important aspect of doing intercultural business is gift-giving. I usually give away books and trinkets. The Japanese offer dolls as gifts in a showcase specific to their culture. The Dutch brought a miniature of an antique house from previous centuries. Then the Dutch businessman would say, "Next time I'll bring that house next to that too" and the street would be completed. Arabs, on the other hand, if you have been in business for a long time, will accept you as a family member and give you a personal memento as a gift. For example, a partner gave me something from his late father.

In general, however, the scale of the gifts from Arabs is large. For example, there is a tradition of sending dates during Ramadan. Yet it's not as simple as that, and they send crates full of them, bless them.

Culture affects the way people live and work. In order to succeed, managers have to understand human nature and personality differences as well as know the culture.[5] By identifying common points without conflicting with people's cultures, you should be able to come together at a maximum point, not a minimum one, and lock your team into a common goal.

Your Chinese CEO may say, let's decorate according to feng shui, while Hindus do not want to consume animal food. Religious belief and culture are often intertwined. If you leave Turks on their own, they will perform ablution and walk around with their sleeves rolled up. We provide the necessary environment in each of our companies for people to practice their religious beliefs. We Muslims are more sensitive about our practices during the day. But our measure should be universal: Your freedom ends where another's begins. The key is to be respectful to one another. Respect and trust are essential; in essence, this means to be respectful to every culture, to every belief, and to trust one another.

References

(1) Meyer, E. (2014). *The Culture Map*, THY Publications, p. 257.

(2) Nisbett, R. (2017). *Dusuncenin Cografyasi*, Varlik Publications, p. 200.

(3) Hofstede, G. (2010). *Cultures and Organizations: Software of the Mind*, McGraw Hill.

(4) Nisbett, R., and Takahiko, M. (2003). "Culture and Point of View," *PNAS*, 100(19), Sept., pp. 11163–11170.

(5) Trompenaars, F., and Hampden-Turner, C. (2020). *Riding the Waves of Culture. Understanding Diversity in Global Business*, 4th ed., McGraw Hill, p. 432.

A Small Contribution to the "Human Resources Summit" with Future Skills

On September 28, 2021, the *Harvard Business Review Turkey* (HBR Turkey) held the New Perspectives in Human Resources Summit. The number of speakers was quite immense, and every aspect of changes in HR management was discussed. I listened to some speeches but did not have time to watch all of them, and later, my colleagues provided me with a summary of the talks and kept me informed. I will not summarize all the conversations for you. Talks were given about the changes in HR with theoretical dimensions. Most of the speakers talked about what they were doing in terms of HR during the pandemic and currently. I think most HR department were similar to one another. That's why I'm going to examine all the talks within a general framework here, and then talk about Perttu Polonen's recently released book, *Future Skills*.

What was discussed at the summit? Working from home, increasing concerns related to the pandemic, reorganizing the workplace for those who have to work, the physical and mental health of employees, employee well-being, as well as managing employee anxiety were explored. It was said that it is very important for employees to feel safe and that they felt safer when clear information was given to them during this period. It was emphasized that companies that take care of the health of their employees and the well-being of society gained significant assets in 2021. After this change, companies have had to be more flexible, agile, and lean. It is important to give meaning to employees while they are doing their jobs. HR managers have become CEOs' right-hand men, and CEOs can become HR managers in the future. It was emphasized that people with superior talents and skills will be needed more in the future.

The study titled "Global 2021 Creating People Advantage" was mentioned. According to this immense research study, the areas with the most competence globally are as follows: (1) Change management, (2) Talent management, (3) Leadership management, (4) Culture and purpose activation. Here are some details from the *HBR* Human Resources Summit:

- For the world of the future, it is necessary to encourage working from home. In this way, more talented employees can be recruited without geographic restrictions. Twenty-five percent physical, and 75% remote work per month is one of the most convenient ways. I call this on-location work because wherever the work is, the work will be there. If your job is related

to a production process, you should be in charge, and if it is sales or shipment, you should be on the job in the field.

- In order to keep up with change, it is very important for companies to increase the personal awareness of their employees, establish the necessary systems for acquiring knowledge and using it at work, retrain their employees (reskill) and help them gain new skills (upskill) according to the skills of the future. It is necessary to adapt the corporate culture to the new period, change the leadership and job descriptions, and create change management according to the DNA of the company. The largest but easiest change here will be to define OKRs as well as KIPs (Key Performance Indicators) for each task. In other words, for remote (local) work, it is necessary to describe the success and achievements in all tasks.

- Managers are now forced to approach HR issues differently. The main topics required for this are inclusivity, empathy, flexibility, open communication, and holistic health (well-being).

- It is important for new employees to be provided with orientation, work with an appointed mentor, and adapt to the hybrid model after gaining experience in the office.

- Machine learning and algorithms cannot answer these questions: Why did I fall short? How can I improve when I'm inadequate?

- Digital learning, and continuous learning should be adopted. The idea that the company should train us is wrong. But of course, HR can also provide opportunities for digital employees. For example, the system provides a chat environment by setting up a meeting for me with an employee by chance every Friday afternoon. While this is an exciting opportunity, it also provides us with socialization and its benefits.

- Data and analytics-based HR management are fairer and healthier.

- Creating sustainable values is only possible with employee quality and ability.

- There are two ways to acquire talents: (1) Future Focused Development Programs, (2) Creating the Required Culture to Attract Potential Talents to the company. At Yildiz Holding, we offer the necessary skills and training for new professions to everyone with equal opportunity as the Digital Academy.

- It is a must for HR leaders to be able to think strategically and analytically as well as to possess emotional intelligence. You may appreciate that this is kind of intelligence based on genes and a person's first years of upbringing in the family. Moreover, people who have or are predisposed to it can be trained further.

- HR has now evolved into developing existing employees, recruiting the right person for the right job, and promoting innovation. HR analytics is very important now.

- Working independently of geography gives companies access to a large talent pool. Of course, you should know the interview procedures and principles in every culture.
- In addition, active learning, analytical understanding, innovation, the ability to benefit from technology, creativity, resilience, stress management, fast adaptation, tolerance, and willingness to take the initiative will be the most important skills of the future. I hope families take care of this when raising children and it becomes epigenetic.

As I perceive it, everyone now says similar things, but these things are very different from our previous understanding. We are now acting with a more up-to-date and new generation in mind.

At this point, I wish to call attention to Perttu Polonen's book *Future Skills*. The shining star of the new generation, this TED speaker is only twenty-six years old and has received education in future technologies at NASA Singularity University; won first place among youth in a science competition, the largest competition in the European Union (EU); and is one of thirty-five innovative people under thirty-five years old in Europe, in 2018, as selected by the Massachusetts Institute of Technology. Polonen drew attention in his TED talk, and his small book is possible to read in a short amount of time. His book needed to be mentioned when it came to the subject of future skills at the HBR Human Resources Summit. Isn't it interesting that a young genius utters opinions that agree with those of my generation? This means that we met in a reasonable place in the light of facts on both sides.

Why are some people smarter than others? Polonen begins his book by asking this question. Those who think deeply, not those who are fast, are smarter, he says. He says the future will belong to those who can predict the next move of their opponent and plan their own move accordingly, that is, those who think more deeply. Then, he summarizes the values and skills of the future in thirteen titles as follows:

1. *Technology and the Future:*

"Information is one of the values we can have in order to easily adapt technological developments and not be afraid of the uncertainty it creates,"[1] he says. If we lack knowledge, we are afraid, and sometimes we take sides because of our fear. However, technology is inherently neutral.

Technology cannot be classified as good or bad. The moral of the technology or the tool determines the person using it and the way it is used. He says that the mentality of the people who hold the power to use a machine, and the masses who interpret the outputs of this power are mostly stuck in their own time, which can have dangerous consequences. "This is why one of the important skills of the future is to have a broad and innovative

perspective."[1] Don't let anyone define you as conservative. Although the beginnings of new ideas are sometimes silent, they will come with a thump at the end, just as the ideas they replace were once popular.

2. *Curiosity and Experience:*

The world needs those who dare to ask questions! Considering that even today, vaccines are met with such reactions and fear, the first vaccine that Edward Jenner discovered in 1796 would have seemed "crazy" to the people of that time. The main reason for all the lives saved by vaccines in the 225 years since then has to do with a crazy question: "Can I protect a person from this germ by intentionally infecting him?" While ideas can exist on their own, questions always wait to be answered. So it's the questions asked, not the ideas, that make progress. The power to ask questions is based on curiosity. Even if you don't like it, follow the answers to the questions.

3. *Creativity and Improvisation:*

The basic point of creativity is connecting things that are related or unrelated to each other. It is through real creativity that Anke Domaske produces a fabric called QMilk from milk. Creativity does not flourish in a culture based on right or wrong. Mistakes can and should be made in the creative process, just like with jurisprudence. No phenomenon develops spontaneously. Mistakes are like the shoes we wear on the rocky road toward the truth. When it comes to creating, there are two types: It is only possible for God to create something out of nothing, and what we do is, we create things that actually exist or can exist which wink at us a little bit. Of course, we don't create something out of nothing.

4. *Problem Solving and Adaptation:*

What will change can sometimes be a simple screw, and sometimes it is a non-functioning organ that does not fulfill its function which needs to be changed, and sometimes a mindset. Change cannot happen on its own, and it needs companions. Because of this structure, a problem-solving skill is the basis of adapting to change, or what is required in order to change. In this context, being able to see a problem from different angles constitutes the perceiving features of the problem, and you will have many different perspectives for changing it. In this context, the talents of the future do not have the luxury of neglecting any field or falling behind. There are many different occupational groups. Each professional group tries to find solutions by looking at problems from their own perspective. For example, when an experienced autopsy specialist who retired last week sees an inactive person on the ground, his/her the approach to the problem will be different from that of an emergency nurse who retired in the same week. Future problem-solvers

need to be able to think from many different perspectives. To understand a person, we need to know what they want to do in the future, not what they have done in the past.

5. *Passion and Character:*

Is the main job of a teacher to convey knowledge? No. Generations growing up with the internet, which contains more information than any human's brain can carry, need experience rather than knowledge. Experiences are one of the main factors in the formation of character, which requires going through various stages for its development. This rote learning explains the difference between teaching and education. There is no shortcut to developing character or discovering passions. Character needs constant development, and passions need to be renewed at various stages of life. The discovery of one's own character can take place through answering a fundamental question. Who am I, and why am I here? But now, change has also become an important feature of the character.

Polonen says, our characters and passions separate us from machines. The machine does the work because it has to; it is cold. We enjoy what we do with passion. In the future, the passionate will win.

6. *Communication and Narration (Telling):*

Polonen poses a very important question at this point: What can you give me that is not available on the internet? He says that a person who is confronted with this question may feel worthless. The internet has everything. This is where awareness and depth come into play, that is, being able to understand beyond what is written and said, to be able to read between the lines! People (customers/consumers) often mean something else or mean something even beyond what they actually say. For this reason, the ability to communicate and narrate what you understand in a way that will benefit the other will be an important skill which will bring success in the future.

7. *Thinking and Interpreting Critically:*

The purpose of the internet is not to educate us but to satisfy us. Algorithms support this. What we need to do in such an environment is to adopt critical thinking. This mindset develops self-confidence and enables us to interpret information. That's why we should know that in the distorting internet world built on "satisfaction," information must be obtained and verified from many different sources. In other words, we must keep our desire and curiosity alive to reach the truth without being caught up in the information, offers, and communication offered by algorithms aimed at managing our perceptions or overwhelming us with the pleasure of satisfaction. How much do the comments distort the truth? Being aware and interpreting are

two different things. The highest level of intelligence is the ability to observe something without evaluation. I hope that researching and learning from the internet and using social media are included in the education and learning that takes place in schools.

8. *Entrepreneurship and Teamwork:*

Polonen says that in the future, each of us will have to be a bit of an entrepreneur because entrepreneurship is a subject rather than an identity. Entrepreneurship is the completion of problem detection, planning, and implementation. According to Polonen, an entrepreneurial character is required in order to be able to continue on the road without giving up in the face of seemingly extremely difficult negativities. He emphasizes that the most courageous and entrepreneurial decisions will be made when you have nothing left to lose. An application requires passion and character. Criticisms that will be encountered during the process should not reduce motivation but instead, open the way. For this reason, a problem-oriented approach is necessary, not the results-oriented approach of the right/wrong thinking system, as stated before. Criticisms deepen the problem in our minds and put the missing parts in place. The person who acquires this mindset understands that it is not right to be disappointed and continues along on their way. What it means to have an entrepreneurial spirit is to act passionately yet be able to criticize even oneself. What it does not mean is that everyone should be an entrepreneur in business life!

9. *Perseverance and Patience:*

Modern life and patience are fighting each other hard, says the young guru Polonen. He emphasizes the importance of time:

> Let's look at the most important people today; they all buy other people's time, right? We are now used to having our orders delivered on the same day or even within the same hour. We can't stand the restaurant that delays the average delivery time by five minutes, and it is highly likely that the courier of that restaurant will not want to wait for us for an extra five minutes. We cannot tolerate the slowdown of the internet at work. It is extremely important to differentiate the depth from it in the face of the speed variable. Learning to be patient takes depth.
> One of the first conditions of learning is patience. But you can't be patient with everything like that, and there is no depth to be patient with the slowdown of the internet at work. To be patient is not to endure what happens but to persevere and resist with perseverance and passion. We need to know which side of the line to stand on. What we forget or lose when we decide to give up on a job is the reason that started us on that job, motivation.

Here, Polonen states that in place of the education system's curriculum that shows what is correct or incorrect, the measure that will be given to us to distinguish correct from incorrect will provide us with the strength of

resistance we need to achieve our goals. When we look around us today, almost all successful people are determined people. The reason for this is that they can break down the thick walls of the education system they were born into by thinking critically. One of the important skills of the future is the passionate resistance you pursue in life with an outcome in mind.

10. *Health and Self-Knowledge:*

Maintaining your health is a must, even if it is difficult. A person who does not have the will to live and does not love him-/herself cannot achieve anything. People with high social anxiety cannot talk without thinking. Therefore, health and self-knowledge are the most important values that a person can possess. A doctor can cure physical ailments, but it is the individual who will reveal mental problems in the first step. You must know yourself. We tend to compare ourselves to others because that is how we are taught. This is an unhealthy way of thinking. We need to encourage our children not to compete but to develop originality and uniqueness. It is necessary to study different perspectives, and to learn the main information and root causes of things. In this way, we can discover the right example for us to follow. In order to determine the right one, you must first know yourself.

Polanen says we should adopt critical thinking in order to criticize ourselves. Shedding its leaves does not kill the plant; rather, it keeps it alive.

11. *Compassion and Honesty:*

We will need compassion and honesty more than ever in the future, says Polonen. He attributes this to our obligation to preserve our values, which will remind us that we are human in the face of machine algorithms. Lying is the biggest theft, as it is stealing the truthLiechanges it for his own benefit. Isn't it merciless to steal the truth?

A machine or algorithm cannot be merciful, and honesty is a necessary truth for a machine, says Polanen, and therefore only humans can possess the values of the future he describes in his book: Thus, human values need to be protected and preserved. Honesty will foster compassion, and compassion will feed and nurture honesty. Meeting the right people also plays an important role in the development of these values. However, we need to be careful regarding charlatans who want to exploit our compassion under in the name of empathy. Reinforcing the seeds of compassion and honesty in the family within social environments needs to be internalized by the individual.

12. *Moral Courage and Ethics:*

Moral courage is a necessary skill to improve the world. It leads us to dare to do the right thing. A person who adopts moral values as a guide has the courage to speak without fear. This courage can sometimes be limited by

the ideologies he/she is stuck in or by sanctions imposed by the dominant powers. Even if the morally courageous person cannot speak now, he/she will leave behind an heir who will speak out. A person's life is too short to solve some problems, but the ability to think ethically is one of the most important skills that will save the world. Today, moral courage is the same as ethical thinking, Polonen says. Decisions that affect millions cannot be left to the few who speak behind closed doors. It is precisely for this reason that decisions that will ease the burden of the world trying to transport 7,780,000,000 people and one hundred ninety-five sovereign states should be made primarily by people who take ethical concerns into account. The change needed for this will happen when people who are not responsible for a problem take a step toward solving the problem. People who can bravely defend unwritten rules without being crushed under bigotry, who are open to change, will possess one of the important skills of the future.

13. *Punishment Study, Love:*

Yes, we will learn about love, too, because only love makes us better people. Educating our hearts will be one of the most important skills of the future. Educated hearts can feel love, and depth. We can summarize this by saying that we love the created because of the creator. When Nothing is Certain, Anything Is Possible!

Curiosity, creativity, character, patience, critical thinking, ethics, trainable hearts, and depth, as I explained above, are the skills that Polonen thinks will be important in the world of the future. Polonen states that the skills that will warm us up and make us feel in the cold world of machines and algorithms will be extremely important. We need dialogue between generations. It is deeply significant for a twenty-six-year-old guru to highlight this. As the wheels of fortune keep turning, the wishes and needs of the young will soon guide the development of industry. We need young people here who really know what they want. What we can do is encourage the proper use of technology. Whatever we do, we must do it for humanity. We must not forget to train the hearts of the youth so that they focus on the correct values in their learning and become deeper individuals. Only then can they overcome their fears and dive into the unknown and achieve dreamlike results using technology.

I wanted to make a small contribution to HBR's Human Resources Summit with Polonen's book. I have added my own experiences and ideas in between. Please forgive me.

Reference

(1) Pölönen, P. (March 2021). Gelecegin Becerileri. Büyükada Yayincilik.

The Sustainable Success Model

Dr. Yilmaz Arguden, Pinar Ilgaz, Hakan Kilitcioglu, and Dr. Erkin Erimez prepared a nice, easy-to-understand management model, named it the Sustainable Success Model (SSM), registered it, and then published their model as a book.[1] If you ask me, I think it deserves a subtitle such as "Good Governance" or even "The Good Institutionalization 101 Handbook." I refer to this book here because it is the answer to the most asked question: "How did you become institutionalized?" The model described in 115 pages provides the answer to this question with plenty of examples. The first question is: why a company exists, what it does, and who is responsible for the profit/loss. I've summarized it under three headings:

1. A corporation is an institution with limited liability, aiming to make a profit for its shareholders. It is established as a legal entity. A corporation is a structure that ensures that the capital assigned by shareholders is allocated to the company's activities within the determined risk limits. In other words, the profit/loss of the company is evaluated separately from the individual. Since the profit/loss is subsequently shared among shareholders, the courage of the executives working in the company in decision-making increases.
2. The primary reason why people invest and innovate by taking risks, that is to say, the reason for the free attempt, is the expectation of making profits. But special attention is needed here. If the gains from the investment and innovations are considered only for the short term, companies may not reach their primary goal in the long run. Although they may achieve short-term success, they can "fail" in the long term.
3. The measure of success of an institution is to create value and benefit its stakeholders. Of course, the value must be a measurable permanent value that it adds to the institution. Creating value alone and delivering this value to stakeholders may not be sufficient to ensure success.

Later, the authors state, it will also be possible to create value by making effective use of intellectual people and relationships. In order for an institution to put forward an effective "value proposition," it must have a "competitive advantage." The authors emphasize that strategic processes should be carefully designed; it must be specified where they will differ from and resemble their competitors; resources must be used effectively and efficiently; and innovation and investment skills should be better than their competitors.

In this context, it is said that the ability to reach the resources that will ensure the sustainability of the solutions produced by the institution with the

right costs is the most important prerequisite for the long-term success of the institution. Of course, the defined success must be "measurable."

The concept of "governance" is extremely important in the authors' SSM. There are two headings under the concept of governance, direction and oversight. This definition is similar to Sir Adrian Cadbury's definition: "the system by which companies are directed and controlled."[2] Boards are the top bodies responsible for the governance of companies. Relationships in the board of directors are based on trust.

I think that all this applies even to nongovernmental organizations (NGOs) and all bureaucratic institutions. In its policies, ARGE encourages its consultants to aid in the development of society by working in NGOs one day a week in order to raise their intellectual capital, which is the common treasure of humanity, to produce innovative ideas, and to develop social and relationship capital.

I think this is valuable exemplary behavior. Because the education systems currently employed in our world are those established to meet the bureaucrat needs of empires a few centuries old, it is now obvious that this is not enough for our future and for the education of today's youth. This also applies to the company and to in-house communication methods and tools. For example, while writing emails in my own organization, I could not succeed in having others skip certain formalities (such as beginning with "Dear Sir" and ending with "Sincerely Yours"). Nowadays, everyone alleviates this problem by setting up WhatsApp groups anyway, but at the expense of fragmentary closed-circuit communication, is it worth it?

According to the SSM, the five key elements for success are *Vision*, *Approach*, *Learning*, *Unify*, and *Ecosystem*. The authors chose the initials of these five elements to form an acronym for the word "Value."

These five main elements have a subtitle. The authors state that the sustained success promised by the SSM can only be achieved when these twenty-five items are linked in the ecosystem (holistic perspective). All of the five main elements mentioned in this model conclude with a subtitle of "sharing experiences." The authors emphasize that it is very important to encourage open communication within the organization for sustainable success. Creating experiences and an environment of sharing opens the way for development and learning and increases the quality. This should be added to every element.

1. *Vision (Right Direction)*

According to the authors, in order for an organization to exist in the greater ecosystem, a "vision" (target) must be determined, one covering the stakeholders and ourselves, who have the potential to create sustainable value.

The subheadings for VISION include goal, mission, values, and a holistic and understandable corporate philosophy related to value creation, code of conduct, the determination of business processes by adhering to the vision and mission, the definition of The Business Model, and the Value to be Created, including the evaluation of the value and contribution created, instead of the business results as a result of activities.

The definition of the Governance Model, which will provide the formation of ethical leadership (gender, experience, expertise, structure, geographic diversity) and the quality and transparency of communication between employees, shareholders, board, management, and stakeholders, includes the definition of the ecosystem of stakeholders, which involves the determination of a rigorous and detailed approach from a holistic perspective, establishing a Business Model Relationship with Sustainable Development Goals (SDG) for people and the world to live in prosperity and peace.

2. Approach (Action)

After the correct strategy regarding the direction the institution needs to move toward is determined, the action plans should be detailed in order to move forward in this direction. The roadmap drawn in this context should be designed with a long-term and holistic perspective, in a structure that can add value and direct the corporate strategy, organizational structure, and business processes. The right business partners, following the trends closely, and developing effective communication with stakeholders are classified as important steps to be considered in the implementation of this component.

Subtitles of APPROACH are studying SWOT and PEST analyses meticulously; forming important inputs of the strategy with the decisions taken in parallel with senior management; and creating a strategy that will create value in the short, medium, and long term, where the "materiality matrix" is defined as a critical concept in the strategy created, only the internal organization not relationship between departments; establishing an organizational structure that will also consider relations with subsidiaries, collaborations, and stakeholders; setting up and operating a process hierarchy that provides improvement in important performance metrics such as speed, quality, and cost management; examining resource management in a sustainable manner to gain the ability to see the whole picture, focusing only on financial resources; employing resource management to prevent non-financial titles from being overlooked; improving the reporting quality to analyze performance under the right indicators; removing the scope of integrated reporting from the financial framework; moving from giving information about the past to a position that can shed light on the future; using Key Performance Indicators (KPI) and performance management; defining the reporting structure; covering the processes of constructing the resulting reports in a depth

that can affect the decision-making processes; and transforming the data into information.

3. *Learning*

According to the SSM, the basis of the development process is the understanding that "if you want your present to be different from the past, you must learn from the past", say the authors. In order to ensure development, it is important for the decision-makers of the institution to define where they are within the framework of the defined criteria, taking into account internal and external audits, and continuing to progress by adhering to the strategy created within the scope of the right direction they have drawn, in order to make the success sustainable.

Subheadings of development are the following: resulting performance included as stakeholders comprise measuring the right metrics operational performance and Measuring Perception QOL; certain intervals, subject to inspection while maintaining governance processes right and wrong action are not taken on releasing a good evaluation of the performance of the board of directors, which creates a learning environment; an internal and external audit, defined as "accountability" and "transparency"; reporting processes based on value creation; the conducting of reporting activities, which includes presenting them in a summary format, in a holistic and understandable way, by evaluating what we have learned in a critical structure; and evaluation and implementation of learning, which establishes a relationship with direction and action plans, covers the process of integrating the institution into business processes within a good setup, and is a critical factor in sustainable success according to the SSM.

4. *Unify*

The unification phase is the determination of the right direction, the use of action plans, and the development-oriented arrangement of all the outputs. The authors explain that it is the process of integrating the institution into the wide ecosystem in which it exists. According to the model, it may be possible to shape success in a sustainable structure thanks to this integration. "Where are we?"; "Where do we want to be?"; "What kind of value do we aim to create?" are the pertinent questions. It will be possible to complete the integration processes as a result of responding within the perspectives of time, impact, inputs and performance, and contributions to stakeholders and society.

Then there is the determination of resource needs and an understanding of the expectations of resource providers, which covers the processes of meeting these expectations by clarifying the expectations of stakeholders inside and outside the organization, as well as the substages of integration

by establishing a bridge between the past and the future of the institution. Additionally, it is important to expand the time perspective by providing the flow on this bridge and the strategic planning cycle in a way that paves the way for learning. Also critical are establishing a connection between strategy and learning; understanding the gaps between the institution's own and its perceived performance and then making an effort to close these gaps; and making the right direction, action, and development process a common communication language for the audience interacting with the institution. Focused Messages must be presented by considering the stakeholder management, which aims to support the quality and sustainability of these areas with business goals by establishing areas where all stakeholders can meet on common ground so as to create interaction and value.

5. *Ecosystem*

Considering the importance of the concepts of "interaction" and "dependency," being able to see and manage the whole picture is described by the authors as the last step that should be taken in order to develop the ecosystem and for the institution to achieve sustainable success. In the big picture, they say that it is of great importance to develop proactive strategies as well as reactive strategies by taking a holistic approach, including the institution, stakeholders, market area, and global trends.

Its subarticles are as follows: Defining the Stakeholder Interaction Area and Creating a Relationship Strategy, which includes the creation of a stakeholder map according to the level of stakeholder interaction and impact level, in order to understand the big picture of the SSM in this context by recognizing the perspectives and priorities of the stakeholders with whom they interact "constructively" in the management of the ecosystem in which the institution exists. It is also critical to determine the priorities of the stakeholders, which ensures sustainability by laying foundations and supporting "reliable" relationships; to improve and interpret the research processes in a quality manner; and to employ the Measurement and Management of Perceptions, which enables oversight of different interaction environments by making inferences about the researched subjects, and by customizing and prioritizing the outputs according to the influence levels and areas of the stakeholders in the system. Measuring and Management of Outputs, including the delivery of the product and resource planning, is part of this context, which is in line with the principles of governance and the actors in the ecosystem.

Communication of Goals and Results describes the presentation of the objectives in a framework that also plays a role in the process.

Next, the authors defend their model as follows: Companies need to meet their goals, that is, to achieve success, in order to continue to exist in the

ecosystem in which they are located. Achievements can soften the effects of some failures, and some failures can provide the basis for learning through effective reporting metrics. However, no success will be able to maintain its validity forever, and no institution will be able to strengthen its position in the ecosystem thanks to its failures. For this reason, in order to make "success" sustainable, it is necessary to build interconnected processes and to control these processes, and present them within a framework that covers the whole ecosystem in a correct communication plan. Then, sharing, developing, and repeating the experiences gained in the processes, together with the processes enumerated in the previous sentence, constitute the basic structure of the SSM.

The authors describe the SSM as having a linear structure; all aspects are intertwined with one another, constructed in a circular structure. They say sustainability, by definition, means a cycle on its own as such, and they say there is no endpoint to be reached. In order for the model to be adapted to business systems, decision-makers within the organization should be able to make sense of this cyclical structure. All twenty-five items under the five main components listed above are related to each other (each component also has a \+1 item, but this item is common to all: learning from experience, so I left them out). The authors conclude by saying that in order to achieve sustainable success, every step from the "Corporate Philosophy," which is the starting point of the model, to "Sharing Experiences, Investing in Intellectual Capital," which is the final point, should be given importance and the fine weaving of their relations with each other should be handled meticulously.

I have come across two metaphors in business management books. One is the metaphor of the machine – an operating style in which the gears of the enterprise work smoothly and achieve the desired result;[3] the other is the organism metaphor, that is, an operating style[4] that adapts the organization according to the changing environmental conditions from birth to death. Arguden et al.'s model seems more appropriate for the human organism metaphor, but frankly, I am for Sustainable Success. At every moment, our institutions must function like a machine and produce value, and necessary corrections must be made according to the changes in people, especially by adapting to the environment. In fact, sometimes existing paradigms must be destroyed, and new structures must be established. Just like our Yildiz Ventures...

With the combination of these two basic metaphors, both Yilmaz Arguden et al.'s SSM and our institutions work smoothly, and the value created by analyzing the environment is constantly increased together with the stakeholders. This is a convenient model, deserving congratulations.

References

(1) Arguden et al. (2021). *Sustainable Success Model*, Arge.

(2) Cadbury Report. (1992). Report of the committee of the on the financial aspects of corporate governance: The code of best practice. London: Gee Professional.

(3) https://www.acgme.org/globalassets/PDFs/Symposium/Suchman_Organizations-as-Machines.pdf.

(4) https://ivypanda.com/essays/metaphor-of-organization-as-organism/.

Turkish Economy at the Crossroads

In the enlightening book entitled *Turkish Economy at the Crossroads*, Turkish economists analyze the position of Turkey today.[1] I will attempt to summarize this book with various quotations from its Introduction. I am afraid this time you really must read this valuable book thoroughly if you engage in or intend to engage in any economic activity in Turkey. I give heartfelt thanks to the editors and the contributors to this book.

The editors of the book are Professor Asaf Savas Akat, currently at Istanbul Bilgi University, who is a well-known and highly respected Turkish economist with a distinguished career in academia, media, business, and public life, and Seyfettin Gursel, who is a professor of economics at Bahceschir University in Istanbul and the founding director of its Center for Economic and Social Research (BETAM), and adviser to Yildiz Holding.

The authors finalized the chapters of their book in December 2019, only months before the Covid-19 pandemic hit Turkey, along with the rest of the globe. By the time the book went into print in the summer of 2020, the world had become a radically different place compared to only a few months earlier. Yet, from Turkey's perspective, we believe that the themes and the analyses of the book remain just as relevant post-Covid-19, as they were pre-Covid-19. If anything, in fact, the pandemic has increased the urgency of the policy choices to be made in order to remedy the structural weaknesses and imbalances of the Turkish economy, and perhaps even to avoid another round of financial turmoil.

Contributors to the book are Sevket Pamuk, Daron Acemoglu, E. Murat Ucer, Izak Atiyas, Ozan Bakis, M. Ege Yazgan, Oner Guncavdi, Ayse Aylin Bayar, Gokce Uysal, Hande Paker, Selin Pelek, Cengiz Aktar, and Atilla Yesilada.

Turkey seemed to have made an irreversible choice since the 1980s by gradually adapting its institutions through a long series of reforms to the requirements of an open market economy with a high degree of integration into the global system, coupled with a pluralistic political regime. Progress rarely happens in a smooth straight line. Turkey also faced many accidents along the way: macroeconomic imbalances, financial crises, political instability, internal strife, and so on. Nevertheless, the overall orientation of Turkish society never wavered. Turkey's determination to reform was crowned in 1995 with a Customs Union agreement with the EU, thus inserting Turkey into the European single market. A decade later, in October 2005, the Justice and Development Party (AK Parti) and its incontestable leader, Recep Tayyip Erdoğan (currently president of Turkey), in power since November 2002,

gave the final push to Turkey's civilizational project by starting the formal accession negotiations with the EU for full membership. Unfortunately, it did not take long for little dark spots to spoil this rosy picture. Early signs, barely noticeable, appeared after the global financial crisis of 2008.

Erdogan was elected the first president of the new regime in June 2018. Less than two months later, in early August 2018, the Turkish lira (TL) faced a massive sell-off in the global financial markets, shedding over 30% of its value in just a few days, the worst ever. It was a devastating shock to the economy. The steep fall in consumption and investment spending hit hard on domestic demand, imports, and the production of non-tradable activities. The limited increase in exports could not make up for the fall in demand; therefore, output fell for two consecutive quarters, the official definition of recession, and unemployment reached record levels.

At this point, a few words are warranted about the natural environment. Turkey's vast landmass is not endowed generously with natural resources. Overall, we can confidently claim Turkey to be a resource-poor country. Anatolia is a high, mountainous, and arid plateau where fertile agricultural land is limited to coastal areas. Production barely meets domestic needs; the exportable agricultural surplus is negligible. Of greater significance, Turkey has no reserves of fossil fuels worth mentioning, which is a geological puzzle in terms of its location (its eastern neighbors, Iran, Iraq, Syria, and Azerbaijan, are major oil/gas producers). It also lacks large deposits of essential minerals for commercialization. This resource base has critical implications. First, Turkey did not have the sizable natural resource surpluses to finance the early phases of industrialization. Second, for resource-poor countries, economic growth and development necessitate, by definition, ever-larger trade deficits in primary commodities (energy, raw materials).

The range of topics covered in *Turkish Economy at the Crossroads* are:

The first chapter, "Economic Policies, Institutional Change, and Economic Growth since 1980," which examines the evolution of the new economic policies and institutions after 1980.

The second chapter, "High-Quality Versus Low-Quality Growth in Turkey: Causes and Consequences," which covers the relations between institutional development and the quality and sustainability of Turkey's growth in the long run from a comparative perspective.

The third chapter, "Productivity, Reallocation, and Structural Change: An Assessment," which supports and complements the analysis of the second chapter by further elaborating on the technical issues of measuring productivity.

The fourth chapter, "Financial Cycles of the Turkish Economy: How Will It End This Time?" which focuses on a crucial aspect of the modern

economies, namely the identification and analysis of the financial cycles in Turkey, especially in the last two decades.

The fifth chapter, titled "Structural Transformation and Income Distribution in Turkey," which focuses on two critical challenges of Turkey's economy not covered in the previous chapters, namely the transformation of the economic structure and its impact on the distribution of income.

The sixth chapter, "Labor Market Challenges in Turkey," completes the macroeconomic and structural analyses of the preceding chapters by examining Turkey's labor market.

The seventh chapter, "European Union and Turkey: Why It Failed? What Is Next?," is a concise and analytical history of Turkey's difficult relations with the EU.

The eighth and final chapter, "Turkey's Development Conundrum: Three Scenarios for the Next 10 Years," is a courageous effort to predict how Turkey will evolve in the next ten years from the perspective of economic and societal development, in line with the major themes of this book.

The problem in Turkey is not as simple as interest rates going up or down a couple of percentage points. It may be having a negative interest rate. However, mainly it is the independence of the decision-making power of monetary institutions, which wipes away the trust of people.

In democracies, even one-third of the votes can determine who rules. So, that is why the constitutional institutions and independent economic bodies such as Central Bank, Anti-Trust, and so forth, are established to maintain the sustainability of the system in the long term. I don't even mention "checks and balances."

Today, the administrative system in Turkey must guarantee to the people and economic actors that the constitutional and decision-making system is independent of mortals and their decision-making, and that commonsense is in power. Otherwise, with our never-ending negotiations over the system and the constitution, there will be no peace. I mean "no peace" in the sense of uncertainty leading people to hesitate to invest, produce more, and export more for the welfare of the country. However, the solution offered for crises in the system today assumes a fast reaction, six months, on the part of people regarding investing in the country to create more jobs and eventually to export more, import less, leading to a "no deficit" level. Six months is short, but it would be wise to try it and, if no progress is seen, switch back to conventional economic methods.

In recent Turkish history, the seventies, during Suleyman Demirel's (RIP) era, import substitution and investing for increasing domestic production in the times of energy crises lead to hyperinflation. This real-life experience is proof of the effect of external and given global factors at any particular time.

So, during the pandemic, global supply chain crises, and worldwide inflation in prices, especially in energy, the global pressure on the Turkish economy is not promising. For more exports to the EU and the USA, Turkey is not in the best mood to pursue diplomacy, and its neighbors are on fire.

Reference

(1) Akat, A. S., and Gursel, S. (eds.) (2020). *Turkish Economy at the Crossroads: Facing the Challenges Ahead*, World Scientific Publishing Company.

How Will a Four-Day Work Week Come into Place? For Whom Will It Be Applicable?

When Tim Ferriss wrote his personal development book, *The 4-Hour Work Week*,[1] in 2008, it attracted a lot of attention, remained on the bestseller list for a long time, and was translated into Turkish by Inkilap. Of course, Ferriss wasn't talking about a "4-hour week" in the context of today's demands for working shorter hours. He was mostly talking about how we can make ourselves rich and have a different lifestyle by leaving the mundane jobs we do and focusing on the ones we are good at. (Meanwhile, Ferriss currently makes a living by selling a nutritional supplement under the brand name BrainQuicken, which he claims strengthens the brain.) Subsequently, in 2011, Kathi Weeks, in her book *The Problem with Work: Feminism, Marxism, Antiwork Politics, and Postwork Imaginaries*,[2] brought the legitimacy of working in a job up for discussion for the first time. Later, in 2018, Dennis Normak and Anders Fogh Jensen's book,[3] entitled *Pseudowork*, was published in Denmark. In this book, they argued that in Denmark and other global labor markets, people pretend to work by inventing jobs themselves, but they don't actually work, so the weekly working hours can be easily reduced to fifteen. Then, Pernille Garde Abildgaard's book *The Secret of the Four Day Week*[4] from Norway followed. In this book, Abildgaard stated that the weekly working time could be shortened based on Parkinson's Law, which says that "the job expands itself according to the time it needs to be completed," meaning that "the job takes as long as the time you have to complete it, and for this, time management techniques such as Pomodoro, Slack, and information sharing technologies such as Yammer, virtual assistants, and project management programs such as asana can be used."[4] He gives examples from companies that lead the practice of work four days a week, with examples from Sweden, Denmark, England, New Zealand, Australia, Netherlands, the USA, and the UK. He examines in detail the preparations for how Richard Branson's Virgin Group and its advertising agency, Mix, switched to working four days a week in England.

Finally, Kyle Lewis and Will Stronge's book, *Overtime: Why We Need a Shorter Working Week*, was published by Verso publishing house, a representative of the "new left" movement.[5] This book has also been translated into Turkish. I would like to focus on this book here, as it clearly summarizes the extent of the issue and the mindset that has developed. In 1856, stone workers marched in Australia, thinking that it was time to apply the eight-hour-a-day working system to the construction industry, and this victory was celebrated for ninety-five years and eventually became concurrent with

Labor Day celebrations. *Overtime* begins with this story and says that the example of the stone workers teaches us at least two things:

1. Freedom from the hardships of work is only given to us when this liberation is demanded and fought for.
2. Reducing the amount of time we work is an aspiration of working people, no matter what form of employment or which era of capitalism.

The book, which is written from this point of view, draws attention to the fact that all these and similar things, such as being heard, spending time with our loved ones, engaging in independent activities, and being free from attachment to a boss, and a job, are essential for being human, whether in the time of the stone workers or now, and it ultimately equates time with life.

Stating that this struggle to reduce the time spent at work is once again on the political agenda, Lewis and Stronge's book touches on the political initiatives that took place long before the Covid-19 pandemic, which caused mass unemployment, and the fact that the world, in general, has now started to adopt shorter working weeks without reducing wages. Moreover, it points to the fact that this is now not a marginal campaign; rather, it is at the center of a renewal that has taken place in socialist politics over the past decade. I wonder if the promise of socialism after the collapse of communism was stuck on this detail. I don't think so. In addition, who would pay for the increased labor costs and the high prices?

Stating that work is the main factor in our lives, as a factor that affects our entire lives, the authors emphasize that the momentum of the campaigns for a shorter work week has emerged in the context of a discredited labor market and that the term "earning a living" has passed. They also cite research demonstrating that a higher capital share accompanied by a lower labor share is linked to higher inequality in the distribution of personal income.

In their book, Lewis and Stronge discuss the similarities between a report written by Professor Philip Alston on behalf of the UN in 2018 and Friedrich Engels' work dated 1845, which deals with the situation of the working class in England, and they state that the introduction of universal lending and aid payments constitutes a concrete example of the approach taken nowadays. According to the authors, without significant collective organization and political regulation, the labor market fails to provide a strong mechanism for economic security and freedom for all. Yes, they are correct: the aim of a person is not to earn a living but to be a good person. But again, what a man earns by his own effort is sacred to that man. Presumably, it is not meant that people should receive unconditional money from the state under the name of salary, under the guise of assurance, as is the case in some city-states in the Gulf countries. The "assurance" must be for a certain period

of time when it is needed. Otherwise, it is open to the exploitation of the unemployed and refugees, as in the West.

Lewis and Stronge propose that a shorter work week in and of itself is not only an intervention to work but also a green policy, providing a basis for the rapid decarbonization of our economies by working less and having an impact in other areas as well. They also say that paid or unpaid domestic, womanized labor is often a feminist issue. I cannot resolve this relationship.

Emphasizing how shortening the working week will have a multifaceted beneficial effect on societies throughout the book, the authors give an example from history while conveying their thoughts in detail. They mention that the Manifesto, one of the culminations of the struggle of the British labor movement in 1912, in which views on the future development of the mining industry as a combination of Marxism and Syndicalism are included, was, in fact, a demand for a future where we would never be forced to work for wages instead of simply calling for better jobs.

Noting that the struggle for leisure time has accompanied capitalism since its birth nearly four centuries ago, the authors repeat the idea that "time is freedom" as found in other books. According to them, the daily work is what we have to do to survive. For example, obligations such as eating and resting are related to the use of free time, and ultimately this is the time that is important to us. In contrast, in capitalism, time is expressed as money and is a production expense for profit-oriented businesses. For this reason, the authors point out that Marx saw this dimension of time as a reflection of different sets of interests belonging to related parties, and the main issue is that we need free time to enjoy the life we work for, but it competes with the time necessary for working as the bosses demand. Yes, we all have to struggle with how to spend our time, which is a numbered day. The use of our time, then, should be of significant benefit to society.

Stating that Marx's critique of work ultimately stems from a concern for human freedom and the forms of oppression that modern society imposes on the individual, and that Marx speaks of the concept of the "free laborer" to reflect the dual character of being an employee, the authors state that employment is fundamentally against individual freedom. They underline that it means leasing ourselves to someone else or a company for a certain amount of time, because the vast majority of people need a job to survive, and when they don't have a job, they are only free to starve! This is an undesirable situation, and capitalism cannot be excused for supporting it.

Noting that many social theorists pay attention to the workplace, which Marx defines as a "hidden abode," *Overtime* continues and includes the views of the political philosopher Elizabeth Anderson on the parallelism between public administration as practiced by states and business life as practiced by company executives. They note Anderson's question, "why

should we take it for granted when it comes to our employer when the private aspects of our lives are not allowed to be controlled in an undemocratic and detailed manner by the state?.(5)" Then, they come to the following conclusion: As in the nineteenth century, time is money in capitalism today, our freedom is precious, and the conflict between our leisure time and that of the employer is not over. The sharing of individual life data is now regulated in all societies. In any case, the desired results cannot be obtained from personalized marketing because it is both expensive and ineffective. No one can deny that the workplace is a "hidden abode." Workplaces and coworkers are now just like school or military friendships. As we experienced while working from home during the Covid-19 pandemic, the rapid and widespread communication, the increase in social life activities, and the fact that these are accessible have shown that the place of workplaces and coworkers in our lives is undeniable. Otherwise, I would not have preferred to slumber in coffee corners like the unemployed. Many activities that bring spiritual satisfaction to people can now originate from the workplace.

Further on, Lewis and Stronge convey their thoughts about work by explaining what they wish to emphasize through examining one of John Maynard Keynes' most memorable and frequently quoted essays, "Economic Possibilities for Our Grandchildren" (1930). According to them, from the point of view of Keynes, who was heavily influenced by ancient Greek ethics, a reexamination is required of the issue of the purpose of economic activity, as well as lifestyle or business forms suitable for art, architecture, sports, education, and other pursuits that people would like to pursue in their own good life imaginings. Keynes predicted that, thanks to ongoing development, fewer and fewer working hours would be required to produce the products we need to satisfy human needs, and that there would be a reduction in weekly working hours. However, the main question raised by the authors is why the reduction predicted by Keynes never materialized. Suggesting that Keynes' mistake was to underestimate economic rationality, the authors express in detail their thoughts on how potential salvation should be attained through a reinterpretation of Sigmund Freud's theory of civilization, with a summary by political philosopher Andre Gorz in his book *Capitalism, Socialism, Ecology*, and Herbert Marcuse's notion of suppression of desire and reduction of working hours. Did Keynes neglect to see that there is no limit to human ambition? So what do we do in our increased free time? How much will fun and laziness satisfy us? How will we be satisfied in this new life order according to our intellectual and social levels? First, education will have to be reshaped accordingly.

Stating that the vast majority of jobs and human skills under capitalism are only developed to the extent that they are beneficial to business, Lewis and Stronge state that even the widely accepted and constantly misinterpreted

father of economics, Adam Smith, was aware of what the division of labor and standardization do to us humans, and that Bertrand Russell's work was conducted in a way that reflects he was among the people who saw the great potential of a culture where forced labor is minimized.

They also emphasize that Georges Bataille said that what is actually devoid of real meaning is the modern idea of routine work.

The authors say that our priorities must be rebalanced; they believe in a shift from a work-centered society to a society where work competes with communal pleasure, the free expenditure of our bodily energies, and the discovery of hitherto unknown human faculties.

Stating that "the pressures of workplace domination and the results of the standardization of the labor process should make us think about what alternatives we would prefer instead of capitalism,"[5] the authors comprehensively discuss Kathi Weeks' work titled *The Problem of Work*, which is recognized as a breakthrough on this subject, based on socialist modernization and socialist humanism. "Working time reduction has to be part of the next economic system, and this is clear from the work that has been done in recent years, both in the UK and elsewhere, including the Covid pandemic."[5] Lewis and Stronge continue:

> Although we all live in a labor-obsessed world under capitalist economic conditions, we do not experience it equally. None of us are equal, but as women, some are more unequal than others, and many women have less free time in modern working life because there is a sexist division of labor in capitalism.
> Domestic roles all involve work, and the real problem is that this work is not taken into account, so it has no economic value.[5]

The authors ignore the characteristics of the work and cause–effect relationship while listing facts one after the other. Just as some jobs cannot be handled from afar, some people have the ambition to work hard and earn a lot: *Übung macht meister* (practice makes perfect)! For example, if we talk about doing housework, washing dishes, dusting, cleaning the bathroom, ironing, doing laundry, taking out the garbage removal, and caring for pets, these are endless cycles. How do we get rid of these tasks? Or do we spend our free time on these jobs and be happier? In fact, one hidden problem that we need to address is workaholism! Without a cure for this, it wouldn't be possible to make me and the team work less.

In the last years of the twentieth century, women, in large numbers, have been involved in business life in various fields. However, despite women's transition from unpaid workplaces to capitalist workplaces, gender norms still remain difficult to change. Women's equality movements have been successful, but women still remain predominantly caretakers and cleaners. These occupations have less job security. Rapidly aging societies will

continue to be more care oriented. However, the wages and conditions of the care workforce, which comprises mostly women, are still extremely inadequate. The reason why this is not a problem in our country is perhaps the low participation of women in the workforce.

As you can see, there are ongoing discussions, thoughts, and research on both the effective management of human resources and the political economy of employing people to reduce the weekly working hours. They say "water flows and finds its way." If these discussions turn into a "movement," the participants will find their way. I think we will find out soon: will working for a shorter amount of time a week remain a dream, or will it evolve into being, or has it has already come in the guise of working from home with the Covid-19 revolution? For now, we do not know. I am not afraid of the future, and I am in favor of trying everything. Frankly, I was against working from home before the pandemic. Now, I think hybrid working is very productive. If working four days a week proves to be productive, why not try it?

I can't help but mention this. I was a student trying to get a passing grade at school. I knew that the main thing was to learn the lessons that I would need in my life in the future. I would even get a certificate of appreciation when I worked for it. However, situations in life are not like that, and there is an obligation to be first, both for your personal career and for the success of your business. This is because anyone can pass in a class at school. However, the positions you can rise to in your career are usually limited to one or two people. If you are not first or second in your job, the survival of that job may be a problem. If we are to succeed now, our goal is not when and how much we will work but what and how we will achieve it.

References

(1) Ferriss, T. (2008). *4-Hour Work Week: Work Less, Earn More and Live Well!*, Revolution Bookstore.

(2) Weeks, K. (2014). *The Problem of Work: Feminism, Marxism, Anti-work Policy and Post-Work Imaginations*, Detail.

(3) Normak, D., and Jensen, A. F. (2018). *Pseudowork: How We Ended Up Being Busy Doing Nothing*, Gyldendal.

(4) Abildgaard, P. G. (2020). *The Secret of the Four Day Week*, Frylund.

(5) Lewis, K., and Stronge, W. (2021). *Overtime: Why We Need a Shorter Work Week*, Minotaur Book.

The Changing Consumer, Sales Channels, and a Goya in Seattle

Numerous studies show that the Covid-19 pandemic affected where, how, and what consumers buy, and more importantly, these behaviors became permanent. According to a global study conducted by Ipsos in 2021 with 25,885 people, 81% of consumers said that they had changed their shopping habits since the pandemic began, and 92% said they would continue their new habits in the future. For example, in the tourism sector, room cleaning has become an undesirable feature as a result of Covid-19. Presently tourism has slowly started to return to normal, but consumers still maintain the habits they acquired during the pandemic. The Hilton hotel chain announced that room cleaning service will be provided on demand only and will only be done automatically after the fifth day.[1]

The Covid-19 pandemic has affected where consumers buy due to the reality that consumers became home-centered, turned to online shopping, then began to learn how to combine physical and online channels in and out of quarantine. This led companies to organize to make holistic sales in the omnichannel, that is, online, physical, and social media channels. Some were caught off guard, while others pushed their future plans ahead and adapted quickly. There is no life for a company that does not adopt an omnichannel sales strategy in almost every category. In the past, multichannel and omnichannel were the same thing, but as the mobile channel structure became more widespread, applications and literature began to separate multichannel and omnichannel structures.[2]

Multichannel management means creating consumer value with different marketing mix strategies specific to each channel by integrating all existing channels, including mobile, so as to acquire, retain, and develop consumers. In omnichannel, in contrast, all channels are managed as a single channel, and this means applying a single marketing mix integration strategy, especially a mobile channel-centered one. Multichannel and omnichannel strategies can differ in detail, with the main principles being the same for manufacturers and retailers marketing single or multiple brands.

Multichannel and omnichannel management primarily depends on managers understanding the logic of holistic channel management, observing how the investment made on one channel affects the other channel, and making the right decisions accordingly. For example, the trick is knowing how a different price or a discount campaign applied in one channel affects the other channel.[3] On the other hand, rather than a "one size fit all" approach

in the supply chain, other tricks seem to be, to produce solutions suitable for the target audience and cooperate with business partners.[4]

In any case, omnichannel and multichannel strategies should not be confused with each other. For example, Apple today works not only with the classic physical store system (brick and mortar) but also with both the physical store and the online store system (click and mortar). Apple stores are not like regular stores. Their aim is not to sell but to support the e-commerce channel where the majority of their sales are generated. In this way, Apple stores work as a contact point with the consumer and serve to convey the Apple experience. While Apple tries to increase the demand for its products with services such as Apple TV\+ and Apple News\+, it offers the same experience with its consistent communication across all channels. Although Apple displays a holistic image in communication. You cannot talk about a holistic sales strategy when you consider the places where you can buy Apple products. Therefore, it can be said that it uses a multichannel strategy rather than an omni strategy.[3]

For a brand that implements the omnichannel strategy, you can complete your shopping journey that starts in the mobile app, in the physical store, or it could be the opposite. Apple, in contrast, does not prefer this approach because it might lose sales, and it is doing the right thing. The key is to maximize sales sustainably. For this reason, it should not be a routine decision to apply multichannel management or omnichannel management to your retail brand or a manufacturer's brand. Like Apple, this decision should be made by considering forecasts, competitive costs, stocking opportunities, and information flow, in other words, all market conditions.[5]

The important point here is that omnichannel shopping is growing rapidly all over the world, and smartphones are now directing shopping. People don't just look at the phone in their hands as a means of speaking or surfing social media. Now, the mobile phone has become the biggest shopping tool for them. Again, according to research by Ipsos, 56% of consumers globally say that checking the same products through online research while shopping at a physical store provides great purchase assurance.[1] What is more interesting is that in all these purchasing processes, consumers do not want to communicate with virtual sellers but with real people, even within the application.

More importantly, they were called opinion leaders, and then they became celebrities, and then they became influencers. Now, their new title is consumer curators. In other words, they became the ones who the consumers came across while surfing the web and social media, and who influenced them with their comments and directions. According to a global study by GFK in 2021, 47% of online shoppers shop influenced by videos, while 45% shop influenced by curators on social media.[1]

The Covid-19 pandemic affected how consumers shop because many went shopping with masks, wanted less contact with people, and wished to avoid crowds. Instead of paying with cash or a card, they preferred contactless payment.

The Covid-19 pandemic has influenced which products consumers buy because trust, protection, and family health have become more important. For this reason, the orientation toward brands and products that are considered safe has increased. Today, to stay in touch with consumers, it is necessary to know all their met and unmet needs. The consumer now wants more dominance, and it has become more difficult to obtain and retain consumers and maintain their trust and loyalty. Yes, consumers turned more toward e-commerce, but at the same time, they have turned to collecting information by researching on the internet and are even specialized in this subject. Of course, as the consumers' pursued research, with the help of "cookies," they began to be watched in more and more segmented categories, to receive more personalized messages, and to be exposed to more product recommendations. Yet, at the same time, consumers began to ask that their personal data be respected. This is a very important breaking point for brands that want to target using data. However, Google has announced that it would not allow third parties to collect "cookie" information beginning in 2023 so as to prevent those who do not understand this dilemma and to prevent bans that may be put in place by regulators in the future. While this may also create a monopolistic opportunity, it reveals that every company can now only market based on the data it collects, which will make personalization difficult, but traditional communication methods may gain importance again.[6] Of course, it is necessary to see the application and decide the application of this approach , but it is also known that programmatic work will be affected.

The developments I've attempted to explain above show how the Covid-19 pandemic has changed consumer behavior, how these behaviors have become permanent, and how this forces companies to act in the omnichannel. There are also developments related to digital shopping platforms, and the trends are very different here, demonstrating the necessity of knowing what companies should or should not do so as to maintain channel dominance. That's why I want to share my views on this subject.

A very interesting article entitled "Don't Let Platforms Commodify Your Business," by Andrei Hagiu and Julian Wright, appeared in the May–June 2021 issue of the *Harvard Business Review*. The researchers carried out this study with funding from the Singapore Ministry of Education and the State of Singapore. Wright made public in the article that he was a consultant to Facebook.[7]

The authors count Amazon, Alibaba, and the Apple App Store as global players, and they are called digital multisided platforms, or MSP (MP for

short). The authors emphasize that MSPs, or MPs make it much easier for sellers and even brands to reach new customers. As we all know, you can open your own store on these platforms as well as sell your own goods in stores through these systems.

Yet as thousands of companies, large and small, are now discovering, relying on selling through these platforms carries significant risks and a number of additional costs. The authors go on to observe that MPs use the dependence of the vendors to their advantage, sometimes unnoticed and sometimes by showing themselves. They increase their fees. They play with algorithms to make the price more important. They make it mandatory for sellers to advertise for continuous visibility in search results. They compete with sellers (brands) by imitating (PL) their products. They impose restrictions on the prices that sellers can set outside of their MP. They also change their rules and designs in ways that weaken sellers' relationships with their customers.

However, the writers say that everything is not over yet. They suggest four strategies for merchants to work on these platforms to their advantage:

1. They can invest by developing websites or apps directly with their own brands.
2. They can use these platforms as showrooms.
3. They can specialize, offer personalized offers, or make many different offers to one person.
4. They can conduct public relations and lobbying activities to reduce the power of the platforms.

An interesting article titled "Walmart vs. Amazon: The Battle to Dominate the Market Industry," by Alistair Gray and Dave Lee, was published in the *Financial Times* in May 2021.[8] In the article, the authors state that Amazon threatened the supermarket giant Walmart, which once changed the way Americans shop, by opening Amazon Fresh, or investing in brick and mortar, in Los Angeles in September 2020. This is said to be a complementary move after Amazon's 2017 acquisition of the Whole Foods chain. Since then, it has been emphasized that Amazon has opened more than twenty stores to strengthen its competition against Walmart.

On the other hand, according to the authors, Walmart senior management was convinced that changing consumer habits during the pandemic would be permanent and that Walmart needed a new business model for online grocery shopping that would increase its competitiveness and prioritize digital transformation efforts. That's why Walmart tells 90% of Americans that any Walmart store is only ten miles away and that if Walmart can improve the digitalization of grocery shopping, it could hinder Amazon's success in this industry. They then explain the difficulty of the job as follows:

However, convenience store delivery is mandatory for Walmart and Amazon in today's terms. The reason for this is that grocery baskets mostly contain low cost products, there is additional labor cost to collect products from the store, the transportation needs to be air-conditioned and the last mile costs of transportation, which means the cost of reaching the consumer from the warehouse shelf. Besides delivery, Amazon has one more thing to worry about, which is that the performance of its physical outlets is far behind its online sales. Here they need to reach a similar level to online sales by developing their business. Amazon is now preparing orders faster and is busy multiplying "Prime Now" points to deliver grocery items directly, in addition to the use of new technologies such as smart lock technology and Alexa assistant. For now Amazon's stores are too few and scattered to have a transformative competitive effect on Walmart's business, but that will change if Amazon begins to have an impact with Whole Foods and Fresh stores in some geographies. The structural challenges facing both companies differ greatly from a technology and customer perspective.

The authors set different goals for Walmart and Amazon: For Walmart, the goal is to "digitize its existing store business to compete with an e-commerce giant that plans to develop by opening a high-tech physical store." For Amazon, the goal is "to compete with a giant chain store with the innovations it develops, while trying to increase the number of physical stores to support its grocery business."

Large investments are required both to achieve goals and to make the business sustainable. In this wrestling match, the one on top will be the winner. Will Amazon come out on top? I think it's too early to announce the winner. But if Amazon wins the match, what other developments can happen in the market? For example, retail platforms like Amazon, besides their sales and brokerage revenues, also create a huge "retail media" power and earn from advertising communication. Currently, it is estimated that the money spent on this retail media is 100 billion dollars, and it is stated that only Amazon's advertising cake will generate 26 billion dollars in 2021.[9] In other words, if Amazon wins over Walmart by becoming more dominant, who knows what the revenue it will earn from advertising alone will be.

While talking about Amazon, a memory came to my mind: in the spring of 2018, I went to Seattle with some senior executives of Yildiz Holding. Our aim was to GOYA (stands for Get out there, Observe Own It, You Provide Feedback, Achieve our Goals) for the Godiva Cafe project, which we parked at the side due to the pandemic. For this reason, while examining the new model Starbucks Reserve stores, I took the opportunity to visit the Google, Amazon, and Microsoft offices. Thankfully, I couldn't see anything different from our pladis and Yildiz Holding offices. The young, libertarian, individualist comfort approach was not different from the one in our offices. We have already made our head offices in Istanbul, London, and New York similar by following such trends.

Shortly before our visit to Seattle, Amazon made two major changes that are unprecedented in its history. The first one was Amazon Go – Amazon opened a store without cashiers and clerks, completely based on beacon infrastructure technology. I was amazed. It was interesting, but I found that it couldn't replace the existing brick and mortar. The second development was Amazon's acquisition of Whole Foods in 2017.

During my visit to Amazon, I met face-to-face with Jeff Bezos' close colleague, Amazon's strategist, for twenty-five years. "Why are you investing in brick and mortar? Is this a comeback from digital?" I asked. The answer I got was: "Jeff must have a reason!" Frankly, it seemed strange to me. At the time, I thought Bezos had to believe in classic physical stores and their power, because although it seems to have some advantages due to e-commerce digitality, it was not possible to provide the same efficiency and profitability as a physical store. Maybe that's why it was developing more quickly in oligopolistic markets.

E-commerce cannot be a profitable alternative for people's daily needs for food and hygiene. The focus and solutions of e-commerce companies must be different in order to include these "recession-proof categories." However, the ".com" extensions of the existing physical markets, which are actually seen as e-commerce, are, in fact, the "last mile" business of transportation logistics. This is also mentioned in the *Financial Times* article, which has been digitized (apprentice) is a unique solution. It should not be seen as an e-commerce application, but it will always be a complement to the physical market. It will be limited to a customer satisfaction model, because the demand for "economic crisis resistant categories" that are not efficient in e-commerce, that is, for the food and hygiene categories that every trader wants, cannot reach the demand level to meet the cost burden of global, e-commerce giants such as Amazon and Alibaba. In order for these categories to be sold profitably, it is necessary to create a larger order and consumer occasion. The *Financial Times* article I mentioned above examines this issue more broadly. For example, in order to ensure efficiency and profitability in e-commerce, "last mile" logistics are carried out by employees living in that region, and projects such as cost reduction are developed, but I see these as futile efforts.[10]

Now, it's time to have a company that aims to bring many global and local brands to the e-commerce ecosystem and introduce them to its customers, offers its customers "e-commerce-specific" products and solutions, and supports e-commerce. That company operates in the B2eB (Business to e-Business) sales channel in the fields of category management, marketing, promotion mechanisms, and customer services for brands/customers. In contrast, in the B2C (Business to Consumer) sales channel, this new company will reach millions of users through stores on MP platforms.

The greatest attraction of e-commerce for all manufacturers and brands in the market is that it looks like B2C sales. That is, it is perceived as "drop-shipping." However, this is a dangerous trend. The existing traditional value chain does not only enrich the business. At the same time, it makes it attractive and sometimes even makes the job come alive. For this reason, I find it more appropriate for traders to get rid of this deceptive temptation and return to reality, getting rid of the B2C charm and trading on the B2eB channel. In this way, you can list your products widely on the existing global giant e-commerce platforms. I believe that in terms of market penetration, it is more beneficial to have your goods in many independent stores within the platforms besides opening a store on these platforms yourself.

How will e-commerce solve the problem of basket size and shopping frequency? For example, regarding snacks, it will create occasional demand instead of impulsive demand! Special packages should be prepared for the occasion of rewarding, sharing, celebrating, and relaxing. It should be essential to be able to sell 10 lira products for ten evenings at once, not a 1 lira product every evening. If I made a 15 lira package, instead of selling it three times a week, let me sell it for 45 liras on one occasion. With this goal in mind, let me market it with products that will create synergies, such as snacks and fruits. Let me offer opportunity suggestions for stocking. Let me develop packaging suitable for secondary usage. I will even set up a subscription system if I can. Let me encourage larger orders with packaging that has a secondary use or a nostalgic meaning. Let's add a second meaning to the product by selling it together with promotional materials that will be perceived as a reward by the consumer. Thus, while offering new opportunities to the consumer on every occasion of their life, responding to their changing habits, we successfully implement multichannel marketing strategies by making product and presentation differentiation, and with algorithms, we prevent destructive price competition with the stores we've opened in MPs and prevent harming the perception of our brands in the eyes of consumers.

References

(1) Ipsos, "Industry Perspective: The Evolving Customer Experience," https://www.ipsos.com/en

(2) Verhoef, P. V. et al. (2015). "From Multi-channel Retailing to Omni-Channel Retailing," *Journal of Retailing*, 91(2), pp. 174–185.

(3) Shankar, V., and Tarun, K. (2020). "Omnichannel Marketing: Are Cross-channel Effects Symmetric," *International Journal of Research in Marketing*, 38(2), pp. 290–310.

(4) Graf, C. et al. (2021). "Into the Fast Lane: How to Master the Omnichannel Supply Chain," McKinsey.com, July 19, https://www.mckinsey.com/industries/retail/our-insights/into-the-fast-lane-how-to-master-the-omnichannel-supply-chain.

(5) "5 Examples of Brands with Great Multi-channel Marketing Strategies," Nexcess, https://www.nexcess.net/woocommerce-resource/channel-strategy/.

(6) Boiten, E. (2019). "Google's Scrapping Third-party Cookies – But Invasive Targeted Advertising Will Live On," The Conversation, Mar. 9, https://theconversation.com/googles-scrapping-third-party-cookies-but-invasive-targeted-advertising-will-live-on-156530.

(7) Hagiu, A., and Wright, J. (2021). "Don't Let Platforms Commoditize Your Business," *HBR*, May–June, https://hbr.org/2021/05/dont-let-platforms-commoditize-your-business.

(8) https://www.ft.com/content/9ab41b9e-a294-430f-951d-49cfc3415460.

(9) Weiner, L. et al. (2021). "The 100 Billion Media Opportunity for Retailers," BCG, May 19, https://www.bcg.com/publications/2021/how-to-compete-in-retail-media.

(10) Hai, H. B. et al. (2021). "Who Is Interested in a Crowdsourced Last Mile? A Segmentation of Attitudinal Profiles," *Travel Behavior and Society,* 22, pp. 22–31.

A Digital Leader Is Very Different from Other Leaders!

In this chapter, I would like to summarize the famous management consultant Ram Charan's book *Rethinking Competitive Advantage: New Rules for the Digital Age*, published in April 2021.

"Why and how did the dozen or so digital giants such as Amazon, Facebook, Google, and Alibaba grow so big so quickly? Will their dominance continue? Do other companies have a chance competing against them?"[1] Introducing such questions, the author expresses that he will answer these questions, sharing the following information: These digital giants have permanently changed the consumer experience, and the way employees do business. More opportunities, lower prices, instant access to information – all of these are the current, common expectations for consumers as well as corporate buyers. Additionally, they are all digital technology-driven, especially in the use of algorithms. Algorithms (the mathematical rules by which data is processed) have always existed. When computers were able to process data fast, and at a low cost, Amazon's Jeff Bezos, Facebook's Mark Zuckerberg, and Google's Larry Page and Sergey Brin were able to use computers to solve a vast array of problems. But how and why did they succeed? And how did they disrupt the existing order? Ram Charan was curious about this and began researching the subject.

Creating competitive advantage in the digital age is different, says Charan. A competitive advantage in the digital age is the ability to be the repeatedly preferred choice of the consumer with continuous innovations for the consumer and to create tremendous value in the business.

Competitive advantage includes how a company perceives the consumer experience, selects its leaders, and organizes the work, and how it accesses its ecosystem, as well as data and finance.

The author summarizes the two aims of the book as follows:

> To completely explain the sources of a digital giant's formidable competitive advantage and to help other companies see a path to building theirs. From my observations of digital companies, I have identified a set of new rules for creating a competitive advantage. These new rules explain what *any company*– whether it is a digital giant or a traditional company – must do to prosper in this digital age. For legacy companies that are becoming digital, this book will point out the pieces that leaders often miss when they focus on technology alone.[1]

Charan continues, saying that the shock of the coronavirus pandemic was unexpected. However, he adds, even in an ordinary period, the question is whether other companies have a chance against today's digital giants. His

answer is a big yes. Amazon's star skyrocketed during the pandemic as it is a digital company. So did Walmart because it was ahead of many other classic retailers in digitizing its business.

However, no competitive advantage is sustainable unless it is maintained and developed after it has been gained. Tools are becoming more and more functional to gain a competitive advantage. Algorithms and expertise are available at a relatively low cost. Cash is the new measure of success, and funds continue to flow to companies that embrace it.

Knowing the new rules of competition will enhance your perspective and help you set a course in the complex and rapidly changing market.

Reference

(1) Charan, R. (April 2021). *Rethinking Competitive Advantage: New Rules for the Digital Age*. Penguin Random House.

Why Are the Digital Giants Winning?

"Imagining the existence of new digital platforms (market places) and revenue pools that can grow at an unprecedented rate is just one of the reasons why digitally-born companies have a competitive advantage,"[1] says Charan. He adds that thinking differently about how to make money and finance growth is second reason, and that using algorithm technology to improve decision-making by reorganizing business is the third. In our current competitive age, traditional companies need to understand what they are facing and learn how to create a competitive advantage from innate digital companies. Some fundamental differences in the way digital companies compete are now clear.

Charan, who reviewed Netflix, Amazon, Google, and Alibaba, summarizes some of their commonalities:

- They imagine a 100x market size growth that doesn't yet exist.
- At their core, they possess a digital platform.
- They possess an ecosystem that accelerates their growth.
- They gain cash and depend on exponential growth.
- They have decision-making mechanism designed for innovation and speed.
- They encourage the leaders in business to learn, reinvent, and execute.

Therefore, today's digital giants and start-ups are focusing heavily on the individual consumer experience and are forming new, large marketplaces. They are rapidly scaling up, collecting and combining data, and engaging relevant partners in their ecosystem. Their business models focus on gross cash margin, cash generation, and exponential growth. They receive massive cash engagements from venture capital (VC) and investors who understand and employ new financial models to finance their growth. Their leaders are extremely determined and committed, with employees who work toward a specific purpose and immediately focus on the next step. Speed, continuous innovation, and disciplined practice are the main reasons for their success.

It is impossible to disagree with the following view(s) of Charan: Consumer tastes and expectations will continue to change; companies must constantly monitor, improve, and redesign the latest consumer experience.

Established companies have the imitated resources, brands, customer base, talent pool, and data that digital start-ups envy. However, none of these are sufficient for competitive advantage in this day and age.

Ultimately, every company will encounter a digital competitor who plays the game by different rules.

A New World with New Rules

Traditional companies are now thinking twice about how they use digital technology, with some hiring chief digital officers and creating data analytics departments and consulting companies to guide them in digital transformation. Some are investing in their digital start-ups. Emphasizing that these companies need to determine how to allocate resources quickly enough to survive an unavoidable decline in the existing business, Charan gives the following information:

Successful classical businesses suffer from this competition in two ways. The first is, new digital competitors offer superior offers to their customers. The second is, traditional competitors cut prices to stay afloat, thus destroying the profitability of the entire industry.

The company looking for a way forward and out must start by understanding the new rules of competition. Charan lists the new competition rules of successful digital companies as follows:

1. The key to exponential growth is a personalized consumer experience.
2. Algorithms and data are essential weapons.
3. A company does not compete. It creates an ecosystem.
4. The financial measure is mostly cash generation.
5. People, through culture and work design, create a "social engine" that drives personalized innovation and implementation for each client.
6. Leaders constantly learn, imagine, and overcome obstacles to create change.

Charan presents the obstacles to progress under the following headings:

- An overreliance on outdated theories: Self-efficacy has a shelf life. Competence should be based on consumer contact experience. Traditional retailers have been late to adapt to the demands of the digital age.
- The psychology of incrementalism and short-term thinking: Chasing an annual bonus. Phrases such as "We are good this quarter" and "We beat our opponent in the last quarter." However, the CEO of Netflix is personally concerned about the number of subscribers and loyalty. He follows the KIPs (Key Performance Indicator) on a daily basis and takes the necessary actions, and he also focuses on long-term decisions.
- The blind spot when it comes to customers: Most business plans don't take into account the shelf life of competitive advantage. There is no clear definition of why consumers prefer them. They cannot predict future competition. Qualitative research is required to interpret the numbers in consumer research and to see the change.
- Acceptance of existing limitations: For digital giants, it isn't important what industry they are in. By focusing on the consumer, they concentrate

on the new consumer experience wherever they see an opportunity to do so and on trying to make the best of an end-to-end consumer experience.

This experience often touches more than one traditional industry. Amazon started with retail, but today it is a major player in logistics, cloud computing, and advertising.

- Belief in mass markets and segmentation: We must abandon this belief now. Personalized experience design and production at low cost through algorithms should now be applied to every product and service.

Advantages of Digital Company Leaders

Charan goes on to elaborate on the advantages of digital company leaders as follows:

1. *10×, 100×, 1,000× GROWTH IN THE MARKET:*

It is in the DNA of leaders of digital companies to seek business opportunities that will scale quickly and grow. They think that they can grow 10×, 100×, or even 1,000 times compared to the existing market.

One of the biggest advantages that leaders of digital-born companies have is their ability to imagine something that doesn't exist and how a consumer can take advantage of it. By leveraging algorithms, companies address the realities of the consumer experience and work out how to make it better.

Leaders at legacy companies have a hard time with "big picture" thinking. They settle for a reasonable incremental improvement, but it is wrong to accept this approach. One way to create a completely new marketplace is to build a new ECOSYSTEM by bringing together the necessary parts from existing sectors. The experience that a consumer wants to have requires seamlessly knitting together different activities without being noticed. Will the company be able to meet or even create a new need on the part of the consumer and keep the expectations alive by creating a new ecosystem? Can it satisfy all of them all the time?

2. *DIGITAL PLATFORMS ARE AT THE CENTER OF THE BUSINESS:*

Unless you put algorithms and data at the center of your business, you won't be able to create a personalized end-to-end experience for each individual. A digital platform in itself is not a permanent competitive advantage, but given the talent it adds to a company, not having a digital platform is a competitive disadvantage. Some classic business leaders misunderstand digital capacity building. They take it as a success for the company to use algorithms to improve some of its internal processes or create a separate online sales channel, which can provide cost advantages and retain some sales lost

by physical stores but that lag far behind the reach of digital giants. For example, Macy's and JCPenney set up online sales sites connected to their main business model to compete with Amazon in e-commerce, but they did not improve their logistics model or customer experience. As a result, their profits dwindled, and they had to close many stores.

The bottom line is this: Understanding the power of the digital platform that will be at the center of your business is as important as knowing supply chains and finance.

A digital platform is a set of algorithms that collect and analyze data. Each algorithm is a specific set of steps to solve a problem. It is a software version of what our brain does automatically. People store the raw data they get and engage in a series of decisions to make predictions.

In digital-born companies, data is at the heart of the business, says Charan. He therefore recommends that if you want to maintain a competitive advantage, you must ensure the data flow you need and make certain it is compliant with the facts of the business. What is important for the algorithm to make a decision or to support the decision of the managers, is the quality, reliability, and timing of the data.

He then continues with his suggestions: Difficulties in data collection can be overcome by asking some basic questions: (1) What kind of data do we need? (2) What kind of data do we have? (3) How much is enough? (4) Is it in the correct format?

Data acquisition is difficult for start-ups as they are just building their customer base. They can get data from third parties, but it is expensive. Legacy companies have a lot of data at their disposal. However, they are buried in silos, are poorly formatted, and are incomplete. Today, software vendors can take that data and turn it into a single piece of data for less than a million dollars.

The problem here is the laws regarding the protection of personal data, but more importantly, it is the loss of confidence as a result of abuse of consumer confidence. Today in many countries, how consumer data is stored, processed, and shared is under legal control.

Especially after the Facebook and Cambridge Analytica crises, digital giants face significant restrictions, but of course, they will continue their work, and there will always be those who control them.

3. ECOSYSTEMS THAT CREATE VALUE:

A company does not compete alone. Its ecosystem competes, says Charan. Are you worried that your company will be surpassed by a digital competitor? Think again. It's not the rival company that threatens you, and it's the ecosystem it creates. In the digital age, those who use digital technology for

the benefit of the consumer and have an ecosystem that allows more than one income stream have a competitive advantage.

The concept of an ecosystem is not new, of course. In its early days, Apple outstripped other mobile phones as it built and developed an ecosystem of software developers creating iPhone apps to meet every consumer niche and need. In the personal computer (PC) era, Intel allied with Microsoft and developed an ecosystem of manufacturers using Intel chips. Enabling their technologies to work together has helped all players grow. Intel currently uses an ecosystem of several thousand partners who install Microsoft products and services for corporate customers and build their customer base. These partners allow Microsoft to focus on building its core business, not doing other work. Apple is known for building an ecosystem of music producers around the iPod and an ecosystem of app developers around the iPhone. Therefore you can expect it to build another ecosystem around the Apple Watch. What you may not realize is how vast this ecosystem can be and how dedicated Apple is to creating it.

Managing an ecosystem requires a certain set of leadership skills. Few companies have this skilled manpower, and it is not readily available in this market.

4. *MONEY MAKING FOR DIGITALS:*

"Money-making is measured by big cash generation, not earnings per share. Funders understand the difference."[1] Digital-born companies can burn large sums of money in their early years in a high-speed race for customers, revenue growth, content, and reach. Their earnings per share, "the stock market's favorite metric," may be zero or negative for years, maybe even decades. Yet these companies are finding the capital they need because some investors know that the metric to make money in the digital age is different.

The success of digital giants lies in generating cash gross margins. This is what Charan calls the law of increasing returns. As digital companies grow, they increase their gross margins as a percentage. Gross profit is like the MRI of the company's monetization model. Jeff Bezos and Steve Jobs repeatedly emphasized that attention should always be on the cash-generated gross profit. At 39%, Apple's gross profit is the highest of the world's computer and cell phone manufacturers.

The intense focus of digital giants on why they use cash, where, how much, and for how long to invest reflects their business conduct. The amount of cash they want to spend can be a huge part of their income and cash gross margins. Even when they generate a lot of cash, they often turn to outside sources for additional financing. In addition, they immediately withdraw from unprofitable areas and turn to more promising areas in terms of generating cash. They spend their money on matters that are important to the

consumer. They use data to experiment, test, and analyze before investing their money.

The costs are initially different for a digital company. Money is spent on gaining customers through marketing and promotions, hiring software engineers to build and maintain their digital platform, collecting data, and improving the ecosystem. There is a major difference between digital-born companies and traditional companies in two areas: operating expenses and general administrative costs. Most companies have capital expenditures (capex), and they use metrics such as internal rate of return (IRR) and ROI to evaluate these expenditures. For a digital company, capex is similar to operational expenditure (opex). Permanent investments such as machinery and factories are not required to establish digital businesses. The costs of building the future are the fees paid to software developers and other experts, the money paid to external software and services, and the marketing investment to achieve scale. Expenditure on such things is written off as an expression of profit and loss, such as operating expenses. These expenses affect earnings per share (EPS), but increase cash by paying fewer taxes. Negative EPS may frighten some businesspeople, but digital business leaders know that growth requires better service, and better service requires more operational spending, says Charan. He adds: "But they also have to minimize their costs and bureaucracy. They must find and improve cost anomalies with algorithms. They should prevent wastage. The author notes that companies generally set a cost reduction target of 30–50%. Fewer organizational layers and less bureaucracy reduce costs in digital companies."[1]

HINTS
FOR LIFE

Charan uses the term "money-making" model rather than a business model. The monetization model explains how the various components of monetization work together, but what a business model is, is somewhat complicated. Yet as Charan explains it, the money-making model is simple, and concrete; revenue growth, gross margin, and positive cash flow are always linked to market realities.

5. TEAMS INSTEAD OF ORGANIZATIONAL LAYERS:

Thanks to the corporate culture, employees create a "social engine" that drives personalized innovation and implementation for their customers.

One of the greatest but least recognized competitive advantages that today's digital giants have over traditional players is a powerful *social engine* that fuels their exponential growth. This social engine, which includes the company's people, culture, and way of getting work done, has tremendous

energy and speed. It eliminates bureaucracy and achieves what many companies find so difficult, such as the ability to constantly adapt and innovate with their consumer. Social engines run on discipline while freeing people's imagination and simultaneously creating value for all customers, ecosystem partners, shareholders, and employees.

Emphasizing that success in digital companies depends on human quality, Charan states that the most important feature of digital platforms is that they so make real-time information transparent and accessible to other people that teams can correct themselves without the need for supervision. The comments he makes later about young people are noteworthy: "Young people want to take part in autonomous teams that take a job from beginning to end and undertake the implementation; the success of digital companies is here. Because young people want to feel responsible for their work they don't want to deal with bureaucratic approval mechanisms among countless layers. Social responsibility and sustainability are important for young people. Companies that are far from these are not attractive to talented young people."[1]

Coordination and control are age-old problems at large companies, Charan says. "But digital giants and even start-ups have shown that technology has come a long way in solving these problems. You could say that zero organization is required when technology makes information transparent to anyone with authority. Technology can make data transparent in real-time, but people still need to gather at the beginning of the day to put the pieces together. This is where agile management practices such as Scrum come into play. Like 15-minute walk in meetings."[1]

If there is a secret formula that makes the various components of a company's social engine even more powerful, such as the minimal organizational layers, integrated autonomous teams, transparency, and individual career opportunity, *it is simultaneous dialogue*, observes Charan.

So as Charan suggests, imagine an integrated team of experts whose natural inclinations are to learn, grow, and strive. They focus on a crystal-clear task they believe in and have specific performance metrics. Their work is not hindered by politics or bureaucracy and is assisted by a leader who clears the way. When this kind of social engine works well, it can accelerate the growth of a digital company.

6. *LEADERS WHO CREATE WHAT IS TO COME:*

Leaders constantly learn, imagine, and overcome obstacles to create the change that other companies must contend with. Leadership is essential to the success of a business.

We are now in a time where leaders are being tested against each other, and in ever-changing conditions. Charan makes a very important point in

this regard: Digital leaders have an advantage, not because they are younger and more tech-savvy, but because they are navigating a digital company on the inherently appropriate route in the digital age.

He states that a leader who matures in a stable business environment, especially one who is in a dominant company, may find it difficult to adapt to the dynamics that exist today. Charan explains the differences between digital company leaders and traditional company leaders: "The most significant difference I see in the leaders of digital companies versus the leaders of traditional or legacy companies have to do with cognition, skills, and psychological orientation."[1] What is particularly important is how these elements combine to connect big picture thinking with pragmatic issues such as the making of money, execution, and speed.

Today's fast-paced digital economy is not a good time for the timid. However, leaders who take bold steps without the necessary skills are also reckless. When leaders fail, it's often because they can't handle the challenges of the job. Misplaced resource allocation and failure to recruit and train required talent are common shortcomings in unsuccessful leaders.

Ecosystems will inevitably compete with each other. Leaders have to harmonize the whole organization and relationships, and share information without hesitation with eco-partners instead of acting alone as they may be accustomed to.

The aging of leadership is a fact. Many leaders in traditional companies have opted for "incremental growth" rather than focusing their cognitive skills on rapid and exponential growth. Many leaders have opted for price increases or acquisitions to increase their revenues rather than creating new market spaces. Many lack the technical skills and knowledge to survive in today's environment, or no longer have the desire to take risks.

There are approximately twenty digital giants in the world. When they first started their businesses, they had no competitors. But now they have to know how to grow, how to overcome the stress of earnings per share. Even those with very good money-making models grapple with the problems of regulation and how to overcome the constraints of their business culture. "I feel confident that a new generation of leaders will arise to meet the challenges of today's digital world because the necessary criteria are very clear, as long as we give them the chance to develop,"[1] says Charan. He probably means they will come from many different sources, as he emphasizes that organizations that understand digital leaders are different, will carefully select them and enable them to thrive. Companies that do this will gain a competitive advantage over those that don't.

"Most companies start not with a blank page but with some key benefits that can be adapted to the digital age. Integrating existing talent with digital technology and discarding those that are no longer useful can pave the way

for 10-fold growth,"[1] says Charan. "Retrain people, reorganize and build a new ecosystem. Humans make the change. New elements of competitive advantage emerge all the time, and the competitive landscape changes. This is what drives the progress of humanity and the improvement of our standard of living. You can be a part of it."[1]

Yes, it is a new world, with new rules, there are differences in digital leaders, and perhaps some of the terms you've just read are new: ecosystem, exponential growth, digital platform (market place), social engine, algorithms, even cash flow and gross profit! When you think about it, you might realize that there are not many new inventions when you compare them to your past work experience. Thoughts and behaviors that formed the basis of these new approaches were always present, but they were expressed differently. Because we were able to computerize business operations forty years ago, we will succeed in digitalization in any case. We need to learn to think algorithmically, just like we learned how to calculate with an "aristo" ruler, to type ten fingers, or to be computer programmers or systems analysts in my youth, and become familiar with coding today. The social engine is teamwork. It is necessary to be partners with young people.

When it comes to marketplaces, the Grand Bazaar (Kapalicarsi) in Istanbul is the best example of this, but the modern-day ones are digital! If your gross profit level is market equivalent or higher, trust that business; it will go on if you do things correctly. Nevertheless, net profit must be your target.

I always tell my team that I aspire to their dreams. In other words, there is no place in the market for those who do not dream about their job and duty and do not dream of growing exponentially. The ecosystem is a beautiful structure, but first, adopting a win-win attitude is a prerequisite. After that, it's like my motto: I earn money while selling goods rather than buying goods, and I prefer all dealers (suppliers) to prefer me when selling goods.

The real benefit of the Charan book, which I've summarized very briefly so far by eliminating examples, can only be fully appreciated after reading and digesting it.

Reference

(1) Charan, R. (April 2021). *Rethinking Competitive Advantage: New Rules for the Digital Age*. Crown/Archetype.

Risk Management in Foreign Partnerships

First, I started writing about negotiations, then I shared my views on working and doing business with people from foreign cultures. Here, I want to share some of my views on a similar issue: partnerships with foreigners.

If you are partnering with a foreigner, of course, different cultures come into play. However, before that, since it is a partnership, it is necessary to look at the basic dynamics that make up a partnership. There are many motivations to combine horizontal or vertical forces and partner with companies from the same sector. These endeavors include: launching new products and lead technology, developing disruptive innovations, reducing costs, increasing efficiency, strengthening sales and distribution, scaling up the supply chain, creating a logistics pool, reducing infrastructure costs, increasing penetration in retail, and getting help in parts of the business where profitable and production difficulties appear. Reasons for partnering can be for obtaining financing, opening up to new markets, improving cash flow, and so on.[1]

Once the partnership is formed, it has the following advantages for partners:[2] They share profits and risks. The skills and capabilities of every partner are available. A synergy occurs, and more balanced decisions are made. There is hope that this partnership will also provide friendship and emotional support amid challenging times. Business opportunities that couldn't be handled alone can be evaluated.

Yet also in partnerships, things may not always go as planned. Inevitable conflicts and unmet expectations are the greatest areas of concern. When any of these occur, the following types of malfunctions are encountered:[2] a battering of parties involved in intense emotional conflicts, reduced productivity among employees and partners, the wasting of time with non-work-related matters, a loss of income upon the termination of the partnership, and the additional costs of conflict and separation.

Whether you are getting married, establishing a law firm with someone, or partnering with a foreigner in a big business, a good partnership necessitates: that the parties must have a clear vision of the future; that they be open to change; that they be of the mindset and character to solve problems with a win-win logic; that they value interdependence, promise, and commitment; that they have trust in each other; and that they share information and give feedback. These are some of the most important features. Often between partners, a "black cat" appears because their vision of the future is not clear. If visions are not shared at the outset, or if one of the parties

changes the vision, a partnership will generally encounter difficulties because expectations will differ.[3]

If the partner is also a foreigner, things can get a little complicated.

At this point, two researchers who work at Hofstede's company, called Hofstede Insight (that is, the cultural researchers I mentioned previously), divided the cultures of the countries into seven clusters of societies with these shared mindsets: Competitor, Organizer, Connected, Reciprocator, Diplomat, Marathonian, and Craftsman, and explained the characteristics of each as follows:[4]

Competitor: Such cultures do not care about uncertainty and love to fight. This cluster includes the USA, Australia, New Zealand, and the UK. These cultures score high on the "individualism index" and view negotiation as a competition. They regard failure as part of the game, and do not believe any rules govern the negotiation. They can criticize their companies, including their bosses. They view their relationship with their firm as purely business and do not expect more from their company or employees. They respect your expectations in a competitive culture and are sincere in building trust. They want to know what drives you. Contribution to success is important.

Organizer: They believe in the importance of structured organizations and of following the rules. Organizer cultures value structure and everything that goes with it, but hierarchy does not govern them. Organizers respect their superiors according to their competencies. In organizer cultures, things are done methodically, step-by-step. No matter where you are in the corporate hierarchy in France, you can't get away with driving a small car, but in Germany, even low-level executives have to drive a good-sized German car. Top executives should drive a premium car. Organizers believe in an open and candid discussion of the issues at hand and in weighing the pros and cons of the various options for addressing them. They want to find the best option, and buy the best technology and the best service or products. Organizers believe in planning for tomorrow.

Connected: They believe in openness and expect you to believe it too. Connected cultures value individuality. They ignore hierarchy and accept people without worrying about their status. They believe in strong ties with others and seek consensus. They don't mind uncertainty, partly because they think long term. Connected cultures are democratic, but if you're not involved in the network of leads, it can be difficult to walk through the door, let alone into a partnership. It is important to take the time to build relationships in Denmark, Estonia, Finland, Iceland, Latvia, Lithuania, Netherlands, Norway, and Sweden. The search for a win-win solution is essential in all matters. People in connected communities

communicate openly and expect a partner to do the same. They can talk candidly about their company's weaknesses and goals, and they want to get inside information about your organization from you. They will want to know why they should cooperate with you.

Diplomat: These cultures value individual freedom and respect hierarchy. Diplomatic cultures, especially France and Belgium, accept hierarchy because they do not like public disagreements and prefer to make arrangements to avoid them. They are usually well-educated and humorous diplomats, but they are also quite aloof. In these cultures, it is necessary to act formally in meetings unless your potential partner asks you to be more comfortable. For example, if you speak English in France, make sure your speaking style matches your correspondent's style.

Reciprocator: People in these cultures interact through the exchange of favors. This culture likes certainty and does not appreciate the public airing of differences. Cultures of reciprocity operate based on the "I pat you on the back, and you pat me on the back" mentality. In cultures of reciprocity, partnership negotiations take a long time, and you may find that the process can go back and forth. This cluster includes many countries in the Middle East, South America, Latin America, Southeast Asia, and East and West Africa: Angola, Argentina, Bangladesh, Brazil, Bulgaria, Burkina Faso, Cape Verde, Chile, Colombia, Costa Rica, Ecuador, Egypt, El Salvador, Ethiopia, Ghana, Greece, Guatemala, Honduras, Iran, Iraq, Jordan, Kenya, Kuwait, Libya, Lebanon, Malawi, Mexico, Morocco, Mozambique, Nigeria, Pakistan, Panama, Peru, Portugal, Romania, Russia, Saudi Arabia, Senegal, Serbia, Sierra Leone, Slovakia, Slovenia, South Korea, Suriname, Syria, Taiwan, Tanzania, Thailand, Trinidad, Turkey, the United Arab Emirates (UAE), Uruguay, Venezuela, and Zambia.

Marathonian: They may hide their true goals. Marathonian cultures, like those in Asia, see bargaining or partnership issues as a permanent process. Individuals in such cultures honor those higher in the hierarchy. They want to get ahead, get praise from their peers, and earn financial rewards. They accept uncertainty as part of the game. Marathonians can hide their true goals from you. *Art of War*, attributed to General Sun Tzu from the sixth century BCE enjoys great popularity in China and around the world. He recommends using cheats to achieve your goals, among other things. To consolidate an agreement, you have to be patient and accept that negotiations can run in circles.

Craftsmen: They pay as much attention to details as a surgeon. Regarding craftsman societies, only Japan is in this category. They believe in meticulous attention to detail, even in mass production. The Japanese pride themselves on their dedication to aesthetics and detail. Focusing on the

relationship first, the craftsman sees the big picture and every little detail as important.

Our Yildiz Holding global experience encompasses nearly every country's culture. Although we first began with exports, we have undoubtedly achieved the greatest accumulation of know-how in the field of partnership with the joint ventures we have realized in our country. Our foreign partnerships have been a sort of preparation for us, at least at the thinking stage, in our opening to the world. With these partnerships, we may not have achieved all the advantages we had hoped for in technology and competition. Our partners found trust in us in the local market they wanted to be in. They proceeded with us based on our local experience and our strength in the market.

The global company we established under the name pladis in the biscuit and snack fields became the third-largest biscuit company in the world. Likewise, we are the largest food company in Turkey, England, the Middle East, and North Africa.

Although we were thinking of opening up to the world at the beginning of the 1990s and are even still dreaming of this today, our close target was to establish partnerships with foreigners in the strategic areas we deemed necessary. Today, conditions have changed for some categories; in this case, we have ongoing partnerships and those we have terminated. The contributions of each of them to our business, including the partnerships we have terminated, have been extremely meaningful.

In partnership with foreigners, the first offer is usually from the foreign side, and some have even wanted to buy us. We have always rejected this option. When they decided to invest in the field of food, the results of their research always pointed to us. Sometimes our strategy to partner with foreigners coincided with their offers. Our first foreign partner became Cerestar in 1993. Cerestar was the largest company in Europe in starch and glucose, owned by Begin Say, one of the largest producers of beet sugar. We partnered with them. Why is that?

The answer is, glucose production in Turkey seemed nonexistent; there was very little of it. Glucose is technically a necessary sugar. If there is no glucose, chewing gum, and chocolate coated and similar products become candied on the shelf. It was not available in Turkey and its price was higher than sugar, even on a dry matter basis. However, technically it should have been cheap, and after we invested, its price dropped. After that, other foreigners and locals invested in the same field. The market has since settled into a smooth course. Cargill is the company that engages in this business on a large scale in Turkey. Years after our partnership with Cerestar, Cargill acquired Cerestar. Cargill has a large-capacity factory in our country. Also, since Cargill bought Cerestar throughout the world, we are a fifty-fifty

shareholder in Pendik Nisasta Company in our country. So, in the end, we were rivals with Cargill, but we became inevitable partners.

Cargill makes the same product in its own factory, and we do the same in our partner factory. We both make good money. No problems arise. At Pendik Nisasta, we used to pay licenses to Cerestar for some production; however, we don't pay licenses anymore and the business has continued like this for years.

For the first time, however, I don't know if it's for the reasons I explained above. Rather, it seems that we couldn't match up with a partner. Let me explain why:

As mentioned above, in the 1980s the investment of a global company called CPC and a Vanikoy which is 100% local company in Turkey used to process corn and produce glucose. In the end, only Vanikoy (the Suleymangil family) survived and as a result, glucose was sold at exorbitant prices. The family had made a new investment to achieve capacity increase, but they were in a financial stalemate. We (Ülker) and Kent (Yakup Tahincioglu), its two largest customers, became partners of the company to continue the investment, because this vertical integration investment was essential in terms of cost and supply. But later, as a result of a family dispute, Vanikoy transferred their majority shares over to Cargill, which made it a very attractive offer to enter Turkey. At that time, Cargill (A. Blankenstein) told us that "We pay well, and I don't recommend you stay with us." I didn't understand. But just before the first Sugar Feast, they had made a hefty price increase in glucose. This put us all in a difficult position. Because orders had been taken before the holiday, prices were agreed. Already, due to such monopolistic attitudes, we had taken Cerestar as a partner and established Pendik Starch Industry Enterprise as a strategic business. We even received incentives as "strategic investment." It was the first comprehensive starch and derivatives manufacturing company in the country. However, we became a fifty-fifty partner with Cargill, which later bought Cerestar. Our strategic investment had become a fairy tale. Pendik remained an efficient and profitable but stale business, and our share was finally sold.

Another example of family company, Arcor, is an Argentinian company. It is a large chocolate confectionery company that is very successful, especially in Latin America. In Argentina, sugar is 250 dollars a ton, whereas in Turkey, it is 1,000 dollars. It is also not possible to import due to restrictions. Of course, we have to protect farming and the sugar beet farmers, but if we want competitive industry and employment growth, we must make agriculture competitive as well. If sugar becomes as expensive as it is in Turkey compared to the rest of the world, everything will go up because sugar is an ingredient in all food. Sugar is a source of energy. If you make

sugar expensive, you're doing a great disservice to low-income people who may be muscular and need more energy.

Returning to the subject of our partnerships, when we decided to make baby food, we brought in an expert from Nestlé. After establishing the baby food factory, Hero from Switzerland approached us and said, "Let's be partners." Thinking about the future, I accepted this proposal, and we formed a good partnership in the end. Our partnership no longer exists, and we only do sales and distribution, but we did a good job together. Then came Kellogg's of the USA in 2005, and we founded Kellogg's Med with them.

In 2009, we established the Continental Confectionery Company with Gumlink, one of the largest chewing gum companies in Europe, and started the production of chewing gum and confectionery with the latest technology. Today, the export of the factory in Corlu has exceeded the production for the domestic market. In 2010, we formed a joint venture agreement with the world spice leader McCormick. In the same year, we signed a partnership agreement with Eckes-Granini Group, the leading fruit juice producer in Europe, to establish a new company to operate in the fruit juice sector. Since we left some categories in our global journey, however, these several companies are no longer in our organization.

We also established a joint venture with SCA in personal care in 2011. In 2012, we established an agreement with Japanese Nissin on instant noodle production, and then later, we ended these partnerships due to our decision to focus on our main business.

As I said, we continued with some partnerships, and we ended them with others, and throughout all of it, we amassed quite a large amount of learned experience. The articles of association and general assembly minutes of these companies have been registered and have been announced over the years. There is information that researchers can benefit from on many issues such as company structure, working conditions, monitoring and control mechanisms, and so on. Of course, it is necessary to keep in mind the managers and lawyers who are experts in this subject.[5] Would I recommend a joint venture to young entrepreneurs who want to develop their own business and step into this world? Under certain conditions, I would say yes. They will benefit, and they have to decide for themselves whether the conditions are suitable or not after they investigate everything thoroughly. For example, it is necessary to remove joint ventures from being only in the domestic market. It is also important to consider which geographies other than Turkey will be included. I think the first stage should be close places, both geographically and culturally. I think it is necessary to extend joint ventures to the old borders of the Ottoman Empire. Sharing the financial risks, expanding the distribution network, and supplying power were very important in the joint ventures we established in Turkey. These three considerations immediately made partnerships possible.

In this context, it is critical to ask, "Why should we be together?" with your partners. You have to find the answer to this question. I believe that it is necessary to decide which joint ventures are strategic and which are opportunistic, today and in the future. What is the importance of joint ventures for Yildiz Holding's vision? What are the geographic and financial risks, and what are the advantages for the partners and for us? What should be the scope of joint ventures? Which categories should they cover? What should happen in the future? How should we combine them with our global strategies? After all, how much know-how and experience do we gain from these partnerships, and how will we benefit from these partnerships in the future?

It is useful to create a strategy by adding more questions to these, reviewing them, and determining the situation for each category, each joint venture, and each market. Then, we can conduct our relationship with a partner accordingly. In this way, it would be advantageous for both parties.

Young entrepreneurs need to make such inquiries for the future of their business. Based on my experience, I can say that there are certain difficulties in partnering with foreigners, the first being the aspect of long distance and the second the different corporate cultures that are shaped by the cultures of the specific countries involved as Competitor, Organizer, Connected, Reciprocator, Diplomat, Marathonian, and Craftsman. In joint venture companies, it is not only necessary to combine business but also to develop their corporate culture. Later, proximities and geographic distances require empathy. We can solve this problem by putting ourselves in the other person's shoes. When I look at Poland, I may say, "Poles and Hungarians are alike." When I look at history, I see the Austro-Hungarian Empire. Although the Austrians do not like the Germans, I know they like the same foods that the Germans also eat, and that Adolf Hitler was Austrian. This is how foreigners perceive us when they come to Turkey. We've all read history. What was in our history? There was the Ottoman Empire. Then, these are the places where our joint ventures will be easiest to establish. This is our goal. Why? Because every time I go there, they offer Turkish cuisine. What they describe is Ottoman cuisine. If you go to Greece, you order the same stuffing; if you go to Lebanon, you order the same stuffing; even if you go to Pakistan you order the same stuffing. It's a culture. What interests us is the culture of living of the people and the culture of food. If you say to the waiter, "bring me your favorite food," in a broad geography stretching as far as Tel Aviv, it is your favorite dish. We should not neglect development in this direction.

If you are going to enter into a joint venture, do not do it only for a partnership within Turkey. As I said, set your eyes on our old borders. If you say these markets are a bit risky, I would say, isn't a "venture" a part of an adventure anyway?

Of course, that is provided that you manage the risks correctly.

References

(1) Bamford, J. et al. (September- October 2020). "Joint Ventures and Partnership in a Downturn," *HBR*.

(2) Gage, D. (2004). *The Partnership Charter*, Basic Books.

(3) Larbie, J. and Townsend, H. (2013). *How to Make Partner and Still Have a Life*, KoganPage.

(4) Coene, J. and Jacobs, M. (2017). *Negotiate Like a Local*, Hofstede Insights.

(5) Relevant provisions in Turkish Commercial Code: https://kms.kaysis. gov.tr/Home/Kurum/24308261and Trade Registry Regulation https:// www.mevzuat.gov.tr/MevzuatMetin/21.5.20124093.pdf can be found in Turkish. For an Overview of the Industrialization Process in Turkey; Dogan, M. (2013). "An Overview of the Industrialization Process in Turkey," *Marmara Geography Journal*, 28, July (Also in Turkish).

How Much of a Role Did Executives Play in the Success and Decline of GE's Life?

Today, there isn't anyone in the world who hasn't heard of the brand General Electric (GE). I first noticed it in the 1970s when I saw it in neon lights on top of a building in Jeddah. The GE logo can be seen on everything, (-) including jet engines, ultrasound scanners, wind turbines, televisions, commercial loan agreements, clock radios, toasters, nuclear reactors, light bulbs, safety systems, silicon tubes, locomotives, washing machines, and so on. I witnessed this once again when I saw a transport truck with the GE logo on a highway in the Netherlands, and I was stunned. Were they doing ground shipment in Europe? However, since its establishment in 1892, GE has been more than just a company for Americans and the American government. Known as a good employer for hundreds of thousands of employees and a safe investment tool for its shareholders for decades, GE's trained technical workers have also become millionaires thanks to stock options. It was an elite training school for its executives and, for others, an enormous (one billion dollar) source of personal wealth (\+). GE has achieved something few companies can do, reaching the equivalent of government credit and trust source for the American society.

GE combines Thomas Edison's workshop with JP Morgan's financial strength to support the country's middle class, military, and economic power; it has an important place in modern American history. Yet, is all this still valid today? When I read the book *Lights Out: Pride, Delusion and the Fall of General Electric*, by *Wall Street Journal* reporters Thomas Gryta and Ted Mann, I realized our saying "Don't question what you are; instead, question what you will become" is very accurate. Consider that twenty-five years ago, GE shares were around one hundred dollars, and by 2017, they decreased to 7 dollars after the departure of the company's legendary CEO Jack Welch in 200, and his successor, Jeff Immelt, in 2017, and GE's market value declined by one hundred forty billion dollars. In 2000, the company was valued at six hundred billion dollars, and now it is not even considered one of the most valuable companies in the USA. *Lights Out* includes the events that culminated in this result and interpretation of what happened.

At the end of the book, the authors state that GE is still a conservative and very hierarchical company, not open to the outside, especially to journalistic inquiry (-). The book is based on six years of interviews conducted by the authors, comparing the information given during those interviews with official publicly available records. The names of those who did not want to be named have been changed. Frankly, I had doubts about the book when

I saw that the management style and actions of Welch, the famous CEO at the time, was portrayed as the cause of GE's failure; however, after reading Bill Gates' review titled "What Happened to GE?", I accepted this book as more reliable.

The book begins like this:

> The company is no longer the media's darling or an analyst favorite, its shares are no longer counted in the Dow Jones Industrial Average, and the once-generous dividend distributing company is nearly disappeared. A share of GE stock was once an essential component of the beginner investor's portfolio but is now perceived as a speculative stock…
>
> GE's fall was very rapid. Thousands of employees lost their jobs. The collapse of a company that taught generations of American businesses what it meant to manage well raises a major question, one that is still unanswered. Just how much of the success of the many other companies that have chased and emulated GE was real?[1]

GE carries the torch of legendary inventor Thomas Edison. However, Edison's relationship with GE was short lived. The father of the General Electric Company was JP Morgan, not Edison. Edison served on the company's board of directors for a short time. Edison sold his last GE shares a few years after the company's establishment to fund failed mining experiments and thus missed out on the company's rapid growth.

The first signs of trouble were barely visible when GE was experiencing its greatest, wildest successes, led by Welch, a hard-hitting Irishman from Massachusetts who was then regarded as the most extraordinary business executive of his generation.

The most influential CEO of the twenty-first century, Welch was an ambitious elementary school student who, after graduating from high school, went to the University of Massachusetts Amherst to study chemical engineering, earning master's and doctorate degrees in the same field from the University of Illinois. He was not interested in an academic career; he was determined to become famous and make money. In 1960, Welch was hired by the Plastics Division of the General Electric Company. Despite battling a stubborn stutter since childhood, he brought "machismo" (-) into the corporate world. For Welch, the world was divided between winners and others, and "challenging" was his normal behavior.

During two decades, as he climbed the corporate ladder of GE, Welch's genius leadership went unnoticed. Welch was not on the list of possible successors made by then-CEO Reginald Jones in the late 1970s. However, Jones was later impressed by Welch's strategic planning ability and by his not being a typical GE person, and thus, Welch was named the ninth chief executive officer in GE history. The book describes the initial situation as follows:

Welch was intent on eliminating bureaucracy in order to reduce excess costs. Welch was implementing and expounding the corporate philosophies that would define the 1980s and '90s and make him a corporate celebrity.

Welch's core mission was to attack complexity, ripping out layers of bureaucracy that had built up inside the company and making the massive company more nimble. Welch would do his best to kill anything that slowed GE down.

Strategy meetings and reviews in the pre-Welch years were structured, daylong affairs dominated by huge binders and projections for the next two decades, one GE executive recalled. Welch saw these as hopelessly lumbering exercises in a fast-changing economy that required constant updating, refining, and shifting the portfolio of businesses, products, and people. Executives like Jones had seen five-year plans for industrial businesses as conservative and essential planning tools, given the amount of investment required to develop new products and bring them to market. Welch called them bullshit.

Welch shunned the extensive planning and shrank the team. He pushed decision making down to the individual businesses but kept a sharp eye on the specifics of each operation. He pushed middle managers to stop writing long memos and to lose their thick planning books. "I don't want planning. I want plans," he would say. Welch's defenders said that he had an uncanny ability to marshal detailed information from deep within GE's business lines, even as he kept an eye on the larger forces that were changing the face of global business, like outsourcing, and trade policy, and the rise of Japan.

Executive teams were tasked with finding and removing layers of management. During one visit to the GE Aviation facility in Lynn, Massachusetts, Welch chatted with workers in the plant's boiler room. He learned that the boiler room operation was supervised by four layers of management, a shocking discovery. That was just the sort of complexity that Welch was determined to carve out of the company. He proselytized the new GE religion: every business should be either first or second among its competitors. (\+)[1]

Welch then sold large businesses that had been at the heart of GE's history. The era of GE selling televisions and toasters came to an end. Later, he purchased RCA Corporation, the owner of NBC, in 1986 for 6.5 billion dollars and entered into new areas with an aggressive form of profit seeking (-).

By 1985, Welch had spent more than eight billion dollars to overhaul factories that were older than five years, for robotics and automation (\+). He also had a hand in the financial services unit, then known as "GE Credit Corporation," a significant source of profit. By 1985, financial services accounted for one-sixth of GE's annual profits. GE's lending operation was as large as some of the largest financial services companies in the USA. At its peak, GE Capital generated more than half of GE's total profits. GE, which entered the financial sector, was criticized by analysts, economy reporters, and investment bloggers for the loans given to its own companies and an inability to calculate the risks. This troubled the next CEO, Jeff Immelt. The USA's most famous industrial corporation had become one of the largest

and most mysterious banks in the country. GE had begun to be perceived as a finance company instead of a giant industrial company and still could not improve its image despite all the communication and marketing strategies. Easy money in financial markets overshadowed manufacturing and sales success, and the stock price was depressed (-).

According to Welch and his associates, the proof of the success of their method was in the numbers. However, a price was paid for the victory, with a large number of employees losing their jobs.

Welch cut jobs and workers wherever possible, creating tension at a company that many workers assumed they would retire from. In the 1980s, he reduced more than one hundred thousand, or a quarter of the entire GE workforce, and moved tens of thousands of jobs overseas, where unions were absent and labor was cheap.

He also employed another famous and controversial tactic called "rank and yank." Welch would force managers to rank their employees' performance for that year, and the bottom 10% would be notified and let go if they did not improve. The constant pressure of this type of tactic increased employee tensions (-). Rank and yank worked well for GE's performance. However, after some managers and some competent employees entered the 10% themselves, they did not find it useful. It was getting harder and harder to be a team in a place where everyone was trying to beat each other (-). For example, a manager turned the system upside down by placing someone else in the bottom 10% to save another employee as a remedy. Welch argued that the company's competitive advantage depends on its workforce, and keeping performance at the same level is a never-ending struggle. For this reason, he made it a principle that his managers should be either first or second in the sector!

Welch was a good educator, a good "coach," but had he neglected the governance rules that would offer support while establishing corporate governance principles? Perhaps GE was now a very intricate, diverse, and complex institution (-).

From 1980 to 2000, while GE's earnings rose from 1.5 billion dollars to 12.7 billion dollars, its revenue increased more than fivefold to 129.9 billion dollars, and the stock price rose more than forty times. GE succeeded in a world where its peers couldn't survive. At GE, the most important thing was the stock price. CEOs and top executives also made money from their own GE shares when the company's stock rose. Of course, the next CEO, Jeff Immelt, knew that GE had achieved this success by doing some accounting tricks, and by focusing on managing the stock, and he followed the same path. The legally permitted buying/selling of its own stock was also one of GE's most common practices (-). Giant conglomerates like GE's historical

rival, Westinghouse Corporation, were disappearing, and others like AT&T were under siege by increased competition or government regulation.

While Immelt was advancing in his career in the GE Plastics Division in the late 1980s, he was looking for an opportunity for promotion.

As Japanese competition began to erode GE's dominant position in the white goods market, GE executives looked for a new part for their refrigerator compressors. With this new part, GE had replaced the traditional piston-driven unit with a revolving design that would reduce energy consumption and save customers money, as the imported models claimed to do, while also freeing up more space inside the refrigerator. This invention was a revolution, but after a while, the compressors started to fail. Their engineers said that two-thirds of the refrigerators they sold would fail within a year and a half. But who was going to tell this to Welch? Then they changed the numbers (-). The new graph of the fault data showed that the faults were not likely to reach critical mass until most refrigerators were out of warranty. But it didn't work. Discovering the problem, Welch fired his entire home appliance team (\+). Welch had an ambitious manager to fix the problem: Jeff Immelt. Immelt managed several hundred sales and marketers at GE Plastics. At Welch's behest, Immelt moved to Louisville, the site of GE's massive Appliance Park factories, and settled the matter. Immelt was in Welch's good books to be the next CEO. As a reward, Immelt was promoted to a new role running all the US operations at GE Plastics, a six billion dollar business.

Immelt graduated in 1978 with degrees in applied mathematics and economics. Like many beginner executives at the time, he went to work at consumer products giant Procter & Gamble, where he shared an office with future Microsoft CEO Steve Ballmer. Immelt's next stop was Harvard Business School, and after graduating in 1982, Immelt intended to follow in his father's footsteps and work for GE. It was a guaranteed choice. GE has provided a good and sustained career for its employees. The pay and benefits were so good that some workers called it "generous electricity." Unfortunately, when Immelt took over the Plastics operation, the previous management had not done the right things; they played with the numbers to pretend that they had met their targets. Now he was faced with a dilemma: if he wanted to stay at GE, he had to play by the rules (-). For a GE executive, the increase in sales and profit figures he was going to commit to achieving in the upcoming quarter or year was more important than financial projections.

There is no scientific rule for choosing the CEO of a company. In GE, the CEO also serves as a chairman, which results in having more influence over decisions. Bad decisions and faulty strategies can also be supported in such a corporate culture.

When the first plane hit the World Trade Center in 2001, it was clear that this event would hit GE hard as well. GE Insurance had a substantial share of drafts for the destroyed buildings. On the other hand, the first recession in the economy in ten years had started, and this was putting pressure on GE; the attacks would worsen the recession. Meanwhile, stocks were falling. This situation brought thousands of questions to mind. There were vexing questions as to whether GE stock was driven by creative accounting games rather than Welch's genius. Now it was up to Immelt to express such concerns. Like his predecessor, Immelt had demonstrated his ability to melt away criticism and unsolicited questions (-). Immelt quickly adapted to the club of a handful of mostly male CEOs who run the world's largest companies. He was able to manage crises without going into detail and sought success, using his team aggressively only to stretch GE's management goals and achieve higher goals (\+). That was GE's way.

Real estate purchases that had begun in the Welch era did not stop when Immelt took over (-). Managing financial results in this way was not Immelt's invention. GE executives were working to make sure earnings were growing on a nice, smooth trajectory at all times. Former CFO Dennis Dammerman, one of Welch's most important executives said, "We're a very complex, diverse company that no one from the outside looking in can reasonably be expected to understand in complete detail. We do not have one story for the investing world, we have a lot of diverse businesses, and when you put them all together, they produce consistent reliable earnings growth." (\+/-)[1]

For this to be achieved, performance targets and the method of reaching them were first determined. Inorganic growth through continuous acquisition was the source of increased earnings. GE could use the unusually high price/earnings ratio for an industrial company as a high-value currency to pay in other deals. By acquiring companies with a lower P/E ratio, GE was getting automatic earnings growth. Accounting principles were distorted to ensure the company would appear to have further profitability after these purchases (-). These principles were not, of course, only distorted by GE. One of the USA's largest companies, Enron, also resorted to similar tricks and was now exploding. GE was not an Enron, but it was not possible to say that it followed the principles of transparency. It was mysterious. GE was a black box with strong and consistent results. The company was pretending to have a stash of cash used to hide poor performance. While GE was not transparent to investors, it largely adhered to accounting and management principles in practice.

The world that Immelt thought he would lead GE into was turned upside down. The recession and the uncertainty that followed the terrorist attacks had dampened the global growth on which GE's industrial businesses depended, and there were changes in accounting rules in the wake of the

Enron scandal. The company's current balance sheet at GE Capital was supposed to convince investors that GE was not Enron.

The holding had a performance-oriented and hierarchical management structure. Managers were expected to meet targets at the end of each quarter, and everyone was making the necessary effort to meet Wall Street expectations. If the targets were not met in a quarter, some assets could be sold to make a quick profit (\+/-), for example, real estate, an airplane, or any other asset within GE holdings.

GE employees said that their tricks were legitimate under accounting rules and had been approved by independent auditors from KPMG. In 2007, the Boston Securities and Exchange Commission office reported that it had opened an investigation into GE. GE's long-term lending by paying high interest on short-term bonds to raise cash, on the other hand, caused the funding source and the loan to have mismatched maturities (-). Changes in interest rates could put future GE profits at risk. Therefore, they "hedged" this situation by using derivatives. GE had failed to comply with Securities and Exchange Commission (SEC) rules and, according to the investigation, tried to cover up its noncompliance to avoid a two-hundred-million-dollar fine. KPMG auditors working at the company allegedly signed off on inappropriate transactions without the approval of superiors in the national office. GE was managed under cover of incomprehensible complexity. For some, the investigation was evidence of abuse that allowed GE's greatness and reputation to be easily swept under the rug.

The SEC investigation looked at historical records to determine whether the company's accounting over the years had been misleading. All GE could do was cooperate and answer questions. As a result, GE's practices were deemed suspicious, demonstrating its ability to manipulate and ignore the accounting practices required by all public companies to protect investors.

Dealing with financial services and loans almost destroyed GE's past and its future (-). To realize the company's vision of growth, Immelt felt that he had to optimize the long-term GE portfolio. When GE's 2008 First Quarter results were announced, the company failed to meet its targets. This was quite bad. Some people assumed that the reports were somehow wrong, but they weren't. GE boasted that it knew the markets better than others and wouldn't be in any trouble for its mastery of risk management. Now, however, it was in the same boat as all other financial institutions, unable to maneuver in time. GE shareholders put stock up for sale. The stock saw its worst drop in recent years, and its market value dropped by fifty billion dollars that day and continued that way. Analysts no longer trusted GE. They were constantly skeptical, even JP Morgan analysts. An analyst noted that GE Capital's tax rate was unexpectedly low at 14% percent compared to the 17%–19% the company had previously predicted.

The analyst, who announced a bombshell that shocked investors, made GE's rating drop to neutral. In other words, GE's top executives demanded success at all costs, and problems were hidden to preserve performance, so later on, small problems became big problems. As GE was protected by official institutions, its media power was also distracting, the authors of *Lights Out* claim (-).

Meanwhile, Merrill Lynch was sold, and Lehman Brothers declared bankruptcy. GE was not Lehman Brothers. It would not fail or have to declare bankruptcy. Because of the size of the military business GE handled, the government wouldn't let GE go under. GE's lines of business, healthcare, jet engines, power turbines, and media were all seen as solid businesses in the future of the USA and the world. GE had real businesses with real assets, and real customers, and was generating cash. Still, GE was in trouble because these meant nothing to investors. GE announced that it would no longer report quarterly earnings estimates. The stock continued its decline as the financial crisis continued. Immelt had to cut its quarterly dividend from 31 cents to 10 cents after seventy years.

Immelt would later say that that day was his worst day at work.

This cut would not only affect investors but also reduce the number of quarterly checks issued to working shareholders and retirees.

S&P downgraded GE, and Moody's did the same. No matter what GE did, it could not provide confidence that it would generate cash from its core businesses in the future. Immelt was generally famous for his instinctive decisions, just like Welch before him. Ostensibly, Immelt was appreciated for his management of GE during the crisis. But he left the board of directors in the background when making decisions. As both CEO and chairman of the board, Immelt did not seek continued advice or approval; instead, he wanted the board to trust, support, and act quickly. On the other hand, didn't Immelt know that the main reason companies have independent boards of directors is to protect the investors who choose them by managing the risks they are exposed to?

Of course, GE was kept in the safe zone with the help of the federal government, and that came with a price. More than two and a half years later, the SEC completed its investigation into GE's accounting practices. The company had exaggerated its earnings by hundreds of millions of dollars and had bent accounting rules to the breaking point. For its sins, GE agreed to pay a fifty-million-dollar fine and actually promised not to misbehave again. Considering what the company did, this fine was rather low. The punishment confirmed long-standing suspicions of the accounting games that had been going on within the company (-). The two-thousand-page-long legislation that was signed by President Barack Obama in 2010 changed everything, from the risky strategies of big financial firms to credit cards and

mortgages. Even though GE was not a bank, it would now be like any other company supervised by federal agencies. Companies that had been trading on the stock market for years with their speculative values were now subject to the Consumer Protection Rules.

In late September 2010, GE and the US Environmental Protection Agency started a long and dramatic fight that went back decades over who was responsible for cleaning up toxic waste in New York's Hudson River. A pair of GE plants had pumped more than a million pounds of toxic compounds into the river over generations, turning one of the most famous and vital American waterways into a two-hundred-mile-long toxic dump. Over the years, GE had ignored the threat to human life while mixing the waste of everything it produced into the rivers, seas, and soil (-). Welch had justified himself in his own conscience, whereas everyone else was against him. Welch did not hesitate to make statements based on the contributions of his industrial investments to human life.

Immelt similarly did not want to pay for what GE had done and spend millions of dollars cleaning up the environment. According to these two men, these conditions were a natural result of the added value of industrialization and mechanization. For this reason, although many environmental measures were taken under Immelt's management, he waged campaigns to exonerate himself under the name of "Ecomagination," turning to products that would reduce carbon emissions, and said that he would spend billions of dollars. His words and actions were not found convincing at all by activists. *Forbes* described part of the "Ecomagination" campaign as "showmanship" in its article titled "GE Is Going Green." "In essence, it's a way to sell more products and services,"[2] Immelt told *Forbes*. GE paid fines of up to five hundred million dollars for polluting the Hudson.

GE needed to reinvent itself. GE never stopped improving its deteriorated image (\+). It didn't want to be an industrial dinosaur, and it wanted to stay young. GE was interested in software development and some exciting concepts coming from the West Coast technology culture through initiatives seeking to integrate traditional manufacturing operations (\+). GE might be old, but it was not a tired manufacturing company that only produced industrial components. It was renewing and constantly updating itself (\+). It was changing the world like technology companies were. It had big data, made up of millions of records produced by machine sensors. "Engineers have to accept that technology isn't everything. Maybe they should work with a marketer to understand customer needs," GE said.[1] GE was still trying to convince the market that it was not a financial services company but rather a digital industrial giant.

However, Immelt kept making mistakes. In 2012, he acquired French Alstom, which competes with GE in the power turbine business and also

makes passenger trains. Yet GE analysts said Alstom's accounting records were inflated.

In 2013, GE announced that it would sell a profitable portion of GE Capital to convince analysts and the public of its seriousness.

Immelt was still pursuing a major industrial acquisition. Even Immelt's oil and gas acquisitions could not convince the market that GE would abandon its dependence on the financial sector. GE's reorientation of its industrial businesses to areas where the global economy could soon begin to grow again also had little effect on the stock price.

Whatever Immelt did, the market did not trust GE. Finding a way out of GE Capital was the only way out of the stock market fear that plagued Immelt. The newly appointed former CFO of GE Capital quickly saw that the company's growing operations around the world were full of disorganization, duplication, waste, inefficiency, and complexity (-). He transitioned GE to lean management in 2013 (\+).

The press and analysts were told this wasn't just about cost savings. Duplicate functions in foreign countries had been removed. The operation had been optimized. Low-profit businesses were exited. Shared support offices were established for small operations abroad. GE sought to be a consumer- and market-oriented company rather than just a bookkeeping business. The only task of all top managers now was to make sales.

Industry giant GE was undergoing a major shift to adapt to the software and cloud economy (\+). However, there was resistance to innovation.(-)

It was widely accepted that the Welch era when GE stock peaked, would no longer return. In the never-ending comparison contest between Jack and Jeff, Immelt was always at the bottom. Immelt spread the story that GE was as innovative a company as Tesla Motors.

In March 2016, *Bloomberg Businessweek* came out with the headline: "How GE Exorcised the Ghost of Jack Welch to Become a 124-Year-Old Start Up."

For several years, digital was the subject of all the company's public statements. Corporate Communications announced GE was the world's first "digital/industrial" company. But GE's plan to move quickly, build a viable product, and then perfect it in the field was partially aborted due to the enormity of effort required.

At that time, even large corporations were becoming the target of activist shareholders. Activist firms were using their stakes to topple their boards and force strategy changes. Trian was one of the largest activist fund companies in the market. Trian had invested 2.5 billion dollars in GE. One year after the Trian investment, GE fell short of its financial targets. In the fall of 2016, the fund was impatient, seeking board membership. GE continued to buy back its own stock, spending more than three billion dollars in the first four months of 2017.

Immelt realized that investors, especially Trian, had lost their trust. He had set a goal for a new CEO to take over in late 2017 and identified four GE members as possible successors. John L. Flannery, with his economic knowledge and mathematical acumen, was a strong candidate to become the new CEO, and he was selected. In 2001, Immelt had taken over a ship that was in trouble but had not yet sunk. What many analysts and investors failed to see was that General Electric was in a shambles, with dishonesty, lack of control, and similar problems. It is a mistake to focus on the negative return on the stock during Immelt's seventeen-year term and compare it to the sixtyfold return over Welch's twenty-year period. This book is a must-read to understand the dangers of obsessively focusing on attracting investors.

Welch is said to be a great management genius, obsessed with numbers, who wrote five books on management and turned GE into the world's largest, most profitable, and most admired company (\+). But what has been written shows that his management strategy went awry. The pressure he created and the behaviors he encouraged brought the end of GE. Welch's managers seem to have created management that focused on numbers, not facts, to perpetuate the myth of unlimited growth with their accounting games. That's what Immelt did as well, focusing only on financial results (-).

Immelt could not eliminate the company's most important risk, GE Capital, and did not immediately intervene in Welch's complex holding structure. At the heart of GE's downfall was how GE Capital exerted such a big influence on the parent company and how adversity in the financial market put GE in trouble. In the 1990s, Welch embraced the idea that making money in financial services was much easier than industrial production. While the financial services unit realized big dividends with enormous risks, the industrial side was more stable but less profitable (-).

Immelt spent over one hundred billion dollars ultimately on share repurchases to support earnings per share and thus its stock price (-). He did not pay any attention to the analysts while he was acquiring expensive companies.

The fact that he visited abroad with two planes was perceived as an indication of a management approach that did not care about waste (-). The board of directors also turned a blind eye to this situation.

There may be commentators who read this book and say that many other factors are prominent in Immelt's failure: The world that Jeff Immelt thought he would lead GE into was turned upside down. The recession and the uncertainty that followed the 9/11 terrorist attacks had slowed the global growth on which GE's industrial businesses depended. Moreover, changes to accounting rules in the wake of the Enron scandal eliminated an easy and reliable source of commercial borrowing that had been used to soften tough times, thanks to GE Capital's balance sheet.

Immelt was an incurable optimist (-). Flannery, who was elected instead of Immelt, soon became known for his indecision and never-ending analysis (-). Flannery's style was tiring out the senior managers who worked with him. Fourteen months before the end of his term, he was fired, perhaps due to widespread public criticism that the board had waited too long to fire Immelt.

Boasting of itself as a talent factory, GE handed over the flag of leadership to an "outsider" for the first time in its one-hundred-twenty-six-year history (\+). New CEO Lawrence Culp has an MBA from Harvard, worked as a lecturer, and was commended for his success at Danaher, a smaller industrial conglomerate. Culp joined GE's board six months before being appointed CEO.

Lights Out explores how the USA's most iconic companies and the world's leading businesses can go astray through mismanagement if things go wrong. This book relates an interesting story of how a thriving company can be completely destroyed by misfortune and poor leadership.

So, will GE return to its good old days? Let's state that the problems at GE are not yet over. As early as December 2020, GE accepted a two-hundred-million-dollar fine to evade an SEC investigation related to another accounting violation (-). It looks like old habits die hard!

GE seems to have habits that are difficult to overcome. So, after reading this book and its reviewers comments, I became curious. OK, Immelt failed, and the failure was credited to him. So, if Immelt was successful, who would this success be credited to?

As you may have noticed, I've marked some sentences or even the end of the paragraphs (\+), that is, positive action, where I agree. Again, I have expressed my opinion concerning that which I don't agree with using a (-) at the end of the sentences. Hopefully this serves a purpose.

References

(1) Mann, T., & Gryta, T. (July 2020). *Lights Out: Pride, Delusion, and the Fall of General Electric.* Houghton Mifflin Harcourt and Blackstone Publishing.

(2) Fisher, D. (2005, August 15). *GE Turns Green.* Forbes. https://www.forbes.com/forbes/2005/0815/080.html?sh=375ea7be2389

Other Topics

Digitization or Digitalization: When You Switch from Analog to Digital

The terms digital transformation, digital disruption, and digital business are "trending" concepts that have entered the minds, languages, and companies of our business world with the rapid development of digital technologies. With all three of these concepts, an attempt has been made to explain the "digitalization" (digitization) of a company.[1] However, do we understand the correct aspects related to this digitalization? I'm not quite sure. For example, could the Tate Modern art museum, which operates as a nonprofit organization in London, understand digitalization better than businesses? You will learn the answer to this question once you read this chapter and reach the end, so be patient.

Even though digitalization is a concept that is in our daily discussions today, we actually saw the first hints of it in the 1970s. This attractive world, which I have been admiring since the late 1970s when I first encountered computers, is a great blessing. We have accomplished many things with computers. Moreover, all of these achievements were realized through assumptions such as zero, one, and two times two. What if these assumptions did not exist? I suppose mathematics is the only language that all people agree on. Most of us, including myself, did not grasp mathematics proficiently, and therefore, we do not question these assumptions too much. Yes, the first time I saw a PC was when I was at the Stanford Research Institute in 1982. They hadn't even been using it yet, and after showing it to me, they put it directly back in the closet. There was a company that produced fresh bread and cakes in ninety factories in the USA where I did my internship in those years. They were collecting all daily deliveries at hand terminals that could be considered mobile and consolidating deliveries from their headquarters in New York the next day. Why do you think this was the case? It's simple, because a significant portion of the CEO's premium account was these daily deliveries. Again, in those years, the mainframe computer in our school (Bosphorus University Business Administration) was as big as the building. Data entry was still made with punch cards. If the cards got mixed up or got damaged at the reader, you would have to start all over again and so were unable to finish on time.

Forgive me as, for the sake of learning, I did the SPSS homework/fieldwork in reverse. So I reached the desired result in one go. In other words, I first created the theory based on the questions, answers, and the output that could be determined. I later found out that scientific researchers call this "ex post facto."[2] So, I actually didn't do much that needed forgiveness.

Today, digitalization is an integral part of our lives, and in fact, it will soon determine the level of the AI program that we use to improve the quality of our lives. Due to the development of digital devices, we began to understand the place of digital products and services in our lives in the period 1990–2000. The retail industry, in particular, benefited from digital channels available in advertising campaigns in the USA.[3] Of course, consumers at that time were only able to make purchases by paying cash through traditional channels. Between 2000 and 2015, a great technological transformation process was initiated, in which people who are now around the age of twenty-five are called the natives of this process. The reason for this transformation was the development of smartphones and social media. During this period, consumers radically changed the way they communicated with us, meaning with brands and companies. When consumers asked a question, they started expecting a reply returned to them in a matter of minutes.

Today is the period when the concept, which was used in a broader sense of trolling, has started to be known as "consumer terror." Imagine that in the 2000s, when consumers/customers had problems with brands, they would apply to newspaper columns and express their complaints through letters they sent to Erkan, the big brother, and Meral, the big sister of the consumer.[4] Expectations on the part of consumers to be able to search, scan, and purchase products and services through multiple channels also increased during this period. While e-commerce had been expanding rapidly to meet these expectations, contactless cards and electronic money alternatives also started to diversify. Since 2015, our focus has been on mobile devices and taking the time to understand how we create more consumer value from the personal data provided by mobile technologies.

While these efforts toward change and transformation continue, I still have doubts concerning what we understand from digitalization. Once upon a time, when the desks in the workplace began to fill up with computers, that workplace was then "computerized." Later, the effort to accomplish certain tasks in a shorter time by using some software was called "computerization." Now, if solving company problems using more software is called "digitalization," this does not suit me. Since 2010, I have attended meetings so on many continents, also In our company meetings, which consultancy companies from outside also attended, I frequently saw that the digitalization phenomenon is a little confusing. Due to this confusion, the distinction between digitization and digitalization has been discussed since 2014.[5, 6]

In fact, collecting and converting signals to 0 and 1 means digitization and using digital data[7] to develop business, transform business processes and create a base for digital business by collecting and analyzing digital information.

But now we can ask a question such as, if our work is analog, are we trying to convert it to digital? At one time, if you remember, songs were recorded through analog equipment and, known as records. Later, digital recordings came out and are now available as apps like Spotify and Shazam. However, if you take a deeper look you will see that everyone still says, "The analog recording of sound is definitely closer to the original." For this reason, now again, we are unable to get past the record player. For example, it is possible for an orchestra to perform by digitally recording the instruments separately and then combining them digitally. However, it is never possible to replace the quality of an analog live recording of an orchestra with a digital recording. When I listen to the two types of recordings with bare ears, I understand this very easily.[8] If we make an analogy, then, our workplaces are actually similar to an orchestra.

All the sections of a business: production, sales, finance, accounting, purchasing, CRM, and social platforms achieve continuous output, leaving data behind. Every system, while working, generates simultaneous income, profit, and social benefits. The harmonious work of the elements in the system maximizes income, profit, and social benefit for that moment.

The question we have to ask here is, should we digitize the output or the data in different sections, similar to digitizing the sounds of the same musical instrument separately? When we get a "digitized" organization, will the result be superior to our analog situation, or will the final performance of the business be lower?

If digitalization does not produce better results, why would it take time, money, and energy to grow and produce efficiency? Therefore, it is necessary to distinguish between digitization and digitalization. Digitization involves activating the ERP system or configuring an operational framework during standard processes and switching from the analog to digital side by streamlining existing process structures. With digitalization, on the other hand, it is not clear what the outcome will be, whether improving the value of the market (digital transformation) or offering a digital value that makes a difference (digital business).

The important thing at this point is the digitization capacity of our company. So our company should be asking the following questions about our business:[9]

1. Can it produce data?
2. Can it transmit data?
3. Can it store data?
4. Is data connectivity available?
5. Is the data relevant to legal regulations? Is a contract required to receive and process the data? Does the data have a dimension that affects society?

6. Can the data be analyzed?
7. Can the data be visualized?
8. Can data be reported?

The answers to these questions are fundamentally important. These comments that I receive determine the digitization capacity of a company and vary according to the digitization capacity. If the digitization investment in the business and the monetization model of the business express a value, then if the investment has a return, digitization means something. For this reason, the model in our business should be reviewed from four aspects before the decision is made to digitize: (1) Competencies, (2) Customer/Consumer, (3) Value Proposition, (4) Value Presentation[10] In reviewing these elements, we should ask the following questions:

1. *Competencies:* Is our existing business model suitable for digitizing, for example, optimization in purchasing, production, logistics, sales, and marketing? Will the output grow the business due to cost savings or increased customer satisfaction?
2. *Consumer/Customer:* Our business necessarily meets one or a group of physical or psychological needs of the customer or consumer. First, these needs must be understood. Therefore, data is needed to understand consumer needs better and sometimes to create new needs, thus increasing consumer knowledge. It is also decisive for the customer's/consumer's own digitalization (level of benefit from digital technologies). We have compared our work to an orchestra before, and here the priority is for consumer data to determine the type and level of music according to customer/consumer needs and consequently strive to show proper performance to the consumer. If the target consumer prefers rap and hip-hop, if we can only improve the pop music we offer as a result of digitization, ROI will be problematic!
3. *Value Proposition:* This is the value offered to the consumer and the price that the consumer is willing to pay in return. The question is, will the consumer still be offered the old value proposition, or its transformed version, or a completely new digital product or additional service as a result of digitization?
4. *Value Presentation:* Is it possible to publish the suggested value as a commercial communication in digital or all media?

There is no doubt that interaction exists among all these four elements. Considering this interaction, when we start by saying, "Let's go digital" without answering the above questions, we are choosing the famous irrelevant "make it up as you go along" project approach, which I would never recommend when we consider the size of the investment in digitalization.

To summarize, before the decision to "digitalize" is made, the digitizing capacity of the business or business model should be measured, looking at the digitization capacity and digitization drivers, how the consumer and other stakeholder relations are affected, and how the emerging big data affects growth, and then digital transformation, the new digital business model (product) or the digital disruption decision that is made.

Tate Modern, which I mentioned at the beginning of the chapterng, is the international museum of modern and contemporary art established in the center of London in the early 2000s. Its history is based on the Tate Museums Institute, which was established in 1897 to better explain art to the public in England. Today, five million people visit Tate Modern annually. Although Tate Modern is a nonprofit institution, it competes with many similar institutions. In the late 2010s, Tate Modern management saw that digital technologies played a major role in creating consumer value and creating new value, decided to pursue the digitization of the museum organization and its processes, and transformed the organization by conducting analysis and then benefiting from interactive services, service robots, and AI digital technologies. It produced projects, and realized the disruption in the meantime, thus gaining new members and increasing its revenues.[11] Tate Modern has two products based on digital technologies. The first one is the Tate "Time Machine." Thanks to this technology, Tate Modern communicates with its target audience through presenting art history. Through explaining how history shapes art, and asking viewers how to shape the art of the future, the museum receives viewers' emails and send them messages via email. These messages are analyzed with AI software and then interaction with the visitors is provided. In "After Dark," the museum can be visited virtually through robots outside working hours. In this way, Tate Modern switches to the digital business model. Tate Modern thus both gains digital members, which increases revenue, and teaches art to more people. To date, forty thousand people have visited the museum virtually.

We, as Yildiz Holding, due to the outbreak of the Covid-19 pandemic, organized together with the Turkish National Cultural Foundation (TMKV), in conjunction with the month of Ramadan, the exhibition *Prophet's Farewell Pilgrimage Sermon*. The exhibition was transformed by necessity to the digital environment, which was possible with our current level of digitization, and thus we enabled more people to benefit from an interactive virtual tour.[12] The result was successful, after which I decided to increase our digitization level, digitize our exhibition works, and produce examples that will turn industry upside down.

As you can see, digital disruption means chatbots, image processing, message services, speech recognition, face recognition, blockchain, big data analytics, AI, robot services, augmented reality, biometrics, IoT, digitized

by digitizing cloud computing technologies, and monetizing, that is, making money by adding innovation to the system or by making use of these innovations, by rapidly innovating, changing the market, and increasing the market share!

It has been more than ten years since Yildiz started the journey of digital transformation based on the logic I described in this chapter. I still see discourses where digitization and digitalization are interchangeably, so I wrote this chapter to provide a little bit of clarity.

We created voluntary digital disruption groups in order to continue our digital transformation journey before the Covid-19 pandemic and to be the best in our business based on our current business models and the technologies we use. We embarked on a Disruptive Digital Innovation journey where we would develop new digital ideas and ways of doing business together. We collected one hundred sixteen project ideas. We started nine right away. Thirty-four of them are currently being worked on.

Our goal in this journey, as I stated in the main hypothesis of this chapter, is to "safely store, repeat"; to analyze on the computer by making all our activities digitized; to make decisions by creating algorithms with the help of technology; to provide decision support services; to break our routine in the market with rapid innovations; and to increase our market share rapidly. In doing so, the future shines brightly, especially by not reducing the performance of the knowledge worker, that is, the employees whose core capital is knowledge, instead of motivating and increasing their performance.

References

(1) Urbach, N., and Roglinger, M. (2019). *Digitization Cases: How Organizations Rethink Their Business for the Digital Age*, Springer, e-book, p. 5.

(2) Salkind, N. (2010). *Encyclopedia of Research Design*, SAGE Research Methods.

(3) Schallmo, R. A. D., and Williams, C. A. (2018). *Digital Transformation Now!*, Springer, p. 5.

(4) https://www.milliyet.com.tr/yazarlar/meral-tamer/tuketici-gunu-senli kle-kutlaniyor-5393897; https://www.hurriyet.com.tr/tuketicinin-erkan-abisi-39266555

(5) Brennan, S., and Kreiss, D. (2014). "Digitalization and Digitization," culturedigitally.org, Sept. 8.

(6) Dorner, K., and Edelman, D. (2015). *What Does Digital Really Mean?*, McKinsey & Company.

(7) Da Mauro, A. et al. (2014). "What Is Big Data? A Consensual Definition and a Review of Key Research Topics," *AIP*, 1644(1), pp. 97–104.

(8) https://www.ufukonen.com/tr/analog-ve-dijital-delay-fark.html

(9) Ritter, T., and Pedersen, L. C. (2020). "Digitization Capability and the Digitalization of Business Models in Business-to-Business Firms: Past, Present, and Future," *Industrial Marketing Management*, 88, pp. 214–224.

(10) Ritter, T. (2014). *Alignment Squared: Driving Competitiveness and Growth through Business Model Excellence*, CBS Competitiveness Platform.

(11) https://www.theguardian.com/artanddesign/2020/apr/06/andy-warhol-take-a-virtual-tour-around-the-tate-modern-exhibition; Alshawaaf, N., and Lee, H. S. (2021). "Business Model Innovation through Digitization in Social Purpose Organization: A Competitive Analysis of Tate Modern and Pompidou Centre," *Journal of Business Research*, 125, pp. 597–608.

(12) https://www.hurriyet.com.tr/kelebek/keyif/yildiz-holdingden-dijital-sergi-hz-peygamberin-veda-hacci-hutbeleri-41516487.

"The Right It" Means "Verify"

Have you ever come across an interesting mechanical device called "The Mechanical Turk"? This machine, which plays chess, was invented in 1770 and wore the Ottoman clothing of those years and resembled a Turk in appearance.[1] It is a real invention and can be found on Google. From 1770 to 1854, the chess robot naturally surprised many people, and there was no one left in Europe that it had not defeated. The automaton had been built in Vienna by the mechanic Wolfgang von Kempelen, who had worked in the service of Empress Maria Theresa. On a wheeled maple cabin with an inscribed chessboard sat the Turkish figure with a mustache, a turban, and a cape. Behind the door of the cabin, inside, many large and small levers, rollers, and other complex mechanical systems could be seen. When the wind-up Turk began to play chess with a volunteer, his eyes scanned the chessboard, he occasionally shook his head, and he moved the chess pieces with his hand.

A chess master would enter the box after the inside of the machine had been shown to the audience. Inside the cabin was a second chessboard that helped the operator follow the game. Under the main chessboard where the vending machine played, there was a spring-shaped mechanism under each square and a magnet under each stone. Thanks to this system, the player in the cabin could keep track of which piece was played to which square and could move the Mechanical Turk by using a special mechanism that notified the main board of his moves on the secondary chessboard.

It is not known who played the game inside the Mechanical Turk from its first production until 1787. One of the people who played chess in the automaton in the fifty years between 1787 and 1837 was the dwarf chess master Jacques-Francois Mouret. So why was this device Turkish? There have been various conjectures on the subject. First, it is thought that the automaton was given a Turkish name because the Turkish culture of the period had attracted attention in Europe. Another notion is that since most of Europe was affected by Turkish raids and lived under Turkish rule for a significant period of time, famous names in Europe were therefore offered the opportunity to beat the Turks on the chessboard. Of course, it is necessary to proudly mention Cezeri, who was born in 1136 in Cizre, one of the first real mechanics and robot masters in history. He is a Muslim scientist and engineer who worked in the Golden Age of Islam. Ebû'l İz Al Cezeri (al-Jazar), who is considered to have taken the first steps in cybernetics and built and operated the first robot, is thought to have been an inspiration for Leonardo da Vinci.[2]

For years everyone tried to unravel the secret of the chess machine "The Mechanical Turk." Some produced very interesting theories, and these explanations were widely published in newspapers and books. After Kempelen died in Vienna in 1804, the vending machine changed hands several times. The Mechanical Turk, who had defeated Napoleon Bonaparte in 1809, continued its chess victories in France and England and gained its greatest reputation in this period. Benjamin Franklin suspected that there was a cheat in the undefeatable Mechanical Turk, but he could not confirm this in his lifetime. The automaton changed ownership until 1854, when in that year it was donated to a museum in Philadelphia. Eighty-five years after its construction, the Mechanical Turk was destroyed in the Great Philadelphia Fire and became part of history. Today, many copies of the Mechanical Turk decorate museums.

The Mechanical Turk reminded me of the Coca-Cola Happiness Vending Machine I saw around ten years ago when I went to the Cannes Advertising Festival. They placed a vending machine with a human in it at universities. He made everyone happy by giving away free products. Later, Unilever, Walkers did something similar, and we adapted it to the concept of "A Happy Moment." We used it in those days and gave surprise gifts to those who dialed the vending machine numbers.

Does one wonder why in all this, I have mentioned the chess machine called the Mechanical Turk? It brought to mind several things.

I recently wrote that one of the issues that occupied my mind is not to produce innovative, disruptive products but to retain them, that is, to be successful in the market. I received a book by Alberto Savoia called the *Right It: Why So Many Ideas Fail and How to Make Sure Yours Succeed*.[3] It is a nice book, its font size is large, and it is easy to read. The author recently worked as Engineering Director and Innovation Agitator Emeritus at Google, Software Research Director at Sun Microsystems, is the winner of many innovation awards, is now working as a consultant, and has been giving seminars at universities on the "The Law of Market Failure." In the book, I came across the Mechanical Turk chess automat. I had never heard of it before. Once I looked into it more, I decided to share what I've read. By the way, how did the Mechanical Turkish vending machine inspire IBM's new product experiment? The answer is at the end of this chapter!

Savoia starts off his book with a very realistic law. This is something akin to the law in natural sciences we're talking about here. Those with a new idea often think, "Failure is not even an alternative," whereas a new idea is "most likely to fail!" The reason he has accepted it as a law is that so many new ideas have failed, so we have enough evidence to accept it as a law. New products mean investment. What kind of investment? Money, time, resources, reputation, in short, everything. You invest because you want

more revenue, profit, market share, new customers, and reputation. If you cannot get as much or more than you invested, it is a failure. Savoia states that the new product failure rate varies according to the type of business and industry. In the consumer products market, Nielsen tracks tens of thousands of products launched each year. Do you know what percentage of products get "failed," "disappointed," and "canceled" results from these new product launches? Eighty percent. This result does not change year to year.

In the software sector, the result is no different. So new product failure is clear, consistent, and persuasive. Savoia touches upon a key issue here. Especially managers in the Fast Moving Consumer Goods (FMCG) sector, if you think that new research and marketing techniques can only be applied to technology-heavy products and therefore don't bind you, that's wrong! Many principles now also bind non-technical technology sectors; thus, accordingly, preparation and implementation are required.

So why do most products fail? To answer, let's first look at the following equation: Correct A x Correct B x Correct C x Correct D x Correct E = New Product Success. Probably the first thing you learn when you take a math class is that if you multiply a number by zero, no matter how large it is, the result is zero. In other words, no matter how successful you do all other factors, if you calculate one factor wrong, the result is 0.

Given the necessary logic and statistical data, many people believe that numerous new products fail. However, Savoia does not believe in the other part of the work: "even if the product is produced perfectly." Savoia gives two very important examples at this point. One is Coca-Cola's New Coke, and the other is colorless, decaffeinated Crystal Pepsi. Both failed. Do you think every Disney movie is successful? No one has heard of the movie titled *John Carter*, which was released after four hundred million dollars were spent to create it. That's because nobody went to see it. The famous director of *Star Wars*, George Lucas, made a movie called *Howard the Duck* after *Star Wars*, but the movie became a legend of failure. Google is one of the most experienced and talented companies that exists today. Everyone knows of the success of Google Search, Google Maps, and Gmail products that it released after the creation of Google. But have you ever heard of Google Wave, Google Buzz, Google Glass, Jaiku, and Google Answer products? Perhaps you have heard of Google Glass, but did you know that it, along with many others, all failed? When you type in Google Graveyard or Microsoft Morgue on Pinterest, you will see scores of unsuccessful products. Many companies do not report their failures and bury them as soon as possible. Nobody writes these failures on their CV.

McDonald's' Morgue includes McLobster, Hula Burger, and McSpaghetti. By the way, the failure rate is not only high in aggressive or attack companies. This rate is the same in more cautious companies as well.

Savoia says that any project fails for three reasons: Launch, Operations, and Premise. Savoia put the "F" of Failure in front of him and created an acronym called FLOP. In other words, collapse! Savoia's claim is as follows; too few products fail because they fail in generating awareness or because they are manufactured incorrectly. The main reason for failure is having the wrong product idea! Businesses have no problems in producing a product correctly and presenting it to the right market. The problem is producing the right one, The Right It!

So let's ask the crucial question, why is the rate of new product failure higher than the rate of success, despite companies spending so much time and money, and with so many successful people working for them? Why does a company with so many experts fail? Don't they know they need to do market research before launching a new product? Why do they insist on doing what's wrong, even though everyone knows that the promise of the right sale, that is, meeting the right need, is the most important issue together with spending enough time and money on market research to produce the right product that supports this promise?

"So the problem is with their research to test the idea of the new product," says Savoia. I agree with him. Most of the time, when new product research is put into my hands, I often respond in disbelief. Savoia also attributes the failure of conducting so much research to the fact that the research is done entirely in a virtual environment and not under real market conditions. Marketers say they portray the idea of a new product in a simple, pure, abstract way in the "thoughtland" that they create through their own thoughts. Once a product idea is found, that idea is animated in this "assumed world," and after a while, biased, subjective judgments dominate and not data, or evidence. Without relying on evidence, a kind of "free shot" state is passed.

I compare the English idiom "skin in the game" to the Turkish idiom "divorce is easy for a single man." Savoia states, "You cannot expect dedication, seriousness, and thoughtfulness from the subject in the study, as it does not feel any risk."[3] This is why the lack of evidence-based judgment in this "assumed world" often finds its counterpart in the idiomatic phrase "divorce is easy for a single man." However, as long as the right market research is not done, the right product coming out of this "assumed world" depends on luck as long as there is no exit into the real world. Unfortunately, most market research for a new product idea is based on the "assumed world." Interestingly, research companies contribute to this "assumed world" with so-called "focus" research, but the result cannot go beyond hocus focus!

One of the interesting examples in Savoia's book is the following: Alberto Beer Company (ABC) wanted to develop a new product to obtain a share of the women's drink market. They had very experienced marketers and

managers. They decided to use a focus group to better understand this market. They brought female drinkers to a one-way mirrored room and asked the following questions: How often do you drink beer when you drink? What do you prefer when you drink other than beer, and why? What is the reason you don't drink beer more often? The results showed that 55% said they found white wine suitable for women, saying, "Telling the bartender, 'Bring me a Bud' is not ladylike." Thirty-one percent stated light beer was "too light" and "tasteless," and non-light beers "heavy and bitter." Thirty-eight percent said that if it was a feminine beer brand, they would prefer to order it from a bartender. Based on this data, ABC Company came up with the idea for a new product called LadyLike, which is light but tastes better, has a more elegant bottle, and has taste varieties. Managers liked the idea. A beautiful logo and a bottle were designed, and they organized a second focus group to make sure that was brought to the right places. A new brand was presented to this group, they tasted the product, and this time, the following questions were asked: Would you prefer LadyLike to white wine? LadyLike, light beer or regular beer? Peach-flavored LadyLike or cantaloupe? The results of the second group were as follows: Forty-seven percent of those who normally prefer white wine said they would drink LadyLike if they could. Fifty-four percent preferred LadyLike to light or regular beer, and 82% preferred peach to cantaloupe.

Of course, when these results came in, a double-digit market share growth potential began shining in the eyes of the managers, and they approved the launch of millions of dollars to the budget and, of course, in the following moments, began dreaming about the bonuses they would receive. Thus, millions of dollars were spent over nine months, and Ladylike entered bars and markets. However, after a few months, six-packs began to be kept in refrigerators with only a bottle missing. All that money and effort, with the slogan that should have been "One sip and that's it!" Few women tried the product that was put on the market, and those who tried it, did not buy it again.

You can find many stories like this in the market, including in Turkey. Research companies, like us, do not brag about their failed work. The most "brand name" research companies be used may, an incredible amount of money spent, there may be show-off flying and fleeing numbers, but we see a team that has been going in the wrong direction. A focus group itself can be useful, but it should definitely be controlled and checked with complementary and reasonably priced research that gives good results. When you have a serious health problem, are you satisfied with a single doctor's opinion?

Speaking of failure, let me give an example from the past, and then you decide. The product name is Maltana, a malt drink that has nothing to do with beer. Since it is not fermented, it is not like nonalcoholic beer at all, because that type of beer is later de-alcoholized. Maltana is a product

currently sold at a premium price on the market, but it didn't do so well due to certain prejudices and thus could not reach the desired boom in sales. The premium packaging and price and the definition of a malt drink made it more difficult. We learn something new every day.

The most important issue in market research is to conduct research with the right tools and techniques. Well-planned, well-executed market research provides interesting consumer insights. The important thing is how much weight we put into these insights when it comes to our decision-making. "If you're doing focus research regardless of what you're measuring, focus research, which gives great results in finding insight, trend-setting, creativity testing, turns to focus in testing new product ideas,"[3] says Savoia. Why? Because the "world of assumptions" contains mental traps. What are these mental traps? The first is an abstraction; the new idea is abstract because it is difficult to explain. The second is guessing because it's difficult to experience a new idea. Third, is that it's easy for a single man to divorce because people can promise plenty if they have nothing to gain and/or lose. The fourth is affirmative bias, which means looking at evidence that supports our own opinion and ignoring others. In Turkey, the best example of this is that most people watch television channels or influencers who support their own worldview. Daniel Kahneman, the winner of the 2002 Nobel Prize in Economics, talks about such cognitive errors in his 2010 book, *Thinking Fast and Slow*. In fact, as you may know, the father of all these errors is the scientist Amos Tverski, who died at the age of fifty-nine. Kahneman and Tverski worked together. Here is what Tverski said about affirmation bias: "Once we put forward a hypothesis or interpretation, we overestimate the likelihood of it happening and it becomes difficult for us to see things in any other way."[4] Now let's consider how the four mental traps above troll together.

Let the first original idea be distorted because it is abstract. Guess the wrong experiences from the distorted idea (misunderstandings of what the new product is); let no one care about gains and losses; let the idea be distorted by false misunderstandings; and let the thoughts that support the obtained biased thoughts be carefully selected with the approval bias. From here to objective, reliable action, is it even possible to get data for this? The "world of assumption" that I mentioned above can produce subjective, biased, that is, false ideas.

So what's the solution? The answer is, producing correct data that is ours. Data beats any opinion! "Don't rely on other people's data," says Savoia.[3] The important thing is to collect your own data. The most important issue when designing research is that the sample is representative. So you should talk to people who have the potential to buy your product.

Twenty years ago, just before the development of personal computing and the evolution of the internet, IBM was a giant in the mainframe and writing business. The typewriter existed back then, and then IBM took the place of the typewriter in editorial work. At that time, few people like secretaries, writers, computer programmers, and so on wrote quickly and accurately.

Many people typed with one finger in the typewriter business, slow and bad. Professional typewriters were available at the time, and they were difficult to handle. IBM decided in those days to produce technology that converted speech to text. Imagine the time when the simple speech-to-text job was discovered twenty years ago. You simply speak, and the words magically appear on the screen. It's like the flying car, which has been in our dreams for almost fifty years. The product seemed to IBM executives that it would reduce the need for professional typewriters and save a lot of money.

That is, if the intended users felt comfortable using the product.

According to the "Assumption World," everyone would love this idea, except professional printers. They thought that everyone wanted to use a computer but did not want to spend time writing. However, the company wanted to see the real reaction of the market in order to enter into this business, which required high amounts of energy in terms of both money and time. The easiest thing was to make a prototype (mock-up) and show it to people. However, there was a problem: at that time, it required a great deal of processing power to translate speech into text; computers in that period did not have that power; and computers were much more expensive than they are today. IBM fell almost ten years behind in making such a prototype. IBM researchers instead had a clever idea. They created a working environment with a computer case, a screen, and a microphone but no keyboard. They stated they had created a prototype of the revolutionary computer that converted speech to text for a certain number of potential users. They gave instructions and asked them about the new invention. Participants in the experiment picked up the microphone and started talking, and with little delay, letters began to appear on the screen. Participants were very impressed with what they saw. Actually, this is what happened: There was no machine to convert a speech to text. The computer in the room was completely a model.

In the next room, a skilled typewriter listening to the conversation immediately typed what he/she had heard in the traditional way, and a model of the words appeared on the screen. IBM learned a lot from this experiment. At first, people who were very impressed in the "Assumption World," changed their minds after they had used the system for a few hours.

They found the new invention quite problematic, as they suffered from throat dryness; the constant conversation created a rather noisy work environment; and it was not a suitable method for rush materials. IBM's model

was not exactly a prototype. It was literally a pretotype, a "pretend" pro-
totype, and it had worked! At that moment, our typists, including those at
IBM, were lightning fast, and they pitied the millions of dollars and months
that had been invested in producing prototypes up to that point. However,
what needed to be done was to use creativity and give the consumer a pre-
totype, pretending to be as little or low level as possible for preliminary
research. Imagine if IBM had produced the prototype with a negative result
costing millions of dollars instead of the pretotype!

Now, wait one minute. Where did this pretotype idea of IBM come from?
It came from the Mechanical Turk. To make a completely Mechanical Turk,
IBM would have had to create little men, put them inside the computer case,
and feed them cheese and crackers from the disc slot, but what the manage-
ment thought of was less troublesome and costly. So they discovered that
this timeless idea was one that didn't make any money that day.

The pretotype is designed to test whether an idea is feasible or not cheaply
and quickly, while the prototype is designed to test variables such as how
the new idea can be made, how it will work, and what size and color it
will be good at. Although the two designs look the same, that is, they are
both in a sense "pasta," they differ from each other, such as spaghetti and
linguini do. Also, the cost is, of course, one thousand Turkish lira, while
it is possible to spend hundreds of thousands of lira for the second one.
Savoia's book offers a lot of tools and tactics to bring the right idea to life
while developing new products, but I think the most interesting idea is that
of the pretotype. Therefore along with the Mechanical Turk Approach, the
Pinocchio Approach (producing products close to the final product with dif-
ferent materials), the Fake Door Approach (fake door, physically looking at
the number of applicants through fake shops, brochures, advertising), and
the Frontline Approach (fake advertisement for clicks theinternet) suggest
that approaches such as the YouTube Approach (collecting ideas with the
help of videos) can be used as a test tool. In this respect, the idea of a preto-
type is really a paradigm-breaking idea and should be added by new product
developers to their processes, and it should be carefully checked whether the
research results come from "easily divorced singles," that is, the work of
the "world of assumptions." Using creativity and correct pretotype methods
will lead to new ideas, and yet businesses will continue to waste resources
on new products if they are not tested under the competitive influence in real
buying environments! There are also new products that will be abandoned
even though they will keep you unhappy as a result.

References

(1) https://en.wikipedia.org/wiki/Mechanical_Turk

(2) https://en.wikipedia.org/wiki/Ismail_al-Jazari

(3) Savoia, A. (2019). *The Right It: Why So Many Ideas Fail and How to Make Sure Yours Succeed*, Harper One.

(4) Kahneman, D. (2017 November). *Hızlı ve Yavaş Düşünme*. Varlık Yayınları.

How Artificial Is Artificial Intelligence?

I have always heard, wondered about, understood, applied, and developed the following terms: pick and place, feeding machines (robots), boxing robots, assortment box-filling robots, automation, input/output, Programmable Logic Controller (PLC), workstation, Supervisory Control and Data Acquisition (SCADA), operation research, supply chain, factory automation, and so on, and the machines and systems that make all of them possible: belts/pulleys, redactors/variators, gearboxes/cams, AC/DC electric motors, drive cards, cascade systems, machine communication systems, industry 4.0, the IoT, and so on. And what else, and what more…

When I look back, these are the terms for which I remember making great effort to find someone who knew some of these, convincing them to teach me about them, or flying across continents just to experience one of them. However, these terms are unfamiliar even to newly graduated engineers, and such machines are now obsolete if we disregard some exceptions. Mechanical, electronic, and computer engineering is now done by combining parts like LEGOs without engineers getting their hands dirty. I do not want to be misunderstood because I do not have contempt for them. In fact, I admire and appreciate them while expressing this fact. In the past, we could only open the hood and tinker inside the car stranded on the side of the road, but now we can access the motor, which only has a plastic cover, through a computer.

Yes, who will be the masters of the future? The nations that have money and use all of these technologies or the poor who produce them for low prices? Or will it be those who create the "know-how?"

I have always wondered how machines work. As a child, I would immediately take apart my toys out of curiosity, and then, of course, they would either remain in pieces or the number of pieces would become outnumbered while I collected other toys. My goal was to do something new. I remember when I was young, I unpacked the newly arrived machines, assembled them, and watched while they were commissioned. It was so exciting, such a pleasure. My father used to take me on business trips. There was no trip we wouldn't take to see a new machine work. Fifty years ago, we went to Scotland by plane, train, and car. The factory owner welcomed us with curiosity and was amazed to see that we were not dressed like the Turks his grandfather, who fought in Canakkale, had told him about.

In any case, let's leave these memories now and return to our topic: AI. As you can appreciate, the necessity and practice of AI cannot be understood without knowing the reason for requiring automation and robotization.

Behind all these inventions, the human mind and practicality exist. In my opinion, humans are utilitarian, lazy, and malefic. Humans have invented machines, automation, robots, and finally, the IoT and AI for their own benefit and convenience. Of course, it is cruel to treat humans, who are perfect beings, like a machine or a part of a facility.

This inevitable change has always been opposed because it is unknown, incomprehensible, and frightening to most. But we know what happened to porters when pallet trucks and forklifts came out, or to horse carriages when trucks came out, and what happened to cabinet workhorses when the engines were invented.

In short, new professions have always been invented,[1] and employment has increased. Thanks to the increased production and productivity, income levels and the quality of life have increased. Humans have continued to chase their whims and then complain.

Now, we are facing a major change again. Change is inevitable! In other words, we will modernize by putting AI at the center of social life and shaping our education and work accordingly.

So, when did all these advances in technology begin in Turkey? The answer is: at a public conference in Erzurum in 1957–1958, where "artificial intelligence" was explained!

If we consider our ability to recognize, understand, and interpret our environment with our senses, or what we define as "intelligence" among us, then the term "artificial intelligence" is a little exaggerated. First, a distinction must be made between "recognition" and "judgment." Machines and robots are now very good at observing and recognizing our environment, making patterns from them, and making predictions, because the image, recognition systems, and statistical estimation methods based on big data are highly developed.

AI (machine learning, deep learning, which is a form of it) is a highly technical, computer science-related topic. From time to time, many executives from IBM have expanded our horizons by introducing the features of Watson, an expert AI program. If you go to Amazon today and search for a book on AI, you will find over thirty thousand books written or that will be written in two years on related topics. There are thirty thousand books on "big data," which has not yet been fully defined. These numbers reveal the extent of the future impact of AI. However, those the number of those who write on this subject in a way that the operators can understand number no more than the number of fingers on one's hand. After reading these book, many say that something is still missing.[1,2] In many business articles on AI, the authors state that authors do not understand the computational logic of the job well enough, but I think this is an effort to hide some moral problems. I will discuss the reason for this below.[3, 4]

I think computer scientists aim to look at neuroscience and cognitive science research and try to imitate the human mind and solve a problem given to them. For example, when you give the voice command "Go to Sariyer" to a device, it outputs the route from Beykoz to Sariyer as text or voice alternately in time. How does that happen? In order to do this, the machine needs to be taught a lot of traffic data, road data, and speed limits, and the machine must detect the current situation from the data and tell you an error-free result. In the meantime, let me state that in the field of AI, the cost of making faulty software and making software without errors is the same. Therefore, you can't get a better one for a cheaper price. In other words, AI software has only one KPI: a correct guess.[5] Returning to our traffic example above, the machine needs to be constantly trained (updated); new roads and intersections, dead-ends, and changing street names need to be constantly transferred to "intelligence." What if, suddenly, the streets become one-way, road maintenance begins, or the route changes? That's the time when the machine (software/algorithm) makes an error. Humans find a way with their own minds. To elaborate on the example above: software, machine coding, artificial learning, AI, whatever it is called, by looking at past data, will predict which road the municipality will repair, which road will be made a dead-end, which road will change its name. Moreover, it will predict the likelihood of the road being blocked as a result of an accident, and it will give 100% accurate estimates. We will see whether it is possible for the machine to sense the behavior of the municipality.

In 1956, ten scientists who were interested in machine intelligence came together for a six-week workshop at Dartmouth College in New Hampshire. Their purpose was to discuss how machines can simulate human intelligence characteristics such as sensation, logic, decision-making, and the ability to predict the future. The organizer of the meeting, US mathematics professor John McCarty (1927–2011), used the term "artificial intelligence" for the first time to attract some attention when looking for a name for the conference where the results of the meeting would be discussed a year later.

In fact, even today, the software called AI contains McCarty's basic idea. McCarty argued that human thinking and reasoning could be defined mathematically like gravity rules defined by short equations; consequently, he argued that abstract moments, thoughts, and logical thinking could be transformed into algorithms, explanatory instructions that guide problem-solving processes. The organization that funded the workshop was the Rockefeller Foundation.

This is precisely why I say this job cannot be solved with the known 0/1 computer software mathematics; the "maybes," "sometimes," and "let's see" options should also be included in the work; and fuzzy logic should be utilized much more. Of course, we do not take into account the conscience

aspect of the matter. If someone connects to websites with explicit videos from their computer after midnight, and the next day AI keeps showing them these explicit videos, here's what I'm talking about – an atrocity!

In 1958, Cahit Arf, a world-renowned Turkish mathematician, held a conference on AI at Ataturk University in Erzurum, entitled "Can a Machine Think? andHow Can a Machine Think?" It made me very proud to learn that he sponsored a conference with such a title. At this gathering, Arf attempted to convince the audience that machines could also think like humans, and concluded his speech with the following remarks:[6]

> Although machines can do some work much faster than the human brain, the understanding, that is, even those whose reception capacities are large enough to fill a large hall, are much lower than the human brain in terms of variety. In contrast to the human brain being improved by itself, the machine remains as it was built. However, it is possible to design a self-evolving machine. However, in my opinion, the main difference between the human brain and the machine is that the human brain can take and process aesthetic agents and make decisions that are of aesthetic nature and feel free to do a job or not, but the disappearance of similar qualities in the machine. What characterizes these characteristics is that they all contain an element of uncertainty, the absence of the rules to which they are infallible. There are non-human natural phenomena that have the character of uncertainty.

Today, AI applications are everywhere. Siri takes our commands and chats with us, making us laugh with her responses. But she also scares us with her smart answers. Alexa and Google Home also serve people's home management and shopping needs by voice command.

Autonomous vehicles are redefining automobiles and transportation. There are automatic algorithms that can buy and sell stocks at a speed that traders cannot catch up with, and programmatic software that shows advertisements at a speed that people cannot keep up with. Before we arrive home, the ambient temperature can be adjusted, Google Maps offers alternative ways to check traffic, unnecessary emails are sent to junk, Instagram and YouTube constantly recommend new videos according to our interests, while Netflix offers movies. All of this is due to software that McCarty and his colleagues initially sparked, and it imitates the human thinking system.

Machines can now make medical diagnoses and prevent fraud. There is even a joke that states: If a machine manages to perform a task that could only be done by humans before, that task does not require intelligence! Yet intelligence is a very abstract thing. What is intelligence? What is learning? After all, computers are still not far from Pablo Picasso's thought that "They have no use, they can only respond to you."[8] But computers have started to respond very quickly by performing rapid operations (data analysis that human intelligence cannot approach) on more subjects.

I decided to do some reading on this subject and compile what I know and write this chapter when I saw my name mentioned in a YouTube video, which belongs to a influencer, announcing a technology named Generative Pre-Training Transformer (GPT)[3] Why was my name mentioned? My answer is coming soon.

As far as I understand, Open AI's GPT3 Natural Language Programming technology, founded by Elon Musk and Sam Altman, is a paradigm-breaking software and will affect "business artificial intelligence" applications the most in the next period, and AI applications and solutions in this period will be more than image recognition. It is said that GPT3 will turn to language processing.[9] GPT3 can write press releases, newspaper articles, and technical manuals when it is given an intention. Also, it can produce these forms of writing in a person's own style. Moreover, GPT3 can write computer code, an algorithm. So, you no longer need an expert software developer to solve a problem; GPT3 can do it. Currently, the system is not without errors, but Microsoft, Google, Alibaba, and Facebook have begun working on their versions.

As far as I see, the issue that has pushed the development of AI applications so stongly is "commercialization." Large companies fund basic research on the latest technology, assuming that commercially significant breakthroughs will occur in a short period. In fact, everything accelerated with the reorganization of Google, Facebook, Apple, Amazon, Microsoft, and Baidu, which have billions of data in their hands around AI. As I said in the beginning of this chapter, nobody cares about building smart minds and creating perfect people. AI is seen as a tool to solve problems.[10] Companies invest in AI software to be leaders in their industry.[11]

Our company's main business is biscuit and chocolate, and with AI applications, we can improve our business, first by making pilot applications and then transforming our production, business, and management processes into a faster, cheaper and more efficient work culture that makes our customers even happier. The aim here is not to remove people from the process, but to create companies for a more efficient future with human–machine cooperation. All jobs and tasks should be evaluated, and AI software–human relations should be studied one by one, with consideration given to the conscientious dimension. Our media planning agencies have been using advertising technologies for five years and have been showing ads in the right place, at the right time, with the right budget, and at the right frequency. So, these technologies are already in our lives, whether we want them or not. It is time to bring these technologies into the workplace in a desired and targeted manner.

We have businesses that collect digital data directly from customers. Online and offline transformation and coexistence are accelerating. Areas

that have high contact with people, such as large cafes and restaurant chains, are trying to adapt to changing consumer habits with the investments they make in AI applications. Likewise, in our retail business, we need to demonstrate how we can improve our way of doing business with pilot studies to stay ahead of the competition.

For example, let's imagine that we produce and serve in a geographic region with a population of four billion. This means we can make 1.5 billion households happy with our products. What if we teach the consumption data of these households to AI machines, and then the machines (algorithm) tell us how much of which product the households can consume according to the weather temperature, and the people's mood, and we send these products to these houses weekly by drones? We can also add the products we have just released into the system; the algorithm can tell us which house will consume the new product (if there is already data, the new product is produced by micro-segmentation); we can add it; and we get the payment automatically. Also, we can take back those that are not consumed.

This situation will make a programmatic demonstration to maintain the image of our brands and promote new products. Wouldn't that be nice?

Likewise, if the AI-based software told us what kind of coffee and menu these homes desired, at what time, in what mood, at what temperature of the consumers in the places where Godiva Cafes serve; and if we have optimized our cafes and stores accordingly, prepared and showcased those coffees and the food these consumers want with their beverages before they arrive, and they were purchased for them before they entered the store, while they were passing by, and automatic payments were made – wouldn't that be great?

While I was writing "So we have to dream first, then we have to see how we can do it," the introduction of a company's AI sales management assistant named "Sellina" came to my email. It was sent by sales tech expert Shubham Gupta. Here's another new profession, and I don't know if they found my address with LinkedIn AI, but it's obvious that Shubham Gupta is still a real intelligence, like us.

In any case, the mail reads like this:

Good afternoon Murat,
If you had a conversation with an AI assistant when you walked into your office today:
Murat: Sellina, could you tell me where to focus on to achieve our sales targets this month? Sellina: Hello Murat, this is what you will do this month to meet your sales targets. Murat:
Thanks Sellina. Can you tell us the best salespeople in my team? Sellina: I'll find it in a second. Here are those who perform well. Murat: Why wasn't Mark's performance good?
Sellina: That's what good performers do, and that's not what Mark does.

Sellina was able to provide surveillance, coaching, and assistance to more than one thousand salespeople at the same time, increasing daily sales by 13%–18%! This is a good start that sounds like the voice control of the voice response system, and it works like an assistant – now there is something that excites me. The sales analysis programs we currently use are doing the same, although not full-time and interactively like Sellina. I guess my expectations for AI are much higher.

What does what I have written so far tell you? It seems to me that as employees engage in "decision-making under uncertainty, more cooperation, more experimentation, quickly solving common problems in different ways and creativity" features in business environments will gain importance.[12] To vary with machines, it is necessary to engage in open communication and take the initiative. "How can we do better?" Employees who think, question, and do are the most important dream of bosses. The fear of speaking up, unwillingness to act, and reluctance to point out problems is the biggest threat to business environments because, if repetitive tasks are to be left to AI, what differentiates the employees will be the ability to see problems, speak fearlessly, and create/produce solutions.

"Micro innovator" is a new term. It means always trying to do the job better. In other words, those who constantly think about how to do their job in a way that is more effective, better, faster, easier, cheaper, and more satisfying to the customer are micro innovators.[13]

This is where AI comes into play. Now, every employee needs to think about how they can do their job better, more easily, more cheaply, faster, and better with the possibilities of AI and how they can make the consumer happy. Currently, few people know the details of how a machine learns. You really need to be a "code writer" for this. For us humans to benefit from AI, we need to know what it does and how to use it to improve our business, not just for using AI software but to really get help! AI requires history data, but not as much as before. In other words, those who have processed trillions of data such as Facebook, Google, and YouTube, until today, seem to have benefited from the advantages of AI, but now monopolies in this area will be destroyed.

For this reason, it is not AI that will create today's advantage but the courage and agility of our employees. Some say that "If your employees do not use their potential such as creativity, empathy, and problem-solving techniques, then in the future, submit all your work to machines with artificial intelligence." If our job were repetitive, routine, or predictable, we would be in a competition to automate our work urgently. There is certainly an automation revolution. What computers cannot do with machines is decide how to manage the company and the machines.

This is exactly why our Human Resources Department established the Yildiz Analytical Academy. Many projects have been created by our Digital Disruption Groups. To create projects such as Route Optimization, Vehicle Load Optimization, Raw Material/Product Optimization, Sales Campaign Optimization, Store Segmentation, CRM Analytics, Product Demand Forecasting, Consumer Behavior Forecasting, Return Optimization, Order Creation, HR Analytics, Demand Sensing, and Unique Customer, we need employees who have knowledge about statistics, data analysis, and machine learning.

Let me say that there should of course be personnel specialized in AI, business analytics, and big data analysis, but now every employee should also have an awareness of what these technologies do, what analyses they do, and how they achieve results to provide us with benefits from these new technologies. Therefore, I congratulate our team who established and are now running the Yildiz Analytical Academy. I think our point of view should not be just starting from the project. We should diversify AI, and imagine which tasks can be done with AI technologies, and then turn them into projects.[7, 8]

Finally, let me touch on one more subject. It is claimed that even those who write these algorithms (an algorithm is a code written for a target) do not know why a specific result comes out after writing it, and this is called a "black box."[14] It has been said that this may bring with it serious moral and legal problems.

The lack of transparency of machine learning is partly due to the way the algorithm is trained, they say. In "deep learning," which is a submethod of machine learning, there is a large amount of data at one end of the representative neural network. For example, researchers introduced millions of dog photos to the machine. As the data traveled between the information layers of the neural network, each layer gradually picked out more abstract features to produce the correct result for the final output layer, like separating a chihuahua from a Miniature Pinscher. However, since this process takes place within a neural network, the researchers could not explain each abstract feature or why the network decided to extract a particular set of features. Unless this was disclosed, the job was getting harder. Since AI coding imitates human cognition, it is normal to include intuition, but while the human can explain his/her own intuition, the machine or the software developer cannot explain it. It was, therefore, possible for the machine to always make choices in favor of sex, race, a nation. I think this is a big lie! Your dog carries your prejudices. If you sulk at a guest, they dog will bite him or her – "crunch"! I think everyone knows full well what they are actually doing, but they already have an excuse for the immoralities and illegal practices that will be turned into: "we don't know, this is a black box."

Normally researchers do not create algorithms that make errors dangerous; rather, the problem is the people who hide the errors, not the systems that hide their errors.[1,15]

As a result, AI is now such a large sector with so many dimensions that it requires us to have software awareness to understand which articles and which news are produced for "sale." Culture and politics also affect AI. The myth of Cambridge Analytica (CA), which uses algorithms to target voter groups, who may have been influenced by the negative aspects of AI software, producing micro-targeted content aimed at the Leave EU campaign, at the US presidential elections in 2016, and harming democracy is still a myth. Campaigning with micro-targets is legal if the data is authorized. There is no research showing that personalized ads produced by CA affected the selection outcome behaviorally. Another example is the largest AI company in China. Real-time detection and identification of moving objects through surveillance videos is a "privacy" problem for the West, whereas the Chinese people do not care at all about this, and instead find it useful.[16]

Despite the GPT3 AI revolution and developments in this area, I cannot understand some people who think: Even the smartest artificial intelligence system is problematic right now. For example, partial blocking or noise deceives facial recognition systems, self-driving vehicles can cause accidents because they do not recognize stimuli, and translation systems cannot identify unusual accents. It is predicted that even the highest-level neural networks are not capable of dealing with a changing situation flexibly as even a young child could. A three-year-old child can recognize a dog, use simple sentences, and figure out how to use a tablet. Ask any robot to do this, and if it has not received any specific training in these tasks, you will see it fail. AI can only be trained for one job. There is no such thing as 'general artificial intelligence.

"Yes, machines and robots are quite unsuccessful in intuition, decision-making, and bringing out something new by blending new information because even though the machines are partially 'conscious' with 'coding,' the 'subconscious' and 'short-way' solution that feeds on emotion, the acquisition of practical intelligence seems unlikely. But even the current benefits of artificial intelligence can provide great advantages in the business environment, customer satisfaction, and cost reduction. Two years ago, artificial intelligence applications did not exist that much in our lives. Also, if algorithms that can draw flexible conclusions from learning activities (the example of changing the street name of the municipality) can be written, the nature of artificial intelligence may change. "Artificial intelligence is ultimately a tool designed to serve the interests of human coding. This should never be forgotten."[17, 18]

I closely follow business technologies and applications for analytics.[19] It is said that the speed of supercomputers in the world has stagnated in recent years, which has slowed down AI. But what is currently being discussed is that quantum computers are coming. Quantum computing is different from computer coding based on the 0/1 we know. Quantum bits can be both 0 and 1 at the same time, according to probability, so it seems that the fuzzy logic that I mentioned at the beginning can be processed more with quantum computers. On the other hand, it is said that AI applications will be more efficient if "cloud computing" is used.[20, 21] There is also the issue that big data leads us to science without theory, which is another story.[22]

I said I would tell you why my name was mentioned in the video about GPT3. As they said, currently, the cost of the latest version of this AI software can only be covered by one or two people in Turkey, and based on the video, I am supposed to be one of them. Let me warn you: if they are going to invent something by counting on me, tell them not to. I am thankfully happy with my own intelligence.

References

(1) Fan, S. (2020). *Yapay Zeka Yerimizi Alacak mi?* Hep Kitap, pp. 214–229.

(2) Chojecki, P. (2020). *Artificial Intelligence Business*, Amazon Publication.

(3) Chojecki, P. (2020). *Dijital Donusum*, Optimist.

(4) Chojecki, P. (2019). *Yapay Zeka*, Optimist.

(5) Brynjolfsson, E., and McAfee, A. (2017). *Yapay Zekanin Vaat Ettikleri*, Optimist, pp. 19–56.

(6) Arf, C. (1959). "Makine Dusunebilir mi ve Nasil Dusunebilir?" *Ataturk Universitesi*, Universite Calismalarini Muhite Yayma ve Halk Egitimi Yayinlari Konferanslar Serisi No: 1, 1958–1959 Educational Year, Erzurum, pp. 91–103.

(7) Alpaydin, E. (2016). *Machine Learning*, MIT Press.

(8) Davenport, H. T., and Ronanki, R. (2019). "Gercek Dunya Icin Yapay Zeka," in *Yapay Zeka*, Optimist, pp. 7–29.

(9) Wilson, J. H. (2020). "The Next Big Breakthrough in AI Will Be around Language," *HBR*, Sept. 25; "Artificial Intelligence: Fear or Rejoice Because of the Next Generation GPT-3," *BBC News Turkish*, Aug. 10.

(10) Fountaine, T., and McCarty, B. (2019). "Artificial Intelligence Powered Company," *HBR*, Aug.

(11) Lansiti, M., and Lakhani, R. K. (2020). "Competition in the Age of Artificial Intelligence," *HBR*, Feb.

(12) Wilson, J. H., and Daugherty, P. R. (2019). "Isbirligine Dayali Zeka: Insanlar ile Yapay Zeka Guclerini Nasil Birlestiriyor?", in *Yapay Zeka*, Optimist, pp. 177–198.

(13) Hurt, K., and Dye, M. D. (2020). *Courageous Cultures*, Harper Collins, p. 224.

(14) Davenport, T. H. (2020). "Is Dunyasinda Yapay Zekanin Durumu," in *Yapay Zeka*, Optimist, pp. 7–18.

(15) Say, C. (2018). *Yapay Zeka*, Bilim ve Gelecek Kitapligi, pp. 93–105.

(16) Lee, K. (2018). *Yapay Zeka ve Yeni Dunya Duzeni*, Optimist, p. 278.

(17) Agrawal, A., Gans, J., and Goldfarb A. (2020). "How to Win with Machine Learning," *HBR*, Sept.–Oct.

(18) Koc, O. (2018). *Daha Iyi Bir Dunya Icin Yapay Zeka*, Dogan Kitap, pp. 51–58.

(19) Thomas, R. (2019). *The AI Ladder*, O'Reilly, p. 16.

(20) Smith, B. (2019). *Tools and Weapons*, Penguin Press, p. 346.

(21) Ghose, S. (2020). "Are You Ready for the Quantum Computing Revolution?" *HBR*, Sept. 26.

(22) Leonelli, S. (2020). "Scientific Research and Big Data," in *Stanford Encyclopedia of Philosophy*, Stanford University, May 29.

Humans Are Now "Digitally Social Animals"

The above title does not belong to me. In a past article, I shared a YouTube video from the 2020 World Economic Forum, in which Klaus Schwap and Thierry Malleret, the authors of the book *Covid-19: The Great Reset*, also participated as speakers. Then, I gave a long summary of what was spoken about, adding my own views. Many of my followers asked for a summary of the book as soon as possible. Thus, I've summarized the book, incorporating my own views as well. The aforementioned title is from sentences in the book. This is actually a summary of the book.

Schwap and Malleret describe their basic scenarios about what awaits the world after the Covid-19 pandemic in three main chapters, macro, micro, and the individual. It is evident throughout history that many of the devastating consequences of pandemics are not related to the pandemic itself but to other social problems caused by the pandemic. What should be seen here is that the social and economic problems that a pandemic of this size will cause are much more important than the emergence of the pandemic itself.

Here, I will change my usual approach and give the results from the book first. Then I will include the opinions that are the source of the result. A summary of the conclusion is as follows:

After the start of the pandemic, the world today is in a different place. In this short span of time, Covid-19 both triggered significant changes and widened the fault lines that already encompass our economies and societies. Rising inequalities, a widespread sense of injustice, deepening geopolitical divisions, political polarization, rising public deficits and high debt levels, ineffective or nonexistent global governance, excessive financialization, and environmental degradation, these are some of the main challenges that existed before, and the coronavirus crisis exacerbated all of them. If we do not do something to reset today's world, we will be deeply shaken tomorrow. Failure to rid ourselves of or to correct the deep-rooted diseases of our societies and economics can increase the risks, as has occurred throughout history. Ultimately, a "reset" may spontaneously occur through violent shocks such as conflicts or even revolutions. The pandemic gives us a rare but narrow window of opportunity to rethink, redesign, and reset our world.

This is about making the world less polluted, less discriminatory, less destructive, and instead, cleaner, more inclusive, fairer, and more equitable than we left it in the pre-pandemic era; it is not sleepwalking through growing social inequalities, economic imbalances, injustice, and environmental degradation. Failure to act would mean allowing life to become crueler,

more divided, more dangerous, more selfish, and ultimately intolerable for large segments of the world's population.

Some people, frightened by the scale of this task, resist rather than agree to act, hoping that the emergency will soon disappear or diminish and that we will eventually return to "normalcy." The argument of passive people is as follows: we have had similar shocks before, and we will overcome them again.

As always, our societies and economies will be rebuilt. Life goes on!

The world situation today is indeed, on average, significantly better than in the past. We have to admit that we, as humans, have never lived in such good conditions. Almost all key indicators measuring our collective well-being (such as the number of people living in poverty or dying in conflict, national income per capita, life expectancy or literacy rates, and even the number of deaths caused by pandemics, etc.) are constantly improving. But to say they are developing "on average" is a meaningless statistical reality for those who feel excluded and even for those who are often excluded. It means billions of people, given the size of today's world population. Therefore, the belief that the world today is better than ever, although true for many of us, cannot be an excuse not to rectify the situation and not relieve the inconvenience of influential elements.

There are two key points to consider about the Great Reset:

1. Our human actions and responses are not based on statistical data but rather are determined by emotions and feelings; narratives guide our behavior.
2. Our expectations of a better and fairer life increase as we develop as human beings and our standard of living increases.

We are now at a crossroads. The first path we choose will take us to a better place, where we are more inclusive, fairer, and more respectful to each other and nature; the other path will take us to a world that reminds us of the world we lived in in the past but is filled with worse and constantly bad surprises. Therefore, we must choose the right course. Achieving the opportunities that appear before us may be more difficult than we had hoped, but let's hope our ability to reset (The Great Reset) is also greater than we had hoped for.

Yes, we are at a turning point, but we have not passed this milestone yet. Therefore, it is still difficult to see what is in front of us.

Extreme environmental emphasis. It is difficult to understand whether it is part of the movement of environmentalists to insist on what they want when they have the opportunity, or whether there is a real need in the world. The environment should not be destroyed, but human beings cannot go back to

the past and survive under the conditions of the first humans. This must be understood well.

The authors of *Covid-19: The Great Reset* first explain the three main contexts of the MACRO RESET rationale. They say that interdependence, velocity, and complexity are great reasons to start over. Here is a summary of the three contexts:

Interdependence: Kishore Mahbubani of Singapore says, "7 billion people living on planet earth no longer live in more than a hundred separate boats (countries). Instead, they all live in 193 separate cabins in the same boat. Therefore, it is necessary not to look at the issues based on contagion but to include all other pandemic risks."[1]

Speed (Velocity): There is a surprising increase in speed, and if only one thing were chosen to explain this increase, it would undoubtedly be the internet. The world, even the moon, is now online, and smartphones are everywhere. The IoT now connects twenty-two billion devices in real time, from cars to hospital beds, power grids, and water station pumps to kitchen ovens and agricultural irrigation systems. This figure is expected to reach fifty billion by 2030. We are heading toward a "Dictatorship of Urgency" that everyone demands so that everything they want happens instantly. After all, the shelf life of an approach, a product, or an idea, the life cycle of a decision-maker or of a project is decreasing sharply and often at an unpredictable rate. At the global level, the Covid-19 pandemic took three months to reach 100,000, twelve days to reach 200,000, four days to reach 300,000, then 400,000 and 500,000 cases in two days. So the number of cases increased exponentially. The same tends to happen for large systemic changes and disruptions in general: things tend to change first gradually and then all at once. Wait for the in macro level reset as well.

For example, regarding the matter of impatience, voters expect immediate results from the implementation of the policies of elected people and are disappointed when they do not arrive fast enough. For this reason, when politicians and administrators do not take into account the expectations of the people within their bureaucracy, they may face bad and unexpected results.

Complexity: In the simplest possible form, complexity can be defined as what we do not understand or have difficulty understanding. In a pandemic such as Covid-19, it was not known which variable was effective for which economic element or how it was related to other factors. Organizations such as the World Health Organization (WHO), the World Economic Forum, and the Coalition for Epidemic Preparedness Innovations established at the 2017 Davos meeting, and Bill Gates have been warning us about the "epidemic potential." These people have been stating the following about pandemic risk for years: (1) It will emerge from wildlife in a highly populated place

where economic development is forcing people to fast change. (2) It will spread quickly and silently using human travel and trade networks. (3) The virus can reach multiple countries due to our inability to confine the virus to one area. All this happened. Many Asian countries reacted quickly to pandemics (for example, SARS) they had experienced before, and they easily survived the Covid-19 pandemic. In contrast, many Western countries were unprepared for such a pandemic.

Speed Interdependence and Complexity, of course, are not just the effects of the Covid-19 pandemic. These effects began long ago and have accelerated with the advent of the internet. The perceived risk of disease, fear, and anxiety, not the real risk, changed people's behavior and made these three phenomena visible. Even now, no one can know for sure whether these three phenomena will return to their previous states when the perceived risk disappears, in other words, whether the need to reset will disappear.

Schwap and Malleret later explain the necessity of ECONOMIC RESETTING by presenting examples: "In all past epidemics in the history of the world, labor has gained strength against capital. Given the fragile economic nature of the changing, integrating, and complexing systems, the consequences of this epidemic are likely to be more devastating than any previous epidemic crisis."[2] They then elaborate and emphasize the need for a reset in key economic variables.

Uncertainty: The high degree of uncertainty surrounding the Covid-19 pandemic makes it incredibly difficult to fully assess the risk it poses. If there was a larger wave following the first wave, that is, the scenario of one or more high aftershocks in the third or fourth quarter of 2020, and smaller successive waves in 2021 (such as the Spanish flu pandemic in 1918–1919), the health system goes bankrupt. In a decreasing trend, an unpredictable small Covid-19 outbreak occurs; since decreases and increases are situational and regional, we speak of a virus that has integrated into society.

It is an economic misconception that several lives can be sacrificed for the continuation of growth: There were thousands of debates over "saving lives instead of saving the economy" during the pandemic.

Governments must do and spend whatever it takes for our health and collective wealth for the sustainable recovery of the economy.

Growth and employment: The length and severity of the recession period and its subsequent impact on growth and employment depends on three things: (1) the duration and severity of the outbreak, (2) each country's success in containing and mitigating the outbreak, (3) the consistency of every society when dealing with post-quarantine measures and various opening strategies. However, these three issues are not known. In addition, the occurrence of large or small new pandemic waves made this consistency difficult to achieve.

Economic growth: The service sector, which represents the largest component of economic activity in any developed market, was the sector most affected by the pandemic. Companies and events in various industries such as travel, hospitality, retail, or sports will face the following triple problem: (1) There will be fewer customers. (2) Consumers will spend less on average. (3) Operation costs will be higher. There is no data available yet on what the consequences of the national income reduction might be.

Employment: The size and severity of an economy is dependent on the unemployment rate of a country. Every nation is affected differently depending on its economic structure. During the Covid-19 pandemic Many companies continued to employ people working remotely. Many companies that worried about sustainability during the pandemic prefer machines to people. Low-income workers in service jobs (such as production, food, and transportation) were the most likely to be affected. Considering that many young people start their jobs in these fields, unemployment for these young people can be high.

What future growth might look like: In the post-pandemic period, it may take years or even decades for a normal national income to emerge as compared to the past. It is up to people to deal with circumstances in the post-Covid-19 period well and efficiently. In fact, this is a new path to a fairer, greener future through institutional changes and policy choices. This path raises two questions:

1. What should be the new direction of the compass to track progress?
2. Who and what will be the new drivers as we move in the new direction?

The possibility of an inclusive and sustainable economy: The enrichment of people does not bring many elements that provide prosperity; this has been proven. After the pandemic, it is possible for the green economy to come into play, encompassing a range of possibilities, from green energy to ecotourism and a circular economy. Innovation in production, distribution, and business models can lead to new jobs and economic prosperity by creating new or better products that result in productivity gains and higher added value. Thus, governments will have tools in their hands to create new sustainable policies and produce more humane public policies in post-pandemic life.

Fiscal and monetary policies: The fiscal and monetary policy response to the pandemic was decisive, large-scale, and rapid. Most governments initiated ambitious and unprecedented fiscal policy interventions in each sector. These types of interventions have seemed to continue even when the situation improved. One of the biggest concerns was that a recession as a result of uncontrolled inflation might arise. Central banks might decide that there

was nothing to worry about. However, banks should define a cap at which inflation becomes devastating.

The fate of the US dollar: For decades, the USA has enjoyed the privilege of holding its global currency reserve. This status has long been 'an imperial power and an economic elixir.' The USA has exploited this position to the point of abuse. Developing and poor countries are no longer able to repay their debt, usually in dollars. Should the dollar not be that strong anymore? This confidence in the dollar will decline over time, eventually becoming the reserve currency of only a few countries.

I also agree that the results of the fiscal and monetary policies implemented may lead to devastating inflation. The understanding of the social welfare state and especially the health investments of these states will change according to the expectations of their citizens and will be an important subject for election campaigns.

The next topic detailed by Schwap and Malleret is SOCIAL RESETTING: The pandemic has exposed the weaknesses of health and living conditions in many countries that have been known as wealthy ones. Developing and poor countries, on the other hand, suffered an economic defeat. Consequently, all countries in one way or another, have succumbed to this struggle. Successful countries did the following:

- They were ready for the future (logistically and organizationally).
- They made fast and accurate decisions.
- They have a cost-effective and inclusive healthcare system.
- They possess high confidence in a leader and in the information provided.
- They prefer to demonstrate a true sense of solidarity, a common good over individual benefit.

Apart from technical ones, inclusiveness, solidarity, and trust are community characteristics that are powerful determinants of success in containing a pandemic.

Inequalities: COVID-19, wherever and whenever it emerged, has exacerbated pre-existing conditions of inequality. The pandemic has actually made "inequality" dominant.It is impossible to ignore the plight of low-income people among people belonging to different social classes. Most evidence shows that inequalities are likely to increaseas a result of the pandemic.

Social unrest: One of the greatest dangers facing the post-pandemic period is social unrest. In some extreme cases, social disintegration and political collapse are expected.

A return to the "big" government: The pandemic has shown that surrendering a country's prosperity to companies does not provide social benefits. It was also understood that governments have not just stood there like a scarecrow. The conditions and positions of these entities were re-evaluated

in order to improve social systems, make life livable, and provide social improvement.

Social contracts: It is almost inevitable that the pandemic will prompt many societies around the world to reconsider and redefine the terms of their social contracts (their constitution).

Yes, welfare should be considered as a whole, but something that has emerged in this crisis is that companies, in order to be more prepared for crises, should be supported by their government, and the number of crises-resistant large companies should be increased by paving the way for healthy growth.

It was seen in this crisis that even giant corporations could not respond to the needs of a crisis environment with their production facilities.

The next topic addressed in *Covid-19: The Great Reset* concerns a GEOPOLITICAL RESET: The connection between geopolitics and the pandemic is two-way. On the one hand, the chaotic end of multilateralism, the global governance vacuum, and the rise of various forms of nationalism made the pandemic more difficult to cope with. The coronavirus was spreading globally, and it didn't pass anyone by. All countries were in this pit together. However, with geopolitical fault lines simultaneously dividing societies, as a result of many leaders focusing on national responses, collective activity was constrained, and capability was diminished. On the other hand, certain geopolitical trends that clearly intensified and accelerated during the pandemic, were already there before the crisis broke out. Increasing nationalism and anti-globalization sentiment emerged with inward-looking economies.

The replacement of the conventional, Western-centered social structure with a multipolar world order has forced many concepts to be reconsidered. For example, how can the US administration accept that 97% of the antibiotics supplied to the country come from China? The lack of continuity at the end of globalization lies in the solution of regionalization. In the next few years, we should expect the tensions between the forces of nationalism and openness to occur in three critical dimensions: global institutions, trade, and capital flow.

Global institutions and international organizations like the World Trade Organization or the WHO have become weakened. Countries are increasingly willing to produce their own trade barriers and restrict capital flows. Every country has a desire to master its own technology. This has led to an increasingly more centrist production and it ultimately supports nationalism and global antagonism. This situation has seemed to become much more dominant in the post-pandemic period.

Global governance: Unfortunately, we are at a critical point right now. Nations, just like humans, need rights and freedoms, norms, and rules.

However, this state of the world we live in is governed by the rule of irregularities. Global coordination is required.

Growing competition between China and the USA: After what has happened between the two countries, an environment has been created that has forced countries to stay at some point between China and the USA. This is a war without a winner, so three different situations stand out. China wins, or the USA wins, or there is no winner. However, it should be understood that this does not matter in all three cases.

Fragile and failed states: The fragile structure of some states is one of the biggest problems in the global world. Especially when a global problem such as a pandemic occurs, fragile state structures are closer to failure and collapse due to not being able to cope with the problems. The essence of their vulnerability is the insufficient capacity of the state and its inability to provide its basic function, the deficiencies of basic public services, and security weaknesses. This can result in their inability to deal with a virus.

Although this situation seems to be an internal problem of a country, it is obvious that the whole world will pay the bill for problem. It will eventually resonate in greater instability and even chaos. The most vulnerable and poor societies experiencing economic misery, discontent, and hunger will create a new wave of mass migration among themselves.

It is very difficult for fragile and unsuccessful states to solve these three issues: (1) They should build confidence; transparency is required; corruption, bribery, and use of public resources for personal benefit should be history. (2) They should solve their structural problems (3) They should be flexible; rapid solutions should be produced according to human, market, and company needs. Otherwise, they will continue to be a threat among the countries of the world as a weak link and create problems for their citizens.

Environmental Reset

Nature's relationship with Covid-19 is much closer than we might assume. Infectious diseases, climate change, and environmental problems arise entirely as a result of nature/human interaction. There are five main features they share:

Diseases spread from nature and animals: Zoonotic diseases are those that spread from animals. Most experts and conservationists agree that this process has increased substantially in recent years, especially due to deforestation (a phenomenon associated with an increase in carbon dioxide emissions), which increases the close interaction between humans and animals and the risk of contamination.

Air pollution and pandemic risk: It has been known for years that air pollution caused by emissions that contribute to global warming is a silent killer

that causes various health problems such as COPD, diabetes, Alzheimer's disease, cancer, and so on. Air pollution increases the rate at which people develop chronic and metabolic diseases and reduces physical resistance, and worsens the condition of diseases that affect the lungs, such as SARS, Covid-19, and MERS, due to the damage they cause to the lungs.

Quarantine and carbon emissions: The elimination of carbon emissions as a result of the actions people take in their daily life is one of the positive effects of the pandemic on nature. However, this is not enough. People should also use alternative energy methods (abandoning fossil fuels) and change their consumption habits. Electric cars and renewable energy can herald a good future for us.

Climate change and other environmental policies: The pandemic will affect the political sphere for years. It can overshadow serious risks such as environmental concerns. It is unclear how much importance countries will place on the environment after the pandemic. Three primary reasons may explain why this is uncertain and why focus on the environment may diminish as the pandemic risk begins to decline:

1. Governments may decide that sustaining growth "at all costs" is in the best collective interest to mitigate the impact on unemployment.
2. Sustainability in general and climate concerns, in particular, will become secondary, as companies will be under pressure to increase their revenues.
3. Continuing low oil prices can encourage both consumers and businesses to use even more carbon-intensive energy.

These three reasons can convince opponents of the value of a green economy, but there are other reasons to turn the trend in the opposite direction. Especially the following four reasons can help make the world cleaner and more sustainable: enlightened leadership, risk awareness, behavioral change, and activism.

As I mentioned above, if we take environmentalism and a green economy beyond being a necessity and turn it into a unfair ideology, the resulting picture may hamper human development. There is a very delicate thin line in this regard; one should not cross that line and threaten human freedom and welfare.

Technological Reset

Technological progress has been made at an impressive speed. AI is everywhere now, from drones and voice recognition systems to virtual assistants. However, this situation brings with it some difficulties, the most important of which is privacy. The excessive interconnectedness of digital networks is a structure that reminds people that they are constantly being watched with

developing technology. With the Covid-19 pandemic, "digital transformation" found its catalyst. All areas of business started to take their place in the digital world. During the quarantine period, many consumers who were previously extremely reluctant to rely on digital apps and services were forced to change their habits almost overnight: watching movies online instead of going to the movie theaters, ordering meal delivery instead of going to restaurants, talking to friends remotely instead of meeting in person, talking to colleagues remotely instead of chit-chatting at the coffee machine. This is like talking on a screen instead of chatting in front of you and exercising online instead of at the gym. So almost instantly, most things became "e-things": e-learning, e-commerce, e-gaming, e-books, and e-attendance. Since the pandemic, some of the old habits have most likely returned (the joy and pleasure of personal contacts can't be matched – we are social animals, after all!) However, we are part of a new social life. Now, humans are "digitally social animals." After the pandemic, companies began incorporating digital platforms that they could experience more intensely into their lives; they integrated remote work systems or joined different remote work, video chat, and sharing systems.

Thanks to the Covid-19 pandemic, we are taking part in a major digitalization pilot study all over the world. We try and take advantage of everything. No one knows how much of what we are experiencing now will become permanent behavior before the risk is over. But let me tell you how many days have passed since the last Izmir earthquake. Is there one earthquake expert, one news report asking "How do you understand the damage to buildings?" left on the screen? One characteristic of man is the ability to quickly forget everything.

Micro Resetting, Business World

A few sectors need to take advantage of the backwind to survive. The technology, health, and wellness sectors are the ones that will grow. The journey will be difficult. We know that.

Micro-Trends: It will be the responsibility of each company to make the most of the new trends. Businesses that prove to be agile and flexible will emerge stronger.

Acceleration of Digitization: Businesses already operating online have gained a permanent competitive advantage. It is no coincidence that companies such as Alibaba, Amazon, Netflix, or Zoom emerged from the pandemic as "winners."

Flexible supply chain: The pandemic ended the principle that companies must optimize their supply chains based on a single source of supply.

This means that flexibility is preferred. In the post-pandemic era, "end-to-end value optimization," a supply chain idea that includes both durability, efficiency, and cost advantage, will be valid. In other words, the "just-in-case" method will replace the "just-in-time" method, which means maintaining the stock simultaneously with the production.

Governments and corporations: During and after this difficult process, governments should treat all countries equitably , small and large, and work on protecting employee rights. In addition, governments should provide additional support for companies' continuity and adjust their economies accordingly. Whether or not stakeholder capitalism, and environment, sustainability and governance (ESG) are explicitly adopted, no one can deny that the main purpose of companies is not to pursue financial profit but to serve all stakeholders. The crisis will have created and strengthened an acute sense of responsibility regarding many issues related to ESG strategies. Following the pandemic, stakeholder capitalism and ESG will become fully integrated and internalized into a company's basic strategy and management in its boardroom. It will also change the way investors evaluate corporate governance.

Sector Reset

Sectors with social interaction at their core were the most affected by the pandemic. Among these are travel and tourism, sports, activities, and leisure, which create a very significant proportion of total economic activity and employment. However, all these sectors entail jobs where social distancing cannot be achieved easily, requiring proximity and contact.

People working in such jobs will be in a difficult situation due to these industries that were closed during the pandemic quarantine. A few consumption patterns, albeit at a different pace, may revert to their previous lines in the long run, as did air travel after 9/11. Others, like online services, will undoubtedly speed up. Some may be delayed (such as buying a car), while more environmentally friendly, new, permanent consumption patterns may emerge. People are generally open to shopping online for items such as household goods and groceries that are heavy and difficult to carry. However, in some areas that require one-to-one vision, such a comfortable change may not be experienced. Online shopping will increase. Just one change, that of spending more time at home, is the beginning of everything. If the economy continues in this wise, many companies will not be able to continue their operations and will have to shut down.

When the gap caused by this closure reaches a size that can no longer be overcome by working at home, landlords or real estate agents will have difficulty renting vacant offices. Housing prices and wages will fall, lowered

purchasing power will make prices relatively expensive, and all this will cause an economic chain reaction. Being resilient, which means "the ability to be successful in difficult conditions," will be an indispensable feature of us, a "must-have"! For those fortunate enough to find themselves in industries "naturally" resistant to the pandemic, the crisis was not only bearable but also a profitable source of opportunity in a troubled time. In the post-pandemic period, three sectors will develop to a great extent. These are the big technology, health, and wellness sectors. On the other hand, the banking, insurance, and automotive industries are three different examples of industries that have to be more resilient to get out of the deep and prolonged recession caused by the pandemic-generated health crisis.

The first rule of adapting to new conditions is to be an agile company. I agree with this. But that doesn't mean being fast. Most people think of being agile as being fast, but it's not. Agility is the ability to solve a problem where small teams are formed. Agility is really about putting the consumer first and focusing on delivering more value faster than competitors, meeting the unmet needs of a customer before anyone else. Moreover, it's not about one person being agile, but the whole company being agile. If companies can manage to be agile, they first survive and then get stronger with micro resetting.

Individual Reset

We are all reminded of our innate human vulnerability, weaknesses, and flaws. This awareness, coupled with the stress of the pandemic and the deep sense of uncertainty about what would happen at the same time, can change the way we relate to other people and the world, even internally. For some people, what started as a macro change may end at an individual level. Psychologists point out that, like most transformative events, the pandemic has the ability to bring out the best and the worst within us. It's as if humanity is being redefined. Numerous examples have shown that people are not only spending more time with each other but are behaving better toward each other as well. As the pandemic progressed, the tabloid appeal of "rich poets and celebrities" dwindled. In such a situation, we seek leadership, authority, and clarity, so the question of whom we trust becomes critical. It is clear that these are not celebrities, so who should we choose to lead in times like this? Our commitment to those close to us is strengthened, to our family and friends. However, there is another side to this: the situation triggers an unsettling rise in patriotic and nationalist feelings and religious and ethnic considerations, which also come into play. While the pandemic strained us physically and mentally, it also helped us to get to know ourselves morally in relation to many issues. Morally, was it correct to lie to

the public for their welfare, or to tell the truth to the public no matter what? Should this be based on the value of human life or on national income? Is it one for all or all for one?

Mental illness has been prevalent in most of the world for decades. The pandemic made this situation worse, and this will continue. Most psychologists seem to agree that the pandemic had a devastating effect on mental health. The main problem is post-traumatic stress disorder (PTSD) that afflicted many people after the pandemic. There is no data about what the mental health status will be in the future for people who experienced quarantine, lost loved ones, got sick, or lost their job or income.

Under these circumstances, many of the pre-pandemic needs of people changed. The list of priorities no longer consists of the social needs of people trying to continue their ordinary lives. In this process, many of us have became more interested in creative arts than ever before; we acquired new hobbies and handcrafts, and our creativity increased. Many of us noticed aspects of life, we had neglected until the present day. Many of us found practical ways to overcome our difficulties and discovered the patience to cope with difficult times, thanks to our creativity each time.

The pandemic changed our perception of time in ways we never expected. People may complain that the concepts of day and night have changed. Many people sleep and awaken at unfamiliar times. There were times when people's days were mixed up, and time never flowed. We have no idea how this process will be reflected in the post-pandemic period. However, it is obvious that most of us will have difficulties in the coming days. It is as if we are currently living and will live with "social jetlag."

Our changing consumption habits during the pandemic have caused us to spend less and consume less. Many of us tried to be prepared for new scenarios by cutting unnecessary expenses during the pandemic. Many of us gave up unnecessary expenses. We spent more sparingly and carefully. Our work for the future is based on savings. As a result, our purchases focused on necessities such as housing, nutrition, and hobby supplies. We increased book and magazine purchases. We focused on "do it yourself" products instead of ready-made products, and we became much more price-oriented than usual. Some people began to care about making or repairing something instead of buying it. Although some people took the path of increasing their morale with luxury consumption expenditures by evaluating the falling prices in this process, our expenditures generally decreased as in a typical crisis environment.

In this period, as mentioned earlier, we did our best to be good and be healthy as humans. Most of us focused on maintaining a healthy body and immune system, and some individuals consciously tried to keep their weight in balance with sports and exercise during the pandemic quarantine.

However, it is a fact that when we do not engage in activity in our life, we gain weight. People are now trying different techniques to heal and strengthen both their lives and bodies.

Obviously, in the present day, everything discussed in *Covid-19: The Great Reset* remains unclear. All the default effects may or may not happen, because the disease itself, its transmission, the recovery from it, and its spread still contain a great deal of uncertainty. No one can say the virus stays on surfaces anymore. Even the emphasis on handwashing has decreased. Have we ever been able to understand which flu we got from where and from whom? Therefore, finding a drug or a vaccine will be the solution to all problems. However, there is no proof that a vaccine will offer complete protection against the virus. I know that as long as this uncertainty continues, economic, social, and individual problems will continue to increase. However, because these problems have been experienced like this, or to an even more severe degree, even if we write such two-hundred-page scenarios, even if we make comments regarding them, it will bring about a big reset (THE GREAT RESET), will bring a restructuring in a wave from the bottom, and if there is no wave from the bottom, a reset happen. What the preference of people will be, I do not know. Another thing I do know, though, is that, regardless of class, humans are fond of human comfort, with strong egoistic feelings of nostalgia unless humans educate themselves on their desires.

References

(1) Kishore Mahbubani: Press the Pause Button. (January 27, 2021). *China-US Focus*. https://www.chinausfocus.com/special/2021forum/remarks/20896.html

(2) Schwab, K., & Malleret, T. (July 2020). COVID-19: *The Great Reset*. Agentur Schweiz.

The Unknowns of the Metaverse World Are Vast, But You Must Be Prepared!

Concepts, technologies, and products that affect the entire world emerge from time to time and are spoken about from country to country, disappearing or taking their place among the norms of daily life. The concept that has occupied the agenda of the technological world, especially in recently, stands out as the metaverse. It is difficult to predict how quickly it will take its place among the norms of life.

As a unifying novelty in the digital and social world, which has now become an indispensable part of our daily life, the metaverse promises opportunities and changes that should already be considered.

First, if we analyze this concept, which is derived from the Greek word *meta*, meaning "after, beyond," and *universus*, meaning "*kosmos*" in Latin, it refers to a fictional virtual universe where the physical world and the digital world are intertwined, and all digital universes are united.

Today's internet users can communicate with each other through various platforms and interact by joining various communities. In the new universe that is planned to be developed, the aim is for someone to do everything he/she does in physical life, in this virtual universe. That is, communication will be transformed into an experience through virtual reality and augmented reality applications, virtualizing our physical existence, almost as if we have a digital twin, our avatar traveling in this new universe, playing games, working, shopping, even having fun. Although all this is still a dream in the process of being realized through today's technology, the idea of the metaverse has never seemed so real to me since the day it first came to mind. Those who say that this is delusional will not be those who predict the future.

The concept of the metaverse was first seen in the novel *Snow Crash* by the award-winning science fiction writer Neal Stephenson. It was translated into Turkish as *Parasite*. Unfortunately, I cannot read such books due to my workload. I learned from my friends that Stephenson writes six-hundred to seven-hundred-page novels about the future. In the novel in question, the subject is a virtual universe in which people are represented by their avatars, and the concept of the metaverse is voiced. Actually, I don't think we heard about this for the first time from Stephenson. Hasn't fiction been created to define this new universe in the films the *Matrix*, *Tron*, *Total Recall*, and *Black Mirror*, and television series that I have watched with interest? The movie that most clearly enlivened the definition of the metaverse in our minds was *Ready Player One*, which was released in 2018 and directed by

Steven Spielberg. The film tells the story of a young man who goes to the virtual reality universe Oasis to get away from the troubles he experiences in the physical world. Although the story is generally a classic struggle between good and evil, the universe in which the story takes place was of a kind that would make it easier to visualize in our minds the metaverse realm, which has the potential to swallow even physical reality in the coming years.

At this moment, I should also point out that my first encounter with this metaverse world was through the tales my late grandmother told me. At that time, I heard stories about saints regarding extraordinary situations such as going to a distant place at instantly, living in a moment for a very long time, and being in more than one place at the same time (thaumaturgical teleportation).[1]

What brought the concept of the metaverse, which had only been on the agenda in movies and most games before, to the agenda of the whole world was: Mark Zuckerberg, the founder of Facebook, announcing in an online meeting with investors[2] that he wanted to transform Facebook beyond being a social media company into a company that offers a virtual world close to reality. Facebook's name was changed to Meta a short time ago to focus on this goal. Zuckerberg claims that he made the name change to permanently alter the company's route to the metaverse and create a new vision, but it wouldn't be wrong to say that data crises such as that involving Cambridge Analytica, which Facebook was also involved in, also played a role in this change so as to ease the burden on the aging tech giant.

Zuckerberg, who allocates an annual budget of ten billion dollars to create the Metaverse world, says that the future of the internet is in the metaverse concept, that existing content can only be accessed, but that with this concept, the internet will be tangible and accessible thanks to mixed reality. Zuckerberg bought the Oculus VR Company, which specializes in virtual reality headsets and software, for two billion dollars in 2014, and in the following period, he made moves to add depth to the company in this area by purchasing a game studio, BigBox VR, besides investing in AR glasses and wristbands. Oculus VR version 2 is said to be more successful and to cause less of a headache with long-term use.

If we compare this new universe, which Zuckerberg describes as the future of the internet, with our current experiences today, data/content on the internet is mutually shared between users and publishers.

However, in the new universe, it is thought to be direct interaction with 3D content beyond pure text or video content, and content can be experienced beyond reading and seeing. For example, you can view a piece of art we exhibited at Contemporary Istanbul only on screens in the Web 3.0 world, and you can read an article about the work. When the metaverse universe is realized, information about the related work will appear on the

screen you are using, and you will be able to experience the work by entering the virtual hall where the work is located.

As far as I know, the plan is to appeal to the eye with virtual reality or augmented reality applications in the early stages of this universe. However, when supported with wearable technology products in the later phases, a person will be able to feel objects at the same time.[3] Indeed, although it is difficult to imagine today, a remarkable future awaits us in terms of showing what man is capable of.

We encounter new technologies every day, but the adaptation of people to these technologies is sometimes determined by the flow of life that moves away from a routine. Virtual meetings, which were not preferred before the Covid-19 pandemic, became a lifeline for all of us who had to stay at home due to pandemic concerns, and serious technological developments took place in this area as the effects of the pandemic became extended, and virtual meetings became the new normal of the business world.

I don't know if it caught your attention, but Facebook, trying to turn the Covid-19 crisis into an opportunity, held a press conference in which it evaluated the increasing awareness of companies and introduced the Horizon Workrooms application produced for the Oculus Quest VR headset.

Stating that video-connected meetings compressed onto a flat-screen were developed in a virtual reality environment to create the feeling of meeting face-to-face in the same office, Zuckerberg stated that meetings held with Horizon Workrooms offer an interactive world due to the use of body language provided by the application, as well as the ability to convey emotion with gestures and facial expressions. Could Metaverse Presentation be the top image for selling this new app? Technology companies connect businesses so much with technology that they start and finish everything with technology, you may suspect. However, I am sure that this revolution is close. Look, even my grandmother was talking about it in the last century.

For Teams, another application that we all frequently use for digital meetings, Microsoft also announced a new metaverse solution, Mesh. In a statement made by Microsoft, they said that[4] with Mesh, they aim to create a mixed reality environment where employees participating in Teams meetings from different physical environments can join the meetings with their avatars, work on the same document, and chat.

At What Stage Are We in Realizing the Metaverse Dream?

Facebook (now Meta) and Microsoft stand out among the companies interested in the metaverse, but these two technology giants are not the only ones investing in this technology. We know that Epic Games CEO Tim Sweeney,

who believes that the metaverse will change the game world from end to end, has also collected one billion dollars from investors by sharing the company's metaverse vision.[5]

Metaverse activity is also experienced in Roblox, an online game development platform that allows users to program new games and other users to play these games. Aiming not to miss Generation Z, especially by investing in the ecosystem already exists, Nike applied to the Patent and Trademark Office and asked for its virtual products to be registered. In addition, global brands such as Nike, Gucci, and Lego have started to offer virtual store experiences on the Roblox platform.

When we put all these developments on top of *each other*, a metaphor comes to my mind that we call "emergence." Emergence refers to the coming together of parts that do not have any function on their own and revealing a talent that is not present in each part. For example, when we evaluate the wheels, wings, radar, engines, and body of an airplane one by one, they do not perform any function, but when they are brought together in a certain order, the admirable "flying" ability emerges.

I liken the metaverse universe exactly to this: technologies such as virtual reality, augmented reality, extended reality, mixed reality, AI, blockchain, 5g, wearable technologies, sensor technologies, and processor architectures, each on its own contains a function, but when these technologies come together in a certain harmony, something "emerges" and gives clues that can transform the metaverse realm from being an illusion into the new normal of the world.

I would like to talk about my personal experience. Until recently, we were in production and distribution activities in more than fifty categories at FMCG. This production continued in more than eighty factories. Although I am not an engineer, I took part in the initiation of these factories and even designed and manufactured their machines. How? First, I incubated and then made it work by imagining it on a flat white wall. I used to say to the engineers who asked, "Well, I saw it working." Then the team proceeded, like it or not.

How Does It Affect Our Business?

I think that the Metaverse universe will first seriously affect the retail industry, which is the most interactive with people. It is not difficult to predict that the purchasing preferences of consumers, who have shifted from physical stores to online/mobile commerce, especially with the effect of the pandemic, will change direction toward the virtual universe, even the global virtual universe, after the metaverse experience. I am also one of those who think that one of the most important challenges facing the retail industry

will be to prepare for the new customer expectations that will be created by the metaverse, which it is predicted will be effectively usable in ten years.

The answer to the question of how this will happen is both very easy and very difficult. It is easy because, according to the description of the metaverse, this universe will be an extension, a reflection of the physical universe. In this case, if we can successfully adapt the practices and strategies applied in physical environments to virtual reality stores, there is no reason why we should not continue our success that we have achieved in the physical world. It is difficult because, although there are many developments that we can speculate on regarding the metaverse, no one knows exactly how this universe will work yet.

Although there are a few examples that are just taking shape before us, we should not forget that these constitute the infancy of virtual retailing. Virtual Emporium is just one of the remarkable examples in this sense. Another representation of this new concept, which allows you to visit virtual stores, offers personalized customer experience, and develops its campaigns through digital channels, is being developed with the cooperation of Central Retail and Thai Telecom operator AIS 5G. This new virtual mall, where twenty international fashion brands will serve together, will be a part of the V-Avenue ecosystem, which also includes other virtual shopping points such as Asian Lifestyle, M Lifestyle, and RS Mall.

When we think in terms of needs and purchasing experience, although we may be able to do such things as access the products we consume in the physical world from our seats in virtual stores, and buy a suit we like after trying it on with AR, it should not be overlooked that an economy will emerge where people will spend within the values of the virtual world. For example, caring about the dress of your avatar in the virtual universe as much as your suit that you care about in the physical world, and allocating a budget for this dress may seem crazy for today's people , but this will be an ordinary behavior for digital natives. NFT paintings, dresses, photographs, and shoes, which we often hear about, through sensational purchase news, will also find their exact equivalent in the metaverse world. Fashion brands and sports equipment manufacturers are already investing in this universe and have already filed for patents to sell virtual dresses, hats, and shoes online.[6]

In the virtual universe, thoughts are usually centered on the objects seen. I wonder, can flavor also be digitized? When you let go of your thoughts on the subject, you reach very interesting points: An incident that neuroscientist David Eagleman discussed in his book *Incognito* was quite remarkable. Erik Weihenmayer, a mountaineer who had lost his sight at the age of thirteen due to childhood illness, regained his sight with a plate consisting of six hundred electrons attached to his tongue and Brain Port[7] glasses, even if

in a different way, and climbed Mount Everest, then appeared on the cover of *Time* magazine. Images from Weihenmayer's glasses were converted into electrical signals, these signals were transmitted to his brain via electrodes connected to his tongue, and these images were created in his brain. This development brings to mind the following question: if we transmit signals from our sense organs to our brain, albeit through different channels, will we achieve the desired result? The Brain Port device shows that this is possible.

Well, why shouldn't the same thing be possible for the digital transfer of flavor to virtual environments? We have heard about Neuralink, another groundbreaking project of Elon Musk, the founder of projects such as Tesla, SpaceX, and Starlink. Can it make this possible? Neuralink aims to create a brain-computer interface with an implant that can be connected to the human brain and digitize thoughts into commands, and manage internet-connected devices with the power of thought. The key point here is to digitize the signals in the brain because if the functions of the brain can be fully digitized, perhaps we can say that it will be possible to digitize human emotions and feelings as well. So, if the feelings of taste and pleasure can also be virtualized and put into algorithms, how will the future of food be shaped?

In such a case, it will be inevitable, for example, that we transform the pleasure created in our minds by our iconic product Halley into algorithms and present it to the consumer in NFT form in metaverse virtual stores. Consumers who want to experience this pleasure by purchasing the virtual Halley and interpreting the flavor algorithm with a Neuralink-like brain interface instead of physically consuming Halley by unpacking it, will most likely be among today's children born into the digital age. This change may seem quite impossible because the idea that we would abandon the pleasure of reading the hard-copy newspaper and instead get information from screens may seem very distant to us. But the flow of life and the preferences of young people are in favor of screens, not paper.

In the event that the metaverse, which is still in its infancy and where dozens of technology companies have invested billions of dollars in contributing to its development, materializes, we will continue to add happiness to life in both the physical and the virtual universe by adapting to this change in the best way, as in previous years and with earlier changes. If one day our customers will be happy by consuming the Halley flavor that algorithms will provide in NFT format, we should start preparing for this, to make them happy. It seems quite far away for now, but the future will come one day.

References

(1) https://islamansiklopedisi.org.tr/tay
(2) https://about.fb.com/news/2021/10/founders-letter/

(3) https://www.theverge.com/2021/11/16/22782860/meta-facebook-reality-labs-soft-robotics-haptic-glove-prototype

(4) https://news.microsoft.com/innovation-stories/mesh-for-microsoft-teams/

(5) https://venturebeat.com/games/epic-games-raises-1-billlion-to-fund-long-term-metaverse-plans/

(6) https://www.cnbc.com/2021/11/02/nike-is-quietly-preparing-for-the-metaverse-.html

(7) https://www.matematiksel.org/brainport-v100-araciligi-ile-dil-ile-gormek-mumkun/

Hype in Medicine and Health Medical Myths versus Old Wives' Tales: Who Is the Snake Oil Dealer?

More than ever, in the age we live in, we need an umbrella that can protect us from the downpour of information. Even if we cover our ears, we cannot avoid the news and may have difficulty determining which is right from which is misleading or hype. The areas of food, nutrition, and medicine that all directly concern our health are undoubtedly the areas where we fall into this trap most often. Every day, we encounter loads of information in the media that can trigger our fears or cause us to change our views.

I have previously shared the success of the Sabri Ülker Food Research Foundation children's books. By collaborating with Sok Markets, they have offer for sale almost a million books that educate children about healthy nutrition and healthy living. In addition to this project, the foundation, in order to convey accurate and scientific information in the field of nutrition and healthy living to every segment of Turkish society and to eliminate information pollution, has begun introducing internationally renowned books in the field of medicine and nutrition in Turkish for adults. The first book of the series, *Tipta ve Saglikta Balon Bilgiler* (Hype: a doctor's guide to medical myths, exaggerated claims and bad advice – how to tell what's real and what's not), was recently published, says Begum Mutus, general manager of the Sabri Ülker Foundation, in the preface of the book.

Known for her work at Harvard and University of California, Los Angeles, Professor of Medicine Nina Shapiro states that the reason she was encouraged to write this book is that many people do not know where to look for unbiased, reliable advice and that the uncontrolled and rapid spread of false information on the internet has left people shocked and confused. She calls it "the dark and light sides of search engines" and also discusses "should you Yelp your doctor?" I think we should stop diagnosing ourselves with what we pick up from healthcare sites, just as many of us are now backing away from folk medicine or old wives' tales. However, maybe our doctors should contact us in a way that we are used to on the internet, because the communication habits of society are evolving rapidly. Of course, I am grateful to my doctors who now communicate with me on WhatsApp and offer consultations via remote appointments.

Information that we believe will always be valid and that we consider having a critical value for our health can suddenly lose its validity. For example, low-fat products were thought to be helpful for dieters until it was discovered that sugar, not fat, could be the basis of obesity.

In the past, we had to bury ourselves among the dusty pages in libraries to access information, and now with a click of a mouse, the world is revealed to us by Mr. "Google," which we consult on everything from health to food, and which was added as a verb to both the *Oxford* and the *Merriam-Webster* dictionary in 2006.

While writing this book, Shapiro was impressed by a friend who had just visited Turkey, and she even came to our country to promote the book. She emphasizes that constantly circulating allegations are mostly exaggerated, misleading, and based on haphazard research, or are a juggling designed to hunt the vulnerable, and adds, "As in any profession, the medical field is full of fear traders and scammers who set their order on fear of illness or those simply seeking to be healthy. The purpose of this book is to keep you alert to the truth about popular health advice and provide an attentive, reliable guide to whether you are a diligent health consumer or patient. We'll look at ways to understand what is actually real from what is hype."[1]

In Shapiro's book, important issues such as conspiracy theories, risk management, correlation versus causation, and what is accurate, repeatable, and well-designed research are discussed. Then, answers are presented to questions that confuse most people: Is there such a thing as the best scientifically proven diet? Is gluten really that bad? Can detox be toxic? Does sugar feed cancer cells? Since when did organic become an "awesome" product keyword?

Even well-educated people can make conflicting choices when it comes to health, nutrition, and medical choices. While some people worry about consuming foods containing additives, they do not mind sending text messages or not wearing seat belts while driving. However, these actions rank first among the causes of death in accidents.

As soon as a person believes something, he/she becomes blind to evidence to the contrary and does not easily change his/her mind. This is called the "Curse of First Faith." As a result, our attention gets diverted from real risks, and incorrect decisions that we shape with artificial fears can increase.

In fact, we cannot blame the internet for being fooled by hype. Over a century before the internet, Clark Stanley built his own reputation by convincing people of the miracles of snake venom. Stanley argued that this medicinal mixture originated from an Indian doctor's secret recipe and was a panacea. However, in 1917, the hype around this product collapsed when federal agents discovered that Stanley's miraculous medicine was a fraud, consisting of some kind of snake oil, some beef tallow, and a little bit of red pepper. Stanley was out of business, but the term "snake oil dealer" is still used today to denote all kinds of fraud.

Shapiro also touches upon the importance of risk perception. Oftentimes we understand what the real risk is only after it happens to us; the widening of the gap between real risk and perceived risk pushes us to make the wrong decisions. Medical treatments, for example, all carry risks, but the benefits of treating an ailment may overshadow the risks that may arise from not doing so. Similarly, carcinogenic substances that occur during the disinfection of water may pose a risk, albeit very low, but water that is not disinfected will cause masses of people to die. Conspiracy theorists inflate health risks that actually do not exist or are very low.

One of the cunning methods of those who lead people with misleading information is the use of the terms "being connected" and "related" out of the scope. The fact that there is a coincidental relationship between two events does not necessarily mean that they have a cause-and-effect relationship. For example, the number of people running marathons and the frequency of obesity have increased like an avalanche in recent years. So can we say that marathons cause obesity? Of course not, because this is just a correlation. "Cause" is the most difficult to prove. One hundred percent correlation is required for this. Here Shapiro provides a deeper example in her writing:

> It may seem like a cause has emerged in a laboratory setting, but this causal relationship may not be seen in humans. There are many easy ways to show that a component is toxic in the laboratory environment; however, such an effect will not necessarily apply to the human body. A very simple example is our old friend table salt, whose chemical name is sodium chloride (NaCl). Leaving aside the heated debates over the positive and negative effects of salt in the diet, salt consists of two simple substances, sodium and chlorine, and both as standalone, are among the deadliest elements. Sodium is a substance that explodes when it comes into contact with water. Our hero sodium doesn't just kill cells; it can blow up laboratories too. Chlorine is a substance found in swimming pool disinfectants and bleach.
>
> It can be toxic in high enough doses. However, enough sodium chloride, in other words, salt, is the indispensable taste in our lives. In another example, the fact that a substance found in okra destroys breast cancer cells in in-vitro (glass petri dish) studies does not mean that okra is a proven anti-cancer drug.[1]

In other words, a factor shown to be caused by laboratory conditions may not have any effect on humans. Moreover, even an ingredient/food referred to as "healthy" may be toxic depending on the dose. For example, you could die if you drink too much water.

Terms such as "natural," and "organic" are given elevated value, while substances that are actually neutral in their effec are cast off in terms such as correlation, relation, connection, and cause. The words chemical, additive, and even plastic have been turned into explosive horror hype. On the other hand, accepting that natural and organic equal "healthy/safe" is always wrong and open to abuse.

Shapiro argues that the term organic when it comes to food is one of the worst mistakes of our time that automatically creates a better perception. For example, the mold aflatoxin, which can be found in nuts, is technically organic, but it is among the deadliest substances on our planet.

Contrary to common perception, organic products do not contain more nutritional value than non-organic ones. In a study published in the journal *Annals of Internal Medicine* in 2012, hundreds of different studies were examined to see if organic foods are healthier than their conventionally produced counterparts. The results showed that there was no difference in the health outcomes of people eating conventional foods and those eating organic foods.

One of the issues currently occupying our agenda is gluten, which is demonized. It is quite surprising that this substance, which has been in our food for thousands of years, has suddenly been demonized. Dr. Shapiro says, don't be afraid of gluten unless you have celiac disease, and even points out the risks of following a gluten-free diet for no reason.

Another wrongly demonized example, monosodium glutamate, or MSG, is also included in the book. In fact, the "Chinese-restaurant syndrome" associated with MSG, discovered in Japan, became famous through a 1968 letter published in the *New England Journal of Medicine*. However, despite decades of studies, there is no evidence to suggest that MSG causes symptoms or other effects related to Chinese restaurant syndrome. In fact, there is no chemical difference between the glutamate ions in the MSG we consume and the glutamate ions that occur naturally in our bodies. Did you know that we are first introduced to this substance through breast milk? So what do you find naturally in many foods like tomatoes, peas, parmesan, Roquefort cheese, or mushrooms?

There are also those who are unknowingly prejudiced. For example, many frozen fruits/vegetables have the same, or often higher, vitamin and fiber content than their fresh counterparts. Unlike similar produce harvested before it is fully ripe, in order to withstand the long journey before reaching the point of sale, fruits/vegetables harvested for freezing are both at the peak of their maturity period and are immediately shocked when they arrive at the factory. You cannot prevent the loss of nutritional value in products that you take into your home and try to freeze by the cracking of the cell membrane.

This frozen produce is significantly more affordable than its fresh counterparts, especially during off-season periods. Many consumers ignore the frozen fruit and vegetable department, and they only buy what is called fresh. However, frozen products can be more advantageous in terms of nutrition, as well as being more economical and more easily storable.

On top of all this confusion, there is also the question of how much we will get caught up in which scientific research. When the *British Medical Journal* evaluated all of the new articles published each year, it found that an average of 6% was sufficient to make sense. So 94% of these impressive studies were not well designed.

In fact, it is inevitable that we will come across studies pointing to the opposite results, especially in an area where controlled human experimentation is sometimes unethical and often very difficult to carry out, such as food and nutrition. For this reason, we need to melt all these in a pot and look at the institutional views (WHO, UN Food and Agriculture Organization, European Food Safety Authority, US Food and Drug Aministration, European Heart Foundation, etc.). When I compare the scientific information in international scientific journals with the information in the media headlines, I compare the situation to the turtle and rabbit race. As in the well-known fairy tale, the turtle (scientific opinions) always wins.

Here is an interesting example for you. Vitamins are very important for living and are defined as organic compounds needed by a living organism. Fat-soluble vitamins (A, D, E, and K) can be stored in the liver and adipose tissues until needed, so we don't need to consume them regularly. We cannot store water-soluble vitamins B and C, however, so we need to consume them regularly. A few billion years ago, the first life forms were able to produce their own vitamins, but many living creatures, including humans, evolved and lost this ability.

Linus Pauling is a name we associate with the vitamin deception experienced today. He won the Nobel Prize in Chemistry in 1954 and the Nobel Peace Prize in 1962. However, this important scientist, with what he did later, sowed the seeds of a worldwide delusion today. In 1965, Pauling wildly embraced a doctor's recommendation of 3,000 mg of vitamin C per day, which is fifty times the recommended daily dose of vitamin C (60 mg) for adults!

The vitamin C craze has been going on ever since, although many studies of thousands of subjects in numerous medical centers in the USA, Canada, and other countries did not find any benefit of vitamin C supplementation or a reduction in the incidence, severity, or duration of the common cold.

However, with a regular diet, we can get our daily vitamin C needs from food, and this is actually what is recommended. Experts say that, although some vitamins are indeed vital to our lives and some have preventive effects, most supplements are not necessary.

When Shapiro suggests that using homeopathy for the placebo effect is your decision, she talks about terrifying examples of putting your health at risk by rejecting or delaying treatments whose reliability and effectiveness

are backed by solid evidence. Homeopathic remedies can cause unwanted side effects; they can interact with medications a person is taking, trigger allergic reactions, and contain substances that are of no benefit or, worse, could be potentially harmful.

While our world is still under the influence of the pandemic, the viruses, vaccines and pandemics we are all familiar with are also discussed in Shapiro's book. After all, anti-vaccination is also a prime area for conspiracy theories. Until the Covid-19 pandemicpandemic, some people were afraid not of viruses but rather of the vaccines that protect us from them.

Unlike most other health practices, we have learned by living through the Covid-19 crisis that vaccines can have widespread effects beyond a personal decision we make for ourselves or for our family. In the first months of 2020 we were all look forward to what the anti-vaxxers would do if a vaccine was found.

Some people may not develop enough immunity, even if they receive all the recommended vaccines. In this case, the issue of herd immunity comes into play. If the majority of a population is vaccinated, those who do not have individual immunity will be protected a slightly as a result of the vaccination of the mass.

Everyone waited with curiosity for the discovery of a vaccine against the coronavirus that the world was struggling with. There had been some pandemics in the past, of which smallpox is an example. Smallpox was declared eradicated in the USA in 1972, after years of worldwide application of the smallpox vaccine. In 1977, there was a single smallpox case in Somalia for the last time, and in 1980 the WHO shared the view that smallpox had been eradicated worldwide. All these outcomes are thanks to vaccines, which societies have been artificially scared away from.

Our ancestors' saying, "Too much of a good thing is bad," is undoubtedly valid for almost everything. Even water, which makes up about 66% of the human body, can become toxic if consumed excessively because it can change the chemistry of your blood. Shapiro refers to this issue in the following words:

> There is no such thing as the best exercise, the best device, the best diet, the best supplement, the best diagnostic test, the best drink, the best skin cream, or the best medical decision. There is no such thing as perfect genetic make-up. Every road that man chooses for his health has more than one turn. At these turns, decisions are made, and directions change, and I hope this change happens for the better. As we continue to learn, what we consider ideal or bad for health continues to change.

Shapiro, a famous physician in her field, reminds us that a study for experienced scientists, no matter how large or small, is not miraculous, groundbreaking, or game-changing, and warns us to be skeptical when faced with

trendy discourses with terms such as miraculous, groundbreaking, and game-changing: "When you read something that seems incredible, be careful and take time to reflect on it. Because if something looks too good to be true, it probably is,"[1] Shapiro concludes.

Shapiro's book was translated into Turkish very successfully. The fact that the translator, Ebru Akdag, is Middle East Technical University graduate in food engineering, dramatically raised the accuracy of the translation. It is very fluid. Akdag is a successful NGO manager and general secretary of MUMSAD (Culinary Products and Margarine Industrialists Association). In order to combat information pollution on food, I curiously following the "food hippie's hunter" account on Instagram. He recently published a post titled "Poison Squad," explaining how the Food and Drug Law was born in the USA, and Professor Esat Karakaya gave his book titled *Dose and Risk in Chemical Food* as a reference. Years ago, I scanned this book by quickly by turning its pages. I found it in my library again and marked it for review. This time, my book proposal is different from the usual, but after all, it is some of what I've personally read, and don't health and nutritional behaviors affect all of our lives?

Reference

(1) Shapiro, N., & Loberg, K. (January 2020). *Tıpta ve Sağlıkta Balon Bilgiler-Şişirilmiş Sağlık İddialarını Patlatmanın İpuçları* (E. Akdağ, Trans.). Sabri Ulker Vakfı Yayınları.

Pseudoscience Creates New Heroes All the Time!

I have written before that food and nutrition is one of the most talked- about subjects, and I have even recommended a few books. It's good that food and nutrition are widely discussed subjects, but what has caught my attention is that what is unspoken is the greater problem. As an example, no one really talks much about bread and meat. Therefore, neither modernization occurs nor efficiency increases in the production of these two sectors. However, all tastes, innovations, excitement, diversity, and presentations take place in our snack category. When all this is present and is in view, of course, people are talking about us. And someone responds to what the people say. So, a mutual discussion comes about.

Which butcher has made a statement so far? Which baker has come out and made a statement! Of course, we can also look at the issue from this angle. It is good that it is being talked about. As they talk about it, people think of snacks because our products are consumed when they are seen (impulsive). As such, there is a true benefit of discussion.

You need to consider: How much do you consume products in the snack sector, and what is the habit of your body? What are your needs? For example, I pay attention to the fact that among our board members, there are people who drink Diet Coke all the time. Thank God they are all healthy. Again, a study says that chocolate makes you lose weight. Well, is a thin woman thin because she eats chocolate every day, or does she eat chocolate because she's thin? A lot of research has been conducted, but there is also a lot that the research does not say. For example, the research does not answer this question.

Let me emphasize the main issue: The main thing is to be conscious. I think the most necessary thing is to know what and how much to eat. If it were as some say, our employees would be obese and sick, but thank goodness they are all healthy, because while meals are free on the job, discount shopping is also possible! Of course, I am making some inferences that are not based on evidence, but this is my observation.

What I want to express is that many people are consuming things that people falsely say NOT to consume, yet they are extremely healthy. Let's briefly talk about palm oil. The countries where palm oil is produced, which it is feared causes cancer, are Indonesia and Malaysia. They consume palm oil in every form. According to 2012 results,[2] while the rate of developing cancer is 21% in Turkey under the age of 75, it is 15% in Indonesia and Malaysia!

At this point, I would like to introduce Taner Damci's book entitled *Being Deceived When Seeking Health*. It is a book full of content like Nina Shapiro's *Hype*, which I reviewed and recommended previously. Please don't just learn a little about this book from me; instead, take the time to read it. This is because the book is fluently and entertainingly written – the opposite of a dull read. There are even start-up recommendations for charlatans (snake oil dealers) at the end of the book. Taner is a faculty member at the Cerrahpasa Faculty of Medicine, Department of Internal Medicine, Department of Endocrinology, Metabolism, and Diabetes. He is also the president of the Turkish Obesity Foundation. He is a long-distance (ultra) runner – sort of like a marathoner. I appreciate him. Damci talks about nonsense that is presented without proof but which is characterized as scientific reality in books, social media, magazines, and on television, and calls these discussions pseudoscience and those who sell them, saviors and fake heroes!

"However, heroes in real life are few in number. They do not even know that they are heroes, or they do not accept the title because they don't do what they do to be heroes. It is often revealed later that they are heroes. But there are many false heroes around us. Those who play this role are deceiving and exploiting us,"[1] he states. He then goes on to discuss why we believe in these heroes, our predisposition to conspiracy theories, and normality. I like his statement that "Although normal is to act in accordance with the value judgments and responses of the general public in behavioral sciences, this is not always good. Because the behavior and mentality accepted in society can sometimes be wrong or even pathological and bad. Repetitive discourses, opinions shared by many, are not necessarily good."[1] He then discusses the concept of risk in health, and the connection between factual lies and evidence, with a philosophical dimension. In his book, he talks at length about fake science and charlatan saviors, emphasizing how lies are told about nutrition and how this leads to gluten-free diet mania, and the vitamin and food additive craze.

At the beginning of his book, Damci mentions the idea of "death" in ancient Greece, in Buddhism, and in Christianity; He explains with good examples that the "delusion of immortality" and the desire for immortality are the reasons why people fall into the trap of pseudoscience. However, the subject of death in Islam is not covered here. The *Turkish Encyclopedia of Islam* explains that, although death is destined in Islam, the purpose of a human being's birth is not to die but to live. Allah actually gave eternal life to Adam's progeny, whose spirit he breathed into the community and taught names (made conscious of). However, life is divided into two phases, the first phase is a kind of training and examination, and the second is the eternity process that will be shaped by the results of what is achieved in the first phase. Death is a tool that connects these two periods of life and

makes man eternal. For this reason, death is expressed with the concept of *likā* (meeting with Allah) about in twenty verses. All religions and human systems regard human life as respectable and take precautions to protect it and declare that those who violate it will be punished. Most of the things that Islam has forbidden are for this purpose. In other words, Damci's fear hypothesis does not hold true for a true conscious Muslim. I think he can focus on this subject in the new edition of his book. Also, he mentions very controversial issues, such as those who believe in religion will not believe in science. Frankly, the subject of science and religion raises a lot of debate. I believe in science and I'm religious, so let's see what happens now?

Explaining how to separate pseudoscience in this section in his book, Damci succinctly states, "Empty tins make a lot of noise."[1] I really liked the suggestions he makes toward a healthy life in the last section, so I will share a little more.

"Healthy living is not just about eating and drinking and staying away from bad habits. It is affected by all areas of life,"[1] says Damci, and offers his suggestions on the following topics:

Being patient and repetitive: In order to be healthier, it is necessary to repeat good behaviors and remove bad ones from our lives. Every food we give up on eating even though we are not hungry, every cigarette we give up smoking, or the stairs we choose to climb rather than taking the elevator is a first good step. The key is patience and repetition. Impatience and haste can cause people to make mistakes. If they are impatient or in a hurry, it is easier for people to be deceived and become a toy of pseudoscience.

Not expecting miracles and not being saviors ourselves: Believing in miracles puts us in the savior trap. Good doctors never play the hero.

It is a good idea to stay away from those who praise themselves, those who constantly talk about what they do, and those who try to explain how wonderful and successful they are on their social media pages.

Not getting caught up in the paradox of happiness and pleasure: We are constantly chasing happiness and pleasure. We pursue happiness in food, clothes, cars, our image on social media, and the "likes" we receive. Soon, these are not enough, and we look for more. There is an environment that pushes us to pursue happiness and joy impatiently and even greedily. This situation, called the happiness paradox, is one of the main problems for people today. However, it is inevitable that there will be ups and downs, happiness and pain in our individual and social lives. The way to avoid falling into the paradox of happiness and enjoyment is to reduce depersonalization with the controlled and beneficial challenges we choose. For example, sitting idly after walking or jogging, which may be boring at other times, can make people feel happy; watching a movie after finishing an assignment or writing can help people enjoy their work more; or drinking a

cup of coffee when they come home in cold weather, rather than drinking it when they have been sitting at home since morning can gives people more pleasure. These behaviors allow us to see something as a reward for our effort. Thus, we do both our work and useful things that we would not do because we are lazy, and we avoid being caught in the paradox of happiness and enjoyment.

Eating less: The biggest reason we eat a lot is that there is a lot of food surrounding us and ready to eat. We might unnecessarily consume foods that we would not eat or even think of eating if they were not around us or in a location where we can reach them easily. With the development of production technology and storage conditions, foods retain their nutritional value for a long time. The impulse to eat is a very strong one. Except in rare cases, the reason why we eat too much is not because of these feelings. Instead, it is because we substitute food for other things in our lives, or in other words, our relationship with them is problematic. One of the reasons we eat when we are not hungry is because we habitually and unconsciously consume food automatically when we encounter it. Sometimes the reason for this lack of awareness is that we are busy with something else while eating. Focusing only on food while eating increases our pleasure and helps us eat less. After all, eating less, or rather not so much, is one of the main conditions for being healthy in every condition we live in Teaching our children to establish a correct relationship to food is critical for their future.

Respect for food: The so-called nutrition gurus of pseudoscience attack our food with great force, sometimes by vilifying foods and claiming that they are poison, sometimes by exaggerating claims about them. Both situations are unfair to our food and to those of us who consume it.

Food is one of the most valuable assets in our lives. Our entire history as human beings has been lived by searching for food. We can achieve and maintain all our moral and social standards only in the presence of sufficient food. In long famines, people move away from their values and lose their the social qualities they have developed. Lists of good and bad foods baffle us. These lists can do harm to our physical and mental health. Such notions can turn people into slaves who constantly wander with dreams of food in their minds and eat the foods determined by others at certain and allowed hours. They do this so cunningly that they say, and then prove that the foods they describe as badin vain. This is ridiculous! However, the fact that our digestive system breaks down all the food we eat makes the ridiculous expectations imposed on them meaningless.

Complex carbohydrates, the most commonly attacked food today, and grains containing them deserve special praise. A massive and unfair smear campaign still continues on cereals which are the pillars of healthy eating. There are even those who go as far as sticking poison, devil, and deadly labels on them. Experienced

representatives of the same mentality that ban grains today will attack our other foods tomorrow. Because the method of pseudoscience is to constantly look for new heroes and villains, our food is just nutrition. That's why they are so important and valuable. To be healthy, we must face this attack, defend our food, and respect it.

Behaving: If we act regularly and conspiratorially, all measures of our health will improve. Moving is good for our heart, brain, and bone and other tissues. The risk of diabetes, cancer, and many other diseases is reduced. All these effects get stronger as we keep moving. The life of those who are active is prolonged, and the effects of aging are delayed. People who move more are more connected to their bodies. It helps if we understand that the promises of a miracle salvation by a short and easy are deceptve. It gets us out of the happiness paradox. After physically moving, we enjoy water, food, and the pleasant moments of life more. Moving helps people look at themselves and their surroundings with awareness. It awakens the vein of goodness in people. It increases our sensitivity to the environment and to other people's problems. Our self-obsessions and fears are reduced. It lowers the chance that we might be influenced by pseudoscientific discourses.

Doing good: Doing good is good for our own health and happiness as well as for other people. Touching the lives of others prevents us from obsessively focusing on ourselves. It breaks the circle of egocentrism that makes people shallow. It gives meaning to our lives. It makes it easier for us to notice the positive aspects and the changes in our lives. It gives us the confidence to feel that there are people and mindsets that can help us when we need it. While individual favors are great, organized ones are more effective and beneficial. Doing good is the cure for an unhealthy mentality where we are constantly suspicious, looking for a way out among conspiracy theories, looking for a flea under everything. It also allows us to better see the scarecrows of pseudoscience.

Breaking the spiral of conspiracy theories: Conspiracy theories need people's minds in order to emerge and spread. In the meantime, they increase the stress on the person in whose mind they have settled and can harm both their mental and physical health. These are also a variant of mass neurosis.

Today, conspiracy theories have become epidemic. These theories have also led to the creation of a market because the tendency to believe in conspiracy theories brings with it certain buying behaviors. We can make an important shift if we, rather than automatically believing and sharing what we hear, question the information and consider the possibility that it may be a conspiracy theory. This can reduce the stress on a person and the reflex of desperately seeking a cure.

Obtaining information from the right source: The source of information is very important. Currently, the most-watched programs and news in the visual and print media are those related to health.

This situation itself can bring with it a health problem, however. In the media, false statements are often carelessly and disrespectfully imposed on the audience as health information. There is no concern for consistency or accuracy. Unfortunately, many people use these forms of media as a source of health information. The internet and social media are double-edged swords. They are a knife with both good and bad effects on our health. Unfortunately, especially in the field of health, the bad effects outweigh the good ones. If we type our physical symptoms and lab results into search engines, we can be dragged into scary areas that have nothing to do with reality. This often throws us into the whirlpools of anxiety and into the lap of fake providers with fake treatments. It would be better not to go to the doctors with the diagnoses that we attribute to ourselves through search engines. Otherwise, the effect and benefit we receive from our physician may decrease.

Going Deeper: Today's common doctrines constantly try to make us become superficial andflat character. We also place more value on this superficial information than it deserves. We try to learn about topics from short videos that do not exceed a few minutes, to follow politics only from news summaries, and to improve ourselves based on book summaries. Even when a person goes a little deep into a subject, he/she reaches the layers undisturbedby superficialinformation. Deepening one's knowledge in any field changes one's view of other fields. One's anxiety is reduced. This in turn takes away from the power of conspiracy theories and provides a realistic and calm view of the world.

Being crazy in the right area: In some areas of life, one should walk on predetermined, proven, and rule-drawn paths and not veer off into adventures. Health is one of these areas. Our health, which is the most important issue of our lives, should not be put at risk. However, in many other areas of life, rules can be broken, impositions rejected, and new rules tried. People live with their faults, flaws, mistakes made in the past, health problems, and risks. The presence of these things should not prevent them from being happy and living a full and enjoyable life. The important thing is to change for the better, especially regarding one's health.

Damci concludes his book by saying the following:

> The spirit of the time in the field of health in society pushes us towards fears, insecurity, and conspiracy theories and makes us unhappy. Both this situation and the pseudoscience that tries to take advantage of it harm us. The power and influence of this book cannot be high enough to bring about great social change or improvement. But I hope it can bring a perspective and awareness to people reading it.

Let me be very clear, and the book was helped me a lot. For example, I advocate freedom in the food sector, and I can even say that I am like that in regard to every subject.

I think that the more freedom there is to achieve perfection not only in the food sector but in every subject, the better, because that's where the problem comes from. Even when buying food in Turkey, the state decides how you will pay the money. The state says that you have to pay in cash for food, whether for bread or chocolate, you cannot get credit, and you cannot pay in installments. Where is our traditional credit notebook? Why so? Are the bureaucrats our fathers, or our husbands? Do we the people not have that much intelligence and authority that the state must interfere with this? First, I find this strange. The more authorities interfere, and the more control they use, the more they do not release people and the more that problems arise. However, the more people are told about a subject, and the more people are educated and freed, the more progress there is.

With protection measures, the consumer is not guarded against fake science and fake products. Real competition protects the consumer. The producer has to be good in a competitive environment. If they are not good, the consumer already punishes them. This is true especially in the era of social media, where nothing is hidden. Thus, it is sufficient to raise the awareness of the consumer because then the producer does their best.

References

(1) Damcı, T. (2020). Sağlık Ararken Aldatılmak- Neden Sahte Bilimi Satın Alıyoruz? Doğan Novus.

(2) http://www.cancerindex.org/Malaysia; http://www.cancerindex.org/Indonesia; http://www.cancerindex.org/Turkey.

All Foods in Nature Are Made of Chemicals!

When I see the news, I know how the food industry, the press, and even science swing around like a donkey's tail, which saddens me. I recently read a news story that stated that "salted caramel, orange and cocoa bean chocolates made from oat milk had been launched."[1] I was once again saddened. I think this tendency plays into the hands of those who knowingly or unknowingly demonize the "processed food industry" for ideological purposes, because to call the liquid obtained by processing oats or almonds with water, milk is to deceive people. Moreover, what kind of a measure is 35% less sugar than common chocolate? At the time I saw this news, I was already reading the newly translated book *In Defense of Processed Foods – It's Not Nearly as Bad as You Think*, by the famous University of Georgia Food Science and Technology professor Robert L. Shewfelt.[2] Honestly, the book appeared at just the right time. Why had this emeritus professor waited until he had retired to write this book (an emeritus professor is retired teacher but is still on the faculty due to his/her knowledge and experience), and I understood because he had courageously made everything clear.

We know that food is the main subject of accusations and praise that hang in the air, as everyone thinks they have the right to talk about it, but as in every field, realistic interpretations on this subject require expertise. On the one hand, there are fear-inducing conspiracy theories, and on the other hand, there are miraculous lists playing into the hands of the merchants of hope and people just wondering what to do. This whole debate's main ground is actually "packaged" or "processed" foods, which are poorly defined. Some people have been conditioned to see these kinds of food as a "hazard." But what if it's not what you think? Here, Shewfelt, in his book, sheds light on all the accusations when it comes to processed food that may come to mind, on marketing strategies in the food industry, and on other questions in my mind and the minds of consumers from a scientific point of view.

Shewfelt says that so-called food scholars, whom he calls "pundits" (wise people), have created a Food Fantasyland that is not suitable for today's lifestyle. The fantasies related to this imaginary Food Fantasyland that are made to seem real are as follows:

- The food consumption opportunities of our great- grandmothers were better than ours.
- The effects of the industrialization of agriculture on society are completely negative.
- We can live modern lives without machines in our kitchens.
- We can do farming without using chemicals.

- We can eat foods without chemical components.
- We are not dependent on chemicals such as oxygen, water, protein, vitamins, and minerals.
- The number of ingredients in a food is more important than its qualities and functions.
- Long and difficult-to-pronounce terms and names represent bad things.

Shewfelt states: "I am concerned that something as serious in our lives as food is becoming reduced to a set of arbitrary rules or mindless consumption of unhealthy junk foods."[2] He is correct. In fact, the most confusing thing about food and nutrition is the changing scientific opinions. The average person, however, expects precise and understandable answers from science.

Yet science itself does not equal truth; science means getting one step closer to reality every day. Proving that something that was considered true in the past is wrong today, does not mean that someone is deceiving us. On the contrary, it means that we are going one step further with advancements in science. However, looking at the food business from this perspective is not what gains favor for the so-called food scientists and the media. Experiments based on precision in areas such as physics and chemistry can be designed. But it's not that easy in nutrition and food science. Food reviews are much more complex than the world of yes/no, good/bad, healthy/unhealthy that we want to be presented with. Complexity is a confusing phenomenon, so most of what we hear in the media in the name of science is an oversimplified, exaggerated, and contradictory version of a statement that is tweezed through the results of an individual study. This may cause us to be confused and spoil our food and what we eat.

Who does not want to eat healthy in every aspect? Yet, it must be admitted that this is not always possible given today's pace of life. We cannot find the time to prepare the foods we want due to the speed of modern daily life, and at the same time, we do not have the opportunity to separate the information that will enable us to understand what healthy food is from the polluted pile of information. Even if we are not interested, we are constantly bombarded with messages about good and bad foods. In the words of Shewfelt: "It is difficult to judge which recommendations come from careful study and which are based on oversimplifications, erroneous suppositions, gut feelings, and hidden personal or commercial agendas.

In fact, most of the foods that are declared miraculous are not as beneficial as they claim, and most products that are rejected as unhealthy are not harmful as stated. Although the 'processed food' opponents categorically mean all processed foods, in fact, almost all of the food we bring into our home is processed; we usually process the unprocessed ones in the kitchen. For example, there is no one among us who does not drink bottled water; but this product is both processed and packaged."[2]

In his *In Defense of Processed Foods*, Shewfelt refutes, with scientific evidence, the following three claims that we constantly confront in today's world:

1. Whole foods are always better than processed foods.
2. Natural is good, and artificial is bad.
3. Science and technology should not interfere with our food supply.

Shewfelt rejects individual charges against processed food in a very entertaining and enlightening way. One of the most striking of these is that processed food is said to be the cause of obesity, which has become a chronic problem. There's usually fast food and junk food at the tip of the barrel in this proclamation. But is it just these products or their excessive consumption? Or are the claims that the calories we get from various drinks do not make us feel satisfied?

Energy balance is always mentioned when it comes to weight. What would you say about the inadequacy of our effort to spend those calories while feeling guilty about the energy we take in? How many of us think we are consistently getting enough physical activity?

In fact, although the progress of science has not yet clearly revealed the underlying problems of obesity, it has shown us that it is much more complex than just an energy balance formula. Genetics are also involved. In addition to the possibility that overweight parents may have overweight children, there is also growing evidence that the mother's diet during pregnancy can cause the child to become obese throughout his/her life. In *In Defense of Processed Foods*, it is stated that if we want to win the obesity war, we should look beyond simple solutions and turn to deeper solutions.

Shewfelt also explores why processed foods have such a bad reputation. In summary of his words:

> While we encounter a lot of rhetoric that defames processed foods, there are actually very few sources that describe processed foods. There is also the concept of formulated foods. Simple processing steps such as heating, freezing, drying, fermenting, or concentrating are all examples of food processing. On the other hand, formulated products can be defined as bringing together the ingredients that make up the whole food when combined.
> But aren't these things we've done in our homes for a long time?[2]

Shewfelt gives an example of what most of us regard as a fresh product rather than processed food, a packet of mini carrots, and explains:

> In fact, these mini carrots are small pieces cut from the primary processing of large carrots before they are shipped to markets across the country. The steps a mini carrot takes from the field to the market; include harvesting, plucking the leaves while in the field, transporting them to the processing plant, washing them to remove the soil, disinfecting with chlorine, and cooling them in ice water. After sorting by thickness, the carrots are cut into 4 cm pieces, roughly peeled, polished, weighed,

packaged, and put in the refrigerator. Although these are also processed packaged products produced by large companies that we suspect will take care of our health and well-being, it does not create fear for us anyway.

The book also deals with the question "Are foods addictive?" The "happiness point" that Howard Moskowitz first defined when he was producing tomato sauces for pasta laid the groundwork for these criticisms. Critics of big producers use the "happiness point" concept, which is defined as the ratio of ingredients such as salt, sugar, and oil to optimize taste, as proof that the industry is making consumers dependent on their goods. It is a fact that serious investments are made in much research to gain the appreciation of consumers. Food scientists have developed tools to test consumers' tastes; the most common example of this is "taste panels." So what's wrong with people being happy with food and drink? We trust people to choose the individuals who will rule them in political elections, but we don't trust people to eat in correct proportions while consuming food that will make them happy? In the media, producers will put together elements that will make their audience happy; architects will add the details people want to their houses; and vehicles will provide the features of comfort that people desire, so every product is designed to make people happy, but when it comes to food, salt, sugar, and fat cannot be adjusted to their taste! Why is that? Because people love to eat and want to eat all the time. People have passed high level of consciousness for a long time, and we cannot treat our customers who receive products and services by paying their money under no circumstances. The only thing we can teach them is that they should eat in proportion, a balanced diet. I suggest that those who want to be informed about this issue should check the relevant publications of the Sabri Ülker Food Research Institute.

Another misconception addressed in *In Defense of Processed Foods* is that these foods are full of additives and other chemicals. This is another generic charge. The term "food additive" can be briefly defined as "various substances added to foods to prevent spoilage, improve appearance, improve taste or consistency, or increase nutritional value."[2] Lists of direct additives should be included on food labels. On the other hand, it is a mistake not to have a statement about what is in unpackaged foods sold in the open, as this does not mean that there are no additives in them. What escapes everyone's attention is that all foods in nature, whether processed or not, are made up of chemicals.[3]

For example, the chemical we know best is H_2O, or water. Another is salt, sodium chloride, salt on the underside, but there are those who worry when they call it a chemical and describe it as "sodium chloride."

Ascorbic acid is vitamin C, and alpha-tocopherol is the vitamin E we know. Shewfelt also warns us against the new "clean label" trend.

Fear is created in humans from warnings that are perceived as "chemical-related." Some manufacturers include ingredients in forms that appear less risky to make their labels look clean. For example, instead of monosodium glutamate (MSG), they write soy sauce, which performs the same function. Soy sauce basically has the same chemical structure and gives an umami flavor. Shewfelt also warns that the "clean label" tactic can be misleadingly used by businesses that do not have good intentions.

So what should we say about the claim that processed foods are not real, natural, or healthy? Raw eggs, fish, meats, fruits, and vegetables can be given as examples of real and natural foods. Can the question be asked, up to what stage they are considered natural? Is it any more real if the egg is cracked, the apple has been washed, the carrot has been sliced, and the tomato dried? If foods are boiled, fried, grilled, chilled, or roasted, are they still natural? So, have you ever thought about why would it badly affect the condition of a food if it were fermented, canned, dried, smoked, pasteurized, homogenized, or frozen? Does food being processed by a large company or a small family business rather than prepared at home make it less natural? Shewfelt questions all this and ends with the question, "Let's say we found a way to distinguish 'natural' from 'processed' foods – does that mean those foods are healthier?"[2]

Another criticism of food processing is that it causes losses in the nutritional value of food. A nutrient loss indeed occurs in processed foods, but why do we ignore nutrient losses in unprocessed "natural foods"? Moreover, in most cases, nutrient loss occurs much faster and to a greater degree in unprocessed foods. For example, spinach can be found at the store fresh and packaged, or in processed, frozen, or even canned form. Spinach is harvested in the field, cooled with water, and transported to the packaging facility for fresh distribution, and to the factory if it is to be processed. The fresh spinach you buy from the market or grocery store has a journey of about seven days until it reaches you, and it loses its nutritional value. That spinach to be frozen is washed, classified, possibly minced, heated to neutralize enzymes, and frozen with high technology in such a way as to prevent loss of nutritional value in at most eight hours after harvest. Frozen spinach in your freezer usually has higher nutritional value than the fresh spinach you buy from the market and bring home, so it is fresher and more natural.

The most important point neglected by the opposition to processed food is that each food we choose to consume or avoid will cause another change. So if we don't eat one, we will consume another food. Each choice has its advantages and disadvantages. "We must have reliable information to make the right choices. Neither the marketing exaggeration nor the ideological appeals and instinctual feelings of so-called experts should drive us,"(2) says Shewfelt.

I talked about the accusations that we are used to hearing so far, and now let me give examples of the accusations of the new generation that the author sheds light on. The most original of these is the "real natural foods were the foods our great grandmothers ate" approach. An educated and modern segment of people who defend this believes that their menus should be designed this way in order to eat healthily. Interestingly, this segment does not miss avocado, quinoa, and chia seeds in their kitchens, which even their mothers do not know as food, let alone their great-grandmother!

The statement that "real foods are not produced in factories, and they are grown in the field" is also a mistake. Indeed, the size of ovens and mixing equipment in large food production facilities is much larger than in households, but the principles of application are almost the same as those at home. On top of this, the processing steps taken in factories are generally done in much more sensitive and hygienic conditions than those in homes. It is not only the size of equipment in the food industry that is advantageous over our kitchens, but also the technology used is more advanced. If it is the technological advances that scare you unfairly, you should know that many of them are also used in restaurants where you eat without hesitation.

One of the most serious and surprising accusations is that every year millions of people become ill, and some even die from food poisoning. However, the solution here is that the food industry employ correct practices. The most important mission of food science is to ensure food safety.

The vast majority of food poisoning is caused by unprocessed and open-served food. It is necessary to add to this the restaurants, sales points, manufacturers that do not provide hygienic conditions or adequately control them, and the food safety violations that we engage in at home.

Shewfelt has a phrase that we need to ponder on more: "responsible nutrition." He describes it as "responsible nutrition. It requires taking into account the sustainability, safety, health, toxicity, quantity, and freshness of the food we choose to consume."[2] It would be best to consider these as much as possible in our food choices. After all, unfortunately, "sustainable options," one of the most fashionable and cool concepts of today, may not be the safest, healthiest, least toxic, and freshest alternative. Of course, it would not be very realistic to claim that we can choose by comparing all these each time. However, increasing our awareness of all these will push us to make more rational decisions.

Shewfelt describes the aims of the food industry as follows:

- Extend "shelf life."
- Increase the variety of safe, healthy, and affordable food in nutrition.
- Ensure the supply and continuity of essential nutrients.
- Ensure the profitability of the business.

Companies that establish these goals in a way to meet the needs for responsible production and consumption will always be one step ahead.

When we look at this from different perspectives, we realize that every food has advantages and disadvantages. The decision we make according to the balance between them is at our own risk. Shewfelt describes it like this: "Processed food is neither the cause nor the solution to health problems. While these are the most appropriate foods sometimes, these same foods can turn into a threat at other times. It is time to use our minds to develop diets that support healthy living by combining the generosity of nature with the benefits of technology."[2]

As in most of our decision-making, on the basis of our decisions about food lie factors such as our ideology, emotions, traditions, environment, upbringing, communication, and accessibility rather than rational approaches blended with science. Emotions lead us to classify foods as good or bad (healthy or unhealthy) when there are no sharp lines in science. However, such a distinction will inevitably bring about an unhealthy life due to unbalanced nutrition and stress rather than a healthier life. While our lives are in a whirl, it is difficult to think about, and do research; most of us find it easier to listen to someone, and go after shortcuts, banned lists, and miracles. However, regarding the subjects of food and nutrition, it is not possible for someone to tell us what and what not to eat where science has come up to until now.

Moreover, there is no one-size-fits-all solution to this issue. Therefore, our decisions about food selection and diet that are best for us are not the news in the media, personal anecdotes, and fad diets, but should be as scientific as possible. Endocrinologists and dieticians can help us in this regard in the most appropriate way for us.

Too much repetition in this book can be criticized, and Shewfelt criticizes the legitimate marketing and advertising efforts of large food companies, but when food scholars criticized as "pundits" (so-called wise) make a statement, the media loves to report their words, and there is no regulation on this issue. However, every step taken by the businesses that process our food is under the control of regulations, and any violations are punished immediately. Therefore, the conscience of society needs to act on this issue. Nobody's statements under the guise of a scientist, other than one who is an expert in his/her subject, should be respected. Studies that do not have any scientific value and that are not in-depth should not be published. Media organizations should determine and publish their scientific criteria on these issues and establish a scientific advisory board to review their actions. Otherwise, this will not only increase the stress level in the quality of life of people and be damaging, but it will also hinder the development of our

food production and processing industry, which is a competitive advantage in Turkey.

References

(1) https://www.thegrocer.co.uk/new-product-development/startup-happi-launches-oat-milk-chocolate-range/652876.article.

(2) Shewfelt, L. R. (2017). *In Defence of Processed Food*, Copernicus.

(3) https://jameskennedymonash.wordpress.com.

Everybody or Nobody? Is It All or Nothing?

Do you remember when you were little, objecting to your parents saying, "Mom, nobody does it like that anymore," or "Mom, everyone does it like this, why can't I?" Likewise, do you remember that eating something in between meals is considered unhealthy or seem harmful in some way? How often do we use these generalizations? Here is how much this generalization and simplistic thinking misleads us, especially if these approaches are used in research as a methodology and if scientific inferences direct our lives with the same generalizing approach.

I recently came across an eye-opening article on LinkedIn that examines the effects of sugar on us in-depth and from every angle. The author of the article, Emeritus Professor Doctor Fred Brouns, reveals scientific facts by evaluating the subject from a perspective different than what we are used to. However, we are accustomed to feeling guilty for the sugar we need in sufficient doses for our brain and body to function properly. Is this subject really that simple?

Broun's article amply answers my question. But first, to understand it thoroughly, let me remind you of some technical information that my job has taught me, which will help us:[1]

1. What we call a carbohydrate is a biomolecule consisting of carbon (C), hydrogen (H), and oxygen (O) atoms. Biomolecules are the basic building blocks in living things.
2. Carbohydrate is synonymous with saccharide, containing sugar, starch, and cellulose.
3. Sugars are the building blocks of all carbohydrates. They are classified as monosaccharides, disaccharides, oligosaccharides, and polysaccharides.
4. Monosaccharides are single-unit sugars such as glucose, fructose, and galactose.
5. Disaccharides are a combination of two separate single-unit sugars, like table sugar (sucrose).
6. Polysaccharides are long chains of single sugar molecules, like starches found in potatoes, onions, and carrots.

Three main factors determine the effects of saccharides on our metabolism and health. First, saccharides can be classified according to their polymerization degree (DP). However, the molecular composition of saccharides with a similar DP may be different; this affects digestion, absorption, and metabolism.

The second factor is the physiological classification based on digestibility and rate, and speed of absorption and glycemic response. The health status of individuals also plays a role in this context. The metabolic responses of an active, fit person and an overweight, as well as sedentary person with insulin resistance, will be different. However, this approach alone is not the answer because what else is eaten at the meal in which these carbohydrates are taken in, and their characteristics affect our body.

Third, carbohydrates can also be classified by comparing functional/technological properties such as relative sweetness, viscosity, and solubility. If a scientific and realistic interpretation is to be made about the effect of sugars on our health, all these factors should be taken into account.

Measuring the effect of a single property of a particular sugar group and drawing conclusions almost always leads to false conclusions. Accusations about fructose, for example, are the best example of this.

Different sugars may be similar in terms of their monomer composition (glucose, fructose, and galactose), but the bonds between these components may vary, differentiating their effect. Glucose and fructose are different when consumed alone, and when consumed together, they can have different effects on the digestive system. Even the same sugar being in a solid, liquid, or viscous state causes different physiological responses.

The potential of carbohydrates to raise blood sugar levels is often expressed as the glycemic index (GI) value. High GI causes blood sugar to rise rapidly, and therefore, a low GI is considered better. For example, the GI of French bread was found to be one hundred, while that of French fries was ninety-five, that of normal boiled pasta was fifty, that of boiled potatoes was fifty-three, bananas forty-eight, fructose fifteen, sucrose sixty-seven, rice fifty-nine, white bread seventy, and whole-grain rye bread fifty-eight.[2]

The GI value alone does not fully explain the physiological effect of foods on health. The amount (dose) of GI consumed is also important. In addition, the GI effect is affected by other factors that influence digestion and absorption in addition to the rate of consumption of food. For example, the amount and type of carbohydrates, the amount and characteristics of fat, protein, and dietary fiber, processing levels, and liquid or solid form.

The sugars you see on food labels usually mean monosaccharides and disaccharides. These are simple sugars that contain glucose and fructose together. But the metabolism of each of them is very different; they differ in their hormonal responses such as insulin secretion, their use as an energy source in the body, and their storage as glycogen or lipid.

The findings from Brouns' latest research are crucial. He states:

"For example, fructose is shown as the culprit of fatty liver. Glucose and fructose are often compared separately as monomers in metabolic studies, but in fact, we

humans rarely consume fructose alone because high fructose corn syrup (HFCS) contains 55% fructose and other sugars. In HFCS-sweetened beverages, juices, and even fruits, fructose is not found alone but together with glucose and other sugars. Therefore, the data obtained from the research results of the experiments prepared by consuming high amounts of fructose, which is well above the general human consumption, do not reflect the normal human consumption in real life, and it is exaggerated. There is no evidence that all of the fructose from sugary drinks and juices, as claimed, goes directly to the liver and converts to lipid (fat). In contrast, most fructose is converted into non-lipid substrates (decomposition materials).[2]

Brouns says: "In the research setting, they only load people with high doses of fructose that are never consumed in daily life. Therefore, it is an urban legend that sugar is harmful to the liver."[2]

Brouns adds,

"The metabolism of isolated monosaccharides and disaccharides (glucose, fructose, and sucrose/table sugar) is basically similar to that found in natural sources containing mixtures of these sugars, such as fruits. It should also be remembered that whether the food is liquid or solid, it can play an important role in the rate of digestion and absorption. The effects of a sugar-added beverage will be different from the effects of other ingredients in the recipe for a sugary snack product; the drink causes a faster rise in blood sugar and insulin."[2]

In the meantime, it is useful to mention that the reason why research on fructose is constantly being conducted in the USA is that they manufacturers use mostly HFCS produced from corn because it is more economical. This is a sugar derived from corn, which is mostly used by a country that is dominant in scientific research such as the USA, and of course, most of the research focuses on HFCS. Perhaps this is the reason why other sugar types are not included in more research.

Almost all of the sugar is obtained from corn in the USA because corn cultivation is preferred by farmers due to its efficiency and cheap cost. While the vegetation period of corn (difference between emergence and harvest time) varies between 90 and 120 days, this period is 170–200 days for sugar beets. For a high yield, while corn has a water requirement of approximately 480 mm during the development period, the water consumption of sugar beet is approximately 900 mm. In addition, beet fields must be left fallow every few years.[3]

There is an economic war between US corn agriculture and Brazilian sugarcane production and Europe regarding sugar beet agriculture. Lobbies wage a constant effort to influence governments. However, sugar always remains on the agenda during this discussion process and all candies, regardless of their type, are assumed as bogeymen.

As a result, tweezing a particular property of carbohydrates and looking at its effect almost always leads to the wrong conclusion, such as the

judgment that fructose is harmful. Assessing a "holistic point of view" can only be done by reflecting on how fructose is used in real life. Stating that it is harmful to health when consumed at excessive levels and in isolation, unlike in daily human consumption, to reject it by saying it is harmful to one's health is for science to demonize a harmless and necessary building block for the body. Therefore, instead of making inferences as a result of research and experimentation based on a single component, it is necessary to focus on the general effects, dose, interaction, and quality of carbohydrate sources and meals and to conduct multicomponent research. Because real life has many aspects, simplifying it in the lab doesn't make real-life simple, but misguided research can make people's lives difficult by suggesting that risks that are not relevant, are important. If we recall the early days of the Covid-19 pandemic, scientists were telling us how long the virus remained on certain surfaces. Therefore, housewives had to disinfect even the packaging of the items they bought. A year later, this information was no longer valid. I hope the number of scholars like Professor Doctor Fred Brouns, who provide us with accurate information about the facts and necessities of life, increases.

References

(1) "Sugars: A Scientific Overview," IFT.org, www.ift.org/career-developm ent/learn-about-food-science/food-facts/food-facts-food-ingredients-and-additives/sugars-a-scientific-overview.

(2) Atkinson Fiona S. et al. (2008). "International Tables of Glycemic Index and Glycemic Load Value," *Diabetes Care*,. Volume: 31 Issue:12 pp. 2281–2283; https://www.glycemicindex.com/oodSearch. php, University of Sidney online searchable data GI.

(3) Brouns, F. (2020). "Saccharide Characteristics and Their Potential Health Effects in Perspective," *Frontier Nutrition*, 7(75), https://www. frontiersin.org/articles/10.3389/fnut.2020.00075/.

Moo's Law: An Investors' Guide to the New Agrarian Revolution

Author Jim Mellon, who is himself an agricultural investor and studied philosophy, politics, and economics at Oxford University, begins his book *Moo's Law: An Investors' Guide to the New Agrarian Revolution*, by quoting Saint John Henry Newman (1801–1890): "Animals have done us no harm, and they have no power of resistance. There is something so very dreadful in tormenting those who have never harmed us, who cannot defend themselves whose fate is in our hands."[1]

In fact, he suggests the question is: "Why do we have to talk about animal rights today when Universal Human Rights have not yet been made a common value for all people living in the world?"[1] It would be correct to answer this question with data, states the author, and he explains: Food accounts for more than a quarter (26%) of global greenhouse gas emissions. It is known that 70% of freshwater consumption worldwide is for crops and livestock, primarily related to farming and meat production. It takes 4,325 liters of water to produce just 1 kg of poultry meat. Just think about the amount of water consumed for other cattle meats. By 2030, it is estimated that more than five billion tons of animal waste will be produced annually by global livestock. This will lead to the contamination of both the soil and water.

Mellon then cites a portion of the text in which Jeff Tietz of *Rolling Stone* magazine explains in detail some of the components of the waste produced by factory-raised animals: ammonia, methane, hydrogen, sulfur, cyanide, phosphorus, nitrates and heavy metals, and more than one hundred pathogens that can make people sick. In today's processes, these harmful components spread into waterways, are used in fields, and are even sprayed into the atmosphere, which authorities have proven can cause serious harm to humans.

It doesn't take any more data or wordage with a second question to understand the seriousness of the issue. The bells are ringing for us. Mellon continues: The United Nations predicts that we will need to produce 50%–100% more meat by 2050. Change is necessary, and if action is not taken without wasting time, putting aside making Universal Human Rights a common value for all people, we will suffer just in how to share clean water. War is a probable outcome.

Mellon's book *Moo's Law: An Investor's Guide to the New Agrarian Revolution* discusses the causes behind radical changes in human consumption of animal products, how such changes can be brought to life under the pressures of the economic system, and the forces that shape them, and makes

predictions about future scenarios by raising for consideration motives that can mobilize and even encourage the key players who take part in this revolution.

As the title of the book makes clear, the point is not to babble about animal rights. The "Agrarian Revolution" is a reality whose needs must be met unconditionally, and there is a wealth of scientific data to demonstrate that we do not have much time left. In his book, Mellon lists seven reasons why this revolution must take place, in other words, why meat should be produced in factories rather than obtained from animals in a new way.

First, we live in a world where current farming and animal husbandry methods directly threaten human health. The Covid-19 pandemic is great evidence of this. Dispensing with a flip-flopping point of view, we should strive to improve the world for future generations, rather than just thinking about our own limited life span. The Agrarian Revolution alone has the capacity to prevent the occurrence of the conditions mentioned above by changing the way in which the proteins we need to live enter the food chain.

Second, as outdated agricultural practices are one of the main causes of global warming, it is necessary to identify these practices, especially with regard to how livestock is raised. For years, such methods have been employed only for the purpose of obtaining a greater profit. How can any long-term benefit be seen with such a system? As the Agrarian Revolution has a structure that will radically change all currently functioning systems, it will bring about a great reduction in harmful greenhouse gas emissions.

Third, the industrial processing of animals and animal products can be described as "brutal" at best and "repulsive" at worst. With the Agrarian Revolution that implements the opportunities created by technology, there will be no need to torture animals to the current degree in order to meet our protein needs and enjoy eating animal products.

Fourth, 80% of global deforestation is caused by the use of existing restrictive farming methods. With the new production methods that the Agrarian Revolution will bring, it is possible to reverse the damage to the land and the extent of land use.

Fifth, the amount of water required for animal production is quite high. In a world where the livability of all countries is under threat due to the lack of reliable water resources, the use of our important but limited water resources will decrease significantly with the applications brought by the new Agrarian Revolution.

Sixth, thanks to the Agrarian Revolution, the quality of protein production processes will improve, and nutritional standards will substantially improve with the addition of healthy nutritional supplements to these proteins. In addition to these positive developments, the unwanted and harmful

by-products of current food production (micro plastics, mercury, and cadmium) will also be significantly reduced.

Seventh, it will be inevitable that we will produce "clean" foods while producing other traditional products (vegetables, grains, and herbs) in factories and laboratories developed using advanced technologies, which are a prerequisite for the realization and continuation of the Agrarian Revolution. The food supply industry will more than make up for the jobs periodically lost on traditional farms and offer a much more decent working environment.

After listing these reasons, Mellon raises another very important question that needs to be answered. He says, "It is possible to switch to creating a guide for investors," only after answering this question: "What are the prerequisites for realizing a revolution with such destructive dynamics in an area where consumers have such well-established habits?"[1]

Awareness of the impact of consumers' consumption habits on the environment should indisputably be considered a prerequisite, but the tone of communication will be extremely important here. Even if the communication strategy, tactics, and tone are correct, it is very difficult to create this awareness. Let's take the example of smoking, whose harm to human health has been repeatedly proven by many health authorities. How are we going to internalize environmental problems and find the courage to break with our taboos and convince people that it is necessary to regularly consume factory-made "meat" that does not contain any animal additives when even the decision to quit smoking for our own health, which is relatively easy, is quite difficult.

Some masses have already accepted this revolution and voluntrily use "plant and cell-based" products regularly. These are individuals over forty years old, with high health awareness and intellectual level, open to change. Also, young people who are between the ages of sixteen and twenty-four, with great environmental awareness and with a highly developed sense of empathy, are also included in this group.

The author says we don't have much time. Since 2020, Mellon has been saying the Agrarian Revolution will happen, and in the future, we will stop torturing animals for meat.

Not a long time ago, in 2000, if they had said to a thirty-five-year-old investor, "There will be no oil-powered cars in Europe by 2035," they would have probably been laughed away. Today, all car manufacturers have adopted the "If you can't beat them, join them" strategy. Mellon's book states that the major food producers are doing the same right now.

The main title of the guide prepared for investors to focus on this field is to end the cruelty against animals discussed in Mellon's book and to leave a sustainable world to future generations.

The visions of these key players in the sector are quite high. They spend a lot of time using technological processes to produce food that, apart from its nutritional value, has a similar texture and taste to meat that is obtained from animals. They struggle with regulations and lobbying activities. Even if these efforts result in the food they produce being described as "Franken food," they are sure to find ways to combat it. In fact, Mellon believes that this revolution will begin soon in Singapore. He says there's no reason why technological processes should intimidate investors. This is because, according to him, the production prices in the future, in the Agricultural Revolution, will be considerably lower than the current costs of production processes for animal foods.

There are approximately 430 players worldwide in the plant-based meat market. Beyond Burger (Carl's Jr. and McDonald's [through Burger King]), and Impossible Burger (through Burger King) are the two brands with the highest brand awareness among these players.

Mellon mentions that giant companies that use traditional production methods have started to follow the strategy "If you can't beat them, join them." He suggests that investors should definitely evaluate this situation in making their decisions. Excluding dairy products and other plant-based foods, the worldwide plant-based meat market is currently valued at approximately twelve billion dollars, and the market size is estimated to reach twenty-eight billion dollars by 2025. While the market for meat substitute products in Western Europe was 1.35 billion euros in 2015, this figure is expected to reach 2.35 billion euros in 2022. Over three hundred million dollars has been invested in this sector over the past two years, and meat production giants are taking action to capitalize on this developing market and meet the growing demand for vegan proteins. Looking at the numbers, the growth momentum of the market is high.

However, there are some situations that may frighten investors. To list the main attack headings against cell- and plant-based foods: There is claim that they are not natural or healthy, and bear the label "Franken Foods"; the environmental damage brought by traditional agriculture is exaggerated; livelihoods and traditions are at stake; in a world where the density of animals is reduced, topsoil erosion will occur, and consumers who want "normal" products will not accept "new" ones that are out of the norm.

However, Mellon refutes such arguments based on data obtained from scientific research. He emphasizes that there is a majority that is willing to consume new products and even does consume them. In addition, the fact that this revolution in the industry is a "necessity" for the future of the world, strengthens the hand of investors, he says. He states that environmental awareness and the number of people who eat vegan are increasing day by day, and people are in search of meaning in their consumption.

Even with strong lobbying, Israel, Singapore, China, and Japan are countries where development is expected in the first phase, while Europe is currently in the people present at event audience, he says. Based on his experience, Mellon states that, besides these countries, the Middle East region will be one of the leading regions in the vegetable- or cellular-based foods market in the future, even if it seems difficult at the moment. The book also contains a section at the end where companies in the sector are examined.

If you ask me, I would call 'nonsense', but I'm not sure. People now make their consumption choices in such a spoiled manner and even under the bombardment of communication by various so-called authorities acting with concern for ratings. For example, the environmentalist, sustainable, and even domestic/national lifestyle and consumption preferences revealed in consumer research are never reflected in real figures. Nobody is a "walk the walk" person, and everyone is all about "talking the talk."

While the number of skilled, and farm animals in the developed Western European countries is greater than the number of their citizens, who will give up this economy or their habits, that is, their comfort?

"Maybe it is necessary to limit the greenhouse gas effect (digestion and defecation) of the human population! Now, we should only be fed with intravenous medical preparations. We should avoid the pets that accompany us in our homes. Maybe the dinosaurs were destroyed by the authorities at that time because their carbon emissions were too high and inefficient"[1]

The discussion in Mellon's book may seem like a fairy tale today, but it can make sense to those of us who are not afraid of change and can internalize it. I think that those who invest in this marginal field, for now, will make good money. In any case, I am not against technologies such as meatless meat, and soilless agriculture. Yet, I do not find all the reasoning given for its necessity justified and logical. Maybe in certain areas in our world geography, it could be necessary in some cases. In Turkey, however, I consider it futile when we cannot even make use of our existing natural resources in the field of agriculture and animal husbandry. However, solutions can arise from it, such as soilless agriculture as a strategic requirement in a desert land or meatless meat production for the mobility of armies.

Reference

(1) Mellon, J. (December, 2020). *Moo's Law: An Investor's Guide to the New Agrarian Revolution*. Harriman House Publishing.

What Does Bill Gates Mean?: Will Our End Be Worse Than the Coronavirus Pandemic If We Do Not Zero Out Greenhouse Gases?

When Bill Gates' *How to Avoid a Climate Disaster: The Solutions We Have and the Breakthroughs We Need* hit shelves on February 16, 2021, I was intrigued, and I bought the book and examined it with genuine curiosity.[1] As I have written before, all Yildiz Holding companies make great efforts toward sustainability. In the most recent S&P Corporate Sustainability Assessment, Ülker is among the top 631 companies, covering 7,000 companies in sixty-one sectors. We became the first and only Turkish company among twenty global companies in the food products category. We care about the issue of climate change.

Gates begins his book by saying: "There are two numbers you need to know about climate change. The first is 51 billion. The other is zero."[1] The first is an average of fifty-one billion tons of greenhouse gases the world releases into the atmosphere annually. The other is the number of carbon emissions that should be our target. In order to stop global warming and climate change, the greenhouse gases released by humans into the atmosphere must be eliminated. Because the number of people is increasing, carbon emissions are also increasing, and the number of trees to clean the air is insufficient; thus, natural transformation cannot occur and the ecological balance is disrupted. According to Gates, if the amount of carbon emissions is not zeroed out, the world will face expected but unpreventable disasters in a very short time. His claim is: "I believe that things can change. We already have some of the tools we need and as for those we don't yet have, everything I've learned about climate and technology makes me optimistic that we can invent them, deploy them, and if we act fast enough, avoid a climate catastrophe."[1]The late scientist David MacKay, a professor at Cambridge University, shared a graph showing the relationship between a country's per capita income and energy consumption. "The chart plotted various countries' per capital income on one axis and energy consumption on the other – and made it abundantly clear to me that the two go together. Eventually, it sank in. The world needs to provide more energy so the poorest can thrive, but we need to provide that energy without releasing any more greenhouse gases."[2]

Gates deepened his research into this subject. He invested several hundred million dollars in "clean" energy companies. He gave orders to establish a

company to design a next-generation nuclear power plant and to generate clean electricity and very little nuclear waste.

He was continuing on that course when disaster struck in 2020. It was no surprise to Gates when the coronavirus spread around the world. He had been studying disease outbreaks and was deeply concerned that there would be such a pandemic and the world wouldn't be prepared for it. In fact, some conspiracy theorists were ridiculous enough to say that he had Covid-19 produced in the lab, as he had predicted the pandemic in 2015!

By November 2020, the Gates Foundation had donated four hundred forty-five million dollars for the prevention and treatment of the disease. The link he established between the coronavirus and greenhouse gases is interesting! As Gates explains:

> Because economic activity has slowed down so much, the world will emit fewer greenhouse gases this year than last year ... Consider what it took to achieve this 5 percent reduction. A million people died, and tens of millions were put out of work. To put it mildly, this was not a situation that anyone would want to continue or repeat ... In real terms, that means we will release the equivalent of 48 or 49 billion tons of carbon instead of 51 billion. Just as we need new tests, treatments, and vaccines for the novel coronavirus, we need new tools for fighting climate change: zero-carbon ways to produce electricity, make things, grow food, and keep our buildings cool and warm, and move people and goods around the world. And we need new seeds and other innovations to help the world's poorest people, many of whom are smallholder farmers, adapt to a warmer climate.[1]

Gates is aware that he is "flawed" in terms of his social status in describing the phenomenon of climate change. He knows all too well the world lacks no rich men with big ideas, and he owns big houses and flies in private planes. "Who am I to lecture anyone on the environment?"[1] he says. However, that doesn't stop him from speaking the truth.

So far, he has invested more than one billion dollars in new initiatives and approaches that he hopes will help the world achieve zero emissions, including affordable and reliable (clean) energy and low-emission cement, steel, meat, agricultural crop production, and more. There's nothing wrong with using more energy as long as it's carbon-free, he says. I wonder. I don't know, but I think unnecessary spending is a waste. The key to addressing climate change is to make "clean" energy as cheap and reliable as the energy produced from fossil fuels. Gates thinks that this will make a significant difference, and create a shift from fifty-one billion tons a year to zero in the world. That's why he says he is making an intense effort toward achieving this goal. The reason he wrote his book *How to Avoid a Climate Disaster* is to share what he knows. Let me contribute to this goal of his by providing a broad summary.

The book consists of an introduction, twelve chapters and an afterword. Let me tell you now, the subject called "green premium" that he proposes to get rid of greenhouse gas is very important, and how logical a 'zero greenhouse gas' target is. Moreover, how much more would people pay for a product or service that does the same job only for social benefit? I am worried about this! In addition, differences in development levels between nations affect their priorities and perspectives on these issues.

Gates asks: "Why zero?", then explains his answer to the question. The reason we want to reach zero is very simple. Greenhouse gases trap heat and cause the Earth's average surface temperature to rise. Fifty-one billion tons is the annual carbon dioxide equivalent emission of the world. Greenhouse gases emissions have increased significantly since the 1850s due to human activities such as the burning of fossil fuels.

Carbon dioxide emissions and the average global temperature have been rising since 1850. How do greenhouse gases cause warming? These gases absorb heat and trap it in the atmosphere. They work like a greenhouse. Hence, the term greenhouse gas. So does it have to be zero? Yes! Because every piece of carbon we release into the atmosphere contributes to the greenhouse effect. This is the law of physics.

In a warmer climate, storms are more intense, with more rainfall in some places, but with more frequent and more severe droughts elsewhere. Warmer air holds more moisture and draws more water from the soil. The warmer climate means more frequent forest fires. The warm air absorbs moisture from the plants and the plant soil. Everything is more prone to burning. Another effect of extreme heat is sea-level rise. This is partly because polar ice melts and seawater expands when it warms up. These new conditions might be good for some varieties of crops such as maize, but not for all types of crops in the world. It will even cause some different plant species to die. Also, the survival of animals is in jeopardy. A number of marine species will disappear due to reduced oxygen and changing ocean temperatures.

You may think that the 1.5–2 degrees temperature difference is not that big. A two-degree increase might be thought to be 33% worse than a 1.5-degree increase, but scientists say the difference is 100% bad. This means twice as many people will have problems accessing clean water.

You have to think about the effects of climate by adding one effect on top of another. All effects will have a cumulative combined effect. For example, as the weather gets warmer, mosquitoes will start living longer. Cases of malaria may appear and insect-borne diseases may be on the rise more than ever before. An interconnected destruction may arise in nature.

In chapter 2, Gates says, "This Will Be Hard," "don't despair, there is a solution!" Then he explains the remedy: Everything we eat, drink, and wear,

along with fossil fuels causes an increase in greenhouse gases. Fossil fuels are everywhere for a very simple reason: They are cheap! Gasoline is always cheaper than soft drinks. People around the world use more than our billion gallons of a cheaper product than diet soda every day, and even that alone is a reason not to give up.

It takes quite a long time to adopt new energy sources. Notice how coal has progressed from 5% of the world's energy supply to about 50% in sixty years. However, natural gas only reached 20% in the same period, and this took seventy years. Nuclear fission went quickly from zero to 10% in twenty-seven years.

There is no true consensus on climate change. Gates says 97% of scientists agree that the climate is warming due to human activity. There are still small, but in some cases politically strong groups of people who cannot be persuaded by science. Even if you acknowledge the reality of climate change, this idea is difficult to accept, as large sums of money must be invested in breakthroughs designed to deal with it. Some people, for example, claim that climate change is happening, but they don't make any significant efforts to try to stop it. Instead, they think that priority should be given to other things that hold a greater benefit for humans' well-being, such as health and education.

In chapter 3, Gates explains and provides answers to "5 Questions to Ask in Every Climate Conversation":

1. How much of the fifty-one billion tons are we talking about? The aviation industry in Europe says it reduces its carbon footprint by seventeen million tons every year. The annual emission reduction of seventeen million is about 0.03% of global emissions. Well, is this a meaningful contribution? It depends on the answer to this question: will the number increase or stay the same? If this program starts at seventeen million tons but has the potential to reduce emissions by much more, that's a good thing. If it will stay at seventeen million forever, that's something else. Unfortunately, the answer is not always straightforward.
2. What's the plan for cement? Steel and cement production alone accounts for about 10% of all emissions. Remember that emissions result from five different activities and all of them require solutions. Below are the activities and their proportion of total emissions:

- Producing something: cement, steel, plastic (31%)
- Plugging in: electricity (27%),
- Growing: plants, animals (19%)
- Travel: airplane, truck, cargo ship (16%)
- Air conditioning (7%)

Reaching zero means resetting each of these categories.

3. How much power are we talking about? This question arises mostly in articles about electricity. In these publications, you can read that a new power plant will produce five hundred megawatts. Is this a lot? When you hear one kilowatt, think of the electricity consumption of a house; when you hear one megawatt, think of the electricity consumption of a small town; when you hear one gigawatt, think of a medium-sized city; when you hear one hundred or more gigawatts, think of a big country; when you hear over five thousand gigawatts, think of the world's electricity consumption.

4. How much space does one need? Some power supplies take up more space than others. This is important because there is a limited amount of available land and water. Generated power per square meter: 500–10,000 watts for fossil fuels, 500–1,000 watts for nuclear, 5–20 watts for solar energy, 5–50 watts for hydropower (dams), 1–2 watts for wind energy, and less than 1 for wood and other biomass. The power density of solar energy could theoretically reach 100 watts per square meter, but no one has been able to achieve this. If someone tells you that one source (wind, sun, nuclear, etc.) can provide all the energy the world needs, ask how much space or what other resources would be needed to generate that much energy.

5. How much is it going to cost? Changing our energy investments from "dirty" carbon-emitting technologies to zero-emission technologies will come at a cost. Here Gates refers to a concept called "green premium." The green premium is generated by looking at the zero-carbon price difference from the original. In the case of a gallon of jet fuel, which in the United States has remained steady at $2.22 for some time, zero-carbon fuel is $5.35, reflecting a difference or a green premium of $3.13. That is a premium of more than 140%. In rare cases, the green premium can be negative. How much is the world willing to pay to go green? Clean alternatives are not cheap enough.

In chapter 4, entitled "How We Plug In?" Gates attempts to explain that our way of reaching electrical energy causes 27% of fifty-one billion tons of greenhouse gases. Electricity sources are: coal 36%, natural gas 23%, hydropower 16%, nuclear 10%, renewables 11%, oil 3%, and other 1%. Two-thirds of electricity production is derived from fossil fuels. Today, the USA spends only 2% of its GDP on electricity. A "green premium" that changes all of the USA's electricity, in the transition to zero carbon emissions, will average around 1.3–1.7 cents per kilowatt-hour, about 15% more than most people currently pay. This means a green premium of eighteen

dollars a month for an average home. It is similar in Europe. Over the past few decades, China has made one of the greatest achievements in history and managed to lift hundreds of millions of people out of poverty, partly by building coal-fired electric plants at very cheap costs.

What about nature? Chinese companies have reduced the cost of a coal plant by a remarkable 75%. If India, Indonesia, Vietnam, Pakistan, and African countries prefer coal plants, that would be a disaster for the climate. Right now, however, this is the most economical option for these countries. Years ago, advanced European countries opposed the dams that were to be built in Turkey, citing the brevity of their economic life and issues related to ecology and climate change.

The sun and wind are discontinuous sources, meaning they do not generate electricity twenty-four hours a day, three hundred sixty-five days a year. However, our need for power is not intermittent. So we will need other options. For example, we should store excess electricity in batteries, although this is quite an expensive method, or we should use natural gas power plants that work only when we need them, which in any case, are not economical. The closer we get to 100% clean electricity, the greater and more expensive the disruption to supply becomes.

Expecting to derive most of our energy from renewable sources is the exception rather than the rule. Therefore, even when we set up solar and wind at full capacity, the world will still require new inventions for obtaining clean electric energy.

Gates talks about fusion, offshore wind, geothermal, battery, hydro pumping, and thermal storage alternatives that will allow us to generate electricity without carbon emissions.

Nuclear fission: Here, he gives one sentence to describe nuclear fission as the only carbon-free energy source in the world that is operated on a large scale, providing permanently reliable "clean" energy in all seasons. No other clean energy source can even come close to nuclear fission figures. The USA derives about 20% of its electricity, and France 70%, from nuclear power.

Together, solar and wind can provide about 7% carbon-emission benefits worldwide. It is thus difficult to foresee a future where we can cost-effectively decarbonize our electricity grid without using more nuclear power! But being a neighbor to Chernobyl is also difficult! Problems regarding nuclear power are known problems. Nuclear energy is responsible for far fewer human deaths than automobile accidents. Yet, just as we do with traffic, we must strive to analyze and resolve issues one by one with innovation. "I am very optimistic about the approach created by Terra Power, a company I founded in 2008," says Gates, adding, "bringing together the best minds in nuclear physics and computer modeling to design the next generation nuclear reactor. Because no one was going to let us build experimental reactors in the real

world, we set up a lab of supercomputers in Bellevue, Washington, where the team runs digital simulations of different reactor designs. We think we've created a model that solves all the key problems using a design called a traveling wave reactor."[1]

There is another completely different approach to energy that is quite promising but is at least ten years away from supplying electricity to consumers: nuclear fusion. As opposed to obtaining energy by separating atoms, as with fission, fusion involves bringing them together, or combining them. Although still in the experimental stage, fusion promises a lot in the future. Fuel will be cheap and plentiful as it will work with commonly available elements such as hydrogen. However, fusion is very difficult to achieve in practice. Gates shares an old joke among nuclear scientists: "Fusion is forty years away, and it will always be."

Storing batteries: "I have spent way more time learning about batteries than I ever would have imagined," says Gates, adding, "I have also lost more money on start-up battery companies than I ever imagined."[1]

Lithium-ion batteries are difficult to improve upon. Inventors have studied all the metals we can use in a battery, and it seems unlikely that there will be materials that will produce better batteries than those already available. I think we can improve them three times as much, but this number will never be fifty times. An inventor I admire is working on a battery that uses liquid metals instead of the solid metals used in conventional batteries. The idea is that liquid metal allows you to store and feed upon much more energy very quickly.

In chapter 5, titled "How We Construct Things?", Gates explains that by continuing construction, we release 31% of fifty-one billion tons of bad emissions into the atmosphere. In the USA, 4.3 billion tons of cement were produced from 1901 to 2000, and 25.8 billion tons in China in the last sixteen years. Moreover, Americans use steel as much as they do cement. Plastics are another amazing material found in many products, from clothes and toys to furniture, cars, and mobile phones. It is impossible to list them all. In short, we produce materials necessary for modern life as well as electricity. We will not give up on them.

If anything, we will use more of plastics as the world's population grows and gets richer. There is ample data to support that this is the case. For example, we will produce 50% more steel by the middle of this century than today.

There is a by-product of steel that we don't want: carbon dioxide. Making one ton of steel produces about 1.8 tons of carbon dioxide. By 2050, the world will produce around 2.8 billion tons of steel each year. In other words, the carbon that steel releases into the environment will increase exponentially. In the manufacture of cement or steel, carbon dioxide is released as an

inevitable by-product, but in plastic manufacturing, about half of the carbon is trapped in the plastic. Plastics can take hundreds of years to deteriorate. However, this is a major environmental problem because plastics that are not recycled will remain in the environment for a century or more.

Gates then turns his attention to the green premium. If you run a vehicle manufacturing company, are you ready to spend 25% more on all the steel you buy? Probably not, especially if your competitors continue to purchase cheaper materials. "The fact that the overall price of the car will only increase a tiny bit wouldn't be much comfort to you. Your margins are already pretty slim, and you'd be unhappy to see the price of one of your most important commodities go up by a quarter. In an industry with narrow profit margins, a 25 percent premium could be the difference between staying in business and going bankrupt."[1] We also do not expect prices to go down as consumers demand more of these "green" products. After all, consumers do not buy cement or steel, but manufacturing companies do. Are there different ways to lower the premiums? One way is to use public policies to create demand for clean products. For example, governments can achieve this by creating incentives or even requirements for the sale of zero-carbon cement or steel. Businesses are obligated to pay a premium for clean supplies if they are required by law, demanded by customers, and competitors are doing so. Now we need innovation in the manufacturing process, and new ways of making things without carbon emissions.

Gates then sets forth examples. Carbonless cement is the most difficult material to produce in terms of reducing emissions. Some companies have some good ideas, for example, taking recycled carbon dioxide during the cement-making process and injecting it into cement on-site. However, even if these approaches are successful, 100% carbon-free cement cannot be produced. Gates states, "For the foreseeable future, we will have to count on carbon capture and – if it becomes practical Direct Air Capture (D.A.C.) to grab the carbon emitted when we make cement."[1] The first requirement for almost all other materials is plenty of reliable, clean electricity. Electricity already accounts for about one-fourth of all energy used by the worldwide manufacturing industry. To power all these industrial processes, we must both use the clean energy technology we have and make new breakthroughs that allow us to generate and store large amounts of zero-carbon electricity. As a road map to zero emissions, Gates offers the following four steps:

1. Electrify every possible process, which requires intense innovation.
2. Get electricity from a carbon-free power grid.
3. Use carbon capture, D.A.C., to absorb residual emissions.
4. Use materials more efficiently.

In chapter 6, entitled "How We Grow Things?", Gates discusses how 19% of the fifty-one billion tons of carbon emissions per year occur in food production.

Although Gates is a lover of a good cheeseburger, he doesn't eat them as often as he used to. Based on what he has learned about the impact of beef and other meats on climate change, he says the following:

> The global population is heading toward ten billion people by 2100, and we're going to need more food to feed everyone. Because we will have 40% more people by the end of the century, it would be natural to think that we will need 40% more food too, but that's not the case. We will need even more than that.
>
> We need to produce much more food than today, but if we continue to produce it using the methods we use now, it will be a disaster for the climate. Assuming that we cannot increase the amount of crops we get on pasture or arable land, an increase in feeding 10 billion people would increase food-related emissions by two-thirds.

He delves further into his concerns stating that by making great efforts to generate energy from plants, we could inadvertently start a competition for the use of cropland. Advanced biofuels can give us zero-carbon alternatives to power trucks, ships, and aircraft. However, if we grow these crops in a field that will be used to feed a growing population, we may inadvertently increase food prices, drive more people into poverty and malnutrition, and accelerate deforestation, which is already advancing at a dangerous pace. First, we need to know exactly where all these emissions are coming from and identify our options for eliminating them using today's technology. Technology can help. For example, two companies are currently working on invisible, plant-based coatings that extend the life of fruits and vegetables but do not affect the taste at all. Another has developed a "smart litter box" that uses image recognition to track how much food is wasted at home or at work. It gives you a report on what and how much you throw away, along with the cost and carbon footprint. Giving people more information helps them make better choices.

Fertilizers provide plants with essential nutrients such as phosphorus, potassium, and nitrogen, which are particularly relevant to climate change. Nitrogen is a complex blessing. It is closely linked to photosynthesis, the process by which plants turn sunlight into energy, making it possible to obtain all plant life and, therefore, all of our food. But nitrogen also has a negative impact on climate change. Adding nitrogen to the soil allows corn to grow ten feet high and produce a tremendous amount of seed. Most plants cannot make their own nitrogen. They obtain this from ammonia in the soil produced by various microorganisms. A plant will only continue to grow as long as it can absorb nitrogen. If farmers have the technology to carefully monitor the nitrogen level and apply the right amount of fertilizer during the growing season, then nitrogen can be supplied efficiently to the

crop. However, this technology is expensive and fertilizer is cheap. Some companies have developed additives that help plants absorb more nitrogen so that less nitrogen is released into groundwater or the atmosphere. Other experts are working on different methods to solve the nitrogen problem. For example, some researchers are doing genetic studies on new crop varieties that use bacteria to immobilize nitrogen.

About 70% of emissions are from agriculture, forestry, and other land uses, and another 30%, in Gates' one-word summary, from "deforestation!" There are several inventions that can help mitigate this problem, such as advanced satellite-based monitors that make it easier to detect deforestation and forest fires as they occur and then to measure the extent of the damage. Gates states that he follows some companies that are developing synthetic alternatives to palm oil so we don't have to cut down a lot of forests to make room for palm plantations. However, this is not a technological problem; rather, this is a political and economic issue. People cut down trees not because people are evil; they do it when the incentives to cut down trees are stronger than the incentives to leave them alone.

The impact of planting trees on climate change has been exaggerated. How much carbon dioxide can a tree absorb in its lifetime? The amount varies, but as a rule, it can be estimated at four tons over forty years. How long will the tree live? If it burns, all the carbon dioxide it stores will be released into the atmosphere!

If you turn a soybean farm into a forest, you lower the total available soybean supply, which will increase prices and may motivate someone to cut down trees elsewhere to grow soybeans. Taking all these factors into account, the math suggests you'd need somewhere around fifty acres' worth of trees planted in tropical areas to absorb the emissions produced by an average American in his/her lifetime. Multiply that by the population of the USA, and you get more than sixteen billion acres, or twenty-five million square miles, roughly half the landmass of the world.

In chapter 7, Gates asks, "How We Get Around?" and discusses how 16% of the fifty-one billion tons of emissions results from the transportation sector. While transportation is not the greatest cause of emissions worldwide, it is number one in the USA and has ranked just ahead of producing electricity for several years. "We Americans drive and fly a lot," says Gates. He continues, "In any case, if we're going to get net-zero emissions, we will have to get rid of all the greenhouse gases caused by transportation in the United States, and around the world."[1] This will be difficult – but not impossible. Then he presents another challenge, stating that it would not be enough to eliminate the 8.2 billion tons of carbon produced from transportation today, as much more than that would be required. Identifying China

as a good example, he suggests that transport emissions in that country have doubled in the last decade and have increased tenfold since 1990.

There are four ways to reduce emissions from transportation. One of them is to travel and ship less. We have to encourage alternatives like walking, and cycling, and it's great that some cities use smart city plans to do this. Another way to reduce emissions is to use less carbon-intensive materials in automobile construction, although this does not affect fuel emissions as previously mentioned. In addition, even though making and using more efficient tools are important steps in the right direction, they would not bring the amount of emissions down to zero.

Even if less gas is burned, gas is still burned. The fourth and most effective way in which zero emissions in transportation can be achieved is to make a transition to electric vehicles and alternative fuels. As previously mentioned, both these options currently carry a green premium.

In chapter 8, "How We Keep Cool and Stay Warm?", Gates details where 7% of the fifty-one billion tons of greenhouse gas result from. By 2050, more than five billion air conditioners will be operational worldwide. This alone accounts for approximately 14% of all electrical greenhouse gases used by buildings. The fact that the air conditioner operates electrically makes it easy to calculate the green premium for air conditioning. To decarbonize our air conditioners, we need to decarbonize our electricity grids. Unfortunately, the demand for electricity is not the only thing that makes air conditioners a problem, as there are also the gases used in compressors.

In chapter 9, Gates tackles the issue of "Adapting to a Warmer World" and discusses what we need to do. People of all income levels are affected in some way by climate change. Everyone alive now will have to adapt to a warmer world. As sea levels rise and floods increase, we will have to review where our homes and businesses are located. We must strengthen electricity networks, ports, and bridges. We will need more drinking water. As lakes and waterbeds shrink or become polluted, it will be harder to provide drinking water to everyone in need. Megacities are in serious poverty, and by the middle of the current century, the number of people who cannot obtain enough water will increase. Separating seawater is a solution, but this process consumes a lot of energy. One idea Gates is watching closely is to take water from the air. This basically involves using a solar dehumidifier with an advanced filtering system, so you don't drink any air pollution. This system is available now but is costly.

The topic of chapter 10 is "Why Government Policies Matter?" National leaders around the world must have a vision of how the global economy will transition to net-zero carbon emissions. This vision can guide the actions of people and businesses globally.

In addition to technology and politics, there is a third aspect that Gates touches upon which must be considered: companies that will develop new inventions which enable them to reach a global scale, as well as the investors and financial markets that will support these companies. He further observes that markets, technology, and politics are like three levers that we need to pull in order to free ourselves from fossil fuels. All three must move simultaneously and in the same direction! For example, if you set a zero-emission standard for cars and you don't have the technology to eliminate emissions, or if there is no company that wants to produce and sell cars that meet the standard, it will not be a very successful policy. On the other hand, to have a low-emission technology, for example, if you do not give financial incentives to energy companies to produce a device that captures carbon from the exhaust of a coal power plant, it will not be possible to develop such technology. Therefore markets, policy, and technology have to work in complementary ways.

In chapter 11 of his book, Gates proposes a detailed plan under the title "A Plan for Getting to Zero," directing readers to a website as Zero Energy Project. Gates' plan is for how we can avoid a climate disaster by focusing on specific steps government leaders and politicians can take (breakthroughenergy.org).

Science tells us to invent new technologies to avoid a climate disaster. Innovation is not just about coming up with a new machine or a new process; it also brings new approaches to business models, supply chains, markets, and policies that will help new inventions come to life and reach a global scale. Innovation is both new devices and new ways of doing new things.

Gates outlines the technologies we need to achieve zero emissions worldwide, although we have a range of competitive low-carbon solutions today. To get these technologies up and running fast enough to make a difference, governments need to invest and encourage more clean energy R & D, he says. In other words, the clean energy supply must be resolved first. The demand side is a bit more complicated than the supply side.

In chapter 12, Gates answers the question about "What Each of Us Can Do?"

> You have influence as a citizen, consumer, and an employee or an employer. When you ask yourself what you can do to limit climate change, it's natural to think of things like driving an electric car or eating less meat. This sort of personal action is important for the signals it sends to the marketplace … but the bulk of our emissions comes from the larger systems in which we live our daily lives. When someone wants toast for breakfast, we need to make sure there's a system that can deliver the bread, the toaster, and the electricity to run the toaster without adding greenhouse gases to the atmosphere.

We aren't going to solve the climate problem by telling people not to eat toast. But putting this new energy system in place requires concerted political action. That's why engaging in the political process is the most important single step that people from every walk of life can take to help avoid a climate disaster … In other words, elected officials will adopt specific plans for climate change if their voters demand it … Whatever other resources you may have, you can always use your voice and your vote to effect change[1]

Gates suggests entering politics. However, I wouldn't advise it.

And he adds: "Buy an electric vehicle. Try a plant-based burger." I haven't tried it, but neither of them possible.

We can consume less meat. The same goes for dairy products. Some steps the private sector can take in this direction include setting up an internal carbon tax.

Some large companies impose a carbon tax on each of their divisions and do not compromise on reducing emissions. We can give low-carbon solutions R & D priority. We can be an early adopter in technology. We can take part in the policymaking process.

Finally, Gates concludes his book with the following sentences:

Unfortunately, the conversation about climate change has become unnecessarily polarized, not to mention clouded by conflicting information and confusing stories … I'm profoundly inspired by all the passion I see, especially among young people, for solving this problem. If we keep our eye on the big goal – getting to zero – and we make serious plans to achieve that goal, we can avoid a disaster. We can keep the climate bearable for everyone, help hundreds of millions of poor people make the most of their lives, and preserve the planet for generations to come.[1]

Yes, it seems that Gates has put both his mind and money into this business, so to speak. The information, opportunities, and warnings given throughout the book are valuable. Frankly, after reading the book, I was left impressed and informed. But what if the 3% of scientists who do not associate climate change with what we do and how we act, are right? Of course, we also know that Gates warned us about the pandemic five years ago and was right about it. That was the reason why I wanted to share a summary review of the book as soon as possible. According to Turk Stat (TUİK) data in Turkey in 2018, greenhouse gas emissions had increased by 85% over the last twenty years and had reached 520 million tons.[2] According to Gates, our contribution is 1% to the world's emissions, which is fifty-one billion tons. In this ranking, China leads with 10%, the USA is second with 5%, and the top 10 countries are responsible for 67.6% of the world's emissions.[3] One hundred companies in the world are responsible for 70% of the emissions.[4] If the issue of climate change is real, the cause of warming is human beings, and the consequences of it will soon affect everyone, not just the responsible parties. As Gates said, we cannot resist the laws of physics, but we can predict them and

take action to avoid their consequences. If you build a house on a streambed, you will endure the results. If we do not reduce greenhouse gas emissions, we will altogether bear the result. But of course, God forbid, should a meteor crash into Earth, a volcano erupt, or a war break out, wouldn't all these sensitive carbon-emission calculations be upset?

I humbly say, in my final words to this chapter, that the remedy for all of this lies within man himself. If, contrary to human nature, a person educates his/her soul, avoids waste, and is satisfied, then the limited resources of this ancient world can easily be enough for us all. As you know, a few is always enough, whereas many never suffice.

I have some ideas: the USA's famous cities whose lights are never off, the illuminated highways and buildings that are so air-conditioned that you have to wear a jacket in the summer and take it off in the winter, the asphalt-covered smooth and flat roads covering vast land, the invention of the wheel, the comfort of constant hot water, the frequency of doing laundry, people obsessed with meticulousness. In short, wastefulness.

The cause of obesity is too much food and an imbalanced diet! Isn't mindfulness and a balanced diet the remedy? If conscious consumption habits were introduced to all segments of society, just like the balanced nutrition program of the Sabri Ülker Foundation for primary schools, the carbon-emission problem could be permanently solved as a result of a life lived reasonably, with content consumption and by avoiding wastefulness.

Yes, Bill Gates has given this topic a lot of thought. How safe would it be to rely on scientists' innovative discoveries regarding these issues, encouraged by companies' ambition to profit? Especially if the only basis for the widespread use of these applications could be the attraction of consumption.

References

(1) Gates, B. (2021). *How to Avoid a Climate Disaster: The Solutions We Have and the Breakthroughs We Need*, Allen Lane.

(2) Turkish Statistical Institute (TURKSTAT). (2020). "Sera Gazi Emisyon İstatistikleri, 1999–2019," No: 33624, Mar. 31, https://data.tuik.gov.tr/Bulten/Index?p=Sera-Gazi-Emisyon-Istatistikleri-1990-2021-49672.

(3) Congar, K. (2018). "Dunya'yi en cok hangi ulkeler kirletiyor? Turkiye listede kacinci sirada?" Updated: Sept. 3, 2018, Euronews, https://tr.euronews.com/2018/09/03/dunyayi-en-cok-hangi-ulkeler-kirletiyor-turkiye-kacinci-sirada-.

(4) BBC News (Turkish). (2017). "Kuresel sera gazi saliniminin%71'ini sadece 100 sirket gerceklestiriyor" [Only 100 companies account for 71% of global greenhouse gas emissions], BBC News, July 11, https://www.bbc.com/turkce/haberler-dunya-40558561.

The Legendary Gen Z: Are Generational Differences Real?

The letters X, Y, and Z … defining the generations never ends. For quite some time now, "get ready, the new generation is coming" articles have lost their impact on me. In this regard, over time, I have reached a conclusion compiled from various sources I've read, experts I have contacted, and academicians I've consulted. Having read more on this subject in recently, I am putting forth in this chapter my ideas to get your opinions. After reading this chapter, it will be possible to understand that we call people born at the same time or living in the same years a "generation" or a "breed," but is it actually correct to claim that the members of these groups are the like each other? Let's see what you will say to my answer to this question.

Let us start with an example: The legend of Generation Y, that is, the millennium generation, is now over, and is anyone talking about it anymore? More than two years ago, in 2018, based on considerable effort, Fatos Karahasan, in her book *Make Way, The Youth Is Coming*, proposed the question: "What Type of World Will Generation Y and Z Build?", starting from Siam's Research with youth in 2000, the "Turkey Youth Survey," together with similar research reports in Turkey and abroad.[1] In the same book, the commonalities between Turkey's Generation Y (those born 1980–1998, aka the Millennium Generation) and Generation Z (those born after 1998–2000) were characterized as follows:

1. Family is at the center of life.
2. They are generally happy.
3. They are concerned about unemployment and financial opportunities.
4. They prefer living in their own cocoons.
5. They stay away from politics and NGOs.
6. They are distant from foreign countries.
7. Education is important to them.
8. They use the internet for entertainment and social purposes.
9. They are prejudiced regarding gender equality when couples live together.
10. Their level of anxisty about unemployment anxiety and their work dissatisfaction are extremely high.

It has not yet been two and a half years, and nobody talks about Generation Y anymore today. Generation Y could not make the changes that were expected of them. One can even say that the age of 35 is already similar to that age in previous generations! Maybe members of Generation Y weren't

different, and what was said to be the difference was what appeared on the tip of an iceberg. Now, there is the legend of Generation Z. They changed the birth years for this generation until 2005 to now, meaning they are only sixteen years old, and they are our hope for change.

Karahasan's book was also based on a popular book at the time, *The Gen Z Effect*,[2] and in that book the characteristics of the generation born after 2000 were given as follows: They were born into the digital age; they are the first global generation; they are children of a troubled world, with helicopter parents; they are the first generation for whom technology has introduced new behavioral patterns.

In *The Gen Z Effect* , those born after 2010 were named the Alpha Generation, and five predictions were made:

1. They will be the most entrepreneurial generation.
2. Those who cannot do without technology will want everything to be arranged according to their desires.
3. They will shop online. They will be lonely and will have psychological problems.
4. They will be pampered.
5. They will be self-sufficient and well educated.
6. They will deal with the world's problems.

Two years later, there were even fewer people who called members of Generation Z "Alpha youth." New sources call more Generation Z. It should also be noted that this generational issue is not a topic whose conceptualization is discussed in peer-reviewed journals and qualified publications. Rather, it is mostly discussed in books written by people from the business industry, industry bulletins, and special reports from research companies and consulting companies, as well as blogs. In David Stillman and Jonah Stillman's book titled *Move over Millennials: Generation Z Is Here*, those born between 1995 and 2012 are considered Generation Z. It is unclear where and how the authors made this determination, but they list the seven basic features of Generation Z as follows:[3]

1. Phigital: Generation Z is the first generation born in a world where everything that has a physical aspect has a digital counterpart. The virtual world is part of their reality. It is said they will prefer companies that use technology well.
2. Excessive personalization: They are used to being treated personally. There is a high expectation that their behavior and wishes will be understood and treated accordingly. They demand personalization of everything from job title to career. This will be difficult for the business world, which is used to treating everyone equally. They even want to write their job descriptions themselves.

3. Realistic: Generation Z is much more realistic and utilitarian in preparing for the future.

4. Fear of missing out: They have an intense fear of missing out on something. They will follow new trends, and they will not be able to stand still because they constantly feel that they are not going in the right direction. Most will want to have different roles in one workplace.

5. They are economists: Since sharing economies such as Uber and Airbnb are in their lives, they will impose more cost-effective and comfortable ways of collective action on the business world by destroying the closed structure inside and outside the workplace. They will try to correct the mistakes they see in the world. The power of the company they work for in creating social awareness is very important for them.

6. Do it yourself: They think they can do everything by themselves since they grew up with YouTube showing that they can do everything themselves. They adopt a do-it-yourself culture instead of a collaborative culture.

7. Ambitious: Ambitious, more competitive, and ready to roll up their sleeves. They want to win.

Later, the authors interviewed hundreds of CEOs, and Generation Z youth tried to tell us that the above characteristics are true, completely anecdotally and without any theoretical basis.

Gregg L. Witt and Derek E. Baird, in their book *The Gen Z Frequency*,[4] describe how brands can tune in to Gen Z and gain their trust. In this book, those born from 1996 to 2011 are called Gen Z. The authors first interviewed nearly two hundred high school students, then tested their findings in a follow-up study with six thousand samples every year.

Accordingly, the seven characteristics of the Z generation are as follows:

1. Independent: They work harder for success.

2. Open to differences: They are open to all racial, gender, and ethnic differences.

3. Activist spirited: They want to work in organizations that are politically aware, want to make the world a better place, and that try to make a difference in the world.

4. Pragmatic: They want a more pragmatic career because they were raised by Generation X, who grew up under difficult conditions, so being a good lawyer is more important than being a good YouTuber. They are financially conservative and do not want to share data on social media.

5. Personal branding: They don't want to overexpose themselves on social media like Generation Y (the Millennium Generation). They manage themselves like a brand.

6. Collaborative: Talking to a student from another country on Skype in the classroom, playing e-sports on Twitch, or playing another game

together taught Gen Z physical and virtual collaboration at an early age. Generation Z is the first generation where access to information through status updates, messaging, selfies, social networking, and mobile devices is now at their fingertips. They talk with emojis.

7. Hyper-customization norms. They are mobile communicators. They want a clear brand history. They want a brand that will help them reach their dreams, and they chase after this brand. They look for a brand that will make a community feel a sense of belonging.

This information is all well and good; however, in this book, there is no information about why they are like this, where they come from, or any statistical figures supporting such evidence.

We move, then, to another study from Turkey. Evrim Kuran has also written many articles and made videos on this subject. She makes a lot of effort to understand this subject. When it comes to her book, *Understanding Generation Z*,[5] Kuran states: "While 33.7 percent of the world population is Gen Z, 31 percent of Turkey's population is in the Z generation. In other words, there are more than 25 million individuals under the age of 19 in our country,"[5] and then she attempts to show that Generation Z is different from other generations. Here, the resources used to support this assertion are interviews with 2,764 members of Generation Z in Ankara, Istanbul, and Izmir. I would like to know how the sample group was chosen. The research results also explain the differences in an anecdotal way. We cannot say that the author has fully clarified the subject. Again in Kuran's study, she says: "In the Dreams Survey we conducted with Generation Y in 2016, almost half of the youth stated that they did not believe that they could make their dreams come true."[5] But Generation Z is hopeful about their dreams, regardless of where they live. Seventy-five percent of youth located in the lower class and 70% of the young people in the lower class believe that their dreams will come true. I think it is not possible to say that this is a generational difference, and the validity of the study can be questioned because a comparison is made with a single question.

The Maya Foundation claims that it has done neuroscience research with Smartlook Analytics Laboratory and clarified Generation Z. Even news of the research topic is titled: "Turkey's Most Comprehensive Research." However, when you read the news, it is not possible to understand anything. In this study, it remains unclear how many people were included in the research, and how Generation Z was clarified by detecting brain chemicals, body reactions, and twelve mood states. The foundation found: They are not afraid of being defeated, and they prefer to interact via video. They care about their university department but do not believe that a degree will provide them with a comfortable life; their purpose is happiness rather than

money. They want to socialize and work voluntarily; they favor face-to-face education; and their biggest problem is materiality. Their anxiety about the future is greater than that of other generations. They are not apolitical, and they do not believe in slogans. Their fathers are at the center of their lives, and they want their political leaders to be hardworking and reliable. To be frank, I wonder how these results originate from a neurological or bio-metric study.

In the meantime, via Google, you can find many reports by research and consultancy companies on "Generation Z." They mostly say similar things, but they all have one thing in common. The samples of their research are either inadequate in number or not conducted with an accurate method. Most of them recite the same words about Generation Z: They use tech-nology well, they want the world to be a better place, they want everything to be personalized, they are used to the game culture, they want to win, and they want to keep their private lives protected.

For example, according to Deloitte's interview with 1,531 subjects from Generation Z (where and how they were selected is unclear),[7] they say they want to work in a job where they interact within their personal lives; they want to work in a diverse and entrepreneurial company; and if they do, they will be loyal to it, not by team play but by individual action. They prefer companies not only with product services but also with high moral and social effects. They want financial security rather than personal satisfac-tion. They question the benefits of graduation certificate, and they want to learn new skills on online platforms.

Deloitte also published a Global Millennial Survey 2020 report. They call Generation Y and Z "resistant generations" due to the Covid-19 pan-demic. According to the report, these two generations have felt fear of unem-ployment and fear of the future more than other generations. At the same time, the long-term effect of the Covid-19 pandemic on these generations is currently unknown, but it is necessary to focus more on these generations because they will establish the future. I wondered if Deloitte wanted it to be like this and if they were trying to attract our attention in this way.[8]

As a matter of fact, all these sources say that Generation Z is fundamen-tally different from previous generations in terms of personality, values, and working style, and therefore they will change the places they work with their work habits! In fact, the same things were said about the pre-vious generation, Gen Y. This is a myth, however, and this legend has been observed to have had a great influence on the hiring, promotion, and man-agement of people. Businesses have found little evidence to support the notion that there are fundamental generational differences. Researchers state, rather, that there is more evidence to show that there are factors of greater priority to consider in workplaces. In short, as we have discussed

above, let's go with the takeaway that the atmosphere of change brought on by the Covid-19 pandemic: a report, a chapter, or an article about the differences between generations is definitely published in the special reports and books of consultancy and research companies that target the business world directly. Generally, it is thought that generations can be distinguished from each other according to factors such as "attitudes and values" and they are shaped by events that occur during the period of time in which their members grow up.[9]

Maturing in a particular time and place often has a very strong impact on people in certain situations. Societies, groups, families, and schools try to teach their members certain beliefs and values about important issues and appropriate types of behavior. They instill judgments and attitudes about right/wrong, good/bad, or justness/cruelty. Those who propose there are differences between generations take their ideas about these differences further and assume that everyone born within a specific time frame, such as twenty years, shares the same experiences, values, and characteristics. However, this approach involves typically stereotyping a person from a different age group over another generational category. Isn't this a bit like fortune-telling? In other words, everyone born on the same day looks the same and shares the same fate. Is this something that really happens?

However, it is always easier to see the wide range of values, motivations, personalities, and careers within one's age group. Is it possible to compare one generation with another generation by simultaneously asking the same question to two age categories? Probably more in-depth research is needed. When members of Generation X are twenty years old, you should ask a same question; when Generation Y is the same age, you should ask the same question; when Generation Z is the same age, you should ask the same question, and then compare your answers. In this way, such a study would reveal whether generational differences are, in fact, real.

Other issues are normal age segmentation differences, and all kinds of social, political, and technological events in the usual course of history have different effects on ages. However, the results of this type of research over the years can only be used by the next generations.

Generational differences categorize people in an overly simplistic way, dividing them into "us" and "them." Generational differences are nothing new. Different generations have always been have always been part of the discussion in society because people see them as different tribes or different cultures as if there were a magical interrupt between them. If the generations are different from each other, they must be managed differently and they require different working conditions.[10]

The most commonly used terminology used to describe generational differences has originated from the USA and comes from Strauss-Howe.[11]

I hope that those who use this terminology today benefit from Strauss-Howe's book, *The Fourth Turning*. The most common patterns discussed in this model are:

The generation known as baby boomers includes those born between 1943 and 1960 and raised after World War II. There was a tremendous population explosion in the USA at that time with the postwar demobilization and a peaceful environment. The name baby boomer defines this time. It is valid for the USA and partly for Europe. But what happened in the defeated parts of the world or in Eastern Europe? Turkey did not participate in World War II, so we cannot speak of its role in naming generations. In those years, Turkey's single-party diverged into a multiparty transition and the 1960 coup took place.

In the Strauss-Howe model, those born between 1961 and 1981 constitute Generation X. Then, Generation Y was born between 1982 and 2004. Generation Z, which was born after 2004 and whose first members will gradually join the workforce, are technically known as the "Homeland Generation" in the USA and, according to Strauss-Howe, have qualities similar to those of the Greatest Generation (born between 1925 and 1942) that fought in World War II. It is as if there is a generational cycle.

The character of the baby boomer generation was shaped in the turbulent atmosphere of the 1960s, and by challenging the events they saw as injustice in the world. The events that had an impact on this generation are the civil rights movement, Woodstock, the moon landing, sit-ins, hijackings of airplanes, and a threat of nuclear war. They don't like traditional hierarchies, and they are expected to act against the rules. Trying new things makes this generation happy.

Generation X has been affected by events of the 1970s and 1980s. There was the worst economic depression experienced since the Great Depression of the 1930s. The members of this generation grew with the environmental movement, the women's movement, a decline in production, and the rise of the service sector. They have a bad reputation at work for being unfaithful to those who are loyal to them. They were told that "greed" was good, and this generation was criticized for their selfish "yuppie" materialistic culture and self-righteous attitude.

Generation Y started to join the working world in the 2000s. Events of the 1990s, the end of the USSR, the unification of East and West Germany, the increasing integration movements in Europe, and the globalization movement have shaped Generation Y. The typewriter era is over in the world of this generation. Information technologies have risen rapidly. Machines and technology are rapidly replacing people in the workplace. The home office era has begun, flexible working has begun, and shared office sharing has begun.

Here again, it is important to show through an example that the definition of a generation originating from the USA may differ from other cultures. The restriction on having only one child per family in the People's Republic of China created a generation of three parents (mother/father and a pair of mothers/fathers from each of their mother's and father's), who are seen as the heirs of the family, which meant they were spoiled and almost emperor-like, and thus this social restriction was immediately abandoned. Otherwise, China would have to import brides for these little emperors of its own creation within twenty years.

It is said that the emojis and selfies of the generation called Generation Z, born in the 2000s, changed the world more than previous generations. However, in order for this to be the case, events in the world must have a stronger effect on children's development levels than their surroundings.[12]

Does parental behavior affect the child's development, or does the China-US tariff war affect him/her? Do peers influence a child's development, or do security decisions of the North Atlantic Treaty Organization (NATO)? Do February 28 decisions or a brother who is two years older? The quality and personal development of someone's education certainly has more impact than UN resolutions. People remember the same politicians at the same time, but they don't automatically have the same views as people of the same generation. It should not be forgotten that, in these new generations, perhaps for the first time in human history, children do not grow up emulating their fathers, fairy-tale heroes, or historical figures. New-generation Japanese children's cartoons are also a separate factor in this, but now future tales are at least as popular as traditional tales.

When discussing the Strauss-Howe model mentioned above, I gave an example of how Turkey's political transformation was different. This example came from a model in a scientific study of Generation Political Transformation in Turkey,[13] which Turkey has adapted based on the reviews, he states, and I have provided my initial response in capital letters beside each point:

- Baby Boom Generation (1946–1964): Multiparty period, sixty coups, sixty-one constitutions (altruistic, obedient, serious, optimistic, prescriptive, idealist) I WONDER?
- Generation X (1965–1979): the 1971 coup, 1968 worker and student movements, economic distress, Arabesque culture, rise of cinema (skeptical, results-oriented) REALLY?
- Generation Y (1980–1995): the 1980 coup, 1982 Constitution, neoliberal policies, consumer society (process-oriented, tendency toward impatience, prone to depression, open to communication, individualistic structure, family-focused, self-confident, complaining) SO FEBRUARY 28 IS THE RESULT OF ALL OF THESE?

- Generation Z (1995–): February 28, April 7 Memorandum, 2001 Crisis, AK Party power, Gezi events, July 15 uprising, internet, iPod, iPad, mobile phone (self-confident, independent, introverted, dissatisfied, communicate through social media, know what they want, want to maintain control, express themselves well) SOCIETY IN THE HANDS OF TROLLS!

To reiterate, the claim is that each society has a different political, social, economic, and cultural structure and that these structures are effective in shaping the character of individuals. I believe this, too. In any case, isn't the political trend in our world developing like this? In the elections where Generation Y and Z predominantly vote, will the policies that win morevotes be more nationalist or more individualist? Even so, this does not show us that similarity in political behavior will lead to the same in other behaviors? Growing up in a similar geographic location at the same time means you have a lot in common. But there are at least three reasons why the myth of intergenerational diversity is misleading:

1. Aging: Quite simply, the aging person changes. All people learn from experience, become more disciplined, and make more personal choices. Some of us are precocious, and some of us never grow up. Young people are impulsive and need time to get used to the work environment. For centuries, from Socrates to Dostoevsky, the younger generation has been described as anti-authoritarian, rude, and disrespectful. This is not a generational feature. Most young people thrive and mature in the business environment.
2. Social experience: Factors affect more than intelligence, education, experience, age, and a generation's identity. If all young people are the same, they will show the same performance in job interviews. However, some people have poor impulse control, some are narcissists, and some are social media addicts. But there may be such people from all generations.
3. Random discrimination points: It is subjective to categorize generations by year. Just as it is unreasonable for a historian to use the period governed by a single ruler to describe a historical period, it is also unreasonable to classify people according to their age.

Most popular books on different generations are enjoyable to read, entertaining but of low scientific value. They just affirm our prejudices. It is as if there is a "Generations in the Workplace Industry" that tries to take advantage of this fleeting enthusiasm. With institutional change and environmental transformation, the way people work, also changes. This has always happened in history. It will happen from now on. The important thing is to anticipate what will happen and to adapt to change beforehand. For example, computerization. Mobile communication, remote work, e-commerce are like this. Now is the time for digitalization and personalization, just as the

printing press was invented and widespread. I still do not understand why the media is not digitalized enough. Perhaps this stems from the charismatic personality of the capitalist or the generation in charge. When the new generation comes to power, though, change will be inevitable. I think there is no need to comment on digitalization as nobody wants to ignore the ease of this process. When it comes to customization, I think differently from the current mainstream and I believe new generations will behave like that. In other words, who does not prefer that those who know you well, should provide you with the needs you prefer just at the right time. I think the new generation, in contrast, will promote their preferences (personal data) so they will be considered by the vendors.

Much of what has been written about generational differences is general advice specific to HR. This information is repackaged and now applies to Gen Z, and soon after will apply to a new generation. In other words, we will ask Generation Z "to explain the vision of the company, provide training and professional development, and explain your job expectation," and will we not ask those questions to prospective employees beyond a certain age? I think we should care about everyone. Creating a good EMPLOYER BRAND is one thing; guiding social development and behavioral models with the THEORY OF GENERATIONS is something else.

So what to do? The answer may be found in Lindsey Pollak's book *Remix*, which advocates that companies should manage different generations together and meet the needs of all generations.[14] Pollak says: Stop being ashamed of your age or generation, empathize with each generation, try to find out what values it comes to work with. Give up the idea of "either that or that" and come to the idea of "this and that."

Properly define what the "box" is, so people learn to think "outside the box." If something works, don't change it but rather improve it. As a leader, think about the origins of yourself and your organization and think about the things that slow you down, and get rid of them. Be transparent. Because of social media and the internet, executives no longer have options other than being democratic and transparent.

It is not just important for members of a particular generation to be successful and happy at work; everyone needs to succeed and be happy. If everybody knows the purpose of the work, knows the functions of the work, knows where everyone contributes, and is crowned with good communication, everyone wins. Inviting the children of Generation Y and Z parents to see the business and get to know the company does not hurt other generations, namely their parents, rather it makes them happy. The most effective type of leadership that gets the most out of all generations is coaching. An employer should explain the "why" to everyone. All employees wonder what the reason is behind a decision. This has nothing to do with

either age or generation. How to communicate may vary depending on age categories. This is the point to be aware of. The solution is to produce valid content and publish it in short/long, formal/non-formal, and video/audio/text wherever possible. In this way, company employees can deal with all problems through surveys, forums, and chats. Use the online/offline hybrid method that is used in education and make flexible programs according to each employee's learning speed. Organize your workplace not as "one size fits all" but also for more flexible, modular workplaces and remote working. Workplace preferences are not related to generational differences, but to personality differences, physical preferences, and the quality of the work to be done.

Corporate culture should no longer be formed from top to bottom, but from bottom to top with practices every day. Offering benefits to employees based on their needs attracts more qualified staff. Yes, the companies and their employees that have taken all of these steps have suddenly seen that what they call a "generational difference" has decreased because the older generations immediately adopt the features considered as the advantage of the new generations. In my own case, working remotely, using only mobile communication, using emojis are all part of my daily work activities.

For me, these generational definitions mean my new generation of consumers. Our goal is #makehappybehappy, with the determination of new consumption occasions from the fashioned human lives that are shaped according to place and time and/or the fulfillment of new needs that awaken or can awaken depending on this life style.

Finally, like all of us, I have lived together as a family with several generations for a long time. My father, mother, and even my father-in-law and mother-in-law, although our table was separate, we all lived in the same building for a quarter of a century. The generational difference was not just about understanding, lifestyle, acceptance, prohibitions, and vetoes, but there was also an exchange of culture and traditions. Today, as I get older, I compare young people with myself and I give them positive points as I look at their lifestyle, kindness, and the tolerance they show me.

Ultimately, we managed to be a very nice family and be happy. Most of our differences were due to our personalities. Experience and fast learning from age differences have helped us learn from each other. Did I feel a generational difference? Of course, in terms of trend technologies, even the reverse mentoring program I received at Yildiz Holding contributed a lot to my knowledge and understanding. In a short time, however, I developed to the same level in many subjects. Am I considered as young as they are now? Do I have to enjoy the same music as they do? By the way, are tastes and colors, a period including music culture, a trend in business, or a permanent leap, a generational difference? I'll leave this for you to discuss.

References

(1) Karahasan, F. (2018). *Make Way, the Youth are Coming*, CEO Plus, p. 200.

(2) Koulopoulos, T., and Keldsen, D. (2014). *The Gen Z Effect: The Six Forces Shaping the Future of Business*, Bibliomotion, p. 256.

(3) Stillman, D., and Stillman J. (2017). *Move Over Millennials; Generation Z Is Here*, İKÜ Yayinevi, p. 224. (Jonah Stillman was 17 in the year the book was published; now 21, he introduces himself as a "Generation Z expert").

(4) Witt, L. G., and Baird, E. D. (2019). *The Gen Z Frequency*, KoganPage, p. 235.

(5) Kuran, E. (2019). *Z: Understanding a Generation*, Mundi, p. 124.

(6) Onder, N. (2021). "Turkey's Most Comprehensive Study on Generation Z," *Marketing Turkey*, Jan. 6, https://www.marketingturk iye.com.tr/haberler/turkiyenin-en-kapsamli-z-kusagi-arastirmasi/

(7) Private correspondence: https://mail.google.com/mail/u/0/?tab= rm&ogbl#inboxFMfcgxwLsJzmlGGVpxwDPDMqgNHCq VCQ?projector=1&messagePartId=0.1

(8) The Deloitte Global Millennial Survey, 2020.

(9) MacRae, I., and Furnham, A. (2017). *Motivation and Performance: A Guide to Motivating a Diverse Workforce*, KoganPage.

(10) MacRae, I., and Furnham A. (2017). *Workplace Myths*, KoganPage, p. 165.

(11) Strauss, W., and Howe, N. (2009). *The Fourth Turning*, Crown Publishing.

(12) Costanza, D. P. et al. (2012). "Generational Differences in Work-Related Variables: A Meta-analysis," *Journal of Business Psychology*, 27, pp. 375–394.

(13) Yilmaz, B. (ed.) (2019). *Generations of Political Transformation in Turkey*, Ekin Press Release Distribution, p. 123.

(14) Pollack, L. (2019). *The Remix: How to Lead and Succeed in the Multigenerational Workplace*, Harper Business, p. 280.

My Communication Style

Here's a question for you: How do you know whether a presentation, a job interview, or an appointment went well? You immediately start off by saying, "if you were affected at first sight …" We often fall into the trap of "first impressions." All image consultants follow the idea "You have one chance to make a good first impression" to create a hit. It is true that you always have experience first impressions. I know from my own experience that the first thing we hear about someone influences our judgment about that person, and in business negotiations the first number we are told forms the basis of bargaining. This is called the anchor effect.

But first impressions are not our only chance to make a lasting impression. The effect of a last impression is more important than the first impression. Where did I learn this? In Mikael Krogerus and Roman Tschäppeler's *The Communication Book: 44 Ideas for Better Communication Every Day*,[1] which I read on a plane trip two years ago. It explained the forty-four most important theories in the history of communication in a way that was like the experience of taking a pill, briefly, and in a fluent way that I found very appealing.

According to the Peak End Rule, the reason why we watch television shows one after another is the "lasting impression" effect. The Peak End Rule is experienced when television shows end an episode on a cliffhanger. When it comes to communication, and how we start a meeting, how we set the tone and break the ice is of course important, but according to a study by Kahneman, winner of the Nobel Prize in economics, the real impact comes when focusing on the last message, not the first message. Krogerus and Tschäppeler conclude each principle with a beautiful parable. The main point of this subject is: "I don't care about the opening sentences. The only thing that interests me is the last sentence. It's the sentence the reader will go to bed with" (Elfriede Jelinek). No communication is impossible. It's a very natural action. We experience it every day, but I understood from this book that most of us do not know how communication works. Even so, there is not a single day that passes without us asking questions, reading, explaining, and writing, listening, discussing, or sometimes just being silent. *The Communication Book* discusses simple tools to facilitate or improve communication.

It takes us on a journey deep into the science of communication.

For example, in what situation are you aware of which "I" is the one speaking? I don't mean this in a way such as "There is one other me in me, who is deeper than me"[2] as Turkish poet Yunus Emre said. But my friends

know, there are many Murats they deal with, such as the spouse, father, uncle, young man, manager/supervisor, industrialist, Turkish man, and so on. Even these have different types: brave, impervious depending on situation., with sarcastic characteristics depending on the situation. Do you think you're any different?

There are examples of spontaneous events, where everyone, was someone else; these are communication examples. In 1964, Eric Berne developed a model in *Games People Play*, and revealed that there are three "me states" that occur when we communicate with others:

1. *Parental ego state:* We are all a bit like our parents. This occurs when we protect others or tell them what to do or not to do. But it also manifests when we are thoughtful, empathetic, and helpful.
2. *Adult ego state:* When we communicate in a thoughtful, controlled, and calm manner, we behave like adults. In other words, we use our adult ego when we express our opposition respectfully, act objectively, and react to constructive criticism.
3. *Child ego state:* Sometimes, we turn into the child within us. We are irrational or defiant, stupid or timid. However, positive traits such as our imagination, curiosity, and passion for learning are more evident in our childish communication.

When we communicate, one of the three ego states is always in use. However, we are not always aware of this; when we observe ourselves, we can find evidence. Suppose a proposal we made in a discussion is rejected by the group: If we react in defense or in defiance, we are in child mode. If we argue rationally and make the proposal ridiculous, we're in adult mode. But if we morally argue that others are wrong and the other party is wrong because we are right, then we are in parental mode. So one has to ask oneself, what ego state am I in right now, parental ego, adult ego, or child ego? I asked the same question to myself. I like seriousness. Personally, I am a serious man, and I both protect and respect the limits of others. Because of the attention I give to this matter, those who do not know me well believe that I am sullen.

However, I do not get angry so easily. The point is to prevent an event from becoming enflamed from the beginning. One's getting angry after the fact hurts one. A bad temper harms the person who possesses it the most. If you maintain seriousness and limits, a topic does not become hot.

I am patient. I value patience both in my business and in my private life. Even under the most difficult conditions and pressures, I do not disturb my mood and my calmness; I wait. My faith also advises me to have patience. So I don't remember having any difficulties when I was patient. I am one of those who believe that salvation can be achieved patiently. But patience should never turn into disgrace! In other words, patience is not just waiting

and stopping, showing consent and bowing. It is a word with resistance in it. Looking at all these features, I can say that I mostly use an adult ego in my communications. Even in communicating with my children, I use my adult ego, I use my "parent ego" as little as possible.

While the family is having fun, of course, my child ego is activated. Another medium of communication where my child ego is active is with my friends. How not? I have friends with whom I have been working for many years. This is so much so that we have spent more time with each other than I've spent with my family. We know each other so well that there is no longer any need to talk and explain ourselves fully to each other. When I am with them, my child ego comes into play, but of course I am a rather big boy. In fact, in my life, there are probably many more Murat Ülkers, the entrepreneur, industrialist, manager, friend, husband, father and grandfather. Who knows which one you might encounter when you meet me.

Most of the theories in *The Communication Book* defend the thesis "good communication is about cooperation." Meanwhile, based on the book, *The 48 Laws of Power*, in which the Robert Greene describes classical power strategies, he proposes some fraudulent strategies, to be used against us, even if we do not use them, so let's learn the following:

1. *If in doubt, do not argue!* If you are unsure about something, try not to reveal your doubt to others. Doubt and hesitation only undermine your arguments. With formulations that work for or against you, your opponent will see an opportunity to attack. Therefore, speak only when you are sure that you will realize your ideas, and do not back down, even if your plan crashes along the way. People forgive the mistakes of the brave, but do not trust those who doubt.
2. *Talk less!* Contrary to what is presumed, you should not try to convince the other person by talking too much. The more you speak, the more changeable and commonplace your thoughts may seem. The victory you get with words is then actually a victory with big losses, because nobody likes to be persuaded. If you always trigger your own reactions with your actions, you will be in control. First, though, be calm and friendly.
3. *Pretend to be ignorant!* We often tend to be dazzled by intelligence and charisma. Try the opposite: make your opponent feel smart. He may then feel smug and become careless. When your opponent lowers his guard, you can attack. Feigning ignorance is the oldest war tactic. The Chinese say, "Look like a pig to kill the Tiger."
4. *Give up!* If you can't persuade someone, reevaluate your own situation: What will it cost me if I give up now? A smiling confession of defeat leaves a more confident impression than a reverse attack. Besides, the less attention you pay to the other person, the less the satisfaction of others.

The quintessence of this theory is also interesting: "Oysters open completely when the moon is full; and when the crab sees one it throws a piece of stone or seaweed into it and the oyster cannot close again so that it becomes the crab's bait. Such is the fate of him who opens his mouth too much and thereby puts himself at the mercy of the listener"[1] (Leonardo da Vinci).

Here they suggest tactically, "talk less," but I am not a talkative person by nature. I'm a little surprised at talkative people – how do they find so much material to talk about. I guess this is because I speak little myself. As I have explained briefly, I do not like to listen to unnecessary words and I stay away from meaningless conversations, especially gossip. My inner circle knows, I don't get angry easily. Gossip is one of those situations where I can lose my temper, but because I keep my boundaries tight, I am exposed to rumors as little as possible. I mean, nobody comes and tries to "tell me gossip." Why should I wonder who is doing what and where? Sometimes my friends make a fuss telling me I am never curious. I have never understood why I need to know other people's secrets. Likewise, I do not share my secrets and troubles. But what if you listen and cure someone else's trouble?

Just as I get angry at gossip, there are other things I get angry about. These are not things that I can personally block, as I did in my private or business life. I get very angry about lies, waste, injustice, and damage to the environment and to society. I get angry, but I do not hold grudges. This is not something I can understand, keeping anger and holding anger in the heart for a long time. Howver, I cannot forgive, because what has happened, no one can turn back time. But every mistake is valuable, if we learn from it.

Feedback is a job and a word I don't like very much, and it is hard to communicate. It is more about culture, perhaps, and I am not very good at giving it either. Sometimes people think that when you exaggerate giving feedback-dose, you might appear rude. If you don't say "no" and almost never say "yes," like I do, then you get "what did Murat Ülker say?" or "I wonder if it was this, or if it was that he was talking about."

There is a chapter titled "How Do We Communicate Abroad?"in The Communication Book: 44 Ideas for Better Communication Everyday'Here, Krageus and Tschäppeler identified three main cultural and communication groups in Richard D. Lewis' book *When Cultures Collide* (2005):

1. *Linear efficient:* These societies, including Germany, Switzerland, England, and the USA, are linearly active. They speak as much as they listen, have a limited body language, speak politely but directly, tell the truth, and value the written word. They don't do multiple things at the same time.

2. *Multiple efficient:* Societies such as Mediterranean or Arab societies are multi-efficient; they talk a lot, gesture, are emotional, distort the facts, value the spoken word, and do many things at the same time.

3. *Reactive:* Societies such as Japan, China, or Korea are reactive; they have a smaller area of speech and try to get the other person to speak first; they have expressive body language; they speak kindly and indirectly; they cannot communicate and confront others face to face.

There are also mixed societies. For example, India has both reactive and multiple-efficient properties. Canada is on the border between linear – both active and reactive. If questions like "What? When? How many?" interest you, you are linear. If you are interested in "how" people communicate and relate to each other, you are multiple-efficient. If you are sure of "who" is saying what and their experience and authority, you are reactive. We sell products from Ülker, Godivam and United Biscuits in a geography where nearly four billion people and seventy nationalities live. We know different cultures closely. Indeed, although the language of business life is common, since we all have characteristics that come from our own culture, these do not easily change. For example, I look at American friends, and they have always smiling faces. The Japanese are not like that. They are quieter. We Turks, in contrast, may seem to be sullen, especially in the morning. In any case, when communicating in different languages, I take that discretionary attitude. Even when I speak English, I communicate much more directly and use American English. When I was young, I used to translate for my father. I remember a doctor we met with in Zurich, and he spoke German to us, and when he called his wife, he spoke French and told us that French was a more suitable language for women. Who knows.

Returning to *The Communication Book*, it covers a lot of interesting topics. I strongly suggest reading it. Some points from the stories in the book are[1] listed below:

- "In the twentieth century the phrase 'I think, therefore I exist' no longer applies, but rather 'Others are thinking of me, therefore I exist.'" (Peter Sloterdijk)
- "After I die, I want my tombstone to say 'Free Wi-Fi' so people will visit more often."
- "When all think alike, no one is thinking." (Walter Lippmann)
- "The most romantic gift is to listen to others' anxieties for an hour without judgment or 'solution' as an analyst might." (Alain de Botton)
- "We have two ears and one mouth, so that we can listen twice as much as we speak." (Epictetus)
- "If you, for example, want someone to confess something, start by talking open heartedly about your own mistakes."
- "Fear and hope look alike ultimately." (Richard Ford)
- "We become quieter if we believe that we are in the minority."
- "If you can't change your mind, then you're not using it enough."

- "When it comes to apologies, keep in mind there are only two ways: you can apologize unwillingly or sincerely. Choose the latter."
- "If you tell the truth, you don't have to remember anything." (Mark Twain)
- "If it's important, keep it short."
- "It takes a hammer to break a precious vase, just a quick action. But one word is enough to break a person's heart." (Eugen Drewermann)
- "The essence of traditional communication: we all like to be right. The essence of nonviolent communication: we are better off if we resolve a dispute than if we win it. Would you rather be right or happy?"
- "Nothing in life is as important as you think it is while you're thinking about it." (Daniel Kahneman)
- "As a leader, get used to the idea that you are primarily responsible for the supply of energy. In other words: motivate, advice, stabilize, provide momentum – and let others shine."
- "As for the person giving the feedback: most people are prone to being critical, as it gives them a feeling of superiority. They feel like they need to crush bad or weird ideas."

Toward the end of the book, self-talk, or inner dialogue, is also mentioned. Self-talk has two functions: the first is concentration, the second is motivation. Like every person, I think aloud and talk to myself. I always do this before my interviews and meetings. In other words, I have the person I imagine in front of me speak in various ways and I try to answer him/her. I recommend this to everyone. In this way, you will have studied various scenarios and prepared for the worst. From time to time I ask myself the question "Why do I live and work?" My answer is "to be good and do good." I want to benefit everyone, even people I don't know.

Even if I cannot prevent evil, I live by trying to spread the good and I strive for this. And thank goodness my work and my mercy allow it.

References

(1) Krogerus, M., and Tschäppeler, R. (2018). *The Communication Book: 44 Ideas for Better Communication Every Day*, Portfolio Penguin.

(2) Çiğdem AKYÜZ ÖZTOKMAK.(2020).*Eş Benlik Perspektifinden Yunus Emre'yi Okumak: Bir Ben Vardır Bende Benden İçeri*.Erdem

Yes or No: You Should Be Honest

In the feedback section of my article entitled "My Communication Style," I wrote: "If you don't say 'no' and almost never say 'yes' like I do, then you get 'what did Murat Ülker say?' and 'I wonder if it is this, or if it was that he was talking about' that people are consumed with." What I want is for them to come to their own decisions. Except for the subjects I have already mentored and specialized in (R & D, investment, undertaking/risk), I no longer tell anyone what to do or even listen to how they do it. I am interested in what they can accomplish (OKR and KPI), because it requires being at the top executive level working with me. It should not be necessary to spell everything out. Life is so short, busy, and there is so much work to do.

There were many comments under the post stating that it is important to give "feedforward," not "feedback." Let me explain it this way. Technically, feedforward is a feedback concept, a technique that emerged in the last two decades with the application of positive psychology in business. It's not too complicated. Let's say you didn't like the presentation of an employee. Criticizing the bad points of his presentation means feedback, but emphasizing the good results he will achieve by stating the points he should pay attention to in the next presentation means feedforward. Many studies show that feedforward is more effective for employee encouraging motivation and performance.[1] For example, my late father, Sabri Bey, would both feedforward and at the same time politely ask us questions as if he did not know or he did not have authority, allowing us to find the answer. He also emphasized the importance of consultation.

The words "yes" and "no" are very strong forms of feedback. In terms of the signal they give, they mean either opening a door or closing it. In everyday life, you habitually use so many yes and no words without thinking too much that you may not realize that these ordinary words can actually affect your whole life, including your working life. Especially as companies move toward a period in which silos disappear, more horizontal relations are developed, and tasks are fuzzy in companies, those who have started to climb their career ladder in terms of yes and no may face difficulties.

Functions in companies have begun to be carried out not only vertically but also horizontally and in cooperation. Top-down mana gement has begun to give way to fuzzy accountability and dotted line reporting, and this matrix organizational structure has started to complicate things.[2] All day, all employees, including myself, try to fulfill requests from different departments.

Looking at the requests received, it is impossible to say that they are formal or informal, large or small. I don't know how many of them are still requested on behalf of my name, and how many of them are requested using the name of Mr. Ali Ülker or Mehmet Tutuncu. I think we have been trying to halt this effect by professionalizing over time and we have achieved this. I explain this to each new coworker during orientation. Be careful. Even I don't want to talk, they make me talk before I speak. They say things are done like this, or Murat Bey wants it like that. Do not hesitate to question them, because sometimes when I say why something is being done, they will say, Murat Bey would like it like this, even to me. However, this prevents institutionalization and competent work by managers. In contrast, we have authorization/approval tables for the delegation and transfer of authority. The description of each job makes it clear who is responsible for what. While all this is going on, it is possible to receive various requests not only from top managers and teammates, but also from departments through the organizational chart, which have been labeled as "internal customers" for some time. These requests continue to come from the other side of the table or by phone, email, digital messages, and now from Zoom and from Teams, not to mention interruptive, and interesting but unnecessary information and requests from WhatsApp groups every minute.

This flow of information worries me. In communication, this is called "overloading communication." Multitasking was known to cause stress, but now it seems that digital stress has been added to it.[3] When the different tasks brought by technology began to be combined with requests from different places, a phenomenon called digital stress emerged. The bombardment of information and news and the accompanying expectations have become truly alarming. Professional success and personal well-being depend now more than ever on how one manages the flow of audio, written, and video information and news, let alone how beginners do this, even at the top of their profession. If everyone and everything is given a "yes," it is not possible to do everything well. To a friend who inquired, "How do you manage such large and diverse businesses?" I once said, "It is not as difficult as you think when everyone does their job. I only have the right to say 'no' (veto), and I use it." But in general, I use little yeses and nos. Because I know the consequences.

Harvard professor Robert Cialdini explains the science of making people say "yes" in his book *The Psychology of Persuasion*, which is one of the best-selling psychology books in the world.[4] There is such research in the *The Psychology of Persuasion*. University students were asked if they could guide young and troubled children for a day to visit the zoo. Eighty-three percent answered "no." Later, when another group of university students were asked whether they would be able to guide young and troubled children

once or twice a week for two years, and whether they would be a babysitter for a day at the zoo, the rate of those who said "yes" increased threefold. Cialdini calls this the rule of "reciprocity" in persuasion. The load reduction in the second question was perceived as doing good, and then the lighter burden was accepted as responding to the good. Cialdini discusses seven such important persuasion principles in his book. In fact, the lesser known book, called *Yes!*, was cowritten with Noah Goldstein and others. His book *Yes: 50 Scientifically Proven Ways to Persuade* has been quite a success.[5] When you realize that there are many persuasive strategies and tactics used to make us say "yes," you once again understand how important and protective every yes or no that comes out of our mouths can be.

The information and news feed today includes more information than anyone can afford. Some of this material is supported by persuasion strategies and tactics. If you take on or do not prioritize more than you can do, you will be exhausted and you will be unable to do the things you need to do. But will you be able to afford to annoy your coworkers and other requesters? What will your attitude be when new career and life opportunities appear? That's why it's so important to know when and how to say no or yes.

A well thought-out no will protect you, and a proper yes can make a difference, lead to cooperation, and increase our impact. So how do we make sure that when saying yes, it is really yes, and when we say no, it is really no? Because simply saying yes or no can have different consequences.For example, a top manager who is very hardworking and knows the technical side of his job very well, conducts investment projects and risk analysis and supervises the relevant units in this regard. His job is to make investment suggestions, but when it comes to presenting the data and reaching a result, he communicates the message in an extremely colorless way. So he uses neither a persuasive nor authoritative tone, and just says yes. The senior management team, then, does not trust his judgments. However, establishing connections with internal customers and gaining their trust should be a priority, right? But does doing this have anything to do with the quality of the work he does? Is this explicitly requested of him? He really has a background in his job, his investment advice is sound, and although he's good, he might lose his job. Because what can the result of a mere answer (yes) cost?

A "no" answer that has been reached as a result of good evaluation protects you. A properly used yes allows you to serve others, to make a difference, to collaborate successfully, and to increase your influence. By saying "no" at the right time, for the right reasons, it should be aimed at gaining a good reputation and making each yes truly valuable. Tulgan explained very well how to do this,[2] saying: first evaluate the demand (request) and either give a logical "no" answer or say a "yes" that will lead to success.

According to Tulgan's model, the information you obtain from the applicant as a result of your questions should include:

1. What is the date and time of the request? (You can watch how the project is developing.)
2. Who is the request from?
3. What exactly does he/she want?
4. When should it end?
5. What kind of resources do I need to do the job?
6. Who is the source of authority in this matter and does this person or group have approval?
7. What are the possible benefits?
8. What are the overt and hidden costs?

You have to gather information to understand the demand. The larger or more complex the demand, the more information you need to gather. Sometimes fulfilling the request is out of the question. Or the demand seems so insignificant that doing it may take less time than taking notes. But if you try to scrutinize every request, small and large, people may accuse you of creating an unnecessary bureaucracy, and they may be right. You may find that a request that seems absurd at first glance is actually wise or rational, and another request is actually illogical. Taking notes should become a habit in response to requests. It would be great if you shared this note with the requester. When you create an approved request from the other party about what is needed, their confidence increases when they witness how you make a "yes or no" decision. A well thought-out no answer at the right time can be a reason preferred by everyone. A bad no given in a hurry can cause problems for everyone, especially you. When you do not evaluate a request correctly, you may create many negative judgments, such as people saying, "ignoring us, not cooperating, running away from work," with the criticisms spoken behind your back. When you refuse to decide because you have no capacity to do so, bad nos begin to occur. False nos often cause you to miss out on experiences that will work for you, and you may start to be rejected and harsh, hurtful feelings may start to form between the parties.

In fact, a correct no is about timing and logic. You should say no to things that are not allowed, cannot be done, or disturb the balance you are trying to maintain. If there are procedures, directives, or regulations that prohibit you from doing that job, or if your superior has forbidden you from doing that job, you have closed the door in the first place, says Bruce Tulgan. It is true, if it is something that can be done for you, you should still not do it, but you can make an attempt to change that procedure, directive, or regulation. If it is not right for you to do that job, stop interacting with the person who made the request. Say, "I have no discretion here. This request violates the

policy, the rules" and reject it outright. It's easy to reject people in the first place, remember.

In the second stage, it is actually easy to say "no." If you don't have the ability to do the job, it is OK to say initially, "this is beyond my skills." Or you could say, "I currently have no experience to fulfill your request quickly and safely." The answer may again be no, but the answer is also "This is not my specialty. But I can learn and do it in a short time. Give me some time." This move will be a real development area for you. so you will be applied for such projects and you can progress in your career.

However, the most common reason for the "can't" answer, or "no," is overload. In these cases, people tend to say things like "If I look at my other jobs, I won't be able to do this anytime soon." This is a mandatory "no." If you can't avoid this, try to take the opportunity to fulfill the request later, or to help when you are available.

The third stage is the most difficult, because it is not clear at first whether it is worth doing, whatever it is. You need to make a judgment about your likelihood of success, the potential ROI, and your and your company's priorities. And sometimes the answer to your request can be "maybe" or "not now." What can you say in such situations? "I need to know more. Let me ask you these questions." Essentially, you make sure that the person who needs help comes up with a more comprehensive or persuasive recommendation.

If you don't think it's a valuable target for you right now, then give any of the following answers: this is not something I should say yes to at the moment because the probability of success is low, or not in line with current priorities, or I don't think the result will be very good. No, if it is a definite NO, report it to the other party and say, I know someone who can do it, or I can help someone else do it for you. If your answer is, I can't or shouldn't do it, or if it's a bad idea or you shouldn't do it, then have this conversation with the person making the request and let them learn the facts.

This is very important: Every definite no allows you to say a more accurate yes. This will be a yes that adds value, builds relationships, and enhances your reputation.

Most people have a lot of work and little time to do it. It might make you feel important to say yes to requests from your superiors, teammates, and others, but can you continue working like this? The only way to be successful sustainably is to be truly successful at saying no in a way that makes people feel respected, and yes only when you have a solid desire and a clear plan of action.[2]

I may not have emphasized the psychological state of the one who received the "yes" or "no" answer; it is possible that a good no can be perceived as rejection and cause negative behaviors that can put the person in various states of emotional deprivation. Being a part of a group and not staying

outside of it are very important social effects for those who demand it. This effect should also be taken into account.

In my article entitled "My Communication Style," I mentioned the "parent, child, adult" egos as proposed by Eric Berne. Namely, these are the behavioral patterns that come into play in different situations in our brain. When answering yes or no, it should not be forgotten which type of behavior can come into play. Our preference should be for adult behavior. Do not forget that #makehappybehappy occurs as a result of a correctly used "yes" or "no."

References

(1) Rice, B. (2017). "Feedforward or Feedback – Reframing Positive Performance Management," *Human Resource Management International Digest*, 25(5), pp. 7–9.

(2) Tulgan, B. (2020). "Learn When to Say No," *HBR*, Sept.

(3) Reinecke, L. et al. (2017). "Digital Stress over the Life Span: The Effects of Communication Load and Internet Multitasking on Perceived Stress and Psychological Health Impairments in a German Probability Sample," *Media Psychology*, 20(1), pp. 90–115.

(4) Cialdini, R. (2007). *Influence: The Psychology of Persuasion*, Harper Business.

(5) Cialdini, R. et al. (2009). *Yes! 50 Scientifically Proven Ways to Be Persuasive*, Simon & Schuster.

What Does Schadenfreude Mean?

In the first half of 2020, Yildiz Holding made six million dollars in cash and early payments to banks in Turkey with revenues from overseas operations. Thus, the total amount we have paid to banks since 2018 has reached 2 billion 561 million dollars, even under the pandemic conditions we were living in. This important news was featured in most newspapers and websites. When I look at the entries and comments on social media, let alone fake accounts, some of the accounts that we suppose are real, are taking revenge on their nemeses with great vengeance. The trolls' uproar overwhelms the thoughts of the others. This has been going on since 2008 when we decided to create a global brand from Turkey and bought Godiva into our business.

Transparency ... even saying this word provides me relief. Either Be As You Seem or Seem As You Are. This is an abstract moral code; it is universal. Well, easier said than done. When we talk about computerization and digitalization, how much easier things would be if we really applied transparency in our mobile world! Of course, if it is wanted. Unfortunately, humanity hasn't made its choice in this direction. When this was the choice, as I summarized at the beginning, false lives and trolling under fake names took place all over the world, especially on Twitter.[1] Facebook to gossip by investigating the privacy of others; Instagram to expose what we eat, drink, wear and don't wear; TikTok to show our privacy like spoiled children who want to attract attention, etc., are other social media platforms that surround society with a pandemic. In addition to the unknown accounts, fake lives, and social relations on these platforms, this type of behavior under a real name shows that society has adopted this kind of behavior that has become so widespread in social life.

In particular, society and politicians who were disturbed by the nontransparent state of Twitter, enacted a social media law. But fake names are dominant in the world, and trolling continues at full speed. Interestingly, for some reason, there is no sound from the volunteer community guards who are pontificating on everything. I guess they got caught up in the two-faced celebrity lust of social media. A similar disease is that of watching porn; it continues secretly as a social disease in all countries and continues to be one of the main causes of unhealthy sexual and family life. In fact, isn't the social consensus here also a hypocrisy?

Have you ever heard of something called schadenfreude? It's a German word, but it's the same in English; *Schaden* means damage, *Freude* means pleasure. Schadenfreude is to enjoy harm, damage, misfortune but that

happened to someone else. Let me explain it this way: Let's say you meet a friend on the road that you haven't seen for ten years. You talk to him, he tells you about his achievements, how he got promoted, how he got bonuses. You, on the other hand, have been working for the same salary, in the same position, for ten years. While you can think to yourself, "How did he do it? Why couldn't I? What did he give up to get this money" what you feel is envy or jealousy. We can explain this feeling by saying, "I am jealous" during a conversation. Jealousy is a very damaging emotion. It is one of the biggest sins in our religion as well as in other religions. For example, according to Islam, envy is not only a sickness of the heart that causes sin but also destroys the good deeds of its owner. The matters deemed necessary for brotherhood and social peace are listed as follows: "Do not pursue gossip, do not investigate the faults of others, do not envy each other, do not turn your back on each other, and do not hold grudges."[2]

Those who are my age and are experienced know that jealousy is not an emotion that can be suppressed, but it is a manageable one. Those with a deep sense of awareness often become aware of the jealousy they feel; they feel ashamed and guilty and educate themselves in their later life. Let's continue with our example. After the conversation, your friend gets into a red sports car and drives off, and while you are watching him, you see a city bus crash into your friend's car. What do you feel? Jealousy? No, you feel this pleasure, which we cannot easily define, that is called Schadenfreude, that is, to enjoy the harm inflicted on another. This word, which appeared in the English dictionary for the first time in 1853, was described by R.C. Trench, Archbishop of Dublin, who first included the term "Schadenfreude" in his book On the Study of Words: "a mournful record of the strange wickedness which is more productive in evil has invented."[3]

The Japanese do not have this word, but there is a saying that "The misfortunes of others are sweeter than honey." The French speak of joie maligne, that is, a diabolical pleasure derived from other people's suffering. In Danish, the word is skadefryd, while the Dutch speak of the feeling of leedvermaak. In Hebrew, simcha la-ed is the name for rejoicing at other people's calamities. It is xìng-zāi-lè-huò in Mandarin Chinese, zluradost in Serbian-Croatian, and zloradstvo in Russian. While the Romans spoke of malevolentia, before that, the Greeks described epichairekakia, that is, to rejoice over an embarrassing situation.

The word "Schadenfreude" has no equivalent in today's Turkish; it is not used, even though this feeling is experienced so much on social media. In the old language, there is the word shamata of Arabic origin. It literally means "to rejoice at the trouble, misfortune that befell someone else." In all religions and in our religion, Islam, Schadenfreude or shamata is a feeling that should be avoided. For example, the following is stated in a hadith: "Do not

shamata your brother in religion! If you do, Allah will take the trouble from him and give it to you."[4]

In other words, weak, low-tempered people seem to have relied on the failure and humiliation of others throughout the ages in different geographies when it comes to making themselves happy. The famous philosopher Friedrich Nietzsche wrote in the 1880s that "To see others suffer makes you feel good" and added that "Schadenfreude is revenge for the impotent." Schadenfreude has been little studied academically. There are almost no academic papers on this subject before 2000. The interesting thing is that parents have this feeling much less for their children. Siblings and relatives, on the other hand, feel more. There are not enough academic studies on this subject. Others have complained about this fact.[5]

Today, in all four corners of our social media, the feeling of Schadenfreude has permeated life. People are trolling and even lynching famous artists, politicians, athletes, phenomena, even ordinary people's successes and failures, let alone fake, from real accounts with disgraceful gossip, spreading false information, slandering, and mocking. And of course, there are those who watch. I guess they have Schadenfreude, the pleasure of Schadenfreude at its peak. For this reason, the majority of people browse social media without knowing why they are browsing, watching silly paparazzi videos, reading how people screwed over each other, and are experiencing a sense of jealousy.

British academic Tiffany Watt Smith, in her book titled *Schadenfreude: Joy at the Misfortune of Another*, says that the word Schadenfreude is used today to describe five different situations: (1) the opportunistic pleasure one gets from an unfortunate situation that one did not personally cause, a kind of entertainment to watch; (2) exuberance in the face of disasters that befell another person; (3) interpreting the other person's suffering as a deserved punishment; (4) appeasing the envy and incompetence of oneself through others' failures; (5) joy over petty blunders and troubles rather than terrible tragedies and deaths. So why this feeling? Is it a lack of compassion, does it come from childhood, is it a lack of empathy, or is it a desire to balance justice? Is it the love of seeing the opponent squirm in hopes of being on the winning side? Isn't it like being happy that the key player on the opposing team is injured in football? Is it our willingness to compare ourselves to others and to make sense of our choices when we fall short? It is a very confusing feeling! There is no clear answer from academics yet. It comes to us with a feeling of embarrassment and actually worries those who feel the emotion. This feeling of shame is because it reveals our own envy and humiliation and how we cling to the misfortune of others like a lifeline to relieve the pain of our own frustrations and is especially exacerbated when it is experienced among siblings and relatives.[6]

I gave an example of a red car above. For example, imagine that the driver died or became disabled in that accident and left a wife and two small children behind. Would you like to experience the pleasure of "Schadenfreude"? So far, research shows that this madness has stopped at some point, but I am afraid that if it continues like this, we will evolve into a society that takes pleasure in the death, disability, and destruction of people's lives. Even now, we are in a very bad place from envy that reaches to Schadenfreude, making a peak in social media. From here on, it is an enmity, in other words a grudge. Schadenfreude is a behavior that we need to take a closer look at, such as the behavior of watching porn, which we try to cover up. This word has no equivalent in today's Turkish and is not used; Even though this feeling is experienced so much on social media.This is a suggestion. We should educate and follow up on the use of social media throughout our lives, first in the family, then at school, and finally in the whole society. Just as adults who witness an abusive conversation of children while they are playing among themselves and warn them that things like that should not be repeated in the presence of adults, a similar attitude should be valid for social media. People who use pseudonyms on social media should be treated with suspicion, and other people should limit their relationship to them. Imagine if your neighbor lived with a fake identity, even had a few fake IDs, and behaved differently, or if an elder who wanted to condemn you publicly announced this in a neighborhood café, or told everyone else but not you or your spouse, or a friend was gossiping about others, making insults and curses with their faces masked in the public square. How would you feel?

The famous philosopher Arthur Schopenhauer defined the feeling of Schadenfreude as follows: "the worst feeling of human nature, an infallible sign of a thoroughly bad heart and profound moral worthlessness," adding that any person caught enjoying the suffering of others should be shunned from human society.[7] I think he's right!

I think futurologists should envision what kind of social life we will have when the morality of society becomes this, instead of envisioning life on Mars. Otherwise, it's like a hell-less cauldron, really; we will be a hypocritical society that destroys the good, the beautiful, and the successful.

These kinds of bad habits have always existed in humans. However, we should keep the bad habits of the person separate and consider the person a good person again. Human morality demands it. For example, we should consider people with bad habits or wrong beliefs, or other political attitudes, according to us, as our fellow human beings and live in peace with love and respect. Those bad habits and mistakes do not belong to the person; perhaps they are a small part of his personality. Similarly, a person suffering from an illness will recover in the future, or it is imperative that we provide the orphan, the incapacitated, and the disabled person with the necessary things

despite their conditions. We may become one of them one day. We know that living with them and showing tolerance and convenience to them is an indispensable condition of social life. Understanding the suffering of others is essential for a good society. Putting ourselves in someone else's position, and having empathy influence our ability to be a proper wife, mother/father, and a good friend. The more empathy becomes important, the more repulsive Schadenfreude will appear.

Few of us take pleasure in the suffering of others simply because there is pain. Rather, we take pleasure in judging whether that pain is deserved or beneficial in some way. In fact, this is evidence not of malice but of a desire to maintain a moral balance. Above all, Schadenfreude demonstrates our capacity for emotional flexibility as opposed to schematized moral rigidity, and our ability to simultaneously hold in our minds seemingly contradictory thoughts and feelings. Schadenfreude and empathy (sympathy) are not mutually exclusive responses but are both felt at the same time. When we increase empathy and tolerance, Schadenfreude will not be able to destroy our society.

Finally, let me end by stating this. As far as I remember, after it was said that it is possible to envy only two people, it was stated that one of them was a person who spent his wealth for good, and the other was a person who acted with his knowledge and taught this knowledge to someone else. Here, the word "envy" is used to mean desire, desire to do good.[8] In other words, if you want to use your feelings of envy and Schadenfreude, then try to compete with kindness and beauty, and spend your energy to be one of those who do good and teach someone something.

Now I go back to the beginning and repeat: "Yildiz Holding made six hundred million dollars in cash and early payments to banks in Turkey in the first half of 2020 with the revenues from its overseas operations. Thus, the total amount paid to banks as of 2018 reached 2 billion 561 million dollars. And during the pandemic."

What did you feel?

References

(1) To understand the world of bot accounts on Twitter, I suggest you take a look at the book *Twitterbots*, MIT Press, 2018, by T. Veale and M. Cook.

(2) Haset, https://islamancyclopedisi.org.tr/haset.

(3) Trench, R. C. (1872). On the Study of Words, MacMillan, in W. T. Smith (ed.). (2020). *Schadenfreude*, Collective Book, p. 23.

(4) Shematet, http://www.dinimizslam.com/detay.asp?Aid=1294.

(5) Dijk, W. W., and Ouwerkerk, W. J. (2014). *Schadenfreude: Understanding Pleasure at the Misfortunes of Others*, Cambridge University Press.

(6) Smith, W. T. (2020). *Schadenfreude*, Collective Book, p. 25.

(7) Ibid, p. 22.

(8) Haset, https://islamancyclopedisi.org.tr/haset.

The Body Keeps Score. Never Mind It's in Our Hands to Change the Record!

You know from my articles that I am interested in the field of psychology. Recently, a friend of mine said, "Take a look at the book *The Body Keeps the Score* – it will certainly interest you." I looked into the book; it was said to be "the best book ever written in the field of trauma." It is packed with up-to-date information since it touches on trauma from a neuroscientific perspective. It was said that it interestingly presents the effectiveness of new approaches that could be used in the treatment of traumatic stress disorder. It was stated that it was an alternative to the classical Freudian psychoanalytic and cognitive-behavioral methods and that it was a great pleasure to read. It was said "It contains lots of real-life examples." The book has been on the psychology bestseller list since it hit the shelves in the USA in 2015. Indeed, the book is based on a diagnosis and treatment approach that shows the importance of the interaction of the brain and body in coping with pain and loss as well as overcoming traumatic experiences and reconnecting with the real world. *The Body Keeps the Score* takes an opposing position to the psychiatry approach based on existing drug recommendations. Instead of this approach, it goes back to the root of mental illnesses through neuroscience, which also makes use of today's advanced imaging technologies. In my article entitled "Dopamine Nation," I stated, based on ideas from that author[1] that drug treatments do not work in depression and that depression deepens at the end of the day. Dutch psychiatrist and the author of *The Body Keeps the Score*, Bessel van der Kolk, holds the same view.

The author defines trauma as toxic stress caused by bad experiences that sever the relationship between mind and body, with lasting effects on brain development and attachment and communication systems. Van der Kolk explains that one doesn't have to be a combatant or visit a battlecamp in Congo or Syria, to experience trauma. Research by the Centers for Disease Control and Prevention shows that one in five Americans were sexually abused as a child; one in four has been beaten by their parents, leaving scars; and one in three couples has experienced physical violence. One in four families has alcoholism problems, and one in eight witnessed their mother being physically abused or beaten.

Traumatic experiences like these leave scars that last for generations. Author van der Kolk, a researcher at the Massachusetts Center for Mental Health, conducted a study with children aged six to eleven. The only difference between the groups he compared is the abuse children experienced within the family. A boy received serious injuries as a result of his mother's

beating; a girl was sexually abused by her father when she was four years old; and two boys were repeatedly tied to a chair and whipped! Even the most innocent images shown to these children during the research caused an intense perception of danger, aggression, sexual arousal, and terror. The real problem is whether it is possible to support the brains and minds of these children, who have been treated cruelly, to redraw their inner maps and develop a sense of confidence in the future.

Looking at society today, I think that the deeply traumatic experiences left by the pandemic had an impact on everyone, from age seven to seventy and that the records our bodies have kept in the last two years will affect our entire future if we do not realize this.

Traumatic experiences continue to affect our psychology, relationships, physiology, and immune system long after the time they were experienced, and with the slightest alarm signal that reminds of the experience, our brain circuits, which are programmed due to a malfunction, are activated and cause us to secrete intense amounts of stress hormones. When individuals recall past events in which they had obsessive and intense deep emotions, their imaginations are stifled and they lose their psychic flexibility. However, imagination is a very important phenomenon for quality of life. It gives us the opportunity to visualize new possibilities, ignites creativity, and enriches our relationships.

In summary, trauma makes a behavioral change to the mind and body and rearranges perceptions. It affects not only how and what one thinks but also the capacity to think. To achieve normalization, the mind and body need to learn to live in the present moment and that the danger has passed.

Children who have a safe past, that is, who grow up comfortably with the affection they receive from their parents, have a lifetime advantage. They become "attuned" to their environment and the people around them, and develop traits such as self-awareness, empathy, impulse control, and self-motivation that enable them to be participatory members of social culture. Children who feel insecure in infancy have trouble regulating their moods and emotional responses as they grow up. If we don't have an inner sense of security, we have a hard time distinguishing between trust and danger. Van der Kolk states that people with irregular attachment are always preparing themselves to be traumatized in later experiences. These words reminded me of what we went through during the pandemic. During this period, in addition to personal and family problems in terms of attachment, did we not have problems of attachment to the world and life?

Ideally, the stress hormone should respond to danger with lightning speed and then bring us back into balance. In patients with PTSD, this balance cannot be achieved. The signals for "fight, flight, or freeze"* continue even after the danger has passed, and this panic situation causes serious

damage to health in the long run. Van der Kolk comments on drugs: "They help people live in the moment rather than being trapped in the past."[2] However, drug therapy should be used as a complement to the entire treatment approach. The negative side of drug treatments is that the underlying causes are not investigated. Later, van der Kolk explains through discussing examples, the increase in the use of antidepressants all over the world, including for children. This treatment makes children more manageable and reduces their aggression. The most critical aspect of drug therapy is that it does not allow the individual to participate in his/her own healing process. However, humans have the ability to regulate their own physiology. Van der Kolk continues, observing that three new disciplines are making a big difference in the approach to trauma, abuse, and neglect:

1. Neuroscience (shows how the brain affects mental processes)
2. Developmental Psychopathology (examines the impact of negative experiences on the development of the mind and brain)
3. Interpersonal neurobiology (studies how our behavior affects our emotions, our biology, and those around us)

These disciplines have shown that trauma creates real changes in the brain, preventing individuals from living their normal lives, and help to recovery.* The fight, flight, or freeze response is how the body responds to perceived threats. It is involuntary and involves a number of physiological changes that help someone prepare to:

- fight, or take action to eliminate the danger
- flee, which involves escaping the danger
- freeze, which involves becoming immobile

There are some methods to mitigate and repair the damage caused by trauma. More importantly, these disciplines provide benefits for living in the present moment and continuing life successfully after a previous traumatic experience.

The author states that "people who experience trauma cannot explain what happened to them, even years after. As their bodies relive fear, anger, and helplessness, the urge to fight or flee is rekindled, but they are unable to express these feelings"[2]. Van der Kolk elaborates, providing evidence from brain scan images:

"People who experience trauma are trapped, unable to bring new experiences into their lives. These problems can occur as various physical symptoms along with fibromyalgia, chronic fatigue, and other autoimmune diseases. The subcortical areas of the brain regulate our breathing, heartbeat, digestion, hormone release and immune system.

However, these systems can lose control when faced with a perceived threat. This explains the cause of common physical problems identified in traumatized individuals. In summary, brain scan images show how persistent the fears of trauma survivors are and how easily physical symptoms are triggered. This points out that we should consider the entire organism, body, mind, and brain as a whole in trauma treatment."[2]

Van der Kolk then offers a solution, saying that "There are three methods of treatment and one of them or all three together can be used in each patient."[2] He explains that what is needed is:

1. Top-down analysis by talking, communicating, and allowing ourselves to understand what happened while processing memories of the trauma
2. The taking of drugs that stop inappropriate, false alarm responses, or the utilization of other technologies that alter the way the brain processes information.
3. A bottom-up method that allows the body to experience visceral experiences against helplessness, anger, or collapse caused by trauma

"The intense emotions of trauma do involve not only the mind but also the gut and heart. The body keeps score. If the memory of trauma is encoded in internal organs, autoimmune disorders, skeletal/muscle problems, radical changes should be made in therapeutic assumptions.

Many treatment approaches to traumatic stress focus on reducing patients' sensitivity to their past. Patients should be helped to live life to the fullest in the moment and stay in the present moment safely. Medicine does not cure trauma, only dull the expressions of impaired physiology. They do not provide permanent learning about self-regulation. They help control emotions and behavior but this comes at a cost because they inhibit the chemical systems that regulate motivation, pain and pleasure"[2], van der Kolk writes.

Now, let us start from a hypothetical example that I hear often:

Everyone, including his supervisor, refrained from Mr. Can, who was a successful senior manager, because, even in a meeting where he was given the right, he would definitely start a discussion, and as a result, there would be a lot of uneasiness and resentment for no reason at all. When the reason for this was looked into, it was discovered that it was based on a memory from high school years. He was in math class, had an open discussion with the teacher on solving a problem, and was proved right in front of the entire class, even getting a very good grade on the next exam. This incident was ingrained in his mind as "if you challenged the authority, you would eventually succeed." Who knows how proud he was of himself, what records his body had kept. Now, he would act outrageously throughout his life on issues that he was confident of and received approval because he had learned this was a way to ensure his success. However, if he were aware of this situation,

he wouldn't really need it, and he would have a successful team around him that loved and appreciated him.

Later, he goes into the details and methods of psychological therapy, allowing the feelings of trauma to begin to be felt and the person to observe himself. However, the underlying issue is the change in the threat perception system of the brain. The challenge here is not to learn to accept the terrible things that have happened to a person but to overcome their inner perceptions and emotions. Perceiving what is happening internally and naming them is the first step to healing.

The trauma therapy goals were:

- Reaching sensory information that is frozen or blocked due to trauma,
- Helping the patient control the energies that emerge as a result of internal experiences,
- Completing physical actions for self-protection when the patient is cornered by fear.

This brings to mind neuro-linguistic programming (NLP), which I once studied, which is a method whose theoretical foundations are still controversial[3] and which even the science of social psychology asserts is a rival to positive psychology, which focuses on human happiness. The close connection between the functioning of our nervous system (neuro) and language abilities (linguistics), and the role of mental strategies that regulate and direct behaviors on the formation of verbal patterns form the basis of NLP.[4] Let me tell you about my first NLP experience; It was years ago, and I was looking for ways to increase my productivity. It was asked asked to me what I liked the most in my youth. It came to my mind that on the day I got my first driver's license, I drove my father's car between Florya and Sirkeci six times on the Istanbul Coastal Road. Then, when I concentrated, I remembered the unique smell in the cars of that period, the feeling of the cool wind coming from the open window, and relived the memory.

This was awareness. Thus, it was possible to relive the happy moment. While actively remembering and reliving similar past memories, you can reprogram your actions and speech by making up-to-date inferences.

According to NLP, language can parallel or even replace experience and actions in our other internal representational systems. As a result, talking about something is more effective than just reflecting onour perceptions. This gives language a much more integral role in the processes of change and improvement.

According to NLP, we take new information about reality from life and add it to our own map, and this experience-based information is constantly filtered, that is, distorted, deleted, or generalized. NLP prevents any event from being corrupted by judgment or interpretation with extremely simple

practices; it allows us to reexperience the event in our memories through our minds. Thus, we can have more meaningful and richer responses. There are four stages at the heart of NLP: (1) knowing what you want, (2) taking action, (3) learning to notice the results of our actions, (4) being ready to change our behavior until we get the results we seek.[5]

Allow me to provide another minor example again:

Thank God I'm healthy today; I'm alive, but tomorrow the pandemic will spread.
Thank God I'm alive healthy, and the pandemic will spread.
Even if the pandemic spreads tomorrow, today, I am healthy and alive.

In these three expressions, only the conjunctions "but" and "and," can change the meaning. If you learn to frame your thought with "even if/though/so," then you may be able to feel better and take the precautions to protect yourself better by being grateful that you are alive, and as a result you may not feel trapped. Obviously, NLP is a technique of learning to frame your thoughts in a positive way. Of course, it cannot be learned by a simple example such as the one I mentioned, but it is not difficult either.

If survival is what you want, you will immediately do whatever is necessary, you will be aware of the consequences of every action you take, and you will be ready to change your behavior and try new things until you achieve the "survival" result. Nowadays, this is also called "mindfulness." In fact, journal-type diary books are published that try to make people aware of their behavior.[6]Of course, the author of *The Body Keeps the Score*, van der Kolk, and other psychotherapists are among those who think that people cannot become aware of their behavior and therefore cannot change. What should we do? Is it best to let everything go and live the moment, or what?

In contrast, we must realize who is keeping the real "record," surrender to Him, and accept what comes from Him, but of course, after doing our best and doing what makes sense.

I pray like this: O Lord, let my end, that you have decreed for me, be good (beautiful), amen, and then I embrace my work.

References

(1) Ulker, M. (2021, December 12). *Dopamin Orucu, Çilehane ve İtikaf - Murat Ülker*. Murat Ülker -. https://muratulker.com/y/dopamin-orucu-cilehane-ve-itikaf/

(2) https://www.amazon.com/Body-Keeps-Score-Healing-Trauma/dp/0143127748/ref=sr_1_1?qid=1648641640&refinements=p_27%3ABessel\+van\+der\+Kolk\+M.D.&s=books& sr=1-1&text=Bessel\+van\+der\+Kolk\+M.D.

(3) Davies, G. R. (2009). "Neuro-Linguistic Programming: A Cargo Cult Psychology?", *Journal of Applied Research in Higher Education*, 1(2), pp. 57–63.

(4) https://www.amazon.com/Sleight-Mouth-Conversational-Belief-Cha nge/dp/1947629026/ref=sr_1_2?crid=12PAIYNOKSPF4&keywo rds=roberts\+dilts&qid=1648642261&s= books&sprefix= %2Cstripbooks%2C260&sr=1-

(5) https://www.amazon.com/NLP-Science-Getting-What-Want/dp/074 9914300/ref=sr_1_3?qid=1648642189&refinements=p_27%3AHa rry\+Alder&s=books&sr=1-3&text=Harry\+Alder

(6) https://www.pandora.com.tr/kitap/iyilestiren-aliskanliklar-gunlugu/ 767821

The First Self-Help Book I Ever Read: Carnegie's Three Fundamental Principles

Until today, he has published summaries of the seventy most effective business books, and the name James M. Russell, is the author of Dale Carnegie's written: *How to Win Friends and Influence People* – the eighth book my parents gave me during my high school years. I later read *How to Develop Self-Confidence and Influence People by Public Speaking* and many more. My father would say that he benefited greatly from these books and give examples: For example, related to the proverb "I learned manners from the ill-mannered," told me the following incident that happened to Carnegie: When Carnegie was young then, businessmen would dictate letters, and secretaries would type them up and complete them with a fresh signature. However, important men, who were very busy, would add the note "dictated, but not read" at the bottom of the letter because they had not found time to review and sign it. When the young Carnegie, who thought this note was a necessity for important men, added the same note to a letter he had written, the only reply he received was "Your bad manners are exceeded only by your bad manners."

Carnegie was a distinguished figure. The book, *How to Win Friends and Influence People*, he wrote can actually be considered the world's first self-help book. The subject is personal development, but it is a book that teaches the reader how to make friends through convincing the other person to be friend, because Carnegie was a skillful salesman. I later found that many of the books that popularized the topic of persuasion came nowhere near the caliber of Carnegie's book. Or most were copies of Carnegie's work or extended repetitions. Russell asks: What do Warren Buffett and Charles Manson have in common? What do a billionaire investor and a bloodthirsty criminal have in common?

The answer: Their favorite book is *How to Win Friends and Influence People*.

Dale Carnegie was born the son of a poor farmer in Maryville, Missouri, in 1888. He was educated at State Teacher's College. His first job after college was to give sales courses to farmers, and later, he started selling for Armor & Company. He was appointed as the firm's manager in the South Omaha region. He died of Hodgkin's disease in 1955.

Carnegie was the first person to discover people lacked the ability to persuade others and spent his life trying to help people improve on this. We can even say that he is the world's first personal development specialist in sales.

Carnegie was giving lectures in eloquence in New York in the 1930s, just after the Great Depression. When Simon & Schuster, one of the biggest publishers today, saw that the lectures were attracting attention, they asked Carnegie to publish his lecture notes, thinking that they would sell well. When he was offered to write a book, he read every book that explained human behavior and told the life stories of successful people. He even set up a team to summarize them. When the book was published, it was clear that the publisher had not been mistaken in its opinion of Carnegie's lectures. The book is thought to have sold fifty million copies to date, including pirated editions. The book was updated by Carnegie's heirs after his death, leaving its core content intact.

Carnegie begins his book saying that in order to master the art of winning friends and influencing people, three basic principles of dealing with people must first be learned. "Use them whenever possible and even ask a friend, partner, or coworker to remind you if you violate one of these policies,"[1] he says. Carnegie, who recommends continuous practice, says that a person should note daily his/her practice and that he/she should be aware of which method is used in what situations.

Carnegie's Three Fundamental Principles

Principle 1: Do not criticize, condemn, or complain!

The first and foremost basic principle of managing people is to be kind. To do this, you should not criticize, condemn, or complain about people. Instead of judging or belittling people, you should try to understand what they do and why. That way, you can be supportive, tolerant, and kind. People love and respond positively to those who behave this way.

Avoid expressing negative emotions, and control yourself. If you want to change others, focus on yourself – "If you want to gather honey, don't kick over the beehive!"

Principle 2: Give honest and sincere appreciation!

Understand people's needs and give them what they want. People have various requests. The most common desires are for health and safety, food, sleep, money and products and services that money can buy, sexual satisfaction, happiness with children, and a sense of importance.

The most important and most difficult is the desire to feel important, although other people isfulfilled in some way or another. It is the desire to feel important that encourages individuals to dress in the latest fashion, drive the latest model cars, and strive to be successful.

The way to understand a person's core character is to know what triggers that which makes them feel important. Only after learning this can you

make that person feel important. Of course, it is necessary to avoid saying or doing anything that will undermine this feeling.

When giving feedback to a staff member, it is necessary to use appreciation rather than criticism to motivate him/her. Criticism of a supervisor is very effective in destroying another person's motivation. Praise the person in every way possible and do not try to find fault with him. Also, avoid giving insincere compliments. People are not stupid, and they can recognize insincerity. Instead, appreciate others honestly and sincerely – "Flattery is telling the *other pe*rson precisely what he thinks about himself."

Principle 3: Arouse in the other person an eager want!

If you want to increase your impact on other people, discover what they want to achieve and help them achieve it. Doing so helps you understand their point of view and examine the situation from their perspective as well – "The need to be appreciated is one of the most basic of human needs."

Carnegie gives the following advice in the second part of *How to Win Friends and Influence People.*

Six Ways to Get People to Like You

Rule 1: Become genuinely interested in other people. Because people see you as a representative of your organization as a manager, you can deepen your employees' commitment to your company by showing a sincere interest in them.

Rule 2: Smile. Smiling is important because actions are more effective than words, and a smile helps show people that you like them. It shows that you are happy to see them and that you want to be friends. Of course, you have to be sincere in all this.

Rule 3: Learn people's names! When you meet someone for the first time, find out that person's name, family, job, or interests. Visualize this information as a picture in your mind. Then, when you see that person again, it is impossible not to remember them. It's important to remember names because people care a lot about their names. Otherwise, would so many people have schools, hospitals, or libraries built and named after themselves? The Dale Carnegie Institute is an example.

Rule 4: Be a good listener. Encourage others to talk about themselves. Paying special attention to the person speaking to you is much more important than looking around to see who else is nearby. If a customer comes to you to complain, simply listening carefully can help dissipate that customer's anger. It can even eliminate the person's complaints.

Rule 5: Talk in terms of the other person's interest. Speaking in a way that interests others and talking about their hobbies and passions makes a

difference. Theodore Roosevelt was a master of this skill. Because he was knowledgeable on a wide variety of subjects, when he was going to meet with an important statesman, he would research that person's interests. This habit allowed Roosevelt to surprise people with the information in his repertoire. Roosevelt knew that the way to a person's heart was to talk about the things they value most.

Rule 6: Make others feel important, and do it sincerely. Find a friendly way to make others feel important. For example, ask yourself honestly what qualities in people you can admire. Psychologist William James used to say that the deepest passion in human nature is the desire to be appreciated. By showing that you appreciate others, you help them feel important. However, you need to be sincere when showing your gratitude so that compliments are not seen as insincere.

In the third chapter, Carnegie talks about twelve persuasion techniques under the heading "How to Get People to Agree with You":

Technique 1: Disagreements only put others on the defensive, and a person who feels lost in a conflict also loses morale. The rule is this: You can't win when you enter an argument. Even if you win, you lose. Even if you are right, it is not possible to change the opinions of others; being right does not change anything.

Therefore, avoid getting into an argument. Understand the other person's point of view, accept disagreements positively, and control yourself – "The only way to win an argument is to avoid it."

Technique 2: Respect other people's opinions. Don't make others think you disagree with them with careless words, looks, intonation, or gestures. When you challenge other people's opinions, you don't make them change their minds, and you just motivate them to respond. You may even gain enemies – "When teaching someone something, do not pretend to be teaching, assume that you have forgotten, not that you do not know."

Technique 3: Admit that you're wrong. If you make a mistake, admit it immediately. Making such a confession is especially helpful when others think you're wrong. You can then tolerate self-criticism more easily. Other people are more likely to be forgiving and supportive when you admit your mistake. Otherwise, they will be more critical and angry with you.

Technique 4: Even if you're angry, start the conversation amicably. You can't win over someone who feels negatively toward you. By calming that feeling, however, you can begin to bring that person into your perspective.

Technique 5: Use the Socratic method. Have the other person say "yes" at the beginning of a speech. Start by talking about things you both agree on. Once you get a "no" answer, you may run into a lot of hurdles to overcome because the argumentative person wants to stay consistent. That's

why it's helpful to start with "yes" questions or an agreement statement. Once the person makes a habit of saying "yes," you can ask the harder questions.

Technique 6: When dealing with complaints, let your customers do the talking. Let them say everything they want to say. The more you listen, the more you will learn about their work and problems, and the better the position you will be in to help. Listen patiently with an open mind, be sincere, and encourage your clients to fully express their concerns and ideas. Let the other person talk more and feel superior.

Technique 7: It is important to aim for collaboration. Let the other person feel responsible for generating ideas. Remember that people believe in their own recommendations. Therefore, encourage them to give suggestions. You can just ask their thoughts and listen patiently.

Technique 8: See things from the other person's perspective. Put yourself in his/her shoes, and empathize so you can better understand what he/she wants and needs. This is especially useful if you are trying to sell someone a product or service. Thus, you can learn the motivation of the person in front of you.

Technique 9: Be sympathetic with the other person's ideas and desires. In this way, you show that you understand and empathize, even if you disagree or would do something differently. "I don't blame you at all for feeling that way. I would certainly feel that way if I were you." These words open any lock. Every human being craves understanding and attention.

Technique 10: People often have two reasons for doing things: the real reason and the reason that sounds good. People are inherently idealistic and think they are acting in good faith. So by being positive about their reasons, you will be more fortunate in changing them – "Appeal to the nobler motives."

Technique 11: Express your ideas by dramatizing, narrating, and animating; this is done in movies and on television – why not by you? Use vivid illustrations to convey your ideas. This approach works because simply telling the truth is not enough.

Technique 12: If nothing works, protest! This technique works because successful people love the chance to prove themselves. For example, industrialist Charles Schwab once drew a large "6" on the floor of a mill to note how many batches of goods the day shift workers produced.

The next day, when the night shift workers arrived, they drew a "7" on the floor to show that they had performed even better. This motivated the day shift workers to work even harder and write "10" on the floor when they went to work. By expressing what he wanted, Schwab encouraged his employees to work more productively and more diligently. This tactic was

effective in asking his employees to do a better job. Money neither brings people together nor keeps them together.

Leaders say Carnegie would apply the following nine important principles to motivate people without hurting or offending them:

1. If you need to discuss a flaw or concern with someone, start with sincere praise and honest appreciation.
2. If someone makes a mistake, indirectly raise awareness of their mistake.
3. Identify your own faults before condemning anyone else.
4. Instead of "directly ordering" someone to do something, say, "What do you think of that?" Ask questions, like having employees suggest their own ideas.
5. Don't blame anyone for their mistake.
6. Appreciate even the smallest improvement, and be sincere and generous in your compliments.
7. Assign a quality to the person next to you.
8. Encourage employees and make it easy for them to correct their mistakes.
9. Get people to willingly do what you want.

My father's saying, "Bendeniz Sabri" (your servant Sabri), as soon as he answered his phone came to mind. When I was little, I used to think that my first name was Bendeniz, but in this case, it turned out to mean, "I am at your service." Of course, it is also an act of courage to say this every time you answer without knowing who is on the other end of the line. Similarly, if anyone has a grudge against me, or wherever there is a problem, I first go to the other person directly and deal with it. In fact, once upon hearing a prosecutor visiting, I said, "If you have anything to ask me, I'm here."

These days, you might think that Carnegie's words are "plain" advice. However, there are still many popular books on persuasion and communication, many of which are shallow and do not go beyond Carnegie. Today, the rules of "empathy, arousing the interest of the other, avoiding excessive criticism, criticizing yourself" are important elements that vary in degree according to culture and time. Second, Carnegie's advice is not to win real friends but to manipulate people to sell to them or employ them, right? It's as if Carnegie is charting a path that proposes to achieve goals through a little flattery, based on the fact that the other person focuses only on him-/herself. Although, he is talking about sincerity here, there is no doubt that the tactics are manipulative. The value of the book still lies in the details. For example, don't give orders, ask questions, listen, and convince people by giving good examples, and these ways of influencing the other person are still valid today. Today, there are undoubtedly many studies and valuable books that explain how human behavior will change, how to communicate better,

how to motivate people, and how to live happily together. Yet, I still think Carnegie's is the first book one should read.

Reference:

(1) Carniege D. (June 2017), *Dost Kazanma ve İnsanları Etkileme Sanatı.* (Nazlı Uzunali Trans) Epsilon. https://www.amazon.com.tr/Dost-Kazanma-%C4%B0nsanlar%C4%B1-Etkileme-Sanat%C4%B1/dp/975 3311214

Athenian Philosophers Seemed to Me as If They Never Lived, But Who Knows

Raphael was an Italian painter and one of the three most important figures of the Renaissance, along with Michelangelo and Leonardo da Vinci. He is a complete artist, that is, both a painter and an architect, as is often seen in the artists from that period.

Raphael's father was also a painter, even first teaching his son the art, and when the father noticed his son's superior talent, he took him to Perugino, where the young man received his first important education. Raphael lost his family early; he lost his mother when he was eight and his father when he was eleven. He could paint with great skill by the age of fifteen, and at seventeen he started painting at master level. At the end of the fifteenth and the beginning of the sixteenth century, it was a great success to be named a "master" at a young age in the art world during the period in which he lived. In time, he no longer fit in Urbino, the city where he was born and was living, so at the age of twenty, he went to Florence to see works by de Vinci and Michelangelo. When he visited da Vinci's workshop on this trip, he saw and was impressed by the *Mona Lisa* (*La Gioconda*) that was there at the time. It is even said that this state of his; his long examination, and his visit to see the painting attracted da Vinci's attention and he asked the young man, "Raphael from Urbino?" In other words, even at that young age, Raphael's fame had exceeded the boundaries of his city and reached the most famous painters of the period.[1]

Now, if we turn to the work *The School of Athens*, it is a great homage to the corpus of philosophy and the history of thought. This fresco, which is a concrete example of the spirit of the Renaissance, features the most famous scientists and philosophers of the ancient Greek period. Another important feature is this: In the work, important names of those who built the ancient Greek culture are depicted in a building of ancient Roman architecture. Thus, two important elements that formed the basis of the Renaissance were brought together in *The School of Athens*. As a reflection of Greek art, where the statues of Apollo on the right and Athena on the left are included, the scene gained a whole new life as the unique invention of architect Filippo Brunelleschi's perspectives reinforces the sense of depth with successive arches.

As for the figures in the fresco, right in the center are Plato and Aristotle, who are the most important names of the era and in the history of philosophy. Plato, a student of Socrates, was also a teacher of Aristotle. Although there is a teacher/student relationship between them, they are representatives of different philosophical disciplines. The reflection of this situation in the picture is as follows: Plato is pointing upward, representing his idealistic philosophy, which is similar to saying that we should look for absolute reality in a world of ideas. Right next to him, Aristotle points to the ground, which is a reflection of his realist world of ideas; this seems to indicate that the material world, nature, is the source of knowledge. They each have a book in their hands; his dialogue *Timeo* (Timaeus) in Plato's hands, *Etica* (Ethics) in Aristotle's hands.

Regarding Plato, and talk his views on art and artists, according to Plato, the world of matter is not real but is a world of appearances; the beings we perceive with our senses are only copies of Ideas. Since art imitates nature, artists/poets deal with appearances instead of facts/essences. That is, they make copies of copies and distance people from real truths. This is why Plato does not include poets in the ideal state.[2]

According to Aristotle, art is an imitation, "mimesis." The artist reflects the elements of nature, human relations, both what is and what can be. The artist reflects the object, that is, the matter he sees, by interpreting it. In this sense, Aristotle states that art is not just an imitation, but an action that goes beyond it and belongs to human beings. Aristotle, on the other hand, differs from Plato in his view of art. According to Aristotle, artists make up for the deficiencies in nature and repair the flaws in society.[2] I wonder, which one do you think is right, or which one do you feel close to?

In *The School of Athens*, we can see that Plato's face is likened to da Vinci's. This can be interpreted as a kind of salute/stance of respect. The face of Aristotle is depicted as that of Giuliano da Sangallo, a famous sculptor and architect who lived in Italy during the Renaissance period.

It is not clear who the figures in the rest of the painting are; there is no complete synergy of understanding. However, if we start from the general acceptance over time, to the left of Plato and Aristotle, Socrates appears in green clothing. He is pictured explaining something to the people around him by calculating with his fingers. Socrates did not leave any written work behind, and all the information we have about him came from Plato.

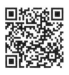

Socrates, one of the founders of Western philosophy, is also the founder of the dialectical system of thought. Observing, "The unquestioned life is not worth living," Socrates says in Plato's *Apology*, "I tell you not to spend a single day without discussing the goodness."[3] What a

valuable piece of advice that still applies. But things didn't end well for him. The philosopher who created environments for philosophical discussion by wandering around the city, was accused of confusing the minds of young Athenians and was put to death with hemlock poison, refusing the exile he was sentenced to. For this reason, the fact that he is pictured in dialogue with those around him is an attribute to Socrates.

Just below Socrates' feet, we see Diogenes sitting haphazardly on the stairs, holding a copper water bowl in one hand and papers in the other. Diogenes is a thinker who chooses to live on the streets, feeds on the wastes thrown in the garbage, and mostly does not prefer to dress appropriately, but wraps himself in dirty rags, and lives nonstandard. According to him, a rich and happy person lives in accordance with the rhythm of nature, is free from the traditions and customs of the society, and is content with little.[4]

When we look at the bottom of the fresco, Pythagoras is visible, who recorded information on the tablet in front of him. Little is known about Pythagoras' life, but he is believed to have been born on the island of Samos, off the Turkish coast. It is also said that he learned the principles of geometry on a trip to Egypt. He is the individual who proposed that the square of a hypotenuse, is equal to the sum of the squares of the other two sides, which we all learn in school. He also claimed, even numbers are good, odd numbers are bad, and the concept of justice is indicated by the number four. He was the first person to coin the term "philosophy" and to apply the word "cosmos" to the universe.[3]

Just behind him, Anaximondros is pictured copying his notes into his notebook. On the upper left step, we see that Ibn Rushd is depicted. Ibn Rushd is a philosopher and a mathematician born in Andalusia.[2] He also played a major role translating Aristotle in the twelfth century, for which he became known. The saying "Wherever we are, knowledge is our homeland, ignorance is a foreign place"[3] is valid at all times.

In the center of the picture is Heraclitus, represented sitting thoughtfully on the steps with his hand on his chin. He is probably the owner of the saying "You can't bathe in the same river twice" that we've all heard. What he means here is that water flows and there- fore the water we touch is constantly changing; according to him, every object and thing is in a state of constant change. The face of Heraclitus is likened to the face of Michelangelo in this work. After the da Vinci on Plato's face, this appears as a second homage.

Another remarkable name in the painting is Hypatia of Alexandria. Famous for her grace and beauty as well as her contributions to science, Hypatia is the daughter of the Alexandrian mathematician and philosopher Thenon.[2]

Below on the right, Euclid (Euclid/Euclides) is pictured making drawings on a wooden board with a compass in his hand, for the crowd gathered around him with curiosity. In the description of Euclid, Donato Bramante, who had a very important place in shaping the history of art, is included.[5]

The last surprise is on the right side of the picture, where Raphael added an image of himself at the age of twenty-six or twenty-seven. He depicted himself as Apelles, one of the ancient Greek painters.

The work is quite impressive both by conveying the spirit of the Renaissance and respectfully giving a place to figures representative art.

Speaking of so many artists, let me mention a memory that is rumored to have passed between two famous artists of the Renaissance period: "One day, while Raphael was with his disciples, he met Michelangelo, who said to him: 'You walk surrounded by an entourage like a general.' 'And you,' responded Raphael: 'You walk alone like an executioner.' "[5]

None of us can do things alone; we move forward with our surroundings in our own time, adding to a legacy that preceded us and gave us the chance to own what we own today. It seemed to me that the Athenian philosophers had never lived until I saw Raphael's fresco *The School of Athens*, but who knows what it is, and who is who?

So I mean this: the formation of history and the value we later attribute to it may not reflect the truth. This is because the hardest thing to obtain is an objective point of view. The judgments that we form by saying, "he said," "he said this," "I understood it this way," and finally "I think it is so," become public knowledge and perception over time and call themselves objective. They are now "generally accepted facts." This is called "intersubjectivity" in social sciences. The origin of paradigms in social sciences is such assumptions.[6] I would like to mention the word *mutawatir* here.

Mutawatir in theology and the *fiqh* method, meaning "successive," hadith refers to a report that claims the truthfulness of the text in itself, while a large number of reporters, at different times that their agreement upon an untruth is inconceivable kept delivering; therefore, it is accepted as unquestionable. The condition of transmission within the framework of the conditions deemed necessary for such a report is also called *tawatur*, roughly meaning "broad authentication." It is called as such because the reporters conveying the news are not doing so at the same time and together, but at different times and one after the other.[7] I think the criterion of being

(*mutawatir*) adopted by many uninterested people can well be used to justify events. Otherwise, official history becomes indistinguishable from accepted facts and believed dogmas.[8] Isn't it already proof of such a will that this painting of an imagined scene made centuries later in the Renaissance period came into being, especially with the faces of the new era's figures? It should not be difficult to guess which willpower, for what purpose, ordered and adopted this work! Right here, I would like to quote from the conclusion section of Necati Demir's Turkish article titled "Some Thoughts on the Origin of Philosophical Thoughts":[9]

Western civilization has developed on a triple pillar. Since its rational front, Greek thought, expansionist worldview, Roman pragmatism, and the fanatical front is equipped with Christian crusader ideology, it turns into a sixfold charismatic structure. The sharpness of its expansionist policy, technological superiority, the unpopularity of its pure rationalism, the Christian spirituality and the bigotry of the Christian crusaders are tried to be eliminated with its humanist packaging. This hexagonal demeanor of the West is vital in maintaining its popularity in any location and time. For this reason, Greek philosophy, one of the main dynamics of Western civilization, had to be protected, even though scientific data revealed that it was not as original as it was thought. However, the discovery of scientific data in Egypt and Mesopotamia as a result of anthropological and ethnological studies, and philosophical data in India invalidated the scientific and rational side of the term "Greek miracle," because it is necessary to explain the qualifications and judgments of each field with the concepts and idioms of that field. The concept of miracle is related to religion, the emergence of philosophical effort is a social event. How can the source of social events be tried to be reduced to a religious concept in the scientific context? It may have been a respected assessment in the era before anthropological and ethnological research on the Middle East, Anatolian, and Indian civilizations, which was firmly believed to be impossible, was put forward. The argument that such a mistake was made as a result of the inability to hide the astonishment with the emergence of a social phenomenon does not sound convincing.

As stated above, Western social theorists may have seen the dissemination of the term "Greek miracle" as necessary for the future of Western civilization, but the question arises of how Western thought, which is based on rationality, feeds good attitudes to this irrational idiom. We do not know if there is a reasonable answer to this question for now. Despite all these contradictory documents and findings, the insistence of most Western cultural historians on the term "Greek miracle" is still incomprehensible. "The truth is that the Greeks were the inventors of a certain formalism. In order to bring order to thought and continuity to action, they have compiled methods of reasoning that have no analogs," says Henry Dumery, making the most reasonable and realistic determination on this subject. The more erroneous, biased, and inconsistent the views defending that the Greeks are the inventors of all kinds of knowledge and wisdom (religion, philosophy, science, art, morality, and law); the more wrong and biased the thought that the cultural accumulation they contributed to civilization is just Greek nonsense. It is the result of an attitude. For Greek philosophy, the descriptions of "Greek miracle," like the praise of praise, or

"Greek nonsense" like the satire of satire are biased, subjective, and unserious, far from any moderation. Greek culture was influenced by Egypt and Mesopotamia in science, by Anatolian cults in religion and also by Indian thought in philosophy. But the ability to use them as materials and add their own cement to the establishment of Greek civilization is an honor of the Ancient Greeks. Western civilization is shaped around the helmet of Greek thought, not Indian thought. However, the failure of Western social theorists to respect scientific dishonesty is the sad part of the problem. Otherwise, science is the property of every segment that demands it. To the extent that contributions to scientific studies and civilization are honorable, it is repulsive to consider them worthy of anyone other than ourselves or to try to hide and conceal the truth.[9]

For this controversial situation that still continues, I would say that the new materialist and rational Western thinkers leaning on ancient Greek mythology and glorifying the ancient Greek philosophers, and even including the Andalusian scholars of that period were probably seeking to gain objectivity. Otherwise, they would either live under the rule of the church as a Christian or surrender to the last updated version of the Islamic creed. At best, the last option would be to return to the stories of ancient Israel. The Old/New Testament stories found together in the present holy book of the West, the Bible, were probably the manifestation of this.

A similar situation is seen in many branches and stages of art. In addition to fine arts, this is obvious in literature, song lyrics, and cinema. It would be naive to think that the actions that create these currents, which produce a great economy while shaping and entertaining visions of the future that make up the thoughts of humanity, will happen spontaneously. Of course, this should not lead us to the assumption that we are under the dominance of conspiracy theories. There is no need for anyone to lead us into disaster scenarios, because we are so cruel to ourselves anyway.

Don't ask where it came from, but I have a similar fictional expectation for sports. For example, football contains a large betting economy that cannot be left to the efforts of 11 × 2 young players in ninety minutes, especially when the ball is round. Greek philosophy is not just Greek philosophy, and football is not just football, you see.

I hope all of our lives will be surrounded by "well-intentioned" efforts that respect the past and our differences, increase the value and fertility of the present, and sow good seeds for the future.

References

(1) https://tr.wikipedia.org/wiki/Atina_Okulu

(2) Eco, U. (2019). *Umberto Eco ile Sanat*, Destek Yayinlari.

(3) Buckingham, W. et al. (2011). *Felsefe Kitabi*, Alfa Yayinlari.

(4) Gokberk, M. (2008). *Felsefe Tarihi*, Remzi Kitabevi.

(5) Loyal, C. (2020). *Uygarligin Ayak Izleri Ronesans'tan Barok Donem'e Sanat Dehalari*, Epsilon.

(6) Babie, E. (2021). *The Practice of Social Research*, Cengage Learning.

(7) https://islamansiklopedisi.org.tr/mutevatir

(8) Aktay, A. (2018). "Tarih Arastirmalarinin ve Tarih Yaziminin Onundeki Temel Sorunlar," *Sosyal ve Kulturel Arastirmalar Dergisi*, 4(7), pp. 57–71.

(9) Demir, N. (1998). "Felsefenin Mensei Uzerine Bazi Dusunceler," *Cumhuriyet Universitesi Ilahiyat Fakultesi Dergisi*, 2, pp. 383–407.

What's at the Museum of the Future?

Recently, I visited the Dubai World Expo and wrote an article summarizing my visit within the context of Sustainability, Opportunity, and Mobility. On that trip, I said I would talk about my observations of the Dubai Museum of the Future, a building with technology, architecture, and historical background, commissioned by the Dubai Future Foundation. In this chapter, I would like to talk about this wonderful museum that brings the past with the present, and bridges the gap between the future and the past.

Resembling a calligraphic space base when viewed from the outside, the thirty-thousand-square-meter engineering, technology, and architectural marvel of a museum speaks volumes, even with its name. Aiming to bring together the most qualified scientists in the world who will build the future of the UAE in science and advanced technology, it points to the past with calligraphic decorations that shed light on the future, on history, and on traditions of the country. Bringing the past and the future together in the present time, the museum symbolizes a great challenge in terms of architecture and structural engineering.

Dubai, the most unique part of the UAE, has always caught my attention among all the Arab countries I have visited. Isn't it very interesting that by preserving its own culture, the region is now a center of attraction, not only commercially but also culturally, for many countries, including those in Europe? However, the people in Dubai still dress, eat, drink, and have fun in traditional ways. They write and speak Arabic. They are rich enough to take a holiday on Friday, Saturday, and Sunday, on the holy days of all three religions, and work only four days a week.

In fact, the situation is so complicated when we look at the alphabetsaround the world. In the former USSR, large masses of people, largely university graduates and intellectuals, were educated with the Cyrillic alphabet. Greeks, Israelis, Indians, Chinese, Japanese, and many more advanced nations; Korea, Taiwan

Forty years ago, I visited Tokyo and Kyoto to compare the westernization journey of the Ottoman Turks, which began with the Young Turks, with a similar journey of similar nations such as Japan. In any case, my analysis shall stay with me for now.

The first Museum of the Future, which opened to display scientific ideas and projections of the future, has a facade of 1,024 stainless steel panels with a 17,600 m^2 closed area, clad on a seven-floor column-free structure. The exterior of the museum, which is 77 m high, has 14,000 m of illuminated Arabic calligraphy. The UAE has been intensely interested in futuristic

structures and projects. This structure took nine years to complete, and this museum building, which may potentially be the new symbol of the country, has remarkable features in terms of sustainability as well as its architectural structure and innovative features. Working with four thousand megawatts of solar energy, the museum also shares an important message about the country's determination to use clean energy.

Although the UAE is known for its striking skyscrapers that emerge from a combination of steel and glass, it also has a very rich fauna. The natural diversity and richness of the country are also reflected on the green plateau outside the museum. The garden area, which hosts one hundred tree and plant species, is adorned with trees such as palm, acacia, and cedar, which are best adapted to the climate of the country, and it is also home to endemic bird and bee species.

Each floor of the seven-floor museum, which takes its design from Islamic literature, points to a different theme. Visitors entering the museum feel themselves in the future and in outer space on the first three of the seven floors. The other three floors host research institutes and universities focused on big data, robotic technologies, AI, and space technologies. The last floor is reserved for children who are the future of the country and of science. The museum will lead the way in the development of smart cities, transportation, health, education, and experimental technologies.

When you see different cultures and witness different lives, various traces are left by that experience in your soul and mind, and these become more evident over time and can be expressed. A few weeks after my visit to the Museum of the Future, the first thought that came to mind, through my observations and experiences was that there is a great deal of difference between the world's cultures in technology and their imaginations of the future. In Western literature or technology storytelling, the future is always imagined as dystopian for some reason. Even great blessings such as AI and robots that can facilitate the daily life of humans are always portrayed as tools of war tools or as a source of domination. In short, these are bad and pessimistic stories. Written culture is formed in this direction, and this point of view dominates television shows and movies. I mentioned this issue in an article titled "The Unknowns of the Metaverse World Are Vast But You Must Be Prepared!", where I mentioned the movie *Dune*.

However, our life experience so far, shows the opposite. The Industrial Revolution, the Space Age, the Information Age, and the IoT have made life easier, increased our well-being, and extended the human life span. So why do we always imagine a pessimistic future in which the creatures we design and develop are hostile and evil? Think about it: the advanced space creatures in movies are always ugly and bad-tempered, even disgusting! If only Freud could explain this.

Constructed in a country that has adapted to technology and the culture of technology much later than Western countries, the image of the future and technology I saw in the Museum of the Future, unlike the West, is utopian, not dystopian – a better and more efficient world develops in contexts such as coproduction, well-being, and health. When technology itself is considered a tool, it is neutral. If you determine the direction of development according to a mission that you will impose on it, and develop the technology to keep it alive and persevere, it will be for the benefit of humanity and the direction of development will always be toward the good. Commercial company partnerships and products realized on this subject are also exhibited in the museum, which is promising.

When leaving the museum building with these thoughts, I overheard some conversations of the visitors. Asian visitors also evaluated the agonic oval structures of the museum in the context of feng shui. I think the effect of the museum on me is not individual but universal.

"Overrated Graffiti Artist" Banksy: While Everyone Else Is Busy Self-Sharing, He Is after Mystery!

A news story was published recently that you may have come across.[1] HM Reading Prison, also known as Reading Gaol, which closed in 2013, was proposed to be turned into a residence, while some opponents of this wanted it to be turned into an art center. While these discussions were going on, it was noticed one morning that graffiti had appeared on the wall of this old prison. In the graffiti work, a prisoner escapes by making knots of sheets of paper coming out of a typewriter. Many commented that the person in the work might be Oscar Wilde, who had been detained in Reading Prison, 1895–1897. Wilde wrote the poem "The Ballad of Reading Gaol," one of his best-known works, in this prison. The poem contains Wilde's well-known verse: "Yet each man kills the thing he loves./By each let this be heard./Some do it with a bitter look,/Some with a flattering word./The coward does it with a kiss,/The brave man with a sword!"

After some time, Banksy shared the creative process of the graffiti work in a video[2] he published on Instagram under the title *Create Escape* and confirmed that the work was his own.

So, the owner of this work of Banksy is who?

When *Time* magazine included him in the list of "100 most influential names of the year" in 2010, he shared his image with a paper bag on his head, and even the documentary *Exit through the Gift Shop*, which he produced himself, was nominated for an Academy Award, which left everyone to wonder whether he would participate in the ceremony, and you guessed it – it was mysterious. Some claim that the artist Banksy is a group of people and those who claim he is the soloist in the band Massive Attack. While many people look for traces about him, we only have the generally accepted information that is believed to be true: He was born in 1974 in Bristol, United Kingdom.

Even if you haven't heard of him, you probably remember the news about *The Girl with Balloons*, which just after it was sold in 2018, slipped down from its frame and was torn to pieces by a paper shredder mechanism.[3]

Everyone was shocked, most of all, I think, the woman who bought the work, whose name was undisclosed. Most of us have watched the video of the news.

It was said in the video that once the work had been sold, an alarm sounded from the painting and it performed a performance on its own,

self-destructing in front of every one's eyes, and this was realized as an act of art. While discussing who carried out this incident, Banksy posted on his Instagram account,[4] so we understood that this was his act. Then he even made the following statement: "As Picasso said, the impulse to destroy is also a creative impulse." This was the product of a fine mind! If you wonder what performance art is, it is a type of art that has a beginning and an end in time, and is limited in time, while a painting is fixed in time, stationary. Banksy added a meaningful memory to the sale of his work, as he was someone who pondered who art belongs to. But this work, *The Girl with Balloons*," which was eventually turned into fragments, was more valuable than its original form.

Banksy is of interest to me because, in a time when everyone is sharing themselves from moment to moment, the mystery is lost. That is, if you are not seen, it is thought you are nonexistent, whereas Banksy conceals himself carefully and stubbornly. He wrote, "overrated graffiti artist" in the section introducing himself on his Instagram profile, in other words, he called himself an "overrated graffiti artist"!

Banksy does not say who he is, nor does he announce in advance where we can encounter his works. Suddenly, he specifies a place somewhere in the world, then people who walk by see it and talk about it, and by sharing it, he maintains the obscurity of personal identity. Of course, when this is the case, works that are said to be his show up in many places. The artist has created a digital solution to this issue and publishes fake and real works on his own site. The artist communicates with us through his social media accounts and website,[5] thus determining his own boundaries and using technology within the boundaries he wishes. It seems as if he is saying, "I have no person, these are my works!"

Banksy is an artist who creates his message-based works on walls in various parts of the world, especially in the UK. Using the world as a giant canvas, his street art works, one of which he produced on the West Bank Wall built by Israel, by traveling to Palestine, is also one of his most talked-about works.[6] At that time, he made huge art holes in the wall in the area of the graffiti, providing quite peaceful views through imaginary windows. He also put his life in danger during this process.

What a work of art shows at first glance is less than all it contains; understanding can change over time, gain dimension with the depth of the viewer, and is open to infinite interpretation. Even if you don't want to think about what an artist wants to show in its simplest form, Banksy does this with a punch that creates questions in your mind. Moreover, he does this by blending it with clever humor.

Banksy, who describes his art as a party to which everyone is invited, stirred up quite a lot of attention when he left a small stone inside a wall

panel depicting primitive people at the British Museum in London in 2005. He drew a primitive man driving a shopping cart on a small stone.[7] That stone stood there for days. I wonder how many people visited that section before the incident came to light and failed to notice the strangeness?

Well, we go to museums to examine the artifacts, and how many people and why has this guerrilla work standing inside the work not seen?

We also have reproductions of Salvador Dali and Picasso on our company ladders, and for some reason no one notices them. I guess one cannot see the value before their eyes when such works are not luxurious enough or appear in an unexpected place.

To understand Banksy, it is necessary to go back a little.

Modernization started in the field of art in the early 1900s. In order to comprehend Banksy, we need to look at the movement against the idea that art belongs to a certain group, which was the point at which critical approaches rose in the art world. One of Banksy's most important characteristics is that his art is critical; until the period of modern art the features that made art unique had been questioned and eroded. The trend called Dadaism was an effort to "destroy" art as we know it. With this aim, they started to present this dual structure between the real object and the artistic representation as an artistic object to eliminate distance. Works by Marcel Duchamp are examples of this. In 1917, he flipped a urinal and displayed it like a fountain.[8] Jean Arp had the same purpose in 1917, when he created collages from random shapes;[9] then in 1989, when Gianni Motti exhibited a work of art with invisible ink that is seen as a blank canvas;[10] in 1958, when Lucio Fontana started to produce works of art by simply cutting a blank canvas.[11] French artist Arman filled the inside of a gallery named "Le Plein" (fully loaded) in 1960, in his exhibition called *Le Plein*, which he was not allowed to enter,[12] and Robert Barry sent an invitation for his exhibition in 1969, but the invitation stated "During the Exhibition the Gallery Will Be Closed."[13] In other words, he presented the closed gallery as a work of art. An example of a Turkish artist in this regard is Bedri Baykam.[14]

All of this sounds crazy, but it sure makes you think about what art should be! What are the boundaries of a work of art, what should it be, who can decide on them? For example, does it have to be aesthetic? Does it have to be beautiful? Behind all of these works, there is an effort to oppose the restrictions on art prescribed within a certain framework and rules. Since Banksy does not want those who are not satisfied with his existing understanding of art, to use one of his works of art as decor because only a certain group could afford it, he mostly produces his works on the streets and in public spaces. Thus, he makes the work of art question to whom it belongs. To whom does the artwork belong – to the artist or to the purchaser of the work? Banksy is one of those who say the work does not belong to anyone

but himself. I agree with him, and I would even say that art works, in my opinion, are timeless. People collect not the works, but the works the owners. At the end of the day, you see that they are doing something to make people talk and question them, and then we start talking.

As you know, this recent period has been exceedingly difficult for the entire world, and especially in the UK, the Covid-19 pandemic was quite difficult. Banksy also gave a message to his fans that he would continue production during the pandemic by sharing mouse drawings from his house's toilet with the note "My Wife Hates My Work from Home."[15] During this period, he drew two rats on the London subway: in one the mouse holds disinfectant, in the other the mouse sneezes. Under the video he shared on his Instagram account, he dropped the note "If You Don't Wear a Mask, You Won't Understand."[16] Later, the artist thanked the health workers who worked by putting their own lives at risk during the pandemic, and created a toy nurse who appeared as a superhero in the hand of a child in the picture he shared with the title *Game Changer*.[17]

Another pandemic work by Banksy was a graffiti image on the wall of a house on Vale Street, which is the steepest slope in Bristol, England, showing an old woman with her dentures coming out of her mouth as she sneezes.[18]

In 2019, Banksy, set up a street stall in St. Mark's Square, then posted a series of paintings depicting a huge cruise ship looming over the Italian city, before local police appear to move him on. He crashed the Venice Biennale, to which he had never been invited, then shared what happened on his account. [19]

In 2013, he produced a new public work every day during October with his *Better Out Than In* project in New York. Residents and officials of the city were on the hunt for Banksy's artifacts for a month. On the first day in Manhattan, the journey depicted a child reaching for a bottle of spray paint on a sign reading "Graffiti Is a Crime" in the painting *The Street Is in Play* and it was presented to people all over the city with different works. A group of people even appeared in eastern New York, blocking the way of people who appeared and demanding $5 from everyone so that people could see them.[20] At this point, I cannot go on without mentioning the exhibition of our Turkish artist Tosun "Baba" Bayrak, who turned New York upside down in 1968, at Riverside, the most avant-garde museum at the time. When the art critic Grace Glueck described the art as "Shock Art" in the Turkish Delight article published in the *New York Times*, she said, "don't go running to the police because it is just art" (p. 83). I remember our artist Tosun Baba with mercy and grace.[21]

While certain people can decide which works to hang on the wall of a museum, this mysterious artist, who produces his art with spray paint accessible to almost everyone, with very dark and sarcastic humor in the public

sphere, has changed some things in the art world and made a sound with almost every step. It seems that it will continue to make sound in for many more years. Who you are is more important than how you look, what you do, what you say, and what you worry about, right?

References

(1) https://www.theguardian.com/artanddesign/2021/mar/16/banksy-on-side-of-former-reading-prison-defaced-with-red-paint#:~:text=A%20mural%20by%20Banksy%20on,of%20paper%20from%20a%20typewriter.

(2) https://www.instagram.com/tv/CMAHrGPFV2V/?igshid=jh2l3l3gknxr

(3) https://www.bbc.com/news/uk-england-bristol-45829853

(4) https://www.instagram.com/p/Bokt23Ehlou/?igshid=1ek66v0c9u8nv

(5) https://www.banksy.co.uk/

(6) http://www.bbc.co.uk/turkish/news/story/2005/08/050808_banksy.shtml

(7) https://www.bbc.com/news/entertainment-arts-44140200

(8) https://en.wikipedia.org/wiki/Marcel_Duchamp

(9) https://www.wikiart.org/en/jean-arp/untitled

(10) https://www.independent.co.uk/arts-entertainment/art/news/blank-canvas-london-gallery-unveils-invisible-art-exhibition-7767057.html

(11) https://www.tate.org.uk/art/artworks/fontana-spatial-concept-waiting-t00694

(12) https://www.theartstory.org/artist/arman/artworks/

(13) https://www.wikiart.org/en/robert-barry/closed-gallery-1969#:~:text=Closed%20Gallery%20is%20a%201969,the%20gallery%20would%20be%20closed

(14) https://instagram.com/boscercevedopdolu

(15) https://www.instagram.com/p/B_Aqdh4Jd5x/?igshid=ac4z197mcgnz

(16) https://www.instagram.com/p/CCn800cFIbe/?igshid=f3hlmqbd1pfc

(17) https://www.instagram.com/p/B_2o3A5JJ3O/?igshid=184y9qoky0ssz

(18) https://www.instagram.com/p/CIn6guyMPeS/?igshid=326kohluwdy5

(19) https://www.instagram.com/p/BxxOKYflVSl/?igshid=1xdf1zcfib3m4

(20) Asatekin, C. (2013). "Banksy ve New York Sokaklari: Better Out Than In," Artful Living, Nov. 18, https://www.artfulliving.com.tr/sanat/banksy-ve-new-york-sokaklari-better-out-than-in-i-180.

(21) Bayraktaroglu, T. B. (2018). *A Turk in America: Memoir of Sheikh Tosun,* Sufi Book Publishing, p. 224.

Sarah Morris: There Is No Objective, Everything Is Subjective!

I visited artist Sarah Morris' studio on a snowy Friday afternoon in New York on March 21, 2021. It was a very tidy, immaculate workshop with large windows, high ceilings, several large and spacious rooms, organized like a movie set.

We are often used to seeing works independent of the artist. However, I think that to achieve an understanding and give meaning to works with the artist who created them, brings about a more holistic understanding of the idea behind them.

Morris humbly shared not only the secrets and limits of her art but also the excitement of her new works and her life, first shyly, then sincerely, and from the heart. It is undoubtedly a precious experience to be in the same environment with the artist, in her studio.

Morris prepares her sketches digitally. She works on color compositions with watercolors. Now there are not only squares but also rectangles, and I feel that there will be other unexpected arrangements in her works soon. She freely paints the forms that she outlines with tape. In fact, she says she can change colors again at the last minute. Just like after face transplant surgery, when the bandages are removed after everything is finally healed, everyone, including the artist can see the final version of the work! How striking is the final work, a surprise.

Morris studies different subjects, sizes, locations, and geographies at various times. She presents iconic monuments to cities, she does light and color works that fill the walls of a museum or a train station, and bravely works outdoors.

I didn't know that the Japanese brand Uniqlo had her drawings on T-shirts until I met her personally; even she can drawing the picture of the sound!

Morris attaches great importance to the place and location of her works. She prepares the position of the work, and the models of exhibitions and buildings; she determines the place where her work will be posted.

I was very excited to see the models of the buildings, three-dimensional models of exhibitions, and miniature copies of her works, and to visit an exhibition when her works displayed there yet. Our artist is a meticulous perfectionist. Even the dyes that spilled onto the ground during her creative process were scattered as if they belonged to a plan.

Her works consist of paintings, outdoor works in iconic public buildings, and even films. However, there is a duality in her works, such as painting

and film are parallel universes, parallel planes, parallel sounds. The name that the artist gave to her studio is Parallax!

It's interesting that Morris works on various dualities in her art. In other words, she creates a "difference-based" aesthetic. There is a richness of meaning, color, and form arising from differences. She works with vectors and coordinates; she processes perspective escape points.

The artist focuses on fundamental realities while constructing her works. Images, industry, and the power of mechanization have led to a kind of reaction in her works. Even though all her paintings consist of simple shapes, they go through a multilayered process, and her revisions on movie posters are made with the anticipation that they will be of historical importance in the future.

Hasan Bulent Kahraman mentions this in his article on Morris titled "The Mirror Wandering around the City: Pictures of Sarah Morris":[1]

> Cubism and Pop Art are two great sources that came out of each other in the 20th century but passed on to the next generations with their inner transformations. From this point of view, an in-between name can be seen as a very important starting point in explaining Sarah Morris's sometimes enigmatic (mysterious) picture. Dutch painter Mondrian was using a space created by Cubism. This was not a direct interaction. It didn't have to be. Cubism broke a 400 year old norm of visuals. All of the new perception planes created involve a confrontation with the old accumulation, envisioning using different ends in the works of the Picasso-Braque duo. The De Stijl movement can be seen as an offshoot of this great body, just as later Pop Art was born using the objects and their markers that Cubism carried on the two-dimensional canvas. It should be remembered that the "grid" understanding included by De Stijl is also an improved possibility of Cubism. Mondrian was taking this understanding to an extreme already in the 1920s and he knew that the new output in question was an extremely important, groundbreaking opportunity. The depth that the 1930s brought to this understanding was surprising. Dividing the canvas, converting the sections into a color space.

I likened her workshop, working principles, and self-discipline to a silkworm. She spins the walls of her cocoon with her paintings, each picture hangs on the wall like a Post-it, a message that only she will remember. She comes out of this cocoon and makes films, spins her cocoons, and paints.

In her life, the artist, producer, and director lives from different angles, every different idea, form, and landscape she experiences; they follow each other from origami forms to spider webs to the state of the moon in the sky.

Reference

(1) Kahraman, H. B. (2011). *The Mirror Walking around the City: Pictures of Sarah Morris*, Dirimart, Sarah Morris Catalog.

Zaha Hadid: A Woman Architect Who Turns What She Visits and Reads into a Masterpiece

Let me share the beautiful things I see with those around me, so those people know and see who wouldn't want to. I can do this in a broader framework on my blog and social media. Of course, this helps me a lot too.

As everyday life passes by, I believe that one of the most beautiful things around us is artistic activities. Art is the thing that can refresh our souls, which are narrowed by many serious efforts during the day and can bring a new vision. Architecture is the most interesting and even visible branch of art that no one can escape from, even embracing and keeping you alive, for example, palaces, museums, concert halls, even places of worship since early times. Today, I would like to talk about a special name, Zaha Hadid, who went beyond the mold with these feelings and led to serious transformations in the field of architecture.

If you want to know who Zaha Hadid is, she was born in 1950 in Baghdad, Iraq. She graduated from the Department of Mathematics at the American University, then graduated from the Department of Architecture at the London Architectural Association School. After her graduation, she started working at the Office for Metropolitan Architecture and became a partner of the company in 1977. In 1979, she established her own architectural office, headquartered in London. In the same period, she taught at many prestigious institutions such as the Architectural Association, the Graduate School of Design, Harvard University, the University of Illinois, the Hochschule für Bildende Künste in Hamburg, and the Knowlton School of Architecture.[1]

Of course, in this period, she put her signature on projects of which one was more successful and resounding than the other. When asked about her source of inspiration, I found it very interesting that she talked about the trips she made with her family, especially her father, in her childhood. They traveled a lot, and their greatest interests were to see museums and historical artifacts in each country they went to: Sumerian ruins, other ancient artifacts in Iraq, and many other magnificent things. Yet, one of the most important places etched in her heart was the Cordoba Mosque in Spain. She even wanted to build a mosque in Istanbul; unfortunately, her life was not long enough. It could have been beautiful, but alas!

This famous architect, whose rejection of angular planes and favor for rounded lines is another delight in itself, actually set an exceptional example as a woman in this male-dominated field. Her team, which comprised four people when she founded her own company, reached three hundred people

over time, and in 2013 she was selected as "Business Woman of the Year" in England. Throughout her life, Hadid always being in search never gave up, always dreamed of new and different forms, and endeavored to turn them into reality.

In fact, as you can see in all these examples, the buildings she designed are like a 3D version of an abstract painting. For this reason, she made her mark in the history of architecture as one of the pioneers of deconstructivism. Deconstructivism is a postmodern architectural movement that emerged in the late 1980s. "It is based on methods such as breaking the integrity of the architectural elements that make up the building, play-ing with the surfaces, shearing and shifting the architectural elements such as the exterior with non-orthogonal corners."[2]

In fact, when you look at all these works of art, we can say that Hadid was also a genius. She produced bold forms in her designs, which were always fluid, walls that are not always as we know them and have been used to, ceilings and floors that are interchangeable. In addition, she produced many different forms that were deemed impossible on paper through consid-ering alternative solutions in a project.

In fact, when we look at Hadid's architectural works, we see ostentatious but simple shapes. Even this contrast is an indication of what sort of genius she was, and she produced comfortable, simple, but far from ordinary works by using different styles and forms.

The airport Daxing in China was among her last works. However, unfortunately, Hadid, who died of a heart attack in the hospital after suffering from bronchitis in 2016, did not live to see it completed.

If you want to learn more about the inspiring life story of this famous female architect, who started in Iraq, continued her career in England, and forged her name in art history with her works in many parts of the world.

After examining the life of Zaha Hadid, I can say that it is not important to travel or read a lot, because you are eternal if you can produce something different based on knowledge. Zaha Hadid, who combined what she saw with her knowledge and created masterpieces, is one of those who left behind a pleasant voice in this everlasting dome.

References

(1) https://en.wikipedia.org/wiki/Zaha_Hadid.

(2) https://en.wikipedia.org/wiki/Deconstructivism#:~:text=Deconstructivism%20is%20a%20movement%20of,harmony%2C%20continuity%2C%20or%20symmetry.

Every One of Ahmet Gunestekin's Works Is a Novel

The story of Ahmet Gunestekin began when he was born into a large family in the Garzan workers' camp in Batman, Turkey. The respect he feels for his hometown, the Anatolian lands, and the legends living in them is also carefully crafted in his art. He was one of those individuals who discovered his passion at a young age, beginning in oil paintings at the age of nine, opening his first exhibition in the corridor of the school in the third year of middle school, and participating in many exhibitions during his high school years. His first professional exhibition took place much later. Even in his childhood, he was determined and hardworking. He graduated from high school in 1984. Throughout his high school life, he wanted to take the Istanbul Mimar Sinan Fine Arts University exams and continue his education there. Later, his thoughts started to develop in another direction, and this was a great contributing factor in the formation of his own style. He states: "I started to drift away from the idea of academia. I realized that I was going in a direction where I didn't belong and that would limit me. By 1986, I had completely moved away from the idea of academic education. I found out what I needed to learn and chose how I would learn."

Each of his works is rooted in a story. I love this. For example, he describes his work *The Gate of Innocence* as follows:

> To understand the door of innocence, one must first understand the Trojan War. According to the legend told by Homer in the *Iliad*, the Trojan War lasted ten years. The reason for the war is the love between Paris and Helen. Paris is the son of the king of Troy and Helen is the wife of Menelaus, the queen of Sparta and the sister of the king of Mycenae. Helen is forcibly married to Menelaus. Paris and Helen fall in love and Paris abducts Helen and brings her to Troy and the war begins. The Gate of Innocence talks about this love. I see love as a kind of innocence, and I feel innocence more in white.

It is a layered work, it has a visual dimension, and it makes everyone feel differently about it. You find yourself in a story in the past, and you may think about concepts such as love and innocence.

There are many legends and tales about Mesopotamian and Anatolian civilizations in Gunestekin's works. He compiles legends and tales firsthand by going to see where they are said to have taken place. During his visits, he learns about the city's memories from the locals, talks to people who know its geography well, tours those places himself, and fills his mind. While doing all this, I appreciate the interest he

shows in instilling a sense of art and aesthetics in children of those regions by having them paint.

In his first period, he shot a documentary series called *Gunesin Izinde* (In the Footsteps of the Sun), which was broadcast on TRT for a long time. Its versatility is admirable. In this documentary series, he reflected on the impressions he experienced while making the *Haberci* program with Coskun Aral and again during his travels. In this project, whose aim is to convey us the mythological and historical information that he has been interested in since his childhood, he took a painter or a sculptor or a photographer to every city he went to. By opening joint exhibitions with them, they found and highlighted the features of the cities that remained in the background, apart from the known features.[1]

I like Gunestekin's early works more. Unfortunately, I have been able to collect only very few of them. The subjects are explained more simply; the colors are more dominant. There is so much that he tells in each of his works. His meticulousness, his style that requires much effort, and the fact that he does not use assistants are also admirable.

Now, his installations and sculptures that depict our historical and contemporary view of acute social issues attract attention. Finally, now we see the *gelene-ek* (a word play in Turkish with "tradition") sculpture series with its interpretations connecting the past to the present. It was very interesting to me. I was especially impressed by the legendary fish that comes from the mystery of the deep seas. I didn't know which one to choose. In any event, he chose it and sent it to me.

He says on this subject: "Tradition is actually a word that educates us. He gives tips, he says, you will add to what comes. I take the past as a reference and carry it to the present time in my own language. That's actually my whole secret. Thousands of years of stories or ceramics, for example, how many centuries culture is it, I carry the same tradition to today's modernity with my own stories, with my own forms."[2] Isn't it a precious and beautiful job to take the richness of a culture, blend it with today's data, and reflect it in the global arena?

His work *Olumsuzluk Odasi* (The Room of Immortality), which he exhibited at Contemporary Istanbul in 2018, was also well spoken of. As you can imagine, it also has a historical background, beginning from the first Babylonian poem, namely the *Epic of Gilgamesh* tablets. Gunestekin says that tablets related to immortality and flood affected him a lot: "According to their belief, when the flood broke out, the ship was hit and while all the animals were frightened and fled, the black snake with its body saved Noah's

Ark from sinking. The snake figure seen in many cultures is the symbol of modern medicine today."

Gunestekin started to think about the artifact when the first finds were made at Gobeklitepe and developed his thoughts over time. In 2018, he started working by transforming a shipyard into a large workshop and the work met its audience at Contemporary Istanbul the same year. This magnificent installation was realized through the sponsorship of Tersane Istanbul. "Otherwise, it would continue to live in a corner of my mind as a thought," says Gunestekin. He narrated as follows:

> The cost was close to one million dollars. I thought that a capital group should definitely support this. I knocked on Fettah Tamince's door and told him about the project. His first reaction was, "When do we start?" It was awesome. Such a courageous act In the current chaotic state of the country, a businessman who has had many troubles said on behalf of art, "Let's do something like this, I'm very excited too." I think it's very important. It stirred up a lot of excitement in the world. At the same time, the artist shared artwork on social media while still under construction. We used this very well. It received serious comments and likes from all over the world. We did the right thing. Because when you do something right, it can be seen in today's communication world, wherever you are in the world.

The installation consists of skulls and horns made entirely of metal. All parts are completely handcrafted, one hundred thirty people collaborated on this work. In thirteen months, 22,000 pieces of horns and skulls were cast in six casting workshops and 35 tons of aluminum were used. It's a heavy piece of work. It has a degradable structure, but even disassembly takes two days. Gunestekin started working on his installation in Tersane Istanbul on the Golden Horn. Before it was exhibited in Contemporary Istanbul, the work was available for viewing for a while at the place where the workshop was held, and after the fair, it was exhibited at the Heydar Aliyev Cultural Center in Baku for about two years. Gunestekin is doing excellent work for Turkey in the global arena.

We see skulls and horns quite often in his works. He explains that he symbolizes immortality with horns for animals and a skull for humans. What irony! He says that he questions death and fear through these images. He also said that for ceramic skulls, ceramic is something that comes out of the earth and that by combining it with the symbol of death, it processes both birth and death together. I find it very impressive that he represents birth and death like this, which is a common point all of us share.

The *Hafiza Odasi* (Memory Room) exhibition that I saw at Pilevneli Gallery in 2020 also contained quite different and unforgettable works. Gunestekin said, "I have always been fascinated by the physical traces our

lives leave on objects. Things accompany our emotional world and trigger our thoughts."[3] One of his works that impressed me the most was the *Hafiza Tepesi* (Memory Hill) installation in this exhibition. "Objects have multiple life forms, they are fluid. They use their power for different reasons. Some objects are evocative; they evoke strong memories and can represent an important part of our identity. The reasons that bring this and other works in the exhibition closer and relate to each other are these dimensions of the goods and space, apart from being just an object and a place." *Hafiza Tepesi*, an installation consisting of thousands of black rubber shoes stacked on top of each other, comes before you with the power and striking quality of the object.

This reminds me of the "93 War" stories I heard from my grandmother, and how they had to walk hundreds of kilometers barefoot in mud, not even having a black rubber shoe, with my aunt as a baby.

Gunestekin has opened many exhibitions abroad. He held solo exhibitions by international galleries in many world cities, in particular in New York, Berlin, Venice, Miami, Hong Kong, Barcelona, Madrid, Budapest, Athens, Thessaloniki, Geneva, Vienna, Baku, Pech, Brandenburg, Weilburg, Dresden, and Amsterdam. The main international museums where his works are exhibited include Vasarely Museum, Janus Pannonius Museum, Zsolnay Museum, Bank Austria Kunstforum Wien, Rosenhang Museum, Kunsthalle Dresden, and Kunsthalle Brennabor. It is very worthwhile that local values are exhibited all over the world and that our unique culture is available to many people. I congratulate him with all my heart.

Gunestekin also produced valuable works for Yildiz Holding, for our Godiva, McVities, and Ülker brands; these are works that consist of dozens of memories in each and that give the spirit of the brand very well on the whole.

One work even stands at the headquarters of Godiva in New York. If you would like to see the Godiva *Love*, please visit our Godiva Zorlu AVM Store.

There are hundreds of works to be mentioned, but I would like to talk about one more beautiful work Gunestekin did in 2021. I know very well

that worked nonstop during the pandemic, and Gunestekin brought together what he had accumulated during this period in the very beautiful nature in Zai Bodrum, Turkey. Zai is a concept culture area nestled in olive trees that are thousands of years old. Gunestekin chose a meaningful name for his exhibition in this beautiful space, *Kutsal Agaclar* (Sacred Trees). Trees have an important place in Gunestekin's art: cedar trees, pomegranate trees, and fig trees mentioned in the story of Noah's ark and in the *Epic of Gilgamesh* have already been seen in his works for many years. When he saw the olive trees in this exhibition space in Zai Bodrum,

Gunestekin said that these two should come together, and it was a wonderful meeting indeed. Public interest in this exhibition was also very high.

By the way, regarding his versatile personality, I must also say that as a businessman, besides his artistry, I like the way he handles his works skillfully, his approach, his communication, in short, his style. It would be an injustice not to mention that he is also a good cook. His patience and hard work are reflected in his kitchen as well, as he is a good host, cooking for hours with the utmost care, preparing accompanying dishes that he has thought about in terms of which flavors will complement each other best, and providing a tasteful layout in his workshop – all of which also reflect his aesthetic taste.

The advice he gives to those who want to be artists, I think, can inspire each of us, especially the youth: First things first. "You have to work hard," says Gunestekin and adds, "it is also very important to be brave and have self-confidence." In whatever we are doing, I think the personal effort we show is the most important aspect on the way to success, and your dedication to your work and your love of your work are your greatest forces that will assist on this path. My dear friend Gunestekin has adopted all these as a slogan and has set a fine example with his actions. I sincerely thank him once again for all his contributions to Turkey.

References

(1) http://gulersanat.com/Icerikler/uploads/2017/01/Ahmet-Gunestekin-Roportaj.pdf.

(2) https://www.aa.com.tr/tr/roportaj/ressam-ahmet-gunestekin-bir-basari-varsa-ben-onu-ulkeme-atfediyorum/1674105.

(3) https://www.perspektif.online/sanatcinin-hafiza-odasi.

About the Author

Murat Ülker was born in 1959. He graduated from the Management Department, School of Administrative Sciences, Boğaziçi University, Istanbul.

Mr. Ülker studied sector-specific subjects at international schools such as the American Institute of Baking (AIB) and Zentralfachschule der Deutschen Sußwarenwirtschaft (ZDS), serving an internship at the American company Continental Baking. In three years, he visited nearly sixty biscuit, chocolate, and food factories in the USA and Europe. He also worked on various projects for the International Executive Service Corps (IESC).

Mr. Ülker joined Yıldız Holding in 1984 as a control coordinator. Over the years that followed, he assumed the roles of assistant general manager, and then general director. As a member of the executive committee and a board member of various companies in the group, he led a series of cornerstone investments.

In 2000, Mr. Ülker became chairman of the executive committee, serving as chairman for eight years. In 2008, he became chairman of the board of directors. As of January 29, 2020, Ülker continued to take an active role in companies affiliated to the holding as a member of the board.

Mr. Ülker is known for his interest in modern art and Islamic calligraphy. He enjoys sailing and traveling with his wife and three children.